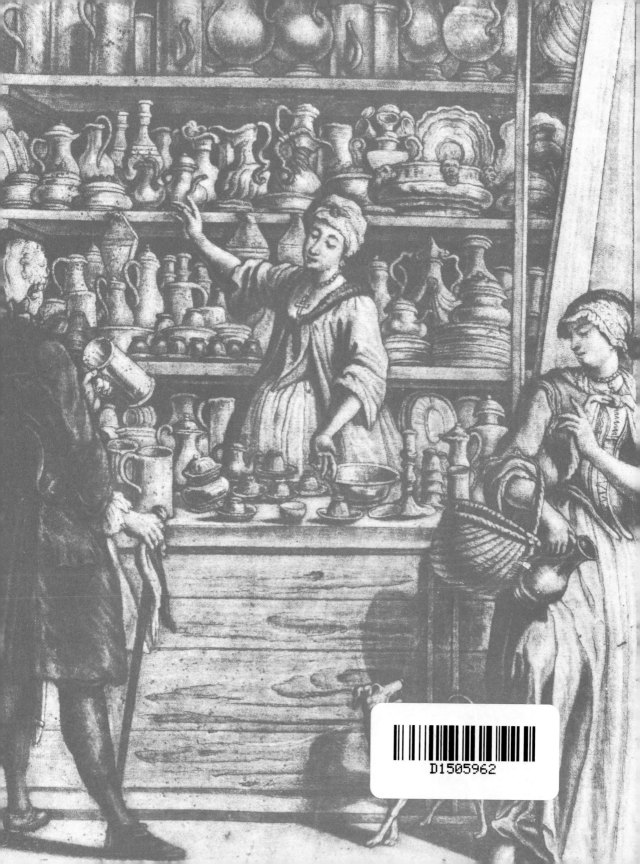

Hanns–Ulrich Haedeke

Translated by Vivienne Menkes

Metalwork

Universe Books

New York City

Published in the United States of America in 1970
by Universe Books
381 Park Avenue South, New York City, 10016

© 1969 by Hanns-Ulrich Haedeke

Library of Congress Catalog Card Number: 75-90382
SBN 87663 110 3

Designed by John Wallis
Printed in Great Britain

Contents

Illustrations

vi

viii

xi

xiv

Photographic acknowledgements

The Author and Publishers wish to thank the museums and collectors listed above, who in many cases themselves supplied photographs for reproduction.

They also wish to thank John Ross, Derrick Witty, Heinz Ollman and other photographers and agencies, who supplied the following illustrations: A.C.L.: 38; Alinari: 168, 169; Annan: 88; Archiv für Kunst und Geschichte, Berlin: 33; Wilhelm Castelli: 91; A. C. Cooper: 238; Deutsche Fotothek, Dresden: 13, 217; Kerry Dundas: 161; Françoise Foliot: xiv, 166, 167; Foto Marburg: 22, 39; Foto Stenz: 187; John Freeman Ltd: 105, 164, 165, 183, 224; Gabinetto fotografico Nazionale: 28; Giraudon: 77, 109, 192; Ian Graham: 182, 184; Helmut Körner: 191; F. Lahaye: 101; Landesbildstelle Rheinland: 122, 126, 132, 133, 135, 136, 138, 139; Landesdenkmalamt Westfalen-Lippe: 176; Mansell Collection: 127; John Marmaras: 78; Ann Münchow: 20; Musée Historique Lorrain: 186; National Monuments Record: 119; Sidney W. Newbery: 108; Josephine Powell: 155; Réunion des Musées Nationaux: 175, 185; Rheinisches Bildarchiv: 12, 21, 29, 36, 45, 66, 87, 115, 181, 190, 197, 198a, 205, 213, 218, 219, 220, 223, 233, 235, 244; John Ross: III, IV, V, VII, VIII, X, XII, XIII, 68, 174, 193, 199, 214, 222; Toni Schneiders: 3; Tom Scott: 157; Edwin Smith: 124, 189; Rudolf Stepanek: 234, 240; Thomas-Photos: 162; Penny Tweedie: 179; Bruno Unterbühner: 125, 137, 147; Herman Wehmeyer: 25; Derrick Witty: IX, 177, 178.

Photographs from Durham Cathedral are published by courtesy of the Dean and Chapter; those from the Wallace Collection by courtesy of the Trustees. These and those from the Tower of London and the Victoria and Albert Museum are Crown Copyright.

Part I Copper

The first materials to be used for making tools were wood and stone: metals did not appear until later. It is difficult to be sure which metal was first known to Man: the answer is probably gold, partly because it can be used in its raw state, and partly because its beauty must have attracted attention to it. Nevertheless, copper is probably the most ancient metal to be worked by Man. Therefore this book begins by considering the metal copper, and thereafter its alloys, bronze and brass.

Copper articles were used extensively before bronze (which is an alloy of copper and tin). For instance, dishes and nails made of copper have been found in burial chambers at Ur and Erech, dating from the third millennium BC and copper buckles and weapons in the palaces of Nineveh. Some pieces of copper and copper axes which have come to light amongst caches of stone tools and gold ornaments in the oldest ruined cities of the Chaldees may date from as early as 4000 BC.

1 Mining and processing

A large number of copper mines were in existence in ancient times. In Egypt, copper was mined from various parts of the kingdom.[1] Copper was also in general use among the Greeks for weapons and household articles until about 900 BC, while bronze was very seldom used; they mined most of their copper on the island of Euboea. The Romans took copper from various provinces of their Empire.[2]

In England, which was later to be an important source of supply, very little copper was mined in ancient times. Caesar, in *De Bello Gallico*, v.2, written between 58–2 BC, expressly says that copper was imported from overseas. Until 1558 the output remained very small; German miners began to work in Cornwall during the reign of Elizabeth I, but these mines did not reach a significant level of production until the beginning of the eighteenth century. Mines in Anglesey began producing copper in 1768, and in 1779 they produced so much that they swamped the market and prices fell sharply.

Copper had been mined in the Roman province of Germania from about 300 BC onwards, and many discoveries of copper weapons and tools from this period show the skilled craftsmanship of the Teutons. There is a documentary evidence of copper-mining in the Middle Ages in Germany from the tenth century onwards.[3] From the fifteenth century to the seventeenth there was a number of small copper works in the Upper Erzgebirge and in Vogtland, and also in Silesia, where mining had in fact begun in the twelfth century. The most productive copper mine ever known in Germany was opened in 1199 in the district of Mansfeld, and from here large quantities of metal were exported all over Germany and Europe.[4]

Copper has also been mined in Hungary, Sweden and Russia.[5]

In ancient times, as indeed nowadays, the metal was extracted by a drying-out process. The copper ore is first of all smelted to convert

the sulphur admixtures into metallic oxide; other impurities are removed by firing the ore for several days. The resulting product is used to charge the smelting furnaces, and what is known as matte or crude copper is obtained. This is again heated in the open air along with charcoal and additional substances containing silicic acid, until it becomes 'black copper'. This is an inferior product and needs to be remelted several times in order to improve its quality. When the refining process has been completed the result is either ingots or round pieces of copper, depending on the quality. But in neither case is it malleable until it has been stirred with a wooden pole, green with sap, and covered with slack. Over the centuries, methods of production have been gradually improved, to make the copper industry more economical; better kilns were designed, the metal was more carefully purified and various ways of using the by-products were found. The English style of reverberatory furnace, fired by pit-coal, appeared in 1698 and remained for many years the ideal model.

The properties of copper were understood and exploited at a very early date. It is a strange reddish colour, harder than gold, but much softer than iron, yet it can be made harder by cold-hammering or cold-rolling. When molten it is capable of absorbing gases, but these escape again when it is cooled, making the copper expand. This means that it is not very suitable for casting and has rarely been used in this way.

Moreover, despite its importance in the production of brass and bronze, unalloyed copper has only rarely been used for domestic utensils. Salts and acids, even those in fruit, will corrode copper; and vinegar, fats and fatty oils become cupreous on contact with it. Nevertheless ways of lining copper vessels with tin have been known since antiquity, and widely used for cooking utensils since the seventeenth century. Copper also gives off a certain unpleasant smell when rubbed, and can destroy the taste of food and drink. Finally, from an aesthetic point of view, its reddish glow cannot compete with the golden shimmer of brass or bronze.

Nevertheless, the advantage of copper for gilding was recognized and used at a very early date; when it is smoothed on over a flame (see the section on fire-gilding, page 38) it combines particularly well with the precious metal to form a very durable surface; also, its reddish tinge helps to produce a deeper gilt. Another favourable factor is that it is so malleable that it can be chased in the same way as silver, which is not the case with either bronze or brass. This meant that, to a certain extent, copper could compete with silver. Copper-gilt liturgical vessels have been produced in virtually every period, one example being the late eighth-century Tassilo Chalice. This was gilded and embellished with a rich decoration in work of engraved motifs and

Metalwork　scenes from the lives of Christ and the saints. It was commissioned by Tassilo, duke of Bavaria, and his wife Siutpric, who was of royal birth. It was made in about 770, probably in Northumbria, to be used both as a communion chalice and as a vessel for distributing alms, and it was probably also used at the wedding of the royal pair.

Similar reliquaries, crosses, portable altars and other sacred objects in the Carolingian period were not always made of gold or silver but sometimes also of copper-gilt.

Over the years various Church synods published a large number of edicts on the question of which materials were to be used for making communion vessels; many materials were strictly forbidden for this purpose, such as horn, wood and glass, whereas gold and silver were stated to be the most fitting substances.[6]

Copper-gilt chalices do not seem to have been frowned upon either in the Carolingian period or in the Romanesque period; indeed the care and artistry with which they were made and their rich decoration of engraving and niello-work show that they were treasured just as highly as altar-vessels made of gold or silver. As far as the layman was concerned, they shone so brightly that they might well be gold. It is, however, noticeable that in the following centuries chalices were generally made of silver, though less often of gold. Most church and monastery inventories list only articles of precious metal, which means that to simplify matters bronze and copper vessels were generally omitted because their intrinsic value was very low.

Decrees issued by the Church synods in the thirteenth and fourteenth centuries do not mention bronze or copper chalices at all. Copper-gilt was often used and sometimes the cup itself would be of silver and only the base and stem of copper. This type of mixed chalice is mentioned even in the inventories drawn up for the highest-ranking churches, such as St Peter's in Rome, where nine are listed in 1454, or St John Lateran, also in Rome, which had two in 1455. From the High Gothic period onwards various other ecclesiastical vessels were made in copper-gilt in all the countries of Europe: these include ciboria, ostensories, monstrances, shrines, caskets and reliquaries. Their design is exactly the same as for articles made in silver. In Italy this type of liturgical equipment was produced in such large numbers that we can almost speak in terms of mass-production. It is assumed that the objects were made by goldsmiths, partly because of the techniques used and the high quality of the finished work, but also because the goldsmiths' guilds would never have allowed coppersmiths to produce this type of article. One coppersmith did make exquisite gilt, silvered and painted figures for the beautifully-made clock on the Frauenkirche in Nuremberg; he also sold settings for jewellery and madonnas and clasps for books and

20

belts, but not without incurring the hostility of the goldsmiths. In 1511 these same goldsmiths of Nuremberg obtained an order against a master-craftsman called Sebastian Lindenast, stating that he was allowed to make only copper utensils, fountains, basins and water-jugs: he was forbidden to do any chasing or gilding or to make jewellery. Council decrees in this period are full of complaints made by goldsmiths against tradesmen offering copper-gilt articles for sale. When the gold and silversmiths eventually succeeded in restricting coppersmiths to ungilded wares, the craft of gilding copper virtually came to an end. It is true that for a short while the goldsmiths themselves were allowed to produce articles in chased copper-gilt, though to prevent cheating they were required to leave a small piece of ungilded copper the size of a *pfennig* showing through; but in 1562 permission to do this was withdrawn by the town council and copper was never again used for delicate chased work.

Ordinances issued by the guild of goldsmiths in London in 1370 also expressly forbade the production of copper-gilt, bronze-gilt and brass-gilt articles, though in fact we have good reason to believe that this regulation was frequently ignored. For instance, in the Victoria and Albert Museum there is a magnificent and very heavy cup which shows traces of having been gilded and lined with tin; it was made in about 1510 and is inscribed with the words: NOLI . INEBRIARI . VINO . IN . QVO . EST . LUXURIA.

The goldsmiths' struggle to prevent coppersmiths gilding their wares soon became irrelevant because of the huge quantities of silver which were reaching Europe from Central and South America. From the sixteenth century onwards so much silver was available that prices fell sharply, while the silversmiths' profits soared now that both churches and private patrons could afford to buy. Copper-gilt objects were still made right up to the nineteenth century, although it was a declining industry.

2 Domestic utensils

On the continent of Europe wrought copper enjoyed a second period of prosperity in the late seventeenth and eighteenth centuries, though this time on a more modest scale; instead of being used for ecclesiastical gilt plate or for show-pieces for the middle classes it was now kept for everyday kitchen and household utensils. After the Thirty Years' War the town households of the wealthy middle-class had grown considerably, which meant that more household equipment was needed. Copper was a relatively economical metal to use for kitchen equipment, since it was both lighter and cheaper than cast brass and also had a number of advantages over forged brass. Copper utensils were lined with tin to prevent the formation of oxides, but the outside was left in its natural state, which needed a good deal of energetic polishing; often one maid would do nothing but clean copper all day long. These utensils would be polished until they shone and then hung up in the kitchen in rows or arranged on open shelves to look as decorative as possible. Their reddish shine looked most attractive beside the silvery shimmer of the pewter utensils, as we can see from paintings dating from this period, or in the few entire kitchens which have survived intact in prosperous farmhouses, or in doll's houses. A large number of different pieces of kitchen equipment were made in copper: large bread-bins (some of which are even adorned with magnificently chased royal coats-of-arms and emblems, which means that they must have been used in castle kitchens), cake-tins and pudding-tins, bowls, buckets, jugs, pots, cauldrons, basins, salt-cellars, jars, screw-top flasks, teapots, snail-pans, sausage pans, etc.

All these utensils were used exclusively in the kitchen, since the food was actually served at table in silver or pewter dishes. A few copper articles did infiltrate the dining-room and were even treated as display-pieces, the most important being the wine-coolers which appear in

many paintings from the sixteenth century onwards. They seem to have been popular with painters as objects for the foreground of banquet scenes. It seems reasonable to suppose that these wine-coolers, and the jugs and flasks made of pewter or some other metal which accompany them, were rather like dressers in that they were intended for show; but on the other hand they were also used for a specific purpose, whereas dressers were purely ornamental. They are often magnificently tooled and decorated, and of course they were not only made in copper; examples made in silver, bronze, brass and pewter are also found.

In the eighteenth century in Holland, copper coffee-pots and teapots were made with brass-gilt handles and knobs. The sides are decorated with chased interlaced flowers and other Rococo motifs. The copper always has a dark-brown patina and was clearly intended to retain this colour, for it makes a most attractive contrast to the shining gilt handles and knobs. The pots are all designed in the same style and very possibly came from the same workshop; they are extremely lavish and the quality of the workmanship is often as high as that of chased silver articles. A far plainer type of jug was made in Holland and the Lower Rhine area in the eighteenth century; this banqueting jug is generally made of pewter, often with a decoration of coloured lacquer, though a few copper or brass examples were also made.

Herrengrund cups

Another type of copper vessel, known as a 'Herrengrund cup', is fairly close to the show-pieces made in the sixteenth and seventeenth centuries. A number of legends have grown up round drinking-mugs of this kind and the mystery of their origin has been deepened by the curious inscriptions which appear on them. These are the facts: there are deposits of a cupriferous ore, especially calcareous copper-sulphate, in three places called Herrengrund, Libethen and Neusohl, which lie quite close together in the county of Sohl in Hungary. Water seeps through the ore, washing out the copper and becoming richer as a result; it is now known as 'cement water' and is first collected in hollows and then channelled into ducts, where iron scraps have already been placed. The copper in the water either settles on these to form a sort of metal crust or sinks to the ground in the form of sludge. The copper sediment is removed periodically and then smelted. This is the raw material from which the Herrengrund mugs are made. The completely erroneous idea that they are actually made of iron or sheet-iron persisted obstinately for many years, the legend being that the water in Herrengrund possesses secret powers which can transform iron into copper, or at any rate coat it with copper. Inscriptions such as '*Eisen war ich, Kupfer*

bin ich, Gold ziert mich, der Wein füllt mich' ('Iron I was, copper I am, gold adorns me, wine fills me'), or '*Im Anfang Eisen, Kupfer jetzund, was nicht für Wunder macht Herrengrund*' ('First iron, now copper, what miracles are wrought in Herrengrund') – only served to magnify the legend in the eyes of the gullible folk of the Baroque period, who were always ready to believe in miracles.

The design of the Herrengrund vessels is closely related to that of silver articles made in southern Germany, Bohemia and Silesia. The most elaborate ones are chased, engraved, gilded, enamelled and set with precious stones or minerals; they were probably made as presents to be offered to princes as a sign of allegiance or as gifts from one nobleman to another. One coppersmith was clearly aware of the high quality of his wares and engraved the following inscription on one of his mugs: '*Für Kayser, Könige zum Trinkgeschirr erkiesen, obwohl ich Eisen war, als Kupfer werd gepriesen*' ('Specially selected for kings and emperors to drink from; though I once was iron, now I am treasured as copper'). The mugs are decorated with little moulded figures representing miners at work, which proves that they were not used for drinking or actual use but were designed purely for show; so were a number of double-mugs and dishes. They were exported from Herrengrund all over Europe and most of the larger museums possess one or two elaborate examples.[7] The golden age for this type of work was the seventeenth century, and a decline began in the eighteenth century, though individual pieces continued to be produced into the Empire period. The rich diversity of shapes and styles which characterizes the High Baroque period was over, and its lavish splendour could no longer be equalled. Also, of course, in the eighteenth century people became less interested in mysteries and miracles; the age of enlightenment had no time for the legends of the Baroque period, preferring to divest ordinary objects of any mystical element and to offer logical explanations for the mysteries of nature.

Iserlohn boxes

We shall now consider a category of objects known as Iserlohn boxes, which were another speciality of coppersmiths. In the eighteenth century the greatest potentates would honour deserving courtiers with a gift of a special box as a token of royal favour. These would some-times be made of gold, or they might be gilt, enamelled or set with precious stones; they could be used as snuff-boxes, provided of course that the recipient did not think them too precious to be used at all. The ordinary man who wished to follow the new fashion of taking snuff had to make do with a simple wooden case, though the middle-classes could buy longish oval snuff-boxes made of brass, or more often of

Copper

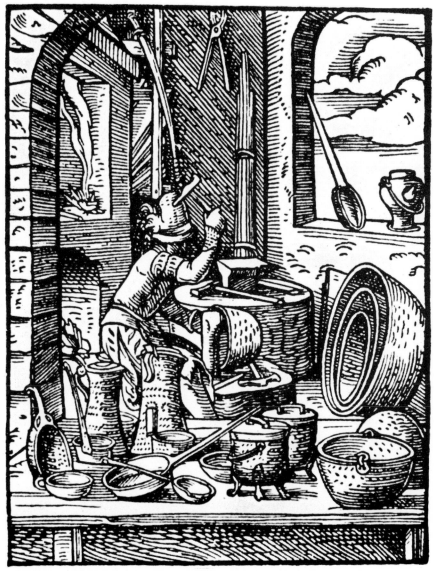

1 The coppersmith in his workshop with various utensils of beaten copper, mainly used for holding and heating water; woodcut, Frankfurt, 1568.

2 The Warwick ciborium of incised copper with gilt decoration; English, late twelfth century.

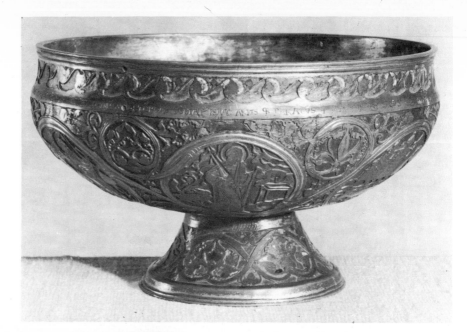

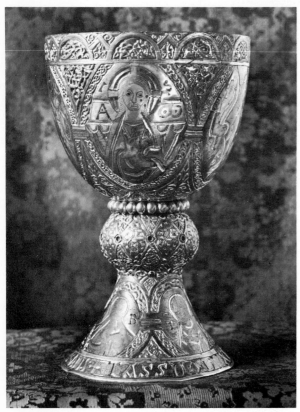

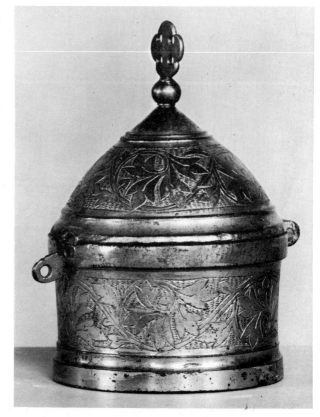

3 (*left*) Copper-gilt chalice, with rich decoration, of Duke Tassilo of Bavaria; late eighth century.

4 (*right*) Copper-gilt pyx with engraved motifs; English, fourteenth century.

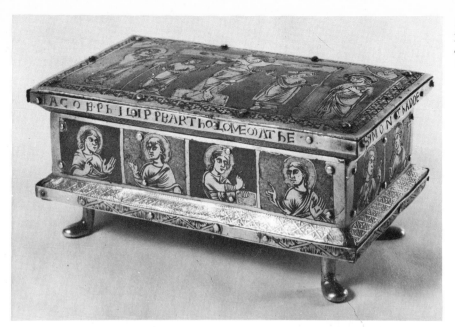

5 Copper-gilt portable altar with *champlevé* enamelling; Westphalian, *c.* 1200.

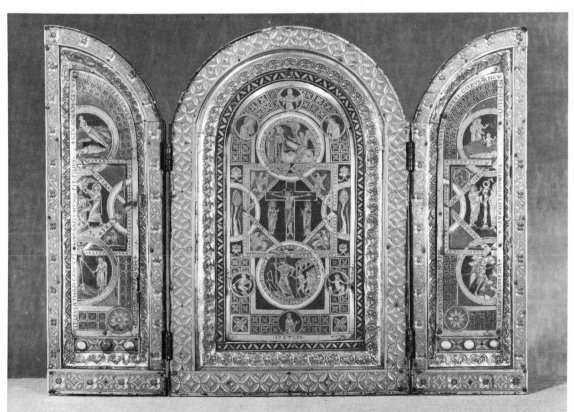

6 Copper-gilt triptych with *champlevé* enamelling; Mosan, *c.* 1150.

7 Copper-gilt censer;
German, fifteenth
century.

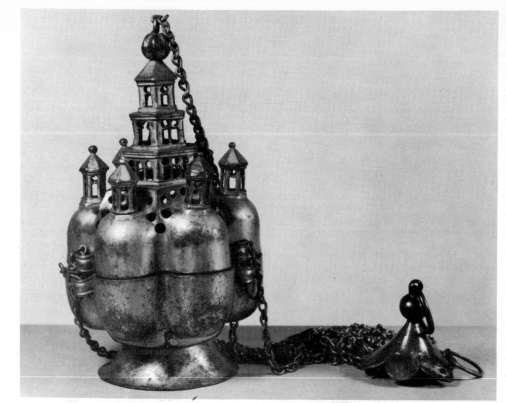

8 (*below left*)
Copper-gilt cross with
champlevé enamelwork;
South Belgian, mid-
thirteenth century.

9 (*below right*) Late
medieval copper-gilt
chalice; English,
c. 1500.

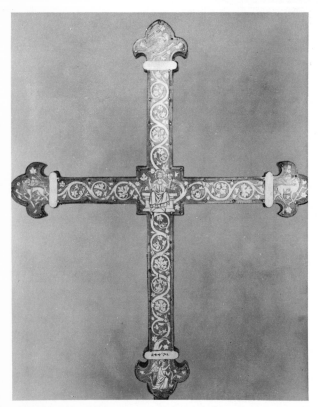

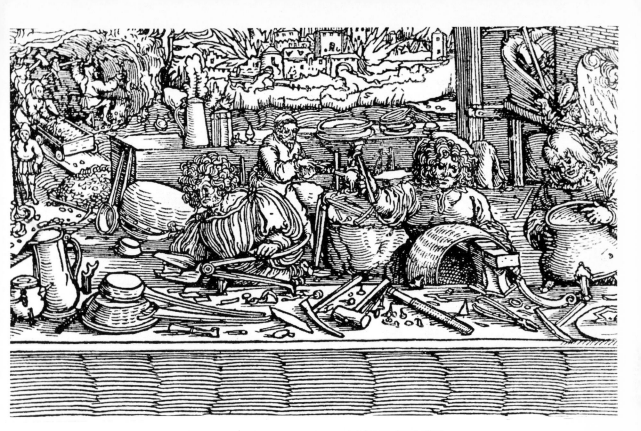

10 Stages in copper manufacture, showing mining, casting and working copper; woodcut, Augsburg, 1539.

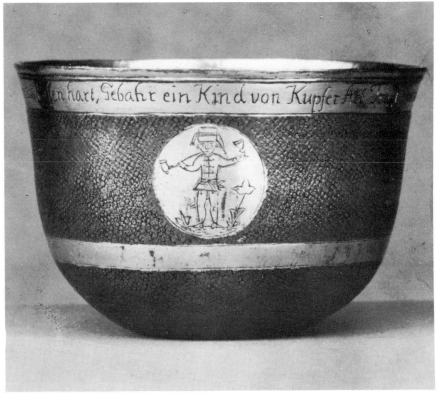

11 Herrengrund goblet, copper, partly gilt; Siebenbürgen (Hungary), early eighteenth century.

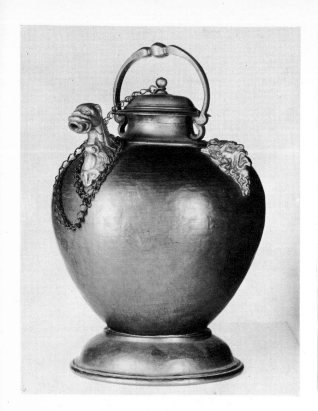

12 (*top left*) Jug of copper and brass with zoomorphic spout and grotesque decoration; South German, sixteenth century.

13 (*top right*) Bin for water or bread, of worked and punched copper; Saxony, early eighteenth century.

14 (*bottom*) Brazier of copper or brass; fifteenth century.

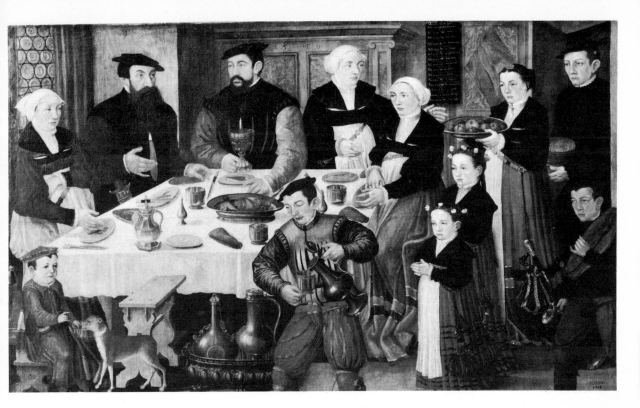

15 (*top*) Family feast showing many metal vessels: silver cups and bottles, pewter dishes and flasks, iron cutlery and a copper wine cooler; Basle, 1559.
16 (*bottom*) Copper wine cooler; English, *c.* 1700.

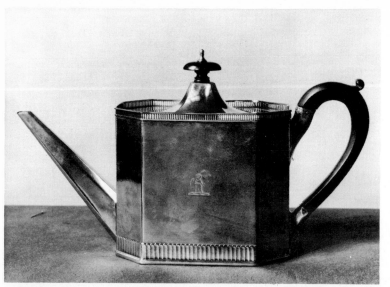
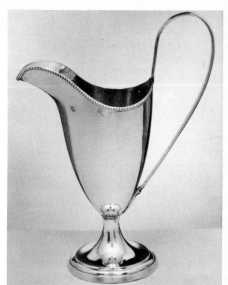
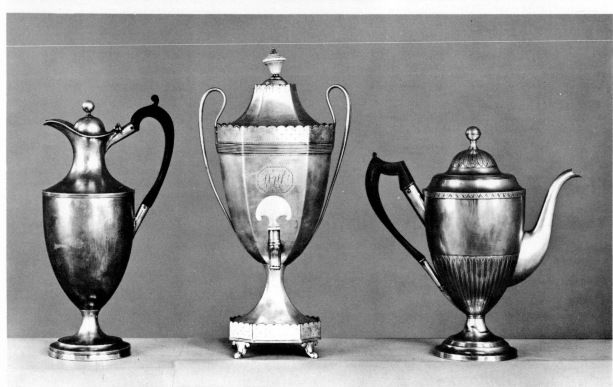

17 and 18 (*top*) Sheffield Plate tea-pot and cream jug; English, late eighteenth century.
19 (*bottom*) Sheffield Plate hot-water jug, tea-urn and coffee pot; English, late
eighteenth century.

copper. The old mining-town of Iserlohn in the Siegkreis, Westphalia, Copper was one of the main production centres for this type of box, though large numbers were also made in Holland. The lid is engraved, chased or embossed with little scenes; the subject-matter is typical of the eighteenth century: *fêtes galantes*, allegories, flowers, rocailles and cartouches. The Prussian king Frederick II often appears in a portrait idealized by the artist's fervent admiration of his monarch; explanatory verses appear underneath. This type of image was modelled on copperplate engravings.

Sheffield plate

In eighteenth-century England, even the middle-classes used silver plates and covers; but in fact they seem to have aspired higher; they not only wanted to eat off silver plates, but also to furnish their homes with silver. In 1742, Thomas Bolsover invented a method of plating copper with silver – creating Sheffield plate – thus enabling metalworkers to produced imitation silverware cheaply and economically. He discovered that it was possible to fuse sheets of silver and copper together, thereby producing a composite plate. It was usual to make a kind of sandwich plate, consisting of a sheet of copper between two of silver, so that the copper was completely invisible. The difference between this and all other plating processes was that the plate was made first, and then fashioned into the necessary shape. In other processes the object was plated after it had been made of some base metal. Although solid silver articles were still widely used in England in the eighteenth century, the cheaper but very similar-looking plated ware managed to gain ground, and by 1760 all articles formerly made only by silversmiths were now being reproduced in Sheffield plate.

Thus, whereas on the Continent the design of copperware in the eighteenth century tended to be based on the traditional craftsmanship of popular art, the producers of Sheffield plate chose from the outset to adopt the style of articles made in silver. They never wavered in this decision, and in fact copied the grandest and most elegant designs. By 1790, manufacturers of Sheffield plate were able to offer 150 different types of article, including candlesticks, coffee-pots, jugs and urns.

Since Sheffield plate was only a third of the price of silver, it provided stiff competition for silversmiths, who tried to overcome it, but were unable to halt its rapid development. This situation is typical of the result of industrialization and mass-consumption. England was the first of the European countries to make the transition to the modern industrial era.

From the 1840s onwards, copper was important for making objects

25

Metalwork (especially reproductions of earlier pieces) by the electro-plating process. This, briefly, involved electro-plating a mould with copper. When the mould had been removed, an object that appeared at first sight to have been worked in copper plate was left.

Towards the end of the nineteenth century some attempts were made at creating an individual style in copper, and there were occasional signs – in interior decoration, for instance – that the inherent properties of the metal were understood and were being used to full effect. But there was no question of a revival in the real sense of the word.

Part II Bronze and Brass
1 Production of bronze and brass

The discovery that copper could be alloyed with tin, an even softer metal, to form the hard metal known as bronze was a highly important one. Bronze was probably first produced by the Semitic peoples of Mesopotamia; the Turmanic people – the original inhabitants of Mesopotamia, outstanding for their advanced metallurgical knowledge – are generally credited with the discovery. Deposits of tin, necessary for the formation of the alloy, could be found at that time ($c.$ 3000 BC) in the mountains of Chorasa and Transoxiana (south of the Caspian and Aral Seas), in eastern Persia and the valley of Etymandros (now Hilmend), and also in Indo-China. It is possible that tin was also imported from India, but it seems to have been rather rare in the ancient world, as Egyptian bronzes made in about 3000 BC have a very low tin content.

It was not until the Phoenicians appeared that bronze production and the bronze trade began to flourish.[1] From the second century BC onwards, their ships plied throughout the length and breadth of the Mediterranean, and even ventured beyond the Straits of Gibraltar into the northern seas, taking their goods as far as Scandinavia. Phoenician bronze consisted of 90 per cent copper and 10 per cent tin, and has been found throughout Europe and the Mediterranean world, from England to Switzerland, from Denmark to Greece. Weapons, household utensils and works of art have all survived from this period.

The Greeks in the classical period raised the technique of casting bronze to a level of artistic perfection that has never been equalled.

Brass, like bronze, is an alloy, this time made up of copper and zinc; but whereas bronze is made by fusing together the two constituent metals in their natural state, until the beginning of the nineteenth century brass was prepared from a mixture of copper and a zinc compound called calamine. Oddly enough, zinc itself was unknown until

well into the seventeenth century, because no one in Europe had known how to prepare it in its pure form. Even the composition of calamine was not properly understood in the ancient world and in the Middle Ages; it is in fact a zinc-ore, carbonate of zinc oxide, and contains up to 52 per cent of zinc. So, although it was used to make brass, it was not until the seventeenth century that it was known that it contained zinc, and that it was this which turned copper into brass. Calamine[2] was sometimes thought to be a kind of stone which changed the colour of copper from its natural red to gold, yet as early as the fifteenth century it was being labelled as ore in the duchy of Limburg, and came under royal prerogative.

The most important deposits of calamine lie in the area between the Meuse and the Rhine. From the time of the Romans until well into the nineteenth century the most important brass-producing centres have been concentrated in this area.[3] The main centres of production are the Altenberg (or Vieille Montagne) mine and Stolberg, both near Aachen, Kornelimünster and Gressenich, also in the same Meuse valley between Givet and Liége, which supplied calamine or sometimes brass to the famous workshops of Dinant. Any calamine ore which was not immediately smelted to make brass would be sold commercially. It went mainly to Nuremberg and Frankfurt, but also found its way to centres all over Germany and to Holland, France, England and Sweden. Since the production of brass required a greater proportion of calamine than of copper, it was more economical to site the brassworks very close to the calamine supplies. The requisite amount of copper would be brought from elsewhere; Aachen and Dinant used copper almost entirely from the Mansfeld area, which was considered to be the best in Europe. The copper trade was chiefly controlled by the merchants of Nuremberg and Augsburg, who had mines in the Harz Mountains, the Erzgebirge and the Alps. Swedish copper was considered to be of poorer quality and was not allowed to be mixed with copper from the Mansfeld area.

Brass production in Nuremberg, which was very important from the fifteenth century to the seventeenth century, depended on the import of raw materials. This was only possible because of the flourishing trade connections enjoyed by the town and the power wielded by the great trading firms. The centres of craftsmanship in Lower Saxony obtained their raw materials from neighbouring mines in the Harz Mountains, while the brass and bronze craft guilds in Lübeck obtained their supplies from the Hanseatic League.

In his book *De la Pirotechnica*, published in Venice in 1540, Biringuccio mentions brassworks in Milan processing calamine found in the region between Como and Milan. Calamine was also mined near

Siena in the sixteenth century, but it was not until the second half of *Bronze and brass* the nineteenth century that deposits were discovered in Sardinia. In 1553 Erasmus Ebner set up a brassworks in the Harz Mountains where a substance known as 'artificial cadmia' or 'zinc-mush' – a product of the sediments from zinc-bearing ore – was used. In England Christopher Schulz and William Humphrey had been granted a monopoly for calamine-extraction and brass-production by Elizabeth I: this was the beginning of the development of the brass industry in Birmingham and Bristol which reached its heyday in the eighteenth and nineteenth centuries. France had no brassworks of her own until the seventeenth century.

The process of alloying calamine and copper to obtain brass is relatively simple. Ever since Theophilus 'Presbyter' described it in his work *Schedula Diversarium Artium,* many writers have described how brass is produced, for example Georgius Agricola in his manuscript *De Natura Fossilium* and Ercker in *Aula Subterranea.* Christoph Weigel paints a very vivid picture of the procedure in his *Abbildung der Gemeinnützlichen Hauptstände bis auf alle Künstler und Handwerker* (Compendium of the main professions useful to the common good, all artists and craftsmen being herein included) (Regensburg, 1698):

The art of brass making requires a great space of ground which must however be roofed over, so that the ascending vapour may be drawn up through the roof. For greater safety, moreover, the laths upon which the tiles rest are fashioned in iron and not in wood. The FURNACES are set in the ground in such a fashion that the wind forces the flames of the fire through the holes which are beneath the furnace and brings the coals to burning. In such a furnace they are accustomed to put round EIGHT great CRUCIBLES, and when these are hot to remove them speedily from the fire and pour the calamine into them; but they have a certain measure by which they reckon how much shall be needed that each crucible shall get its due portion; this being in weight round sixty-eight pound. Hereafter they add to the calamine in its pot, a measure of eight pound of copper beaten small and lay it on the top[4]; then do they return the crucibles to the fire and heat them to redness, and they remain at this great temperature during nine hours. Thereupon the servants try the metal with an iron rod to see if it be melted aright, and let the same stand further for an hour in its flux to refine it. Then do they lift the crucibles one after another out and pour them together into a pit, when they desire brass for casting. And when the metal is still warm they do break it into pieces, but in such a wise that these all remain close together. Then the brass takes on by reason of this hammering a most fine yellow colour, very pleasing to the eye. When they wish to form the metal into POTS and other vessels, or to draw it out into WIRES, they pour the crucibles instead onto great stones which are prepared for this purpose. And these stones are called BRETON STONES, from that place whence they are brought. And the brass is then in the form of great FLAT BLOCKS or SHEETS, and these

29

are afterwards cut by a brass cutter or sawyer into BARS, staves or INGOTS of one, two or it may be three fingers' breadth. They employ a machine for this purpose which is like to that used for wood in the saw-mills. The staves are then delivered to the BRASS-BEATERS or elsewhere, if so desired, for further working. And they add to twenty-eight pounds of copper a hundred pounds of calamine.

A great deal depended on the quality of the calamine and the statement that 23,000 cwt of copper and 40,000 to 50,000 cwt of calamine yielded about 35,000 cwt of brass may possibly be explained by the exceptionally high quality of the calamine found in Aachen. According to Johann Mathesius: 'Brass is made from copper to which calamine is added in such a way that from every four hundred weight of copper is obtained five hundred weight of brass.' In addition to the copper ore, old copper and brass would be added during the smelting process. This scrap metal, known in Germany as *Schrott* and in France as *mitraille*, was much in demand, which explains why so few early brass utensils, and indeed so few metal objects of all kinds, have survived. Countless numbers of worn-out household articles and even valuable works of art would be melted down in this way.[5]

Once the brass in the casting-stones – Breton Stones – had hardened into large slabs, brass beaters would fashion it into plates and sheets of varying thickness. Brass and copper beaters, or *batteurs* as they were known in Dinant, had their own guilds and federations. Originally the brass would be beaten by hand with a hammer, but in the Aachen area conversion was soon made to water-power and foundries would therefore be built by streams and rivers. This was no doubt inspired by the iron-forges which had been known since the fourteenth century. The hammer-mills were allowed to make only sheet- or plate-brass, which would then be sold as a partly finished product; the production of basins, pans or similar articles was strictly forbidden. A number of decrees tell us that the owners of water-foundries and hammer-mills were even so continually trying to produce articles with the hammer and thus compete with the coppersmiths. The coppersmiths themselves were artisans with their own separate guilds, who worked by hand and made mainly household articles from plate-brass. They tried to prevent the spread of these mass-produced hammer wrought goods, feeling that their craft and with it their livelihood was being threatened. The problems of mechanization and mass-production were the subject of legislation in Aachen as early as 1520-1 and continued to keep the authorities and the guilds busy thereafter.

The brass trade had been flourishing since the tenth century, and the metalworks at Huy and Dinant are mentioned in a list of tariffs issued in that period by the customs house at Visé on the Meuse.

Trade in brass and brass articles was controlled by the Hanseatic League from the thirteenth century onwards, and the same is true of the export trade in copper. In London the *mercatores de Dinant in Alemannia* had a special headquarters, the Dinant Hall, near the German Steelyard. Apart from England, France was the most important market outlet for articles made in the Meuse area. Later Dinant was succeeded by Aachen as the chief centre of production; it had a highly developed system of manufacture and distribution by which rich entrepreneurs could own a single unit comprising foundries, smelting-works, beating-works and the actual workshops in which the articles were made; thus very few partly finished products were exported. Tenth-century contractors would take advantage of the monopoly for ore-extraction by embarking straight away on refining all the raw material in the district, a principle which evolved in the seventeenth and eighteenth centuries into a system of controlled economy.

In Aachen, whose golden age did not come until after the decline of Dinant and Bouvignes in about 1466, the production of works of art, both hammered and cast, trailed a long way behind the production of brass-plate, sheet-brass or wire. From this point of view Aachen cannot be compared with Dinant or Nuremberg; but on the other hand it enjoyed an absolute monopoly of brass production from the fifteenth right down to the eighteenth century and supplied its partly finished products to the whole of Europe. The chief reloading point, apart from the fairs in Frankfurt, Nuremberg, Naumburg and Leipzig, was Antwerp harbour, which shipped brass to France, Spain, Portugal, Scandinavia and the Baltic countries. Later, when Antwerp was crippled by sieges and by a levy imposed by the Spaniards in 1576 and 1585, the brass trade was transferred to Amsterdam and Rotterdam. One immediate result of this was that the production of works of art made of brass was revived in the northern half of the Netherlands.

The use of bronze and brass

Whereas bronze had been known to the civilized world thousands of years before the birth of Christ, brass did not make its appearance until relatively late. Early references to its use are very scarce. Many experts assume that it was produced centuries before the birth of Christ on one of the Greek islands or off the coast of Asia Minor, and that the ancient Greeks used sheets of brass to cover pillars and floors and to make jewellery, but this view has not so far been confirmed by archaeological evidence. Aristotle mentions that the Mosseinoecians who lived near the Black Sea were able to produce a very shiny light-coloured ore by adding a type of earth instead of tin. This was presumably

31

what we would call brass. Strabo, Pliny and Sextus Pompeius Festus all mention *cadmia*, which probably refers both to the ore (calamine) and to the alloy (brass), and they also speak of *aurichalcum*, which really means gold-ore.

The earliest known brass objects were made in the Roman period and include sheaths, vessels, clasps or brooches, as well as rings and other items of jewellery. In fact the alloy from which these are made contains some tin as well as copper and zinc, so that the term brass-bronze can be used in describing them. The northern province of Germania is a particularly rich source of brass objects. Bell-shaped buckets, for example, have been found along the Rhine from Freiburg-im-Breisgau to Nymwegen in Holland, and also in Lower Saxony and in Champagne.[6] A sheet of metal discovered in 1859 near the part of Basle known as Augst bears the inscription *Deo invicto typum aurochalcinum Solis* ('To the invincible god – brass statue of the sun-god'). The most recent of these finds dates from the middle of the fourth century AD, but this type of work was in its heyday in the second century.

The end of the Roman occupation of the Rhineland meant the decline of a thriving art industry. The majority of the mines and metalworks on the left bank of the Rhine were destroyed when the Franks invaded, though the tradition of extracting, processing and casting metal does not seem to have died out completely, for with the development of Carolingian art at Charlemagne's court at Aix-la-Chapelle (Aachen) came the revival of the craft of metal-founding.

The appearance of the foundry at the court of Charlemagne marks the beginning of the bronze-casting era in the West. We must pause here to take into account an essential, if unfortunate, factor in the study of the further development of bronze-casting and metalwork in general. From now on we cannot always decide with any degree of certainty whether a given article is made of brass or of bronze! Metal articles dating from the Carolingian, Ottonian and Romanesque periods have a patina ranging in colour from dark brown to dark green. The metal itself, occasionally visible in places where the article is broken or damaged, ranges in shade from gold or reddish to tones that are silvery, greenish or yellowish. It is thus not always possible to distinguish between the metals just by looking at them, the only satisfactory method being to subject them to chemical analysis, although this is only very occasionally a practicable solution. Even in modern times tin and zinc have sometimes been added to copper.[7]

That is why works of art of brass will from now on be dealt with jointly with those made of bronze; this has in fact been the usual practice in books on the subject. For metalworkers and metalcasters of the past the distinction between the metals was always a question

32

1 (*opposite*) Bronze pricket candlestick in the form of Samson astride a lion; North German, thirteenth century.

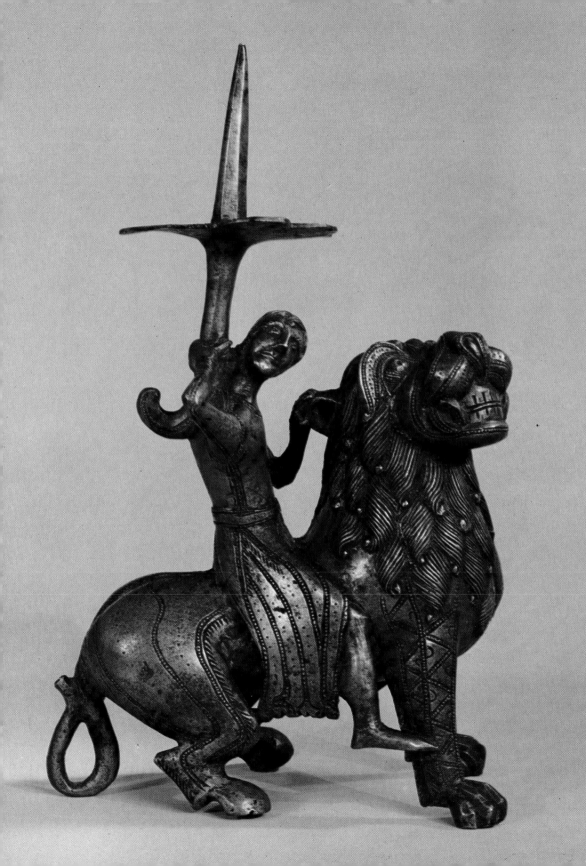

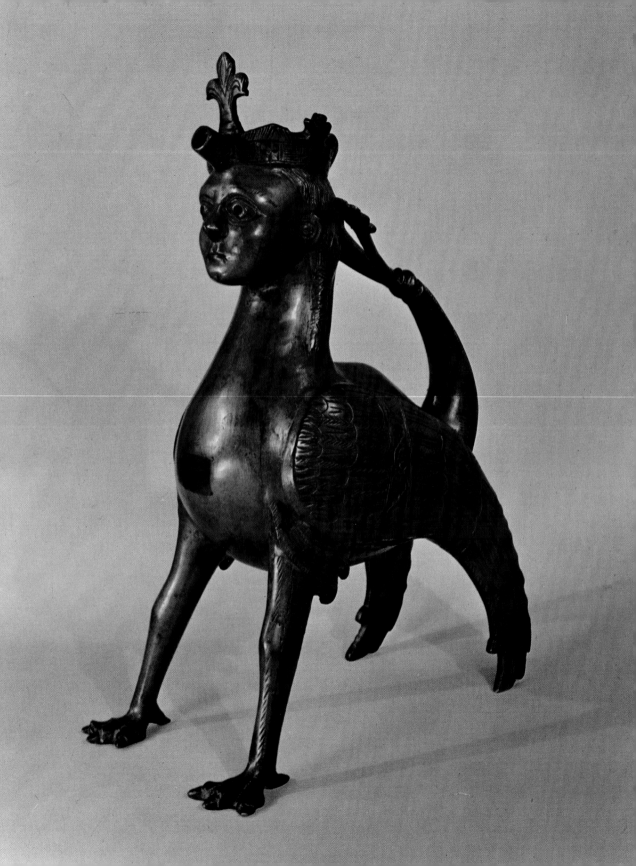

of usage rather than of fundamental principle. In areas where there were calamine deposits brass-casting would obviously predominate, though in the same area bronze-casting might also occur. Objects like bells and gun-barrels were nearly always cast in bronze; embossed work was reserved mainly for brass since it was more malleable than bronze.

With the voluntary tightening up of the guilds and their regulations in the fifteenth century we find that in some of the Hanseatic towns the precise contents of alloys used for certain articles were laid down in minute detail. For instance, cauldron-founders had to make their cauldrons, crucibles and mortars from a specific mixture of copper and tin, while basin-makers were allowed to use only brass. In the early days, however, from the ninth to the thirteenth centuries, these distinctions were far less precise, since the craftsmen themselves were not at all clear about the exact composition of their wares. In England brass-workers called themselves braziers and not coppersmiths, from as early as the sixteenth century. Earlier, the term 'lattener' appears, referring to the brass alloy known as 'latten'. Some European languages do not even today make a clear distinction between the different metals.[8] This vacillation in terminology, together with the wide variety in the composition of the various metals, in pre-Gothic times at any rate, allows us to deal with the artistic, stylistic and historical development of bronze-casting without maintaining a constant distinction between brass and bronze.

Bronze and brass have a number of positive qualities: they have an attractive pale golden sheen, they are hard and durable, they can be exposed to air and water, they can be cast and their surfaces can be treated in various ways. On the other hand they have certain disadvantages which considerably restrict their use: when exposed to moisture and oxygen or in contact with certain acids they disengage oxides harmful to the human body, if, for instance, they are absorbed along with food. Brass and bronze are therefore unsuitable for table-ware and cutlery; brass utensils have been used in the kitchen for boiling water, cooking broth or roasting, but they had to be scoured out immediately after use to make sure that no oxides could form. Dishes for food, drinking vessels and plates were always made of wood, clay, pewter or silver, and later of pottery or porcelain. The lavish decoration which was used to adorn the tables of the rich was limited to utensils made of precious metals – bronze and brass were not treated in this way.

Although kitchen utensils were generally designed according to their function and for convenience in handling, stylistic considerations were not ignored and their design always followed current fashions.

Brass and bronze were chiefly used for lamps, for basins and ewers

33

11 (*opposite*) Bronze aquamanil in the form of a fabulous creature, with wings and clawed feet; Hildesheim, mid-thirteenth century.

for washing, for religious articles, mortars, etc. The following chapters deal with the history of this artistic development, together with its economic and social significance.

Our knowledge of bronze and brass articles is drawn from a variety of sources. The most valuable information about stylistic developments is offered by actual pieces which have survived, but here the first difficulty arises: relatively few early bronze articles have survived in the West, and those which have present a haphazard and unrepresentative collection. There are several reasons for this: first, domestic items such as simple cauldrons, jugs, bowls and other vessels were considered to have a merely functional value and it did not occur to anyone that this type of article might have any historical or antiquarian interest. Articles that were worn out or unfashionable would be sent back to the foundries to be melted down – to be used again; there was a huge demand for scrap metal because brass-smelters liked to add a certain proportion of used metal to improve the quality of their products. Many fine and valuable pieces were also swallowed up in the salvage campaigns organized during the two world wars.

Whereas worn-out household objects would generally be destroyed for the sake of domestic economy, genuine works of art, mostly ecclesiastical, would often be melted down in order to raise funds or as a result of the lack of appreciation of the artistic achievements of earlier periods. Thousands of these religious works went into the furnaces to raise money for new purchases; many formed the booty of looting soldiers and much more was destroyed in revolutions, especially the French. In spite of this, far more religious pieces have survived over the years than ordinary household articles. Church plate was less affected by changes in fashion than everyday utensils, less subject to ordinary wear and tear and was generally treated with greater respect; at the same time, churches were less likely to be attacked in time of war than private buildings.

In the field of non-ecclesiastical brass and bronze articles, we notice that the more sumptuous and elaborate pieces would survive longer than ordinary popular utensils.

So when we study the random selection of pieces which have survived, an impression is created which is not truly representative of the social significance and function of the development of metalware in these times. As we have seen, compared with the ecclesiastical and secular treasures which have survived because of more favourable conditions, the number of surviving everyday pieces presents a very small and haphazard collection. We know, of course, that many more similar objects must have existed, and we can also assume that there was a greater variety in shapes, and that much is still unknown and

34

may have to remain so. Yet it is difficult to build up an accurate picture *Bronze and brass* of the relative importance of those objects we know about. Contemporary reports and documents dating from the Middle Ages are disappointing because although writers described with enjoyment the costly tableware and decorative articles made of silver and gold and rock-crystal, they hardly mention articles made of brass and bronze at all.

One of the few sources of information about household articles is provided by wills and inventories. In these the actual belongings of a household are listed and the value of some of the items stated, so that it is possible to get some idea of the kind of household equipment used and the standard of living enjoyed by the various social classes. Inventories of the articles to be found in monasteries can also be illuminating.

Household and kitchen utensils made of bronze very rarely appear in paintings or drawings up to the Gothic period, and even in the thirteenth and fourteenth centuries miniatures and frescoes tell us very little. At the beginning of the fifteenth century, painters do occasionally offer a glimpse into the homes of middle-class burghers, and their love of realistic detail has enabled them to capture customs and fashions of the everyday life of their period of which no other evidence has survived.

Casting and processing

From a very early date bronze has, by tradition, been used mainly for casting, and has only rarely been hammered or chased; for these effects, brass or occasionally copper were chosen because they are more malleable.

In the ancient world and in the early Middle Ages the *cire perdue* or 'lost wax' method was used. In his famous book *Schedula diversarium artium*, which appeared at the end of the eleventh century or the beginning of the twelfth, the monk Theophilus Presbyter gives a very vivid description of this process as it would be used for making a censer. He says that the first step was to make the moulds for the two halves of the receptacle out of clay which had been carefully prepared in advance: the moulds were in the shape of the censer, but the detail was left until later. Then the surface of the mould was covered all over with pure kneaded wax, taking great care to apply it evenly over the surface. The details would then be modelled in the wax with special tools. Casting pipes and air vents would be added and then the whole coated with several layers of thin clay. Before beginning the modelling, the craftsmen would fix iron and bronze rods through the whole structure at various angles to hold the inner core and outer shell

35

firmly apart. This precaution was essential for the next stage in which, once the outer casing of clay had dried, the wax was melted away completely over a fire, leaving only the hollow mould in which the censer was to be cast. The mould was then baked hard, and when cold was placed in a hollow and the molten bronze or brass poured into it through the casting pipes. When this was cold and hard, the inner and outer clay moulds were broken open and the censer obtained, which now merely needed retouching with a file and chasing tools to produce the required finish.

Benvenuto Cellini, who lived four hundred years after Theophilus Presbyter, describes the various techniques used by metalworkers in his *Trattati sopra l'oreficeria e la scultura*, drawing on his own personal experience. The methods he describes indicate that the technique of bronze-casting had improved considerably by this time. Cellini's starting point is a clay model which has been prepared in advance and is coated with hammered tinfoil. Then a mould of the clay model is made in plaster of Paris: this may be in several parts, particularly for a large object. The tinfoil ensures that the plaster cast will separate cleanly from the clay model: once it has been removed the individual sections are coated on the inside with an even layer of wax, and then an inner clay model is made to fit exactly into the outer shell. This is then fired, slipped back into the plaster-mould and recast in wax. When the plaster-mould has been removed this wax coating can be retouched carefully before the final coat of clay is applied. The wax is melted out when this final coat is dry. The mould is now ready for casting and the caster can pour in the molten bronze. The advantage of this method, compared with the normal medieval practice described by Theophilus Presbyter, is that the artist makes a complete clay model and can judge what his statue will be like, whereas the only model for his counterpart in the Middle Ages was his clay core covered in wax. Wax-casting is a very delicate process, highly suitable for making really fine pieces, but complicated, time-consuming and expensive, especially if we remember that the wax mould cannot be used more than once.

Simple everyday household utensils are cast by a different method, and the following brief account of the casting of a bell also applies to other hollow-ware such as buckets, mortars or measures. First of all an inner clay core is made, which is then covered with loam or clay and turned on a lathe with a template. This is the inner mould, which corresponds to the hollow centre of the object. The outer surface of the core is then insulated and covered with a layer of clay (the thickness of the clay depends on that of the proposed metal walls). It must then be carefully modelled, all details such as relief moulding, inscriptions,

etc., being added at this stage. When the model is dry the shell or *Bronze and brass* outer section of the mould is shaped round it in clay, and when it has hardened this outer shell is divided into sections and lifted off. Then the clay model is removed and the shell, which has been exactly fitted together, is put back over the central core, leaving the hollow ready for casting.

As we have said, this method can be used only for articles with hollow centres such as bells; objects like tankards or jugs, where it is not easy to reach the hollow centre, are cast in a sand mould, as are simple round objects. 'Sand' is in fact a misleading term, since it conjures up a picture of little grains of sand trickling through one's fingers on the beach, whereas in this context it means a substance full of binding agents. In the early days the sand mould would be made up of quartz-sand, loam, calves' hair or horse manure, but nowadays chemical binding agents are added to the basic substance. This mixture will amalgamate into a fairly compact mass if it has been well pounded together and then left to dry out for a while. This is how the bronze- or brass-caster sets about using a sand mould. First of all he needs a model. He will generally use a model made of wood, or occasionally of lead, stone or other materials; the caster would sometimes make his own models, especially in the early days, but usually it was the turner's job. The model has to be so designed to imprint the outline of the object to be cast on to the sand mould, and a second wooden model is also needed to make the sand mould corresponding to the hollow centre inside the tankard, jug, etc. The caster then takes a lidless and bottom-less iron box, sets it on the floor beside him and fills it with his moulding-sand – at this stage the sand is quite loose. The wooden model is then divided lengthways into two and one of the two halves laid on top of the loose sand, with the join level with the top of the box and the sand reaching the top. The sand is then pressed down all round it as firmly as possible but the upper edge is left clear. Then the other half of the model is fitted carefully on top, a second iron box is placed exactly over the first and also filled with firmly packed sand. The sand is left to set for a relatively short time; then the second box is lifted off and the wooden model taken out with the utmost care. The firmly packed sand mould is again left to dry and sometimes will even be lightly fired. The caster now has an outer mould or shell, and must start all over again to make the inner core which will correspond to the hollow centre of his finished product. The mould for the inner core is again made in two separate halves, and these must be fitted very carefully inside the two halves of the outer mould. The mould-boxes are then once again placed one on top of the other. Casting-channels have been made in the model and molten bronze is now poured down them; air

37

Metalwork escapes through air vents, which have also been provided in advance, and so the molten metal can run into all the hollows. The whole is left to cool for several hours, and then the iron boxes are removed and the bronze object is lifted away from the sand (the sand inside can be crumbled away without too much trouble). The casting-plugs, seams, and supports are removed and the casting is turned on a lathe, smoothed, and if necessary repaired.

Gilding

In the Middle Ages and the Renaissance, the dull gleam of bronze or its dark, sombre-looking patina were clearly much admired, but brass pieces would be painstakingly polished to give them a sheen which looked almost like gold. No doubt household utensils such as dishes and bowls and candlesticks were particularly susceptible to endless cleaning and polishing by house-proud housewives, as they are even today. On the other hand brass and bronze articles used in church would often be gilded to make them look like objects made of precious metal, thus giving the faithful the impression that they were glowing with celestial light. Gilding was by no means restricted to the medieval period and was used a good deal in later centuries. The many metal items in use in the houses of princes and noblemen had to be as resplendent as possible, but since precious metals would normally be too expensive quite a number of pieces would be gilded, though even that was by no means cheap.

The oldest and most reliable method is fire-gilding, which was known to the ancient world and continued to be practised down to the nineteenth century. It is described by Theophilus Presbyter in his treatise on metalwork. The basic principle is that the gold is liquefied by being amalgamated with mercury and then painted evenly over the metal object, which has previously been cleaned and moistened with nitrate of mercuric oxide. The next step is to hold the object over an open flame until the mercury has volatilized, leaving the gold firmly stuck to the metal surface. The whole article is then washed and polished with haematite. Special effects can be obtained by leaving some patches of dull unpolished metal to contrast with the highly polished areas.

The design of an object cast in bronze depends on the care with which the artist shapes and handles his wax model, since the tiniest detail can be worked in at this stage. In the Middle Ages all details would be marked on the actual mould, so that all that had to be done when the object had been cast was to smooth and polish it, though the artist might occasionally reach for his chasing tool to elaborate or emphasize decorative details.

38

The art of bronze-casting depends for its effects on moulding and sculpturing, but it was not long before casters attempted to embellish their products by inlay work. For inlay work the artist would engrave a design or some decorative motif into the surface of the article with a graving-tool, making sure that the indentation was slightly wider underneath than on the surface so that the edges overlapped a little. The ground was then made rough; threads of some contrasting material were laid in the channelled grooves, or pieces of metal exactly corresponding to the cut-out shapes of the pattern could be used; and these pieces of inlay were then hammered down firmly. Finally the surface was filed and polished smooth. Bronze was generally inlaid with silver, though copper or gold were also occasionally used. Inlay work has been common in the East for a very long time, and the technique was also known to European artists in the pre-Romanesque and Romanesque periods, as Theophilus Presbyter's detailed description proves. It then fell into oblivion and was not properly revived until the sixteenth century, inspired by the example of various weapons made in Turkey. From that time, all over Europe ceremonial armour and weapons were inlaid, the favourite combination being iron inlaid with gold – in fact bronze was rarely used.

2 The Carolingian period to the Romanesque

Western medieval cultural history begins with Charlemagne and his kingdom: his reign saw the beginning of art and culture in the West, and the political, economic and social evolution of Europe on lines laid down by the world of classical antiquity, though with the necessary adjustments to suit a world ruled by a Christian emperor.

Bronze-casting was of great importance even during this first phase of Western art, and was mainly used for church furnishings. There is no evidence to suggest that bronze articles of any particular artistic merit were made for the secular market of the Carolingian period; indeed, a marked preference for sacred art was shown by artists at this point, as befitted the spirit of the times, and this tendency continued for several hundred years.

Some of the documents concerned with the life of Charlemagne shed light on the type of utensils used by him and by his retinue, the most useful being the writings of his biographer Einhard. Charlemagne followed in the footsteps of his predecessors by spending most of the early years of his reign on the move, travelling ceaselessly round his empire and staying in imperial palaces, in castles, monasteries and episcopal palaces; embarking on journeys which took him to France, Spain, Italy and Austria, and to the furthest corners of his realm. This restless existence meant that his way of life had to be simple and unpretentious, so that, although he was received everywhere with great pomp and ceremony, there was no question of his own personal household articles evolving an individual style. Indeed, his furniture and the utensils used for preparing his meals in his own castles and palaces may well have been no more elaborate than those used by the ordinary people and peasants throughout his kingdom. They would usually be made of wood or clay and would comprise pots, bowls, tankards, plates and jugs. At the age of fifty-two, Charlemagne was finally able to take

40

up permanent residence in his favourite palace at Aix-la-Chapelle (or Aachen); this marked the beginning of the golden age of Carolingian art.

Religious metalwork

According to his contemporaries, Charlemagne was a simple and unassuming man who dressed in the simple clothes of his humblest subjects, though the other side of the coin is revealed in Einhard's descriptions of the lavish and ceremonial splendour with which the emperor was waited on at table, with kings and dukes acting as his servants.

The same lavish splendour could be seen in costly gifts from the emperor of Byzantium and the Moorish princes of Spain.[1]

The most important statues cast in brass at Charlemagne's court in Aachen were made for the Palatine Chapel. The emperor took an enormous interest in this chapel and in its furnishings, but he himself lived in a half-timbered building which boasted neither brass doors nor bronze grilles – such luxuries were the exclusive province of the Church. In reviving Western art on the foundations laid down by antiquity, Charlemagne also resuscitated the art of bronze-casting which was soon thriving in the imperial capital of Aachen. The origin of the famous bronze doors of the Palatine Chapel and the eight bronze grilles in the gallery running round the Octagon have long been the subject of argument among scholars. For a time it was thought that they were products of classical Rome and various literary allusions were taken to indicate that at Charlemagne's bidding they had been stripped from ancient buildings in Italy and brought to Aachen as booty. But, in 1911, the remains of a foundry were discovered in the Katschhof in the town, and it now seems certain that the bronzes were all actually cast in Aachen. The artists were probably from Lombardy and may have been working in France for some time. The Palatine Chapel originally had five double doors, but only four have survived. The style is deliberately antique: clearly the artists looked to Roman models for the design of the jambs and for the lions' heads and the acanthus decoration. The casting of the portals was a truly amazing technical feat, especially when we consider that each wing of the double doors weighs 43 cwt. They were made at the end of the eighth century, as were the grilles in the Octagon gallery. The grilles are each cast in one piece, and were originally gilded. A close study of the different grilles reveals a stylistic development which took traditional Lombard and Frankish styles as its starting point, then turned to an imitation of Roman marble-work and led finally to the classical style which

Metalwork characterizes all the works of art produced at Charlemagne's court. The famous bronze equestrian statuette of Charlemagne, which is now in the Apollo Gallery in the Louvre, was made in the second half of the ninth century, either at Aachen or possibly at Metz. It is about eleven inches high and horse and rider were cast separately; the emperor's head and the horse's tail and hooves were joined on afterwards. The bronze doors, which used to be in the castle chapel at Ingelheim, were no doubt also made in the foundry at Aachen.

Pious members of the nobility made a large number of endowments to the Church during this period, thus contributing to the growth of the economic, spiritual and political strength of the clergy and the monasteries. A large number of liturgical objects such as chalices, reliquaries, portable altars and book-bindings were known by the names of their royal donors; they would often be made of gold and precious stones, particularly in the case of articles made in the area dominated by the cultural influence of Charlemagne's court. Precious metals were thought to possess magic powers, so that, by dedicating them to the Church, men felt that they were honouring God and would be entitled to enjoy His grace. According to the *Scriptores Rerum Merovingicarum*:

Chalices made of gold and precious stones shed a brilliant light, vessels rise up like towers, crowns sparkle, candelabra glitter, round golden fruit glisten, while wine containers and filters give off a coloured glow. The bread for Holy Communion is placed in patens and finally huge wax candles are set in holders . . . (Vol. IV, page 574 in *Monumenta Germaniae*).

No specific mention is made of the metal from which the candelabra, the tower-like vessels and the candlesticks were fashioned, but we can assume that it was bronze, copper or brass, gilded and worked as painstakingly and as skilfully as if they were precious metals.

Charlemagne's reign was thus one of the golden ages of monumental bronze-casting, but it was followed by a period of two hundred years when very little of this type of work seems to have been produced in the Frankish Empire; in fact we have no evidence that anything was made either here or in the rest of Europe, except for an occasional literary reference to a bronze crucifix or similar object.

In 1007 Archbishop Willigis of Mainz commissioned some bronze doors for his cathedral and the artists clearly adhered very closely to the style of the doors in the Palatine Chapel at Aachen; but when the art-loving Bishop Bernward of Hildesheim commissioned a cathedral door eight years later, this purely tectonic arrangement was abandoned in favour of a pictorial scheme made up of scenes from the Old and New Testaments. The same type of figurative decoration can be seen on the bronze cathedral doors in Gnesen and Augsburg, which were

42

also made in the eleventh century. The Hildesheim doors were made *Bronze and brass* near the copper mines in the Harz Mountains in Lower Saxony, an area which was gradually becoming an important bronze-founding centre; it was in fact one of the most important in Europe for the next two hundred years. Bronze articles were exported from here and from the neighbouring towns of Minden, Goslar, Lüneburg and Brunswick to the furthest corners of Europe, to England and the Scandinavian countries, to Italy and Bohemia.

The other main bronze-casting centre was the area round the River Meuse; the principal towns here, all of which belonged to the duchy of Lower Lorraine, being Dinant, Namur, Huy, Liége, Maastricht and Aachen. Like Lower Saxony, this centre also had a thriving export trade. The two areas completely dominated the bronze-casting industry from the Ottonian period right down to the Hohenstaufen period (1138–1254), so that foundries elsewhere were rare and the few others which did exist generally adopted the style created in the main centres. Southern Germany, for instance, did not make a significant contribution to this particular field of metalwork, while France could meet requirements with its Limoges enamels; England seems to have concentrated on importing from the Continent. The sudden appearance in the Harz area of certain stylistic peculiarities normally characteristic of the Meuse district, and vice versa, shows that the two centres did sometimes exchange ideas and styles, perhaps as a result of artists and artisans moving from one centre to the other, taking with them their knowledge and experience. This type of exchange can be traced in various Romanesque candlesticks, a large number of which have survived from the eleventh, twelfth and thirteenth centuries.

Candlesticks
One particular group consists of monumental seven-branched candlesticks, based on a traditional Jewish design. Moses was commanded by God to have a *menorah* made and it was cast of gold and placed in the tent of the congregation (*Exodus* XXV, XXXVII and XL). This sacred symbol was revived by the Christian Church during the Carolingian period and different forms of it can be seen in churches throughout Germany, England and France. In fact more than fifty examples have survived, all made at some time between the eleventh and fifteenth centuries.

The earliest and most important is a candelabrum in the minster at Essen which was donated by the Abbess Mathilde (973–1001). It was made by the hollow-casting process and is made up of forty-six different pieces; it stands approximately 7 feet 4 inches high and the span of the branches is 5 feet $4\frac{1}{2}$ inches. In spite of its traditional Jewish design,

43

this particular candlestick also has certain Byzantine and Lower Saxon features, and it seems certain that it was made in one of the foundries in Lower Saxony. A large number of seven-branched candlesticks were cast in the twelfth and thirteenth centuries; they began to take on the appearance of trees as an element of plant life entered the design – this suggests a reference to the Tree of Jesse, a motif which occurred frequently in paintings at about the same time. Two of the most famous examples of Romanesque candlesticks can be seen in Milan and in Klosterneuburg; the one in Milan was probably cast in the city itself in about 1200; the other came from the same workshop as the doors of St Zeno's in Verona, at some time during the first half of the twelfth century. Another fine example is in St Vitus Cathedral in Prague; it was cast between 1130 and 1140 in one of the workshops in Bohemia, perhaps in Prague itself; while yet another in Brunswick was made locally in about 1170–80. Although all these different foundries and workshops were far apart, they were all under the influence of the Meuse area and various points of style recur again and again.

A comparatively large number of seven-branched candlesticks are mentioned in documents relating to English churches and the following churches are known to have possessed one: Abingdon, Christchurch, St Augustine's Abbey in Canterbury, and the Cathedrals of Durham, Hereford, London, Norwich, Salisbury and Winchester; but unfortunately not a single example of these has been preserved, so it is difficult to know what they were like or where they came from. The only information we have is that Abbot Hugo 1 (1099–1124) obtained the candlestick in St Augustine's Abbey in Canterbury 'from overseas' – no doubt from the Meuse district.

All the work we have just been discussing – the bronze grilles at Aachen, the church and cathedral portals made in the twelfth and thirteenth centuries, the seven-armed candlesticks – is on a monumental scale. These splendid pieces are worthy of the first great phase of Western art and of their position as landmarks in a Christian world not yet rid of its pagan enemies: their enormous physical size is matched by the grandeur of their spiritual content and by their artistic perfection. Bronze articles on a smaller scale were also made during this period, but most of them were again housed in churches or monasteries.

In the twelfth century it was the custom for small candlesticks to be placed on either side of altars, flanking the crucifix, and a large number of these have survived, most of them still in their original pairs. The majority were made in the metalworking centres of Lorraine and Lower Saxony. Imagination, artistic skill and feeling for style have been combined with theological considerations by artists and patrons, and

44

a number of different designs were created. The most usual type in the middle of the twelfth century was known as an interlaced candlestick, because its design was based on a series of fluted interlaced tendrils; candlesticks of this type would generally have a squat stem and a knop. Variations of this popular group continued to be made well into the thirteenth century, though the finest examples are definitely those of the first period and later pieces display a noticeable decline in quality.

Richly interwoven ornamentation is a very typical feature of Romanesque candlesticks and appears on virtually every one in some form. The base will often be adorned with figures representing angels, the Evangelists or the Prophets, or with grotesque or fabulous creatures, or ordinary animals, all woven together to form a decorative whole. All candlesticks in this group are mounted on three feet, which might be moulded to look like claws or dragons coiling downwards. It is impossible to state with any certainty whether these dragons have any symbolic meaning or whether they were used simply because they blend with the vegetable ornamentation. A highly elaborate candlestick, now in the Victoria and Albert Museum, was donated to Gloucester Cathedral by Abbot Peter (1104–13). It is usually thought to be English, though it has also been suggested that the abbot may have commissioned it from one of the foundries in the Meuse valley.

Crucifixes

Compared with the number of candlesticks which have survived, very few bronze crucifix-stands have come down to us. With the actual cross and the crucified figure of Christ they formed the centre-piece on church altars and resemble candlesticks both in their structure and in their decoration, since they, too, were supported on three feet and had the same type of ornamentation on their bases. Unfortunately only a few Romanesque crucifixes have survived intact – i.e., complete with stand, cross and the figure of Christ. On the other hand smaller images of Christ, of the type which were used on processional crosses, are often found. From the eleventh century onwards various districts and artistic centres began to develop a number of individual designs, with the Meuse and Lower Saxon centres again leading the way. The Rhineland and the Cologne area with their many monasteries also evolved a style of their own, but it was still fairly closely related to the Meuse style. Meanwhile southern Germany, Italy and France all turned to other sources, drawing the inspiration for their individual styles from local traditions, from Byzantium and from the ancient world.

A good deal of monumental sculpture was produced in Europe during

Metalwork the twelfth and thirteenth centuries, and dozens of crucifixes and statues of the Madonna and the Saints mark the early stages of a development which was to reach its greatest heights in the Romanesque and Gothic periods. Bronze-casting played its part in this development- A good example of this now hangs in the abbey church at Werden: a near life-size crucifix made in 1060, probably in one of the foundries in Lower Saxony for a monastery in Helmstedt. The figure was cast in one piece, except for the arms, which were added later. This elegantly stylized figure, with its delicately chiselled details and moving expression, is one of the finest sculptures of its day. A bronze crucifix in Minden appears powerful and sturdy beside this delicate work, though it, too, was cast somewhere in Lower Saxony. The influence of Lower Saxony seems to have spread to Saxony itself and to Thuringia at the end of the eleventh century and in the twelfth, as we can see in statues such as the life-size tombstones made for Rudolf of Swabia (d. 1080) in Merseburg Cathedral, for Friedrich of Wettin (d. 1152) and Archbishop Wichman (d. 1152) in Magdeburg Cathedral, or the life-size statue in Erfurt Cathedral of a highly stylized typically Romanesque figure bearing a candle, cast in about 1160.

Reliquaries

Some of the finest examples of Romanesque figure-sculpture in bronze can be found in reliquaries. These would be made in the shape of a human head, a hand or a foot, depending on the type of relic they housed. Once again it was Lower Saxony which produced the largest number and the finest, though some were also made in France. We shall simply mention here a reliquary in the shape of a head which comes from Cappenberg in Westphalia, another one from Fischbeck which is now in the Kestner Museum in Hanover and a third in the Lamberti Church in Düsseldorf; all of these were cast in the second half of the twelfth century. With their elaborate stylization, they represent the highest level of high Romanesque art, often surpassing contemporary wood and stone sculpture in their artistic perfection.

Chandeliers

A few large chandeliers have survived from the eleventh and twelfth centuries, all of them representing a sort of halfway stage between sculpture and functional equipment. A far larger number is known from contemporary documents and descriptions, but most of these have been destroyed over the years, either through ignorance or through sheer vandalism. One of the earliest was a large chandelier donated to the church of St Michael in Hildesheim by Bishop Bernward in about 1000, but it was melted down in the seventeenth century. Bernward's

46

successor, Bishop Hezilo (1054–79), came across a second unfinished *Bronze and brass* chandelier of a rather similar design, which had apparently also been intended for St Michael's; Hezilo had it completed and donated it to Hildesheim Cathedral where it can still be seen today. The circular crown is almost 20 feet in diameter and is made up of twelve towers alternating with twelve gateways and interspersed with seventy-two candleholders perched on the rim of the metal hoop. It is thought that the twelve Apostles used to stand in the gateways, accompanied by the twenty-four Prophets in the open niches in the towers, plus allegorical figures representing the twenty-four Virtues, but none of these figures has survived. The inscriptions tell us that the whole chandelier was intended to symbolize the celestial city of Jerusalem, as were other chandeliers made in the Romanesque period, such as one donated to the minster in Aachen by Frederick Barbarossa in about 1180–90, and another given by Abbot Herwich to the church of Komburg Abbey, near Schwäbisch-Hall. A number of eleventh- and twelfth-century chandeliers of this type could also be found in Belgium and France, but they have all vanished in the course of time, many of the French ones falling victim to the Revolution. In the Romanesque period, chandeliers seem always to have been designed as hoops and would be either completely round or arched, with candleholders perched on the rim and architectural structures set between, but it was not long before Gothic artists departed entirely from this style. Both cast and chased copper were used, and the circular hoops could be gilded, engraved or enamelled; the whole effect must have been magical in the shimmering candlelight.

Religious metalwork from the Meuse area
One of the earliest and also one of the finest pieces of monumental bronze to be cast in the Meuse district was a font made by Reiner of Huy, which is now in the church of St Bartholomew in Liége. It was originally intended for the church of Notre Dame des Fonts in Liége, but it was damaged during the chaotic revolutionary period and finally found its way to its present home. The bowl is cylindrical and was originally supported by twelve oxen, which symbolize the twelve Apostles; this composition was inspired by the 'brazen sea' which King Solomon had built in the temple at Jerusalem (see page 200), though the shape of the bowl itself is modelled on the wooden christening buckets which were used in the early days of the Christian era and which were later copied in stone. In fact, the same design continued to be used for many years, although the Gothic period brought various changes. The sides of the bowl in St Bartholomew's are decorated with scenes moulded in relief showing St John and St Peter being baptized;

47

Metalwork although there is no inscription to tell us the name of the artist, the literary evidence leaves no doubt that it was made by Reiner of Huy and consecrated in 1113 or 1114. He is referred to as *Renerus aurifaber Huyensis* in an inscription on a censer which is now in Lille Museum.

Although no large-scale pieces in cast bronze have come down to us from the period just preceding the Liége font, there must already have been a well-developed artistic tradition in this area, since inventories drawn up for various monasteries in Belgium and France reveal that their churches possessed rich collections of bronze or brass objects as far back as the tenth century. Chandeliers and bells were made, as well as candlesticks and crucifixes. At the beginning of the eleventh century the monastery church at Fleury on the Loire was decorated with 'sheets of the purest brass' (*camminis purissimi auricalci*) and various other brass items. The metalworks at Dinant, which produced most of the bronze statuary in the Meuse area, specialized in what are known as 'eagle lecterns' – i.e., Bible-stands with ornamental pedestals generally taking the form of a pillar or column surmounted by the outspread wings of an eagle, or occasionally a griffin or a pelican, on which an enormous missal could be placed. A lectern of this type was ordered by Abbot Folcuin (*c.* 965) for his monastery at Lobbes (Hennegau). The eagle design was used in the following period, but in fact the earliest one to have survived was not made until 1372. It was made for the church of Our Lady at Tongern, near Liége, by an artist working in Dinant, called Jean Josés; his nephew Nicolas Josés was commissioned in about 1480 by Duke Philip of Burgundy to design and make all the furnishings for the Carthusian monastery of Champmol near Dijon. He was asked to make an eagle-lectern and four pillars surmounted by angels holding the instruments of Christ's Passion and escutcheons, together with forty-five pots, eight basins, twenty-seven cauldrons, some large and some small, thirty-five pairs of candlesticks for use at table and eight large candelabra. The details of this commission are clearly authentic, since they appear in contemporary documents.

The craft of bronze-founding was thriving and with it the town of Dinant; its fame soon spread to the farthest corners of Europe and commissions came from churches and monasteries, royal households, municipal authorities and the aristocracy, and many other rich and powerful figures. Incense-bowls, aspersoria (vessels for holy water), censers, tankards, braziers, warming-pans, lavabos, pots, chimney-pieces and many other household articles could be commissioned from the Dinant workshops or bought at fairs. They became known as 'Dinanderies' or Dinant wares and were highly prized.

Alas! pride comes before a fall. The arrogant citizens of Dinant believed themselves to be invincible and recklessly opposed the mighty

48

III (*opposite*) Bronze-gilt cup made in England in about 1540, with the inscription, 'noli inebriari vino in quo est luxuria'.

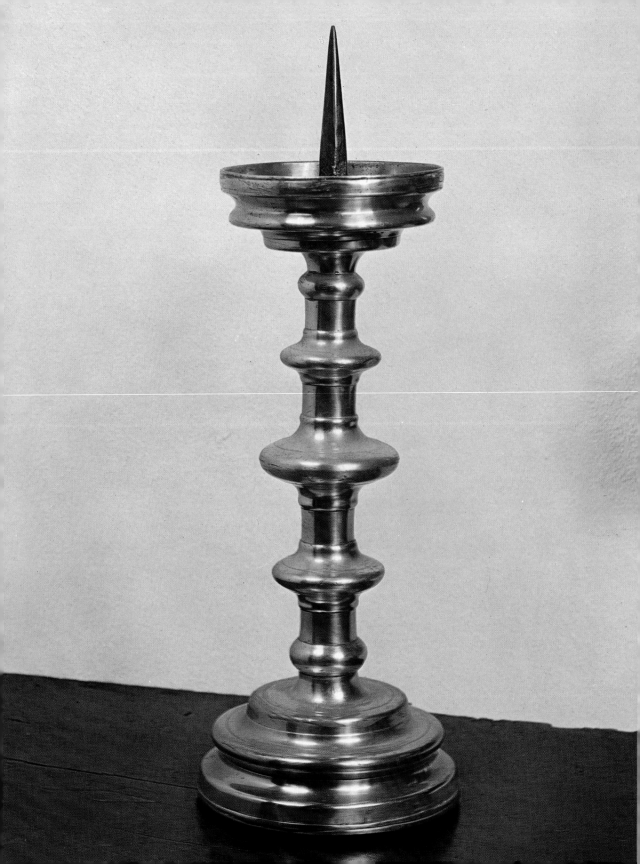

duke of Burgundy when his support was sought by their old rivals in the town of Bouvignes. In 1466 Philip and his son laid siege to the fortified town, took it by storm and destroyed its flourishing community. The devastation was complete and the brass industry in the Meuse area was struck at its very roots. Any bronze-founders and metalworkers who survived moved to towns in the immediate neighbourhood or farther afield, which meant that there was a sudden upsurge in the brass-founding trade in various towns in the Low Countries such as Brussels and Tournai, Namur, Bruges, Malines, Louvain and Middelburg. The main beneficiary, however, was the neighbouring town of Aachen, since it already had the good fortune to be situated near the largest known deposits of calamine in the area.

Although the political downfall of Dinant and its total destruction undoubtedly had an immediate effect on the development of other brass-founding centres, it was not the sole deciding factor. The Meuse area and Lower Saxony could not continue to enjoy the monopoly which they had held in the field of bronze and brass production since the Carolingian period. Trade and commerce were developing rapidly and so also were methods of transport, so that bronze and brass-founders were no longer compelled to work close to the mines but could set up in business almost anywhere. The Hanseatic League, with its newly evolved system of trade, which was almost an early form of capitalism, had a good deal to do with these developments. The power and spirit of enterprise of the great traders, together with support from municipal councils and the growth of the trade-guilds, combined in encouraging the spread of the brass and bronze industry all over Europe.

Enamelwork

Before ending this section, which has dealt mainly with bronze articles used in churches, we must at least glance at a particular branch of metalwork responsible for some of the finest pieces made in the twelfth and thirteenth centuries. The art of enamelling was known from a very early date; it reached its highest point in Byzantium, but was also very popular with the tribes who took part in the mass-migrations. In Byzantium the preference was for gold, but in the West, from the eleventh century onwards, bronze and copper were mainly used.

There are four different kinds of enamelling: *champlevé*, *bassetaille*, *cloisonné* and *plique-à-jour*. *Champlevé* enamelling almost entirely uses a gold background: in *cloisonné*, the cells for the enamel are formed by flat wires, soldered to the surface of the object: in *plique-à-jour*, the enamel fills openings, like windows.

Enamel is a glass substance which melts at 800°C, and is translucent,

49

IV (*opposite*) One of a pair of bronze pricket candlesticks with a wide collar drip tray; Venetian, sixteenth century.

Metalwork opaque or opalescent, depending on the exact composition of its constituents. The molten enamel is applied in cavities engraved into the surface of the metal to form an ornamental or figurative design; the metal will be either copper or bronze and the artist traces his design with a graving-tool. In the early days each channel would be filled with just one colour, so that a mosaic effect was achieved, but as more advanced techniques were developed it became possible to use several different colours in a single figure or decorative motif. This meant that little pictures could be made. This technique, which is known in France as *émail champlevé*, can be used either to cover the whole surface, so that all that can be seen of the metal are thin strips outlining each motif or figure, or alternatively the decorative area can be left un-touched to stand out against an enamel background, while the details of the design are picked out with a graving-tool on the metal surface.

In the tenth and eleventh centuries, enamelling was mainly restricted to flat metal surfaces, such as those on caskets, reliquaries and shrines. Later on, curved objects, such as candlesticks, crucifixes and busts, would also have enamel decoration. This type of work was in its heyday in several parts of Europe in the eleventh and twelfth centuries, the main centres being the Meuse area, the town of Limoges and the surrounding district, and Lower Saxony.

Artists working in this specialized field needed to possess a complete mastery of the techniques of working with both precious and non-precious metals. Theophilus Presbyter's twelfth-century treatise (see page 29), proves that he had just this versatility and we can assume that he was not alone.

In the twelfth century artists begin to appear as individuals for the first time and many names are known to us from this period. Godefroid de Claire, who lived and worked in the Meuse area, pro-duced a whole series of articles with chased silver decoration and a large number of pieces made of gilded and enamelled copperplate. He often used the two different techniques in making single articles, and would use chased silver-gilt figures to decorate reliquaries or shrines made of enamelled copper. Although he used mostly the *champlevé* technique Godefroid also returned to the *cloisonné* method, although he used copper instead of gold. His workshop was highly productive and must have been of considerable size, since it produced the smaller type of church furnishings, such as small folding altars, portable altars, crucifix-bases, etc., as well as shrines and reliquaries. There were many other workshops in the Meuse area and in the old district of Lorraine. In 1142, for instance, Abbot Suger of St Denis stated in an official report that he had a huge crucifix-base made by 'Lorraine goldsmiths'.

50

The greatest of the artists in the Meuse valley who worked with bronze and enamels was Nicolas of Verdun, who was active during the last two decades of the twelfth century and the first thirty years of the thirteenth. He worked in various places throughout Europe and examples of his work can be seen in many different centres. The extent of his travels can be seen in the fact that in 1181 he was completing an altarpiece 16 feet 3 inches across and decorated with fifty-one panels in *champlevé* enamel in Klosterneuburg near Vienna, while in 1205 he was putting the finishing touches to the shrine of the Virgin Mary in Tournai; another of his shrines was one dedicated to the Three Wise Men in Cologne Cathedral.

There had been a thriving enamelwork industry in Cologne ever since the beginning of the twelfth century, and the large number of pieces which have survived show that its development increased steadily in the twelfth and early thirteenth centuries. It was thought for many years that the wonderful shrines and reliquaries produced in this area all came from a single workshop attached to the monastery of St Pantaleon, but more recent research has suggested that there were various independent workshops which were not necessarily attached to monasteries. But although the enamelwork decoration on these Rhenish shrines is of enormous importance for the art-historian, we must not overlook the fact that their component parts of cast and gilded copper or brass were also of exceptionally high quality. One exquisite example is the crest surmounting the roof of the Anno Shrine in Siegburg, which is decorated with luxuriantly interlacing acanthus foliage, peopled with playful *putti*, which make the shrine seem like a piece of classical art.

Champlevé enamelling did not reach Hildesheim until the middle of the twelfth century; it probably came via Cologne and soon became popular in this area, which was already famous for its bronze work and had in fact been making shrines very similar to those made in the Meuse area and the Rhineland, except that they had no enamel decoration. Once the technique of enamelling had been accepted in Lower Saxony, a local style began to develop quite independently of the other enamel-producing centres. Its most distinctive feature was the use of little gold dots scattered over a blue background, with the engraved figures standing out against this background; the dots are in fact worked on to the copper underlay and jut through the enamel.

The splendidly colourful effect of enamel was so popular that another type of reliquary chest was very rarely made, though there are one or two in Lower Saxony. The sides of this type are decorated with figures which stand out like fretwork against a smooth gilded background; the details on the figures are always engraved. Alongside some

51

Metalwork particularly fine examples of this type less elaborate containers are also found which were clearly made for poorer parishes in the area.

Enamelwork reached great heights in eastern France in the twelfth and thirteenth centuries, particularly in Limoges, though its origins in this area can be traced back beyond the Carolingian period to the time of the Romans. Huge quantities of enamelled copper articles were made in Limoges, much of it mass-produced rather than made by individual craftsmen. The workshops catered for both the ecclesiastical and the secular markets, and presumably followed the principle of keeping a number of lines in stock, rather than executing individual commissions, as was the normal practice elsewhere. An amazingly large number of enamelwork articles from Limoges can still be seen in museums in France and elsewhere, which gives a good indication of how much must have been produced. The list of enamelwork items produced in this period includes shrines and ciboria, abbots' croziers, tombs, crosses, pyxes (vessels for the sacramental wafer), book-bindings, reliquaries, doves for the Holy Eucharist, censers and candlesticks, ewers, basins, love caskets, chests, buttons, belt-buckles, harness-mounts, etc. This wide variety of wares was matched by the widely varying quality of Limoges enamelwork, which ranged from articles embellished with the most painstaking figure-decoration in the late Romanesque style (inspired by Byzantine work) to crude ornaments made in the most slap-dash manner and obviously intended for cheap consumption in the mass market.

Italian enamelwork in about 1200 was inspired by Byzantine examples, gold and silver normally being used as a base rather than copper.

Metalworkers of the Romanesque period

In the early Middle Ages and in the Carolingian and Ottonian periods, ecclesiastical splendour was all-important and secular art insignificant by comparison. Even in the late Middle Ages the splendour and costly treasures which filled the churches meant far more to the true believer than can be experienced by our jaded and satiated contemporaries today, even when confronted by the most fantastic optical effects. The life of the average northern European was wretched in those days, with few pleasures, intellectual or otherwise. Society was made up of three different strata: the nobility, the clergy and the peasants – town-dwellers played as yet no independent part in society. The courts were the main centres of political and intellectual life, but those who took part in it formed a very small élite. The nobility and their vassals lived in castles and their chief interests were warfare and hunting;

52

they were as unfamiliar with the type of art and culture which flourished in ancient Rome and Byzantium as the majority of the peasant population. Early Western art was entirely in the hands of the Church and was almost exclusively directed to the service of God. Architecture was confined to cathedrals and minsters, and it was here and only here that paintings, carvings, gold and silver shrines were to be found, together with shimmering fabrics glowing in the light of a thousand wax candles sparkling in their costly holders. And all this splendour was available to every Christian, however humble. Anyone might gaze on and enjoy the finest works of art, which were indeed intended to impress and delight the faithful as well as being devoted to the greater glory of God and the Church.

But who were the men who made these glorious works of art? Where did the bronze-founders come from and what sort of lives did they lead? What was their position in a society which had no place for the artist in its hierarchy? An answer to these questions can sometimes be found in the signatures which occasionally appear on censers, shrines, candlesticks and other objects, and from contemporary documents and other literary sources.

One medieval artist, Theophilus, who has already been mentioned on several occasions as the author of the *Schedula Diversarium Artium* (pp. 29, 35), called himself 'Presbyter' and must therefore have belonged to the clergy. Rogkerus of Helmarshausen was a monk and worked as a goldsmith, as well as with bronze and copper. Gozbert and Absalom who made a bronze font in St Maximin's in Trier were monks, while Reiner of Huy was probably a lay-brother in a monastery. Some of the other artists who were active in the pre-Romanesque and Romanesque periods may well have been monks, working under the protection and control of the monasteries, with their workshops actually inside the monastery grounds.

Others belonged to associations of artists and craftsmen, attached to building works, who would hire themselves out to the largest building contractors and stay with them for years or even decades until the work had been completed. Bronze-founders would also presumably group themselves into similar though no doubt smaller associations, and would travel to a town where some large building operation was in progress; they would stay as long as there were doors to be cast, candelabras, bells and other smaller items to be made, and would then move to other sites, sometimes in answer to a summons from one of the great ecclesiastical figures responsible for building churches and cathedrals and sometimes merely taking the chance of finding work. It was from these travelling groups that the permanent workshops developed: finally, at some time in the thirteenth century, these groups

53

Metalwork began to settle down in one town or another. The master-craftsman would officially become a citizen of the local community, while his assistants, journeymen and apprentices would work under his supervision; the whole system was under the control of the local authorities. And so artisans who had once been free to travel as they wished now became official residents of one specific town and had to belong to the appropriate trade organization, i.e., the guild. The later development of the guilds in the Gothic period, involving the artisan in a series of compulsory rules and regulations, customs and injunctions, will be discussed in a later chapter.

Craftsmen working under the protection of the monasteries in the pre-Gothic period enjoyed some artistic freedom. Since their only obligation was to their work and to their clients, they were free to choose whatever material and methods seemed to them the most appropriate. The distinction between the craft of the bronze-founder and that of the gold or silversmith was fluid and at this stage there was no question as to who was allowed to gild copper or bronze and whether a bronze-caster was entitled to adorn his work with precious stones. This was in marked contrast to later centuries, when the different trades were rigidly defined and jealousy between guilds gave rise to constant disputes.

Secular metalwork

The golden age of sacred art, which lasted for the first three hundred years after the formation of the Western world, i.e., roughly from 800 to 1100 AD, was followed by a period in which work of a new kind slips quietly into our field of vision: these articles would be used for worldly purposes rather than exclusively for the greater glory of God.

Candlesticks
Among this work was a type of candlestick in which the part supporting the grease-pan is designed in the shape of a dragon. Since the fluid unsymmetrical design of these dragon candleholders would scarcely have formed suitable accompaniment for a crucifix, we can assume that they were not set on altars but were intended for secular use in the castles of the nobility (this theory is supported by the fact that relatively few of them have survived).

Round candlesticks were made from the Romanesque to the Gothic period, but it is difficult to decide whether they were used exclusively in churches or in private homes – in fact they were probably intended for both purposes, as was the case in the following centuries. The most characteristic feature of early circular candlesticks is their base, which

54

is supported on three claw feet. In the earliest examples the base would *Bronze and brass* be a shallow curved saucer, but it was later shaped like a dome or a bell. Initially the knop was always set directly on to the base, with a short squat shaft leading to the grease-pan. In later models the shaft has become slimmer and the knop will sometimes be as far up as the middle. In the thirteenth century circular candlesticks always had claw feet, but these became more and more rudimentary until in the fourteenth and fifteenth centuries they almost disappeared. These candlesticks with their simple unified structure represent a reaction to the picturesque and fantastic detail characterizing earlier candlesticks with their interlaced ornamentation and fabulous beasts. Their style heralds the arrival of a new age of strict and austere spirituality – the Gothic period.

But before coming to the Gothic period we should look at bronze articles of the High Romanesque period which draw their inspiration from chivalry, the only worldly aspect of contemporary life which was considered worthy of a place beside the religious aspect. It is embodied in a group of candlesticks that are in the shape of human figures. There are mounted warriors in full armour supporting the candleholder with its spike for spearing the candle; others represent kneeling pages in court dress holding the candle-socket in their outstretched hands; and a further group is of Samson, in whom the virtues both of the true Christian and of the true knight were combined. Twelve candlesticks depicting Samson are known, though of these only five show him in the traditional pose of wrenching the lion's jaws open while his knee is planted on its back. Presumably the decision to show him sitting on the lion's back, as most bronze-founders do, was governed by both technical and aesthetic reasons, since this made it easier for him to hold the candlestick aloft in one hand.

Aquamanile
Another branch of the bronze-founder's art which is closely related to these candlestick figures and statuettes comprises a series of ewers, known as aquamanile, that are very important from both the artistic and the historical point of view. This particular genre was at its height at the end of the twelfth century and during the thirteenth.

The men who took part in the Crusades to the Holy Land brought back with them not only reliquaries and war-booty but also various customs adopted from the heathens (with whom they had sometimes been on very friendly terms), new techniques and artistic skills. The majority of the Crusaders were rough and boorish men; they learnt much in the field of table manners, and brought many new ideas home with them. For instance, the ceremony of washing hands before

55

and after meals was a novelty to them, although they always ate with their fingers and forks were never used. Water would be poured by servants from jugs made in the shape of various animals. Some of these animals would be closely related to the concepts of chivalry, but others would be fantastic creatures, strange and demon-like, or even deliberately comic. These aquamanile offer a sort of mirror-image of courtly life in the age of chivalry as we know it from the romances and the love poetry of the *Minnesänger*. The favourite animal was of course the lion, symbol of valour, pride, physical strength and power. The water streams out of its open mouth, and the handle on its back appears often in the shape of some fabulous serpent-like beast. The quality of the stylization, the modelling and overall execution vary considerably from one piece to another, some of the lions being so primitive and archaic in appearance that their creators clearly possessed rather more enthusiasm than skill, while others are modelled with great subtlety and supreme artistry.

Although ewers in the shape of lions are by far the most common, we do also find winged dragons, doves, cockerels, centaurs and sirens. A large number of ewers show the delight in details of courtly life. A good example of this is a series of knights: some are in full armour with coats of mail and helms; others bear lances or shoulder their swords, or are armed with shields or rounded helmets. We also find proud figures of knights victoriously crowned after jousting tournaments, ladies with falcons on their wrists, huntsmen followed by their dogs, a deer cast in relief lying across the horse's neck. This type of ewer must have been commissioned by some noble lord, despite the fact that most examples have been found among collections of church plate. This simply means that when they were no longer considered fashionable enough for use in private households they would be donated to churches to be used in the liturgy.

Once again the two leading centres for the production of aquamanile were Lorraine, the Meuse area and Lower Saxony; inspiration seems to have travelled eastwards since the earliest examples were made in the Meuse area, but then foundries in Lower Saxony, with Hildesheim as the main centre, took over and from there the idea spread to other districts. Ewers do not seem to have been popular in France and Belgium, but this is not true of Scandinavia where the huntsmen ewers were apparently made exclusively in one of the Scandinavian foundries.

The production of ewers continued into the Gothic period without a break, though production was beginning to wane towards the end of the thirteenth century and the beginning of the fourteenth. A typical feature of ewers made in the early Gothic period is the bib-like collar

56

Bronze and brass: Carolingian and Romanesque

20 Bronze wolf-door from the Palatine Chapel at Aachen; ninth century.

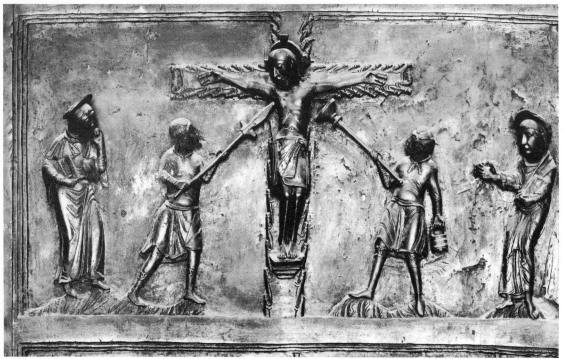

21 (*top*) Cresting of the Anno shrine in cast bronze; Cologne, 1183.
22 (*bottom*) Crucifixion scene from Bishop Bernward's bronze doors at Hildesheim; 1015.

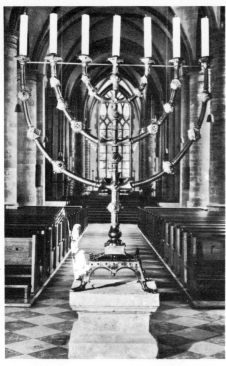

23 (left) Seven-branched candlestick from Essen Minster, made up of 46 pieces of hollow cast bronze; c. 1000.

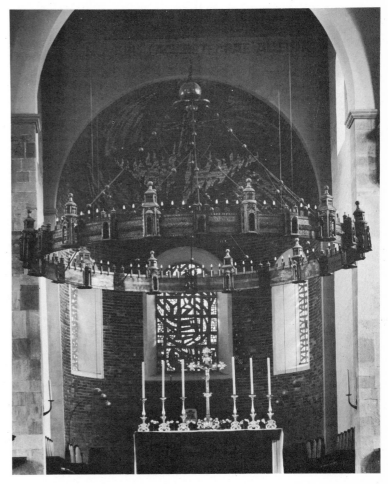

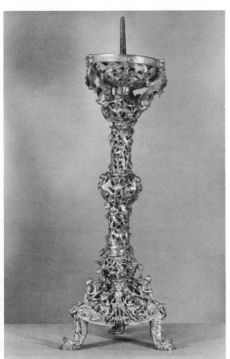

24 (left) Candlestick, cast in bronze, with richly interwoven ornament, made for Gloucester Cathedral; 1104–13.
25 (right) Chandelier symbolizing the celestial Jerusalem, from Hildesheim Cathedral; mid-eleventh century.

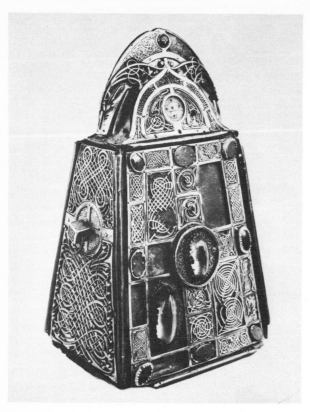

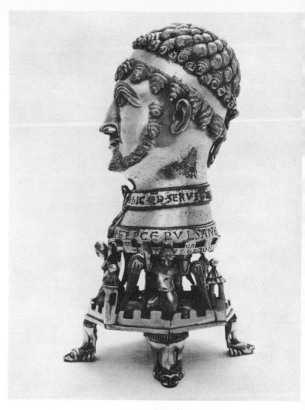

26 (*top left*) Bell reliquary of St Patrick, bronze, decorated with gold, silver, enamel and filigree work; Irish, *c.* 1100.

27 (*top right*) Reliquary in gilt bronze in the shape of the head of Emperor Frederick Barbarossa; Lower Rhine, *c.* 1155.

28 (*right*) Gilt enamelled bronze reliquary of St Thomas of Canterbury; *c.* 1200.

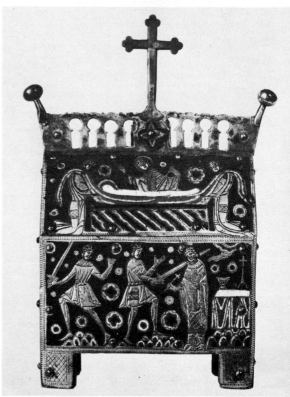

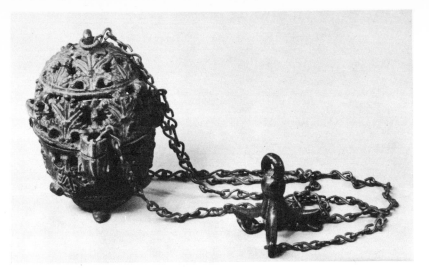

29 Censer of openwork bronze with chain, made by the *cire perdu* method; Lorraine, *c.* 1000.

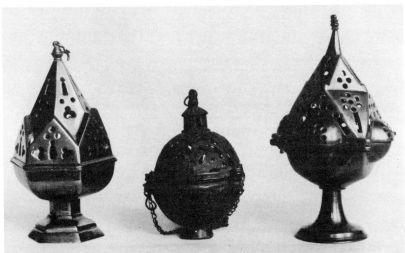

30 Mediaeval censers made in cast brass.

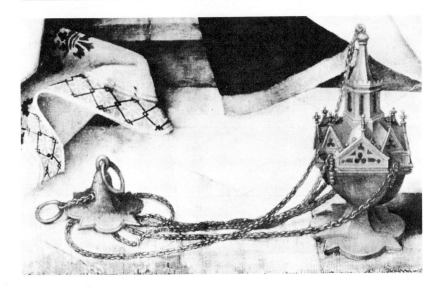

31 Bronze censer from a painting of *The Death of Mary* by Hans Holbein; 1501.

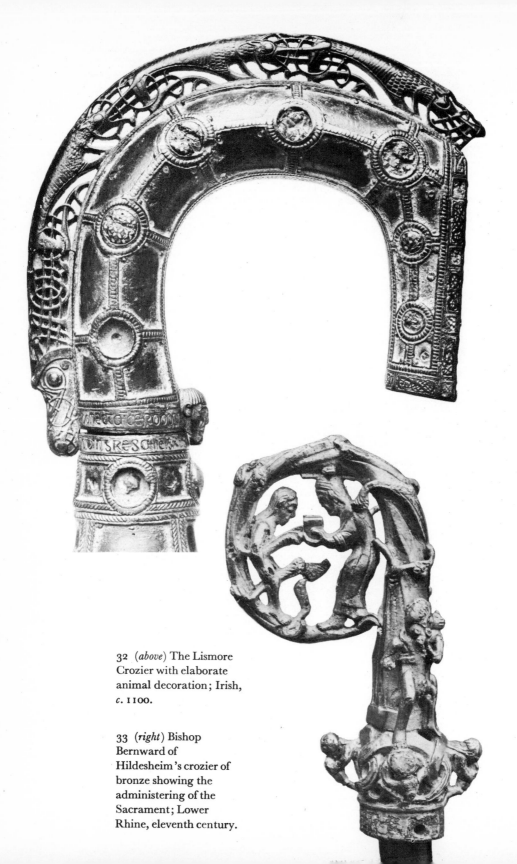

32 (*above*) The Lismore
Crozier with elaborate
animal decoration; Irish,
c. 1100.

33 (*right*) Bishop
Bernward of
Hildesheim's crozier of
bronze showing the
administering of the
Sacrament; Lower
Rhine, eleventh century.

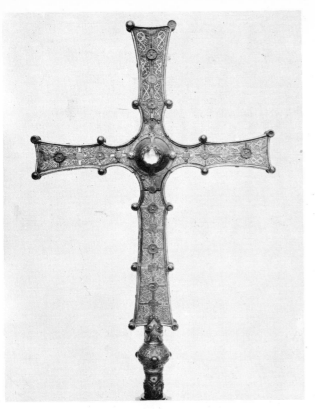

34 (*top left*) The Cross of Cong, a processional cross and reliquary made of gilt bronze with intertwined design of ribbonwork, stylized animals and serpents; Irish, 1123.

35 (*top right*) Romanesque processional cross of gilt bronze; German, twelfth century.

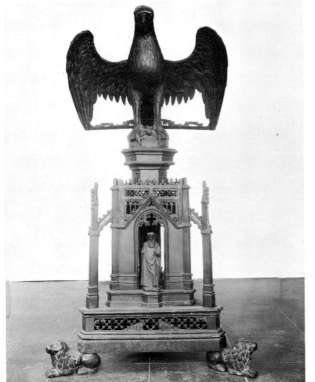

36 Eagle lectern in bronze; Dinant, fifteenth century.

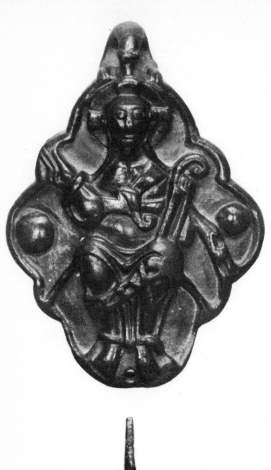

37 (*top*) Bronze reliquary showing Christ enthroned; English, *c.* 1000.

38 (*bottom*) Circular pricket candlestick with claw-footed base; Netherlands, thirteenth century.

39 Cast-bronze effigy of Rudolph of Swabia from his tomb in Merseburg Cathedral; *c.* 1080.

40 (*opposite*) Pricket candlestick, cast in the shape of a dragon, with magnificent decorative details; Lorraine, twelfth century.

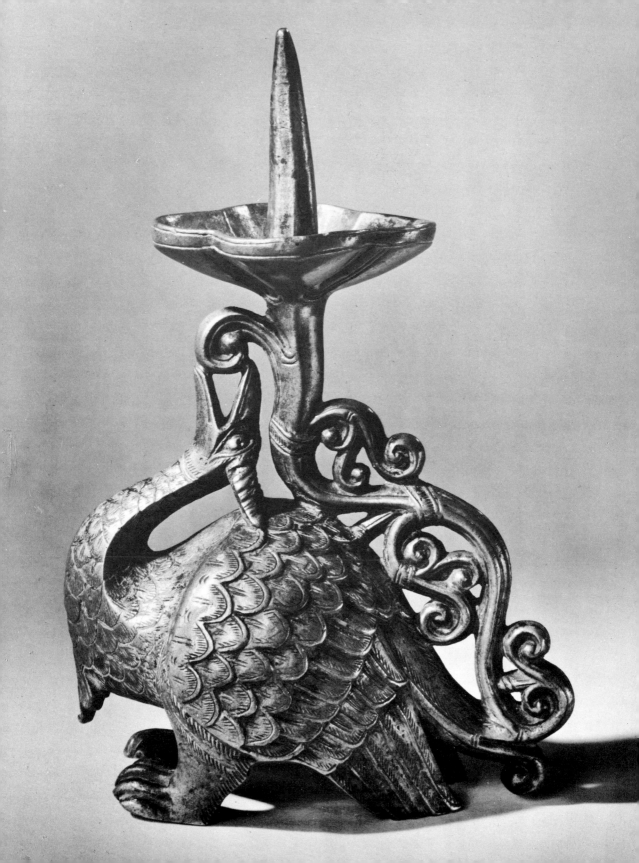

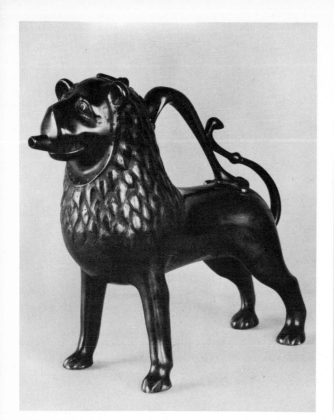

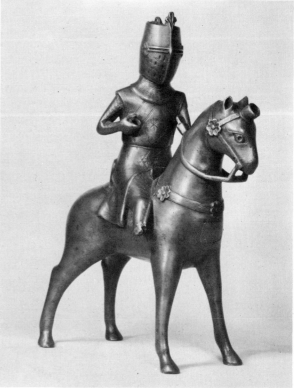

41 (*top left*) Cast brass ewer in the form of a lion; Dinant, thirteenth century.

42 (*top right*) Bronze aquamanil in the shape of knight on horseback; English, *c.* 1300.

43 (*right*) Bronze ewer or aquamanil cast in the shape of a lion. A serpent biting his ear forms the handle; Flemish (Dinant), thirteenth century.

44 (*opposite*) Bronze aquamanil of a lion with flaming tail; German, fifteenth century.

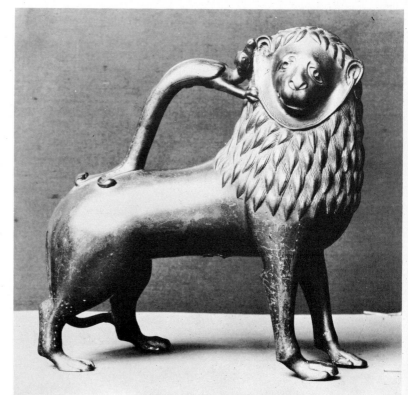

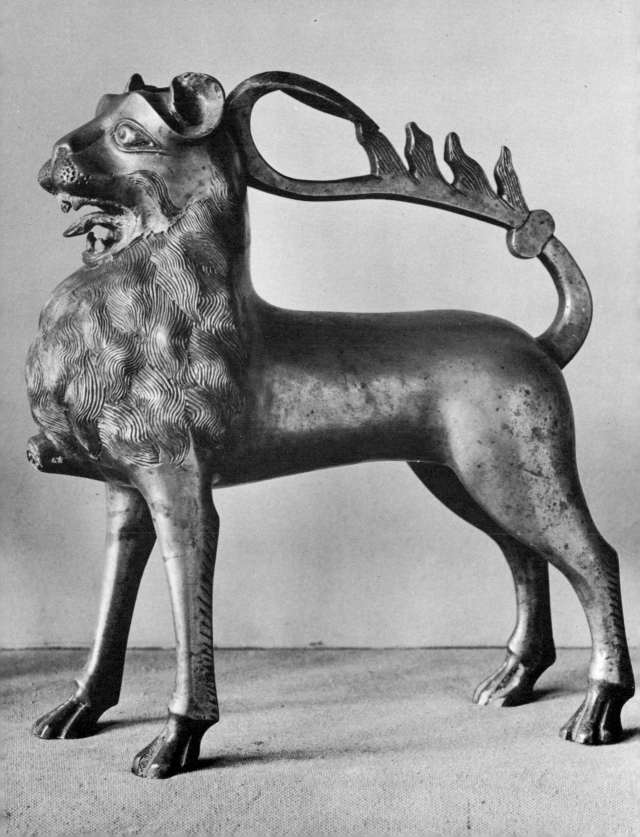

45 Bronze door-knocker; Lower Saxony, later twelfth century.

46 Sanctuary door-knocker in the form of a lion's head from Durham Cathedral; *c*. 1140.

which runs under the lion's chin from ear to ear. The stylization which is so characteristic of Gothic art can be seen here in the design of the animals, with their slender bodies set on long spindly legs. Their makers were clearly not unduly worried by practical considerations even when making what were intended to be functional objects. The lions moulded in this period are anatomically correct in every detail, with the result that the ewers are supremely elegant and give the impression of mighty strength held in check. Beneath our gaze the handle and tail seem to arch and writhe nervously as they intertwine to form an ornamental pattern.

In the first half of the fourteenth century a bronze-founder called Hans Apengeter of Sassenlant makes his appearance as one of the few artists to sign his work, which included some lions, with his own name. In those days ordinary town-dwellers and craftsmen had just begun to adopt surnames, so 'Apengeter' was as much a description of his trade as a family name (it means cauldron-caster).[2] Apengeter, or his workshop, produced bells, fonts, candlesticks, corn-measures and door-handles between 1327 and 1344. He was born in Halberstadt but worked in various places in northern Germany, and examples of his work can be seen in Kolberg, Rostock, Wismar, Lübeck, Kiel, Stettin, Göttingen and Hildesheim. This throws interesting light on the way that a workshop operated and suggests that its members must have travelled far and wide, executing most of the larger commissions on the spot rather than in the workshop itself. From 1332 to 1344 Apengeter was in Lübeck, which by this time had become an important metal-producing centre specializing in brass.

The turn of the century saw the first appearance of the lions with flame-like tails which were a typical late-Gothic design. The tail, which generally also forms the handle, is held high and embellished with little tongues of flame which were clearly intended purely as ornament. The elegance which characterizes fifteenth-century architecture and sculpture sometimes results in an effect of pretentiousness and over-elaboration; this tendency can be seen here in the daintily poised feet, the affected pose of the body, now lean rather than plump, and the elaborately curled mane.

The heraldic lion bearing an escutcheon on its chest brings us to the last phase in the history of bronze-cast lions and of aquamanile in general and to the beginning of the Renaissance. The escutcheons are engraved with the family coat-of-arms or sometimes with guild emblems. In quantity these bronze-cast lions are second only to the ewers depicting horses or equestrian figures. The most important of this last group depicts St George killing the dragon and is in the Carrand Room in the Bargello in Florence. It dates from some time

57

before 1400. Finally we must mention a pair of ewers depicting Phyllis riding on Aristotle's back; this was a favourite theme in the Middle Ages and was used as a symbol of worldly love triumphing over wisdom.

Hanseatic bowls

Ewers must presumably have been accompanied by basins and this supposition is confirmed by various medieval documents; but what did they look like? This type of basin is variously referred to as a *bacinum*, a *pelvis* or a *pelvicula*, and one particular copper basin was described in about 1100 as a vessel with a handle in the shape of an animal and silver decoration on the inside. It is generally assumed that a fairly large number of chased and engraved dishes of roughly similar design were used with the ewers. This type of basin was made in the twelfth and thirteenth centuries, mostly in northern Germany from the Lower Rhine to the Baltic and this is why they are known as Hanseatic bowls – the term is purely geographical. Descriptions of basins of this type occur in the earliest documents, and most of them are now in museums or other public or private collections, though a few can be found in churches. They are always round, some being deeper than others, with a narrow but pronounced horizontal rim and no feet. The inside is always engraved with a variety of scenes, which fall into three groups: (a) scenes from classical mythology, sometimes forming a coherent cycle of events and generally taken from Ovid; (b) biblical themes taken from the Old and New Testaments and the legends of the saints, again presented in the form of a sequence of scenes; and (c) various allegorical figures personifying vices and virtues, the liberal arts, the seasons, etc. The variety of the themes is an indication of the encyclopaedic knowledge which was an essential attribute of a truly cultivated man or woman at that time. At the same time the combination of temporal and religious themes shows that the basins were intended to serve a didactic purpose: 'As the user plunges his hands in the water, let him be constantly reminded of the need to lead a virtuous life.' The labours of Hercules, the tragic story of Pyramus and Thisbe, the life of Achilles and other incidents are displayed with genuine relish for their narrative interest, but the moralizing and didactic elements are always present. A textbook called *Hortus deliciarum*, written by a certain Herrad of Landsberg towards the end of the twelfth century for the instruction of the nuns of her convent, contains an illustration of a bowl decorated with allegories of philosophy and the liberal arts. This suggests that the engraved basins may also have been used for instruction in convents, but they were used even more frequently at ceremonial banquets given by the nobility in their castles,

58

together with the aquamanile shaped as lions or horsemen which have *Bronze and brass*
been described above.

Hanseatic bowls were probably made in the centres which manufactured candlesticks and ewers – i.e., the Meuse district, Lorraine and Lower Saxony. As the style of the engraving varies considerably, we can assume that these vessels were not necessarily made and decorated in the same place.

3 The Gothic period

During the twelfth and thirteenth centuries the little market centres, which had grown up near episcopal sees or beneath castle walls, were developing into towns. At first, life in the town was still not much different from the life led by the peasants in the country districts, and even the actual houses were of the same wattle-and-daub construction. But in the late thirteenth century and in the fourteenth, conditions began to improve: solid stone houses, free-standing furniture instead of built-in benches and cupboards, rich clothes, expensive furs, jewellery and other luxuries. Individual citizens – mostly merchants – could amass considerable fortunes, often in a very short space of time, and this meant that they were in a position to live very lavishly. But although they must have spent the most fabulous sums on their wardrobes, furs and jewellery, the furnishings and fittings of an ordinary town-house would still be very modest. The same simplicity could be seen in household utensils, which remained predominantly functional down to the fifteenth century and were not made decorative until the late Gothic period. A document drawn up in 1469 in connection with the inheritance of a German aristocrat refers to the following furnishings and household articles: four beds, seven tablecloths, seven hand-towels, one water-tub, two large and seven small pewter bowls, three tankards, two brass candlesticks, ten clay bowls, seven plates, three boxwood spoons, one large glass and six small, three cauldrons, four pots, two pans; we can assume that the cauldrons, pots and pans were all made of brass.

The guilds

Many of the people who left the land to live in the towns had done so to escape compulsory serfdom. But although this nominally gave them

their freedom, they were still bound by strict municipal regulations from which there was no escape except in rare cases. The social code was based partly on the concept of the natural order which had survived from the early Middle Ages, but it was also intended as a means of stabilizing the social and economic system. In this, the newly formed guilds or corporations of craftsmen played an important part throughout Europe. They made their appearance in the first half of the fourteenth century and, as the fifteenth century progressed, they began to achieve considerable political power and significance quite apart from their economic importance.

The basic principles underlying the guilds were based on practical considerations. Their regulations controlled the work executed by the craftsman within the social structure of the community, and ensured that each individual could earn enough to lead a life appropriate to his social position. It was therefore essential that there should not be too many members of a given trade in any one town – otherwise competition would be too fierce. A master-craftsman was allowed to engage only a set number of journeymen, and the number of working hours was strictly laid down – for instance, it was a firm rule that men should not be expected to work by candlelight or with oil-lamps. There were regulations about the use of tools, the quality of raw materials used, about prices and restrictions on competitors. A craftsman was allowed to make only certain articles and attempts to encroach on another's territory were severely punished. This policy applied particularly to the metalworking trades in the late Gothic and Renaissance periods, for at that time there were careful distinctions between the many branches of the trade.[1] On the one hand, this system of specialization meant that each craftsman could produce outstanding work in his own field and that every possible aspect of a craft could be explored; but on the other hand there were both dangers and disadvantages in a system which depended on too many and too subtle distinctions. There was much petty jealousy and envy often caused a craftsman to inform against a colleague. The craftsman's pride in his work declined, and his ingenuity was hampered by the realization that a new invention might be construed as an infringement of the rules, because he had exceeded the limits of his field. From time to time these highly specialized trades would be so short of commissions that many of the craftsmen would be compelled to look for extra work, perhaps becoming watchmen or messengers, in order not to fall into complete poverty.

The strictest method of control was provided by the rules governing entry to a craft and, later on, admission to the rank of master. Even in the admission of new apprentices strong measures would be taken to ensure that one particular craft was not over-subscribed. A boy apprentice

61

Metalwork had to be born in wedlock of parents who were themselves legitimate, and sons of men practising dishonourable trades were excluded – 'dishonourable' referred to executioners, barbers, millers, shepherds or card-painters. At the end of the Middle Ages an apprentice had to serve six years, though in about 1700 this was reduced to four and in about 1850 it was further reduced to three. In fact exceptions were often made to this rule.

When he had completed his apprenticeship, the young craftsman had to be taken by a guild-member to an open meeting of the guild, where he had to ask publicly, in the presence of masters and journeymen, to be released from his apprenticeship. His request would then be granted and he would be treated to impressive warnings and advice from his master. A cup of wine concluded the official part of the proceedings and there followed a banquet which all heartily enjoyed, but first the new member would be forced to undergo some sort of facetious and often unpleasant ritual to prove his courage. He would also be subjected to all sorts of banter and trick questions, worded in such a way that he invariably failed to give the right answer.

Now he was free to begin his compulsory years of travel as a journeyman. He would travel for six or eight years, depending on the rules laid down by his particular trade; this phase of his career was specially designed to enable him to visit many different places, and gather knowledge and skills from far and wide. This is one explanation for the appearance of any one type of vessel in different areas.

Another result of the compulsory travel period was that journeymen took measures to ensure their success when they were abroad. A sort of labour exchange would be set up to help newly arrived journeymen and they would be found lodgings and given financial assistance until work was found for them. Journeymen would hold meetings in inns and taverns to discuss any claims and demands which they wished to put to the masters, and this unofficial journeymen's union developed over the years into a considerable force. They were utterly self-confident in their dealings with the masters and were quite capable of gaining their point, so that many a controversy would end with the master being boycotted by the journeymen, which meant that everyone would refuse to work for him. The tavern meetings initially performed a necessary service in looking after the practical and social interests of the journeymen, but over the years they degenerated into wild drinking-bouts and the authorities rightly began to object and to prohibit them. As a result the meetings lost their earlier significance and by the eighteenth century all that was left was a collection of rituals and customs.

Craftsmen worked long hours, generally beginning their working

62

day at sunrise and finishing at about seven in the evening. Journeymen and apprentices had to get up at four in the morning in summer; they lived in their master's house and had set meal-times and breaks. When the journeyman returned from his travels he could, if he wished, have his name put down as a prospective master in the guild. He then had to wait for another year during which he was not allowed to marry, and at the end of it he could enter for the master's examination. He would be allotted a workshop in which he must make the test-piece set for him by the guild within a certain time-limit, and it had to be all his own unaided work. This piece would be examined by the guild's board of examiners and if it met the required standard the candidate would be publicly admitted to the guild as a master before the assembled guild-members. Speeches would be made, a toast drunk to the new master and then he would have to arrange a celebration meal at his own expense. This often involved a good deal of money, and it is partly true that the costs were kept deliberately high so that many would-be masters were discouraged from entering for the examination, and the guild was thus kept to a manageable size.

Journeymen who were not in a position to become masters led very humble and often thoroughly wretched lives; if they were married they had a real struggle to make ends meet. In their old age they would be completely dependent on their masters and had to remain in their service for the rest of their lives. Social insecurity and discontent were rife, and tension between journeymen and their masters sometimes led to economic warfare and strikes, and boycotting of individual masters. A newly appointed master was expected to apply for the freedom of his city during the year following his promotion and he was also expected to choose a wife, preferably the daughter of a master practising the same trade as himself, or a widow. This would increase his chances of opening a workshop without further delay, since otherwise he would have to wait until there was a vacancy.

The guild authorities made strict regulations which even concerned the private lives of their members, but they also created privileges for themselves and were rigidly selective in order to ensure their continuation and the safeguarding of their members' livelihood. Union members today would find these regulations extremely authoritarian and it would be difficult to find anyone who would accept such a limited degree of personal freedom. But although the guild system may have seemed too restricting, even in those days – and there certainly was some opposition, as we can see from the many occasions when the rules were violated – it was on the whole accepted as part of the divine scheme which assigned each individual to his place in society.

The sixteenth century – the beginning of the modern period – saw

Metalwork the first attempts to break up the guild system, but such attempts were only very occasionally successful, any success being the result of the pressure of economic circumstances. For a long time the guilds managed to hold on jealously, and often childishly, to the privileges and regulations they had established for themselves, often to the detriment of their own members. In the eighteenth century they began to lose their hold, eventually disintegrating completely under the combined effects of the French Revolution, Napoleon's rise to power (which affected the whole continent of Europe), and the Industrial Revolution. Their disappearance brings to an end a whole chapter in the history of European craftsmanship.

Household utensils of the Gothic period

Although, as we have seen, works of art were reserved exclusively for the Church and the nobility, ordinary household articles were necessary for the ordinary man: the peasant, the craftsman, the town-dweller and the landed gentry. Unfortunately very few domestic utensils have survived, since they were generally made of some perishable material such as wood, though quite a few ceramic articles have come down to us. The little that has survived suggests that the way of life enjoyed by the various social classes was not as sharply divided as before, and this is confirmed by the few descriptions of ordinary life which have been preserved. This means that the domestic habits of peasants, town-dwellers and landed gentry were much the same, and they used the same type of household utensils. Even the rich and the powerful in the Carolingian and Hohenstaufen periods had not yet begun to amass the wealth of lavish tableware which was customary among their counterparts in the late Gothic and Renaissance periods. Armour, clothing and jewellery, as well as food and drink, would often be on a lavish scale, but tableware and household furnishings were still extremely simple. Bronze and brass were both expensive and relatively rare at this time, so people had to be satisfied with wooden or earthenware bowls, the whole family eating from the same dish, as is still the custom in various country districts today. The one and only spoon would be made of wood or clay. Everyone would have his own iron knife which he would carry round with him, but he would eat with his fingers. Forks were extremely rare until the fifteenth century. At night the rooms would be illuminated by the scanty light of pinewood torches or earthenware oil-lamps, for bronze lamps were too expensive to be used anywhere but in churches.

In the early medieval period, townships were still very small and simple in their way of life. Since these settlements had few inhabitants,

64

v (*opposite*) Bronze mortar with an inscription of Gothic lettering and early Renaissance decorative motifs; Flemish, 1540.

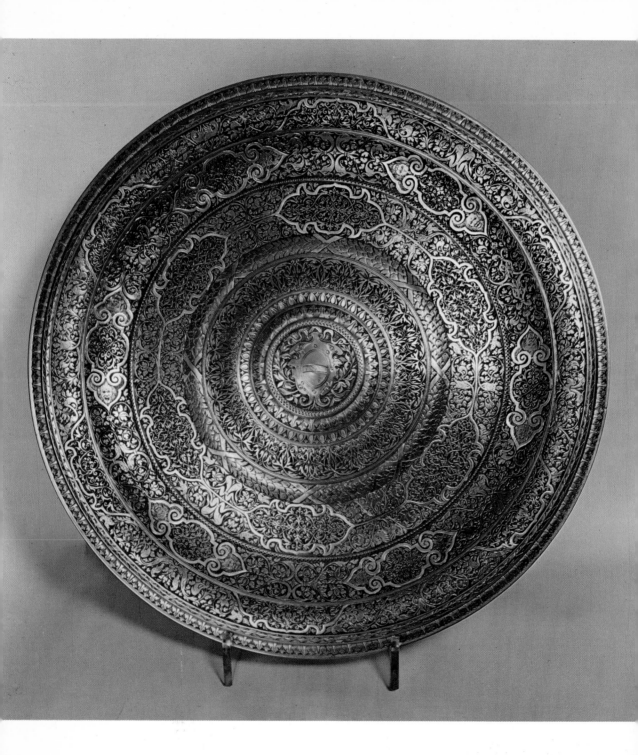

there were no specialized craftsmen among their ranks; qualified crafts- *Bronze and brass* men were compelled to work where there was a larger consumer demand. This meant that the poorer classes in particular had to rely on their own skills and make do with the barest minimum of utensils. Even the rich and the aristocracy had no alternative but to be satisfied with little. Less primitive utensils for household use appear at first only in the houses of the clergy and in wealthy monasteries. This was partly because it was in ecclesiastical circles that the champions of culture were to be found, but also because their material wealth gave them the opportunity to enjoy such luxuries; in fact, we know that complaints were frequently voiced about the unnecessary extravagance of the clergy. Abbots and bishops would summon bell-founders, candle-stick-makers and door-founders to work for them, and it seems certain that the desire to have ordinary utensils made in bronze originated here.

The bronze household utensils which have come down to us from the Middle Ages are as humble and unassuming as their ecclesiastical counterparts are rich and varied, the main reason being that articles in daily use soon became worn out and, if they were made of bronze or brass, were handed back to the foundries to be melted down.

Cauldrons

The most essential piece of household equipment was a receptacle for boiling water, as indeed it is today. The same type of three-legged cauldron was used all over Europe in the Middle Ages, with only minor regional variations; it would be placed either on the hearth or else suspended above it from two round handles. The spherical shape of the earliest examples, which date from the thirteenth century, gives a clue to their origin. They are in fact modelled on ceramic vessels, as is proved by a number of receptacles of the same type, made of glazed earthenware or a kind of stoneware, which have been found in the Lower Rhine area. These again are modelled on the same spherical prototype, which was used from the Stone Age onwards and was copied by the Vikings, the Franks and the Anglo-Saxons. This vessel is known as a *chaudron* in French, while the German term is *Kessel*, or *Grapen* in northern Germany.

In the thirteenth century bronze-founders began to adopt this home-made design for their own work. The shape they used was a popular and simple one and they kept the practical features, such as the legs and the round handles at the side, which had already been added by potters; they did not attempt to add any extra embellishments. During the thirteenth and fourteenth centuries new ideas began to develop and infiltrate the design, so that from now on we can recognize a number of different styles as characteristic of one particular area or period.

65

VI (*opposite*) Venetian dish of bronze, decorated with inlaid silver. The motifs are classical, but show strong Saracenic influences; sixteenth century.

In England the earliest cauldrons were shaped in the same way as their German counterparts, with the same three legs, the same lipped narrow opening and pair of ear-shaped handles at the sides for hanging above the hearth. But as early as the fourteenth century the spherical design was abandoned in favour of a more practical and economical design. The bottom of the cauldron was now made as wide as possible, which also made the cauldron flatter, as can be seen in a large cauldron which, traditionally, was donated to the Trinity Hospital in Leicester by Henry, Duke of Lancaster, in 1331. The widest part of the curve of the body was simultaneously transferred to a lower point so that the weight appeared to be at the bottom, while the collar-like lip was widened; the result was that the cauldron now resembled a pouched bag. If we compare this shape to the spherical one, perfect in itself, we will see that aesthetic merit has been abandoned in favour of more practical considerations. Whereas three-legged cauldrons reached their greatest heights in France and Germany during the period from the thirteenth to the fifteenth centuries and then gradually dwindled in the sixteenth, in England they continued to be made and their design was improved and modified. The round handles gradually disappear, which means that instead of being suspended over an open fire the cauldrons would now be placed on the hearth. For greater ease in handling there was now a protruding handle like that of a saucepan which would usually be set just below the overhanging rim, and would sometimes be strengthened by a curved piece forming a quarter of a circle. The handle itself would normally be flat, sometimes inscribed with the words 'pitty the pore'. This type of three-legged pot with its handle continued to be made in the seventeenth and eighteenth centuries, though changes would be made all the time; the sides might be made higher or lower, the mouth smaller or larger, the body could be full-bellied or slim, the rim could curve inwards more sharply or spread out into a flat lip and the legs could be longer or shorter. The original spherical shape did not die out completely, but with time became less and less common. The legs had initially been quite long, but later on, i.e., in the sixteenth and seventeenth centuries, they were shortened until they were no more than shrivelled stumps.

Any decoration on these cauldrons is usually very simple, since the effect of the design depended on the carefully proportioned lines of the body. One motif often used was a thin line, ridge or furrow running horizontally round the sides – this type of decorative motif was also used elsewhere in Europe. Another example consists of vertical lines running up the body; these might continue the line of the legs, giving a rib-like effect, a trend that is an indication of the Gothic style. English makers often attempted to decorate the point where the legs

66

joined the body with little ornamental details moulded in flat relief *Bronze and brass* (reminiscent of iron nails). The intention was to make the join appear more attractive but the result was in fact to draw attention to its shortcomings. Relief decoration was rarely attempted on other parts of the cauldron.

It was a short step from the pouch-shaped cauldron with a handle to the open pan. This was of course much more suitable for stewing and roasting, since the contents can be more easily watched than in the narrow-necked cauldrons which were probably used only for heating water or cooking broths. In England this development followed a logical sequence: the cauldron passed through various intermediary stages, during which vessels with a pot-belly but a wider mouth were produced, until the actual saucepan was developed, with its flat base, high cylindrical sides and long handle. The three legs were still added even in the seventeenth and eighteenth centuries, though they were sometimes no more than short stumps.

In Germany, the Low Countries, northern France and the Alpine districts the same types of vessel were made, but there they developed along rather different lines. The earliest spherical pots with handles and three legs in Germany were earthenware; they date from somewhere round 1150 and have been found during excavations in the Lower Rhine area. Bronze cauldrons did not appear until later, the earliest surviving examples dating from the beginning of the thirteenth century. Those dating from the medieval period are generally small, with apertures measuring between 3 and 12 inches. The cauldrons made in the thirteenth century have very thick walls, whereas those of the fourteenth and fifteenth centuries would generally be rather light with thin walls. They would be cast in two-part clay moulds over a clay core. Articles made by this method can be picked out easily because they have casting-seams running down the body. The casting-pipe, through which the molten metal was poured, was always placed in the centre of the base. Very few cauldrons were made by the lost-wax (*cire perdue*) technique. In the seventeenth century sand moulds would be used instead of clay.

The spherical shape was particularly common in northern and western Europe and in the Alpine districts in the thirteenth and fourteenth centuries, but it was also often used later.[2]

The earliest cauldrons are generally set on high legs, often ending in claw-feet. This motif was probably borrowed from the aquamanile, which were in their heyday in Germany at the time when the first cauldrons were being made. Dutch cauldrons, on the other hand, have short legs which are often mere stumps. The early vessels have very little ornamentation, many of them having completely plain walls,

67

though a few are decorated with raised or incised horizontal lines. The English custom of trying to hide the join of the legs with ornamental trimmings was never adopted in Germany.

In the fourteenth century a new, rather squashed-looking pot took its place alongside the pot-bellied ones; the widest part of the body is set lower and the base is flattened, but the English type of pouch-shaped pot was rarely made on the Continent, where designers kept to a uniformly squashed shape, rather like a bundle or flat parcel.

Yet another variant, which appeared in the fifteenth century, was a three-legged pot which was clearly influenced by the basin shape: low, broad, and with a wide mouth. Although the characteristic features of the cauldron are still present, this type of vessel, which incidentally holds far more than the normal cauldron or pot, could scarcely have been suspended from a pothook over the fire, since the weight is no longer evenly distributed; instead it must have stood on the hearth.

In the sixteenth and seventeenth centuries, cauldrons began to get bigger and their capacity increased proportionately. It is not unusual to find vessels which hold as much as fifteen to twenty litres, and one of the largest, made in 1592, holds almost seventy-one litres. Many new designs were invented in the sixteenth and seventeenth centuries but the old shapes were not abandoned, so old and new can be found side by side. The spherical shape, which predominated in the early days, was supplanted in the Renaissance and Baroque periods by various new designs, some of which are rather reminiscent of basins, while others are more like buckets or kettles. Later examples had wider apertures and flatter bases, which meant that a larger area could be exposed to the heat.

In southern Germany and Austria and also in France coats-of-arms and inscriptions or dates would often be added to the mould, so that they appeared in relief on the sides of the cauldrons. Engraved or chased decoration is also sometimes found.

A few of the cauldrons made in Germany, mainly those from the north, bear founders' marks. These appear on the inside of the rim behind one of the handles, or on the outside of the rim, or sometimes on the shoulder of the vessel, still close to the handles. The founder's mark is sometimes accompanied by the coat-of-arms of the appropriate town; this may be the result of a resolution drawn up in 1354 between the Hanseatic towns of Hamburg, Lübeck, Rostock, Stralsund, Greifswald, Wismar and Stettin, but it does not seem to have been followed closely since only a minute proportion of surviving cauldrons are stamped with their city-mark.

Three-legged vessels were used in the houses of country-folk and

town-dwellers alike; they were considered to be some of the most vital pieces of kitchen equipment and their importance is shown in frequent references to them in inventories and wills. Many a large household would possess several cauldrons of different sizes. For almost six hundred years this type of vessel had a special position among household utensils, until in the eighteenth century it was driven out of the kitchens of Europe by kettles and other kitchenware made of cast iron. Vast numbers of these beautiful vessels, so perfect in the simplicity of their strong lines, vanished over the years with the spread of industrialization.

Three-legged jugs

The use of three supporting legs is not restricted to round pots, cauldrons and coppers, for bronze serving-jugs would also sometimes be set on legs, though they are fairly rare and are found only along the north German coast. This type was short-lived and was mostly made in the late thirteenth and fourteenth centuries. The design did not undergo any systematic development: we can find examples with an elegantly shaped body, rather similar to pewter-jugs being made at the same time, or even bearing a resemblance to certain pieces of silverware, alongside inelegant, tear-shaped specimens. The feet on this type of vessel are not very long and are always claw-shaped; the spout is generally fairly long and tubular, and curves first downwards and then horizontally, ending in an animal's head. The handle forms a simple curve. The use of these jugs is not clear; they were certainly not used to heat or serve water, since that function was reserved for cauldrons and for lavabos, which have not yet been mentioned. But as hot spicy wine was a favourite drink in the Middle Ages, it seems quite likely that this filled the three-legged jugs.

Lavabos

In a nobleman's household a ewer would be used for washing one's hands after a meal; it would be ceremonially handed to the master of the house by a page or one of his servants, for the action of washing hands was regarded as a solemn rite with its parallel in the priest washing his hands during Mass. The analogy was emphasized by the similarity of the vessels used for both the religious and secular ceremonies. But as town-dwellers began to develop their own middle-class culture ewers gradually disappeared and were replaced by a different type of vessel with which hand-washing became less ceremonial as each person could do it for himself. The new vessels are known as 'lavabos' and are shaped like a pot with two curving tubular spouts, though they may very occasionally have a single spout. The basic shape is very close to that of a cauldron. They would generally be hung in a niche

Metalwork on a free-swinging hook, above a basin which would also be made of brass or bronze. To wash one's hands, one tilted it sideways so that a little water could trickle out – very little would be wasted because the lavabo would automatically swing back to its original upright position.

Although lavabos were still basically functional objects, metal-workers now took the opportunity of displaying their artistic skill by lavishing great care on their moulding and decoration – this had not always been the case with cauldrons.

The earliest lavabos can be dated round 1400 on stylistic grounds and this is confirmed by a comparison with cauldrons made at that date. They are particularly common in northern Germany and West-phalia and in early days would generally have a squashed-looking appearance, like a bundle or package, and in fact this basic shape did not change much over the next two hundred years, particularly in the more conservative area of Westphalia. Only very few made in the late fifteenth and the sixteenth centuries seem to have been inspired by the spherical pot that formed, as we have seen, the prototype for the tradi-tional cauldron shape. Details are treated with painstaking care, and it can be seen that in many cases the artistic ambitions of the maker took him beyond the bounds of ordinary craftsmanship. One feature which persisted for many years was a spout shaped like the head and open jaws of some fabulous creature. It is difficult to discover the source of this type of spout, but it remained popular for a long time and was indeed still being used to embellish teapots and coffee-pots as late as the Rococo and Empire periods. It is possible that it originated with the small animal heads on aquamanile, since on these, too, there were sometimes small spouts, set in the jaws of a lion or other, fabulous, creatures. Alternatively they may have been inspired by certain oriental designs, possibly from the Far East, or by the Old Norse animal shapes which appear so frequently from the time of the Vikings onwards in the popular art of North Sea districts.

The point where the handle joined the body of the vessel gave the bronze-founder another opportunity to demonstrate his skill, and although the handle itself is often merely set in a simple eye or loop it is not unusual to find a human bust concealing the join, embellishing the vessel at the same time. In general these little figures wear their hair styled in the latest fashion and are dressed in contemporary clothes; their style and dress is rather reminiscent of the self-portraits which architects sometimes placed in their churches.

Lavabos continued in use until the seventeenth or eighteenth centuries, when they were replaced by larger vessels in pewter or faience. The new jugs had sloping backs and would be hung flat against the wall; there would be a small tap which could be turned

70

to let a little water run into a basin below, the basin generally being made of the same material and in the same style as the jug.

Free-swinging lavabos made of bronze sometimes appear hanging on walls in Gothic paintings of domestic interiors dating from the fifteenth and sixteenth centuries. Annunciation scenes are particularly rich in this type of detail and, in such cases, the lavabo clearly belongs in the room, which will be furnished in a style both lavish and intimate. The artists clearly wished to provide a suitably majestic background for Mary and for the miracle about to take place, and therefore painted the most magnificent room they could imagine, drawing on their own period and surroundings for costume and interiors. We can therefore infer that the lavabo had its place in the patrician household of a wealthy town-dweller, while the ordinary citizen, the small craftsman and the peasant would not be familiar with such luxury and would simply use a well, or possibly an earthenware jug, for washing their hands. Lavabos may have been used in churches, but there is very little evidence to substantiate this.

Jugs

A comparatively large number of pewter jugs from the mid- and late-Gothic periods have survived, but brass jugs are far less common. The main reason for this discrepancy is of course that pewter is much more hygienic than copper for use at table because it does not form a deposit of verdigris or other harmful oxides. But all the same, a few brass jugs have survived in northern and western Germany, which suggests that they must have been used over a fairly wide area. But they did not have any stylistic influence and in fact, with only a few exceptions, they seem to have been copied from vessels made in other materials.

Firstly there are jugs set on a foot or pedestal, most of which are pewter. The body generally has a squashed appearance and is set on a tall slender stalk-like foot matched by a long slender neck, so that the whole vessel has the effect of a pillar. Although very few pewter jugs of this type have survived from this period, they seem to have been used a good deal at council meetings and are fairly often mentioned in guild documents and elsewhere. Brass jugs were made in this pedestal style but were always smaller than the pewter ones, which in fact held a considerable amount. Brass-founders concentrated on the details of the design and the decoration of raised or grooved lines is always executed with great delicacy and finesse, while the handles are not merely bent into a ribbon-like curve, but often moulded to resemble mythical creatures with arched backs. One extra feature invented by the brass-founders is a spout in the shape of a snake, which never

Metalwork appears on pewter jugs; the brass-founders must have been familiar with this concept from their work on lavabos.

Another type of brass jug was designed independently by brass-founders in the Low Countries. The shape is not very successful from the aesthetic point of view, but a study of various paintings reveals how this particular design developed and for what practical reasons. The bottom half resembles a goblet or drinking-mug while the top half, which is parcel-shaped or spherical, bulges above it. At the front of this top half appears, as if stuck on, a spout in the shape of a beak; there is also a lid, which may be dome-shaped, lightly arched or completely flat, and a handle. The jug would be used for washing, and a basin was specially designed to go with it: the jug was made to be placed in the centre of the basin, the height of the slender foot corresponding exactly to the height of the basin, so that the bulging top part rose from the basin as the crowning element of the whole set.

It seems probable that small bronze buckets made according to the same design and again with matching basins were also used for washing.

Buckets

The bucket represents one of the basic shapes of vessels and presumably originated from a hollowed-out tree-trunk. This basic shape later developed into a cask with cylindrical sides made of wooden hoops bound with metal which is still used today by town-dwellers and country-people alike, along with many other variants which evolved later.

The basic shape of the wooden bucket has held its own for over two thousand years: but when, why and by whom was it first made in the less humble material, bronze? The answer, as so often in other cases, is that a grander version was first required for use in churches and cathedrals, and this was then adapted for the more elegant of medieval households.

In the Romanesque period, bronze buckets were used for holding holy water, but they were easily recognizable as descendants of the original wooden bucket since they still had the same cylindrical or slightly conical sides and the same horizontal lines running round the base, the centre of the body and the rim. Of course these lines no longer held the bucket together, but were merely a reminder of the circular hoops on wooden casks. In fact these vestiges of hoops persisted into the late-Gothic period and even longer, though by then they were regarded as ornamental and were redesigned to look more decorative. The join of the handles gave another opportunity for decorative detail, and here close-fitting mounts alternate with animals' heads and human busts. The handles themselves were sometimes also

72

Bronze and brass: Gothic

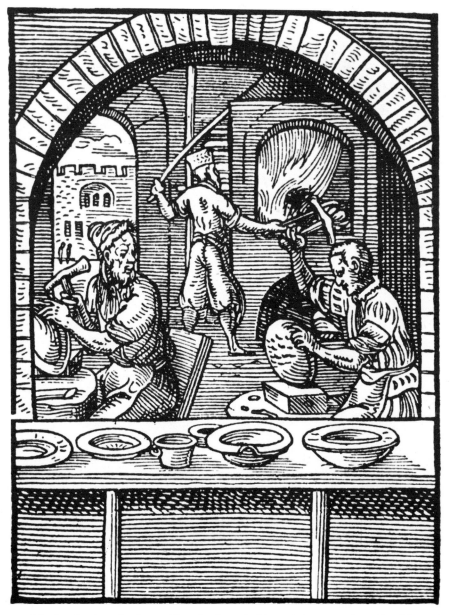

47 The bowlmaker, forging and beating brass in his workshop; woodcut, Frankfurt, 1568.

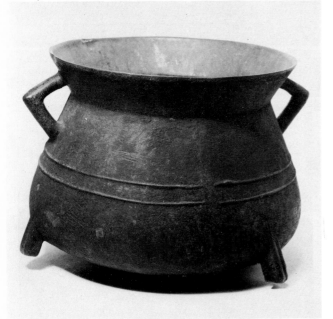
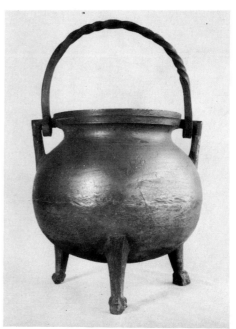

48 (*top left*) A bronze cauldron, known as the Bodleian bowl, with a Jewish votive inscription; French, late thirteenth century.

49 (*top right*) Bronze cooking vessel resting on three clawed feet; English, fourteenth century.

50 (*bottom left*) Cauldron cast in bronze, with a full base and squat legs; English, sixteenth century.

51 (*bottom right*) Bronze cauldron with handle; South German, c. 1600.

52 (*opposite*) Cauldron hanging over the kitchen fire; from a painting by Pieter van der Bos, early seventeenth century.

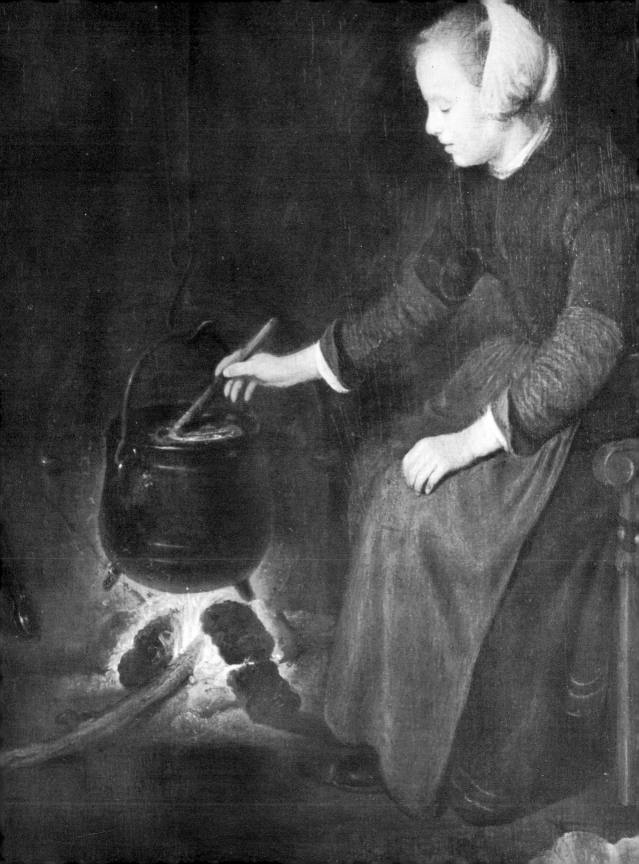

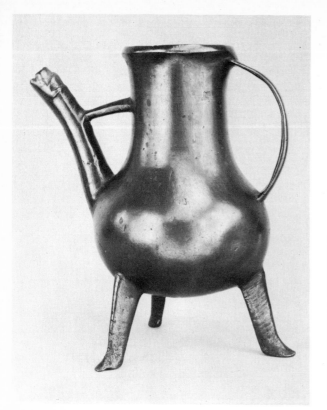

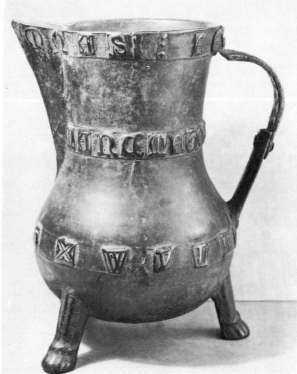

53 (*top left*) Three-legged ewer with a zoomorphic spout; English, *c.* 1400.

54 (*top right*) Bronze jug with Lombardic lettering— 'Thomas Ellyot, he recommand me to eu Wylleam Ellyot'; English, fourteenth century.

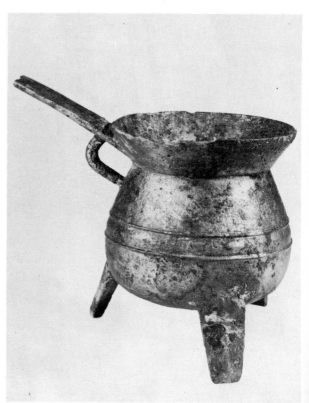

55 (*right*) Bronze skillet with long handle; English, fourteenth century.

56 Detail from a painting of *The birth of Christ*, showing an open pan with handle and legs; Master of the Lüneburger Golden Table, *c.* 1410.

57 Cauldron with long handle; English, *c.* 1400.

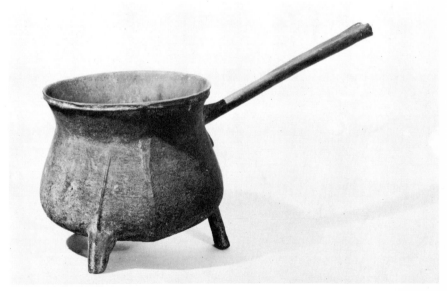

58 Bronze open skillet; English, early seventeenth century.

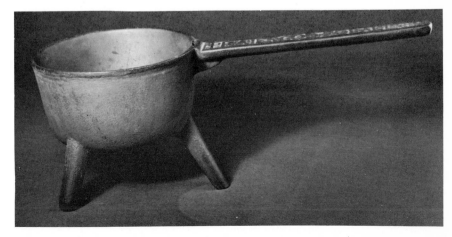

59 (*below*) Lavabo and basin, and bronze candlestick with snuffers, from an Annunciation scene; Master of the Pollinger Tables, *c.* 1440–50. 60 (*right*) Bronze jug with foot, used with a basin for washing. Spout and handle incorporate animal forms; North German, fifteenth century.

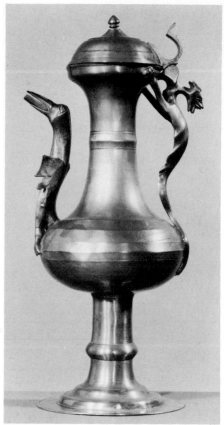

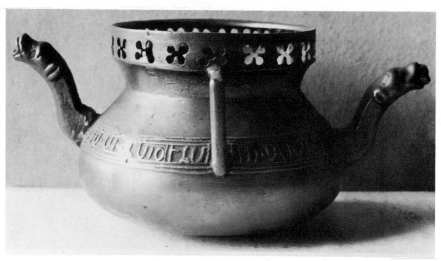

61 Copper lavabo or cask; Lower Rhine, *c.* 1500.

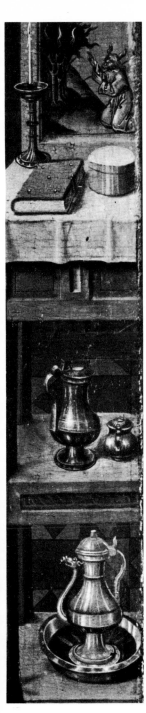
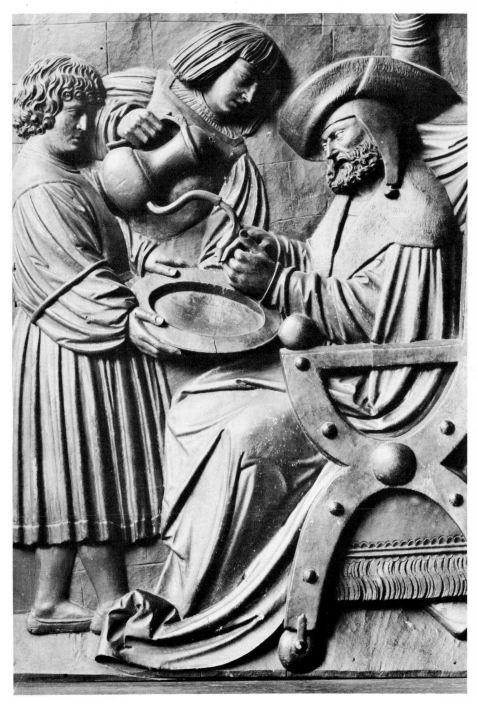

62 (*left*) Bronze vessels from a scene of the *Birth of Mary*; Swabian, 1489; the lower jug shows a form very close to plate 60.

63 (*right*) Pilate washes his hands, a scene showing the use of bronze jug and basin; workshop of Jörg Kendel, Biberach, *c.* 1520.

64 (*top left*) Brass holy-water bucket with Saracenic decoration in silver; Venetian, late fifteenth century.

65 (*top right*) Detail from a painting of the *Death of Mary*, showing a bucket made of bronze or brass with decorative heads; Hans Holbein the Elder, *c.* 1500.

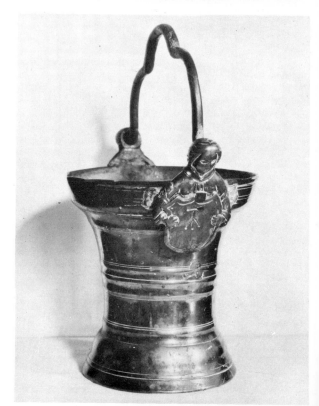

66 Bronze holy-water bucket, decorated with angels holding shields; Rhineland, fifteenth century.

transformed into a pair of snakes with their heads meeting in the centre. *Bronze and brass*
In northern Germany bronze buckets would sometimes be set on three short legs, not for any practical reason but to create a stylistic similarity with the cauldrons and three-legged jugs which we have already discussed. In fact it is possible that these three-legged buckets found in northern Germany were not used for holy water but as ordinary water pails for domestic use.

From the stylistic and historical points of view, it is only a short step from the large bronze buckets with their wide apertures to the font-shaped baptismal bowls sometimes found in smaller churches.

While the basic cylindrical shape remained unchanged throughout the twelfth, thirteenth and fourteenth centuries, in the late-Gothic period bronze-founders began to design more elegant buckets whose flowing shape caught and reflected the light. One of the most characteristic features of the late-Gothic period, when there was so much turbulent intellectual activity, was the wide and rich variation of styles. These buckets for holy water are clearly products of their age, reflecting as they do the rapid changes taking place in sculpture and architecture. In this they are clearly more closely related to sacred art than to ordinary domestic ware, which, as in the case of the three-legged pots, was always highly conservative and stubbornly resisted change for many centuries.

4 The Renaissance

In the fourteenth and fifteenth centuries the towns of Europe, headed by the imperial free cities of Germany and the chief towns elsewhere, became metropolitan centres of trade and manufacture. Craftsmen could now live within the shelter of the city walls, supplying aristocrats and humble citizens alike with their wares. City life created new needs which the craftsmen attempted to satisfy, for the new consumer demand was the basis of their existence. The guilds kept all in order.

Brass and copper producers were no longer compelled to restrict their business to areas where the metals were mined, for as new trade routes were established the problem of transporting goods over long distances was no longer insurmountable and bronze and brass foundries could be set up anywhere. The *batteurs* who had escaped from the ruins of Dinant settled down in the Low Countries, establishing new production centres which soon made Holland and the southern Netherlands important producers of bronze and brassware of quality. In the fifteenth and sixteenth centuries the leading town in Germany – and indeed in the whole of Europe – was Nuremberg, which was soon to become famous throughout the world for its metalwork.

Nuremberg

Nuremberg was unique in Germany in having a system in which trades were not grouped into guilds but were governed by the town council, which was composed of members of a few of the most powerful Nuremberg families. The town council therefore took over the normal functions of the guilds. The advantage of this system was that any decisions taken would be far less impartial than was usually the case when the guilds were in charge. In 1348–9 the craftsmen of Nuremberg rose in

74

protest against this situation and demanded that a guild system be put into operation, but their revolt was totally unsuccessful.

There were two different types of trades: those whose members worked on a freelance basis and those where the craftsmen were bound by an oath. The latter had to obey strict regulations and laws governing the admission of apprentices, the length of apprenticeships, the examinations which led to the rank of journeyman and master – in fact, anything to do with the craftsman's way of life. On the other hand, anyone who wished could practise one of the free trades, though this often led to much shoddy workmanship; the main aim of the free trades was to be elevated to the rank of an oath-bound trade, but they were not always successful in this. As well as the trades whose members were sworn in by oath, which included the craft of metalworking, there were also restricted trades whose members were strictly forbidden to leave the town – the purpose of this restriction was to prevent the special secrets of the trade leaking to other centres and being copied. This policy of restriction was in fact followed only for a short while in Nuremberg but the town council would often try to prevent local craftsmen from leaving the town.

The town council in Nuremberg kept a close watch on the quality of goods and very strict rules had to be complied with; the quality of the raw materials used was also under strict control. Certain categories of brass and bronze goods would be stamped with a control-mark to show that they had been inspected for quality: this consisted of the Nuremberg coat-of-arms – the harpy – and the master's armorial bearings, or family crest, or initials. The marks were punched with an iron stamp and can be found mainly on sets of weights, which would at the same time be guaranteed as accurate. Although it has always been usual throughout Europe for pewter to be marked, this is rarely the case with bronze and brass articles.

At the end of the fifteenth and the beginning of the sixteenth centuries the metalworking craft in Nuremberg, then at the peak of its development in trade and economic affairs, experienced changes which are characteristic of the economic and social tendencies of the age. Two new designations begin to appear in contemporary documents: 'piece-workers' and *Staudenmeister* ('bush-masters'). The piece-workers formed an economically insignificant and inferior body made up of elderly journeymen or young masters who worked for others rather than running their own businesses. They worked on piece-rates, settling the fee for each job in advance. Later on they came to be known as *Heimarbeiter* or workers in a home-industry. The term 'bush-master' was applied to craftsmen who were not considered to reach the highest standard because they had not taken the requisite examinations, in particular

75

Metalwork that for the rank of master. It was felt that they were incapable of producing anything but inferior work and they were not allowed inside the city walls; so they set up their workshops outside the walls, in gardens among bushes – hence, their name.

The free trades gradually became financially dependent on the large trading houses, whose sudden rise to power in Nuremberg is a typical example of the way in which early forms of capitalism began. The merchants would offer an advance to the craftsmen in the form of cash or raw materials, plus a share in the profits, but only on condition that each one worked exclusively for his own employer. In this way the independent craftsman sank to the level of working in a sort of cottage industry, while the big *entrepreneurs* gained control of the whole metal-working process – extraction of the metals, manufacture of the articles, and finally marketing the finished products – and thereby multiplied their profits. The new era had begun. The name for this way of working is a 'transfer system'. The town council approved of this, appreciating the possibilities for mass-production and the opportunity of extending the market outside the city limits, both into Germany and abroad. In other towns where the craft-guilds were in control of trade and were not answerable to the local council, the transfer system was not as successful. It was applied mainly to the manufacture of sheet-brass and to wire-drawing, both of which required mechanical equipment for the foundries, which in its turn required a considerable outlay of capital. Of course the existence of the transfer system did not mean that all the independent trades vanished, but there were still a number of small changes.

The main change in the metal trade occurred between 1525 and 1575 when trade and economic affairs were at their peak in Nuremberg. Up to then the various trades had been run on the same lines as in the rest of Europe. The earliest branch of the brass trade to be mentioned as a specific group were the basin-makers, who were also known as basin-beaters or basin-pounders and are first mentioned as a group in 1373. They were certainly active before that date, but did not acquire any artistic or economic importance until the great advances by the free imperial town of Nuremberg in every possible sphere of trade and industry brought its metal production level with that of the old centres of Dinant, Aachen and Lower Saxony.

Bowls and basins

Up to 1493, the craft of basin-beating was a free trade, which could be practised by any citizen who wished, but then the Nuremberg council decided to elevate its status to that of an oath-bound trade. A series of solemn regulations and restrictions were drawn up, all based on the

76

political and economic interests of the town, though they had a social significance, too. These regulations persisted for about a hundred years. Although they had originally been conceived with the general good of the citizens of Nuremberg in mind, they were often interpreted for personal gain and profit and eventually had to succumb in the face of new developments. The basic rule was that only citizens of Nuremberg were to be taken on as apprentices, which was understandable and in the interests of the town, preventing the possible influx of craftsmen from elsewhere, who would be beyond the jurisdiction of the town. At the same time it meant that the craft was practised by a hand-picked élite, so that there was no question of the struggle for survival which could often result in shoddy goods. Each master was allowed to employ only a certain number of apprentices and journeymen, a rule which was designed to prevent individual workshops from becoming too powerful. In 1535 a new regulation stated that basin-beaters themselves must smelt and cast their brass, but in fact it is not clear whether this ruling was always obeyed or whether basin-beaters preferred to work from material already made into sheets or plates. Another point which is not clear is whether they would hammer the sheets to the required thickness themselves or would give them to professional brass-beaters with their own foundries.

The fame of the basin-beaters of Nuremberg rested largely on their large bowls with decoration embossed in relief. Within the trade these bowls are known somewhat gruesomely as 'blood-bowls' because they were sometimes used by doctors to catch the blood when patients were bled – blood-letting was one of the most important methods of treating illness in those days. The term 'barber-bowl' also occurs quite frequently in regulations published in Nuremberg, because at that time the barber and the surgeon were one and the same person. Even today one can often find tiny polished bowls hanging outside barbers' shops in Germany.

Nuremberg bowls are used as fonts in a number of churches, and they were also used elsewhere for washing hands, though they were essentially show-pieces and were never in ordinary household use as were cauldrons, buckets and jugs; rich relief-moulded decoration was their most characteristic feature and practical considerations were firmly kept in second place.

In the fourteenth century secular objects of display began to appear at the greatest and most sumptuous of the royal courts in Europe. The court of Burgundy serves as one of the most glittering examples of a princely household, whose members devoted themselves to worldly pleasures with exquisitely refined taste. At medieval court banquets, where the public were allowed to be present, the custom was to display

77

Metalwork costly tableware made of silver, or occasionally of pewter or brass, or possibly bronze, on a sideboard or dresser (French *dressoir*): the aim was simply to provide the guests with a splendid show. Countless numbers of display pieces were made that were never even intended to be used – both the craftsman and his client were agreed on that point. This type of display article was in its heyday from the fifteenth to the seventeenth century and included such objects as rock-crystal vessels, cups made of ostrich eggs, columbine drinking-mugs, vessels made of coconuts or nautilus shells, all in extravagantly costly mounts set with precious stones. From the fifteenth century onwards the richer town-dwellers aspired to own the same kind of luxuries. Gold and silver were quite beyond their reach, since in those days the metals themselves were very expensive, for the rich deposits of silver in America had not yet been discovered and comparatively few silver mines were worked even in Europe. But since the rich bourgeoisie was determined to join the fashion of displaying lavish tableware, they instead turned to humbler materials, though the designs and decoration might be just as lavish. The relief-ornamented basins made in Nuremberg in the fifteenth century are the result of this trend, as also is the display pewter which made its appearance in the second half of the sixteenth century.

There were several processes involved in making these bowls. First of all a piece of brass of the required size was cut out and roughly shaped with a hammer over a domed anvil; then a horizontal rim was made and trimmed. Next this roughly shaped piece left the workshop to be turned on a lathe either by professional brass-turners, or alternatively by copper-founders who also had the necessary equipment. The turning may originally have been done for the sake of economy, to use the very valuable metal sparingly. At all events the extreme lightness and delicacy which were the most characteristic feature of Nuremberg wares were highly prized all over Europe. The town council ensured that the exact design of the lathes remained a closely guarded secret.

There were two basic shapes: deep rounded bowls, which date from the fifteenth century, and flat dishes with a broad rim, dating from the first half of the sixteenth century. It can be assumed that the bowls belong to the same tradition as the Hanseatic Bowls, which have already been discussed on page 58, whereas the broad-rimmed dishes were inspired by plates.

The relief decoration on the bottom of the bowls was punched through from the other side with a stamp. If a series of motifs in rows was required, the different stamps would be applied either side by side, or one after the other. A metal stamp would also be used for embossed scenes in the centre of the bowl. As the sheet metal is fairly thick, the

78

outlines of the design are never very sharp, which explains why the modelling of the figures and decorative motifs is mostly somewhat flat and soft-looking. In the better pieces the design has been retouched with various iron tools. Another reason for the flatness of the relief may be that worn-out punches were used which were no longer capable of making a sharp impression. There was a strict rule in Nuremberg – and undoubtedly elsewhere as well – that punching was always to be done by hand, so screw-presses can only have been used very occasionally. Embossing by free hand was not very popular among Nuremberg craftsmen.

Nuremberg was not the only town to produce embossed brass bowls. Splendid examples can also be found among work done in Dinant and its immediate neighbourhood, from Bouvignes to Aachen. Presumably some were also made in those towns in the Low Countries to which the *batteurs* of Dinant fled after their city had been destroyed, and yet others were made in the Hanseatic town of Lübeck. What has been said about the techniques used for this type of bowl applies equally to the bowls made in other places. The same style and decoration is found in all examples of this type of bowl, of whatever origin.

The whole of the bottom of the high-rimmed basins made in the Gothic period would be covered with relief decoration, the diameter never being very large. The favourite themes at the end of the fifteenth century were the Annunciation, St George killing the dragon, St Christopher, St Sebastian, the Fall of Man (with Adam and Eve standing beside the apple-tree), a unicorn hunt, or Samson taming the lion. However, more worldly themes may also occur, such as an allegorical female figure (presumably taken from some fifteenth-century romance), a stag, angels bearing coats-of-arms, an escutcheon, a scene showing a husband being soundly beaten on his bare buttocks by his lady wife, a deer-hunt with a suggestion of trees and clods of earth in the background, a pelican with its young (symbolizing maternal love). At the beginning of the sixteenth century, a naked girl holding a bag of gold in one hand and a bird in the other would sometimes appear.

This varied subject-matter already gives us some idea of the people who commissioned or bought the bowls: they would be used to adorn the homes of the rich burghers and the castles of the aristocracy. A study of contemporary paintings of domestic interiors reveals that they would either be displayed on dressers or possibly hung on the wall. They generally appeared singly, occasionally in pairs, but never in a whole row.[1]

Nowadays a comparatively large number of relief-decorated bowls can be seen in museums and salerooms, but smoothly polished bowls dating from the sixteenth century are exceedingly rare. This is a

79

Metalwork characteristic result of the selective principle which caused articles bearing pictorial decoration to be prized and carefully preserved while simpler undecorated utensils were unhesitatingly melted down once they were considered unfashionable or no longer useful.

The transition from the Gothic period into the sixteenth century and the Renaissance had only a gradual effect on the style of this type of basin and was accomplished without any sudden break, various Gothic motifs and images being retained and married with the new style. On the other hand, various fundamental changes were made to the basic shape: the deep rounded bowls disappear and are replaced by flat dishes much larger in diameter in which the new taste for elaborate decoration can be satisfied. The central area is now bordered by a concentric circle of decorative rods, whereas in the Gothic period decorative scenes were always unframed and filled the whole floor of the bowl. In the sixteenth century representational scenes and figures sometimes give way to non-figurative decoration, of which one of the most common ornamental motifs is known as the fish-bladder, which is highly typical of the late-Gothic period. Several of these motifs will be arranged in a circle in the centre of the bowl, giving the dual effect of swirling movement within a static pattern. Decoratively interwoven siren motifs borrowed from Italian art are also found, but on the whole craftsmen preferred to retain the well-known pictorial themes of the Gothic period.

As well as being decorated by moulding on the bottom the narrow rims of Gothic bowls would also contain a small number of embossed motifs such as stylized palmettes, circles, leaves or flowers, punched at regular intervals. On the other hand, Renaissance bowls with their wider bases had room for other types of decoration. As we have seen the central motif would be bounded by one, or sometimes even two, concentric bands of decoration, but this would be cast in the mould rather than be chased or embossed. Two different themes predominate here: interlaced scroll-like waves and lettering. These interlaced patterns originate in the art of antiquity and invariably reappear whenever any culture draws its inspiration from classical sources, as did the Renaissance. Lettering was particularly popular at the end of the Gothic period and in the sixteenth century; the decorative value of the Gothic script, with its tiny beautifully formed letters, had been discovered early on and it was often used for ornamental inscriptions – the makers of the curved jugs used by the guilds showed a special liking for them. After a while craftsmen began to use a series of letters side by side without forming proper words; the decorative pattern which the letters made was pleasing enough in itself, and caused less embarrassment since in those days very few people could read or write.[2]

80

VII (*opposite*) Coffee-jug of copper gilt with elaborately worked handles, taps and feet; Dutch, eighteenth century.

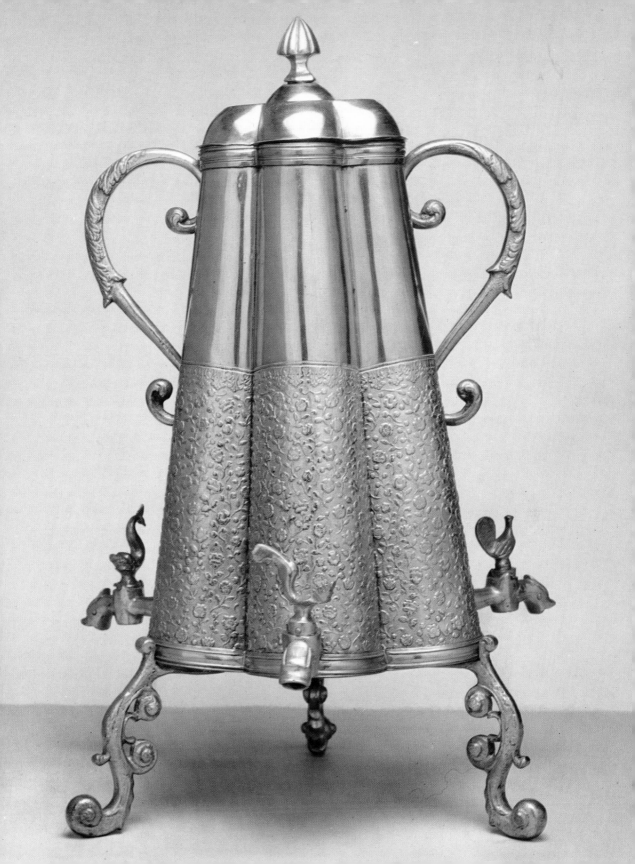

The concentric bands of lettering or the scroll-motifs are generally followed by a smooth undecorated area as far as the point where the sides begin to curve, though occasionally a fish-bladder motif does appear on this spot. In the sixteenth century the rim is fairly broad and is again decorated with a row, or possibly two, of punched motifs.

As we have seen, it was in 1373 that brass-beaters were first mentioned in Nuremberg, and brass basins dating from the second half of the fourteenth century have come down to us. The craft seems to have reached its artistic peak in about 1500 and continued to expand and enjoy its greatest popularity until about 1550. A decline had already begun by the second half of the sixteenth century and accelerated over the next few years.

By the beginning of the seventeenth century the situation had deteriorated to the extent that a new generation of apprentices could no longer be found in Nuremberg itself and masters were allowed to look for new blood outside the town. By 1635 the whole craft of brass-beating had virtually died out. One important reason for the decline of what had been a highly prosperous trade may have been strong competition from the pewter trade. In a later chapter I shall deal with 'display pewter' – i.e., pewter articles with decoration moulded in relief – which was modelled on French pewterware and became fashionable in about 1570 in Nuremberg, where a group of pewterers produced pieces of the very highest quality. These pewter bowls and jugs coincided better with the aesthetic sensibility of the Mannerist style now predominating than did the earlier Renaissance motifs. Display pewter could be adorned with highly figurative images – sequences of scenes from the Bible and mythology or delicately detailed ornamental motifs – all of which appeared in the pattern-books of the fashionable copper-plate engravers of the time. The large brass basins with their clear and simple outlines could not compete with this wealth of elaboration and public taste abandoned them in favour of the latest fashion.

Now that the brass-beating workshops were at such a low ebb a large number of journeymen found themselves unable to become masters and achieve a master's rights and privileges, for the prospects of earning a living were poor. It also seems likely that the decline of their craft was accelerated by competition from the braziers, who were now also producing cast basins.

In the Low Countries, where brassware is still very popular even today, brass bowls were still being made in the seventeenth century; one theme which was particularly popular was a scene showing the spies from the Jewish tribes returning from the Promised Land with their bunch of grapes.

The town of Dinant had lost its former importance when it was

81

VIII (*opposite*) Travelling jewellery-box made in brass and steel, with magnificently worked locks and hinges; English, 1688–94.

Metalwork destroyed in 1466. Later the Archduke Maximilian attempted to rebuild it and the old metal industry was resuscitated, though it never regained its earlier importance. The goods now produced may have included relief-moulded bowls, but it is difficult to place the surviving bowls because there are very few indications of where they were made. Furthermore, many motifs seem to travel from one centre to another, probably as a result of the movement of craftsmen.

Venetian dishes

At the beginning of the sixteenth century the craft of making elaborately decorated brass dishes was also enjoying great prosperity in Venice, but the difference was that inspiration was drawn from other sources. Her dominion over the seas and her extensive trading connections had made Venice not only one of the richest towns in Italy but also in the whole of Europe. The palaces of her great merchants were magnificently luxurious and the influence of the East had inspired great advances in many of the comforts they enjoyed. At the beginning of the sixteenth century one or more Islamic artists, probably from Persia, appear to have been resident in Venice, making large brass dishes up to 22 inches in diameter, which they decorated with great artistry. Unlike their counterparts in Germany and the Netherlands, the Venetian craftsmen engraved the surfaces of their bowls and also inlaid them with silver. It was not long before workshops manned by local craftsmen were producing showpiece dishes of this type, adopting a number of Islamic designs. The subject-matter used for the decoration is characteristic of the late Renaissance: interlaced ornaments, flowers, busts, erotic scenes, grotesques, sirens, birds, battle-scenes, hunting-scenes, triumphal processions, incidents taken from mythology. There is almost always a coat-of-arms in the centre, which proves that most of the clients were members of the aristocracy. The local artists took over the deep bold engraving characterizing their Islamic prototypes, but only very occasionally used the silver inlay which was a speciality of Saracen artists. Brass dishes were never embossed in Venice; on the other hand, when we turn to copper dishes we find very few engraved in the same way as the brass dishes and chased copper dishes are far more usual. There are also a very small number of jugs which may possibly belong with the brass dishes, but since they are so rare we can assume that the dishes were intended mainly for decoration rather than for practical use. At any rate, not as many of the Venetian dishes have survived as have those of Nuremberg; craftsmen in Nuremberg worked with stamps and punches and could therefore produce large quantities of a single design, with the result that their goods were much cheaper, whereas each engraved Venetian dish was made with painstaking care to fulfil

82

a special order and fetched a high price. In the Victoria and Albert *Bronze and brass* Museum in London there is a presentation dish with the armorial bearings of the Delfini which is engraved with the name of the artist and the date: HORACIO . FORTEZZA . FECE . IN . SEBENIC . DEL . LXII (i.e., 1562). It is most unusual for this type of work to be signed and dated, so this is an indication not only of the artist's self-assurance but also of the importance attached to show-pieces in Venice.

Weights

We must now turn back to the brass-workers in sixteenth-century Nuremberg as their work dominated the market in central and southern Europe. Second in importance to the basin-beaters were the weight-makers who were grouped with the braziers. They monopolized the weight-making trade throughout the Holy Roman Empire right down to the eighteenth century. Their speciality was nests of weights: basic-ally a bronze or brass bucket containing a whole series of buckets fitting neatly one inside the other, each one getting smaller than the last. Each bucket corresponded to a compulsory specific weight and had to be officially tested. The outer bucket is about 8 inches high and very elaborately decorated, although the inner ones are absolutely plain. The handles at the side are often transformed into horses' heads, dolphins or some imaginary creature; the lock matches the handles, while the two mounts for the ring for carrying the whole set are richly decorated with moulded busts of men and women, helmeted warriors, mermaids, masks or fabulous beasts. A careful study of a whole series of these weights shows that the decorative motifs were used first in one workshop and then in another, and were occasionally borrowed for chandeliers and other items. The outer walls of the main bucket will also be encircled with rings, and the spaces between the rings are often decorated with raised friezes of interlaced ornament or rows of embossed motifs. Since it was very important that these sets of weights should be strictly controlled, the town council required makers to stamp them with the master's mark, the town-mark (the letter 'N'), and finally the inspector's mark. Sets made for export did not have to be marked.[3]

There are two reasons for treating the metalworkers of Nuremberg, their products and their social conditions in such detail and at such length. First, in the sixteenth century Nuremberg was the most import-ant centre in the whole of Europe for the metalworking trades and its position as leader was never disputed; secondly, contemporary docu-ments which have been preserved in Nuremberg convey a complete picture of how trade and commerce worked in a community, a picture which can be regarded as typical of the towns of Europe in the

83

Metalwork late-Gothic and Renaissance periods. Trade and craftsmanship went hand in hand and were closely linked with art and scholarship. Nuremberg developed an economic structure which was to remain a landmark throughout the following centuries.

As we have seen in the case of the basin-beaters, certain branches of the metal trade rose to great heights, only to sink into a decline within a very short space of time and leaving the field clear for a different branch offering new styles.

Scientific instruments

Instrument-makers were among the most eminent of all metalworkers, since they not only had to master the techniques of metalworking in general but also needed to have a thorough understanding of the instruments they were making.

Even in the Middle Ages a large number of instruments and appliances had already been invented for measuring time, for astronomy, for astrology – very important in those days – and for surveying. We can only mention a brief selection of items here, since there is no space to go into the subject in greater detail. Sun dials, mechanical clocks for churches and decorative clocks were all made from various metals including brass. Bronze-gilt and copper-gilt were used in particular for small sundials like those used for travelling and at table. Armillary spheres would be constructed to represent the celestial firmament with the earth as the centure. In the sixteenth century these were often purely ornamental and would therefore be decorated with great artistry. The planetarium represents a further development of the armillary sphere and shows the movements of the planets as they had been plotted by Copernicus. Astrolabes, generally made of bronze or brass and only very occasionally of wood, were used for measuring time, as were quadrants. The various instruments for surveying included theodolites, tools for drawing full and half circles, folding rules, altimetres, compasses and octants, while instruments for taking observations were triangles, sextants, periscopes, gunners' levels, spirit-levels and compasses. A large number of specialist books have been written about these instruments and their makers.

Instrument-makers would sometimes specialize in one or two specific instruments, though there were also certain highly versatile craftsmen who were not satisfied with only making the instruments but also undertook a large amount of research into their own specialist subject, and made a number of inventions. Conversely, many were scientists who preferred to make for themselves the instruments which they had invented or improved.

So there were men who had to be simultaneously scientists, technicians

84

and artists and were far more than mere craftsmen. In a few towns clockmakers and sundial-makers did organize themselves into guilds with the same kind of rules and regulations as other trades, but on the whole the craft was treated as a free trade which could be practised by any citizen. Scientific instruments have never been consumer goods. The number of people likely to order or buy them was very small for scientific research was restricted mainly to the universities and to court circles. The Habsburgs showed a particular interest in scientific apparatus: Maximilian I had a lathe and would occupy himself making instruments; Charles V engaged several scholarly instrument-makers to work for him and gave them financial support; and Ferdinand I was a great patron of science, commissioning several sundials. But Rudolf II commissioned the most work, for he had a passion for beautifully made equipment. Many European princes wished to acquire scientific instruments for their collections of *objets d'art* and curios, the most sought-after being unusual and artificial clocks and astronomic instruments run by clockwork, though ornamental sundials and astrolabes were also popular. Some of these royal collections are now housed in museums, and one built up by the elector of Saxony was transformed over the years into an Institute of Mathematics and Physics which still exists in Dresden.

The close connections enjoyed by instrument-makers with royal courts, universities and ecclesiastical colleges, who were also great buyers of scientific instruments, were reflected in their social and economic status. They were fully conscious of their superior artistic skill and scientific knowledge and would often sign their instruments with their full name or with a monogram, a custom otherwise generally observed only by painters. They seem to have made a good deal of money; quite a few could afford to have their portraits painted and would pose surrounded by examples of their work.

Scientific instruments were exported far and wide. For instance, in the sixteenth century, German sundials travelled as far as Turkey and would be specially provided with inscriptions in Turkish. Clocks from France and Germany could be bought very cheaply in Constantinople, and ornamental clocks were sent out to China in 1617. In the eighteenth century French and English instrument-makers supplied clocks and surveying-equipment to Germany and Austria, while navigational instruments made in England were used all over the world and were copied by many other countries.

85

5 Domestic metalwork from the Gothic period to the nineteenth century

Mortars

The earliest and most basic form of mortar is a hollowed-out stone, a type of trough which was used in the ancient world for grinding corn into flour with a pestle. This work was of course later taken over by the mill-wheel, but ever since classical times, mortars have been used for pounding spices and medicaments, the earliest examples probably being made of turned stone or wood. Classical writers such as Plato, Juvenal, Pliny and Celsus were familiar with the mortar and regarded it as a piece of the apothecary's equipment. The Romans built factories in southern England to manufacture mortars for export to Italy and Gaul. They were made of white clay baked in a very high temperature to make them as hard as porcelain. Apart from these mass-produced mortars examples made in bronze have also been found, for instance, in Colchester.

Mortars were commonly used by apothecaries in Persia and the Arab countries where medicine was already very advanced in early times. The earliest western examples begin to appear in the eleventh century, presumably modelled on Islamic examples. In the twelfth and thirteenth centuries they were used by apothecaries everywhere, and in fact still have an important place in chemist's shops today. Even at that early date a mortar was the symbol for apothecaries.[1]

Mortars have also been used from a very early date for pounding spices in the kitchen. In the Middle Ages it was customary for aristocrats and rich burghers to give their daughters-in-law a set of cast-metal kitchen utensils as a wedding-present: one of the favourite items was a mortar, occasionally adorned with romantic inscriptions.

Mortars made in the early Gothic period – the thirteenth and fourteenth centuries – are quite different from those of the fifteenth century.

86

In the few examples which have survived the body is relatively squat *Bronze and brass* and is divided into sections by a series of rhythmically-spaced horizontal ribs, which were presumably a relic of the Romanesque style. The squared-off handles are often arranged so that one is fixed to the upper part of the body and the other to the lower, though they are still opposite each other. There are vertical ribs on the base, which would in later years be continued right to the top. Mortars made in northern Germany, which are rather different from those made elsewhere in Europe, are characterized by a flat base which makes them more stable. In the fifteenth century mortars for practical use were decorated for the first time, particularly in southern Germany and in France. The vertical ribs are transformed into feet at the bottom and are raised to stand away from the vessel; they will sometimes flower into lilies or some other appropriate motif at the top or be crowned with a blackamoor's head or the figure of a saint. Occasionally we may come across animals moulded in relief between the vertical ribs, or luxuriant foliage, or oak leaves with acorns; some particularly valuable examples even depict the Virgin Mary, accompanied by saints beneath ornamental canopies. This is the beginning of the decorative style which was to characterize mortars for the next few centuries. The handles at the side are made in a variety of styles; some are squared-off, others rounded, while some mortars have a single handle only, or a pair of handles shaped like rods, or even no handle at all.

The arrival of the Renaissance in Italy had a great effect upon the applied arts, both influencing traditional bronze articles and creating a number of new styles and designs. The mortar proved to be a particularly suitable vehicle for the newly revived and revitalized style of the ancient world. The basic shape soon became established: with the diameter of its aperture half as large again as the internal diameter of the base and its height roughly equivalent to the larger diameter at the top, it conformed with the requirements of the laws of harmony and proportion. Apart from a few early examples which adhered to the old traditions we never find the old flat base and sloping rim. Mortars of the Renaissance have a variety of differently shaped rims, and the broad central area on the walls of the vessel is always adorned with a frieze displaying the wealth of Renaissance ornament now in vogue. The favourite motif is a foliage-scroll which originated in the classical world and was used in a variety of different ways in the Quattrocento. It could be enlivened with erotic figures climbing in the interlacing foliage, or with imaginary creatures, animals, portraits and idealized heads in profile, or hunting-scenes. We also find acanthus-scrolls, leaves and flowers, *putti*, armorial bearings supported by figures and illustrations taken from the Bible and from mythology.

87

Metalwork In the sixteenth century a variety of designs was used for mortars, and alongside the traditionally shaped vessel we find some shaped like drinking-mugs or like urns or buckets. The sides of the vessel are no longer decorated so often with a horizontal frieze but with scattered moulded patterns which wind round the sides in an informal design.

While handles frequently appear on mortars made in the fourteenth century they are rarer in the fifteenth since convenience was often sacrificed to the maker's desire to create a harmonious structure. In Italy mortars were cast by independent artists and craftsmen – but in fact, bronze-casting in general was counted as a free trade. Donatello's influence was as great in this field as that of Benvenuto Cellini. The artists who made cast-bronze mortars include Cavadini, Lenotti, the Florentine master Juliano de Navi, Alessandro Leopardi from Venice, Antonio Viteni and Crescimbeni of Perugia.

In the early years of the sixteenth century, the influence of these mortars artistically designed with ornamental reliefs made itself felt in the countries beyond the Alps. The Low Countries grasped at the new style eagerly, as did their neighbours in the Rhineland and southern Germany. Northern artists took over Italian subject-matter, Italian decorative motifs and Italian designs, but interpreted them in their own way. In fact, their work still contains a good deal of the Gothic style, both in the decoration and figures and in the formation of letters in inscriptions.

In consequence the basic shape of the mortar made for many years in Latin countries was adopted in the north: the shallow mug-like structure, the strongly curving and projecting base and rim, the decorative friezes separated by projecting horizontal ribs. The tall slender Gothic design with its vertical ribs disappeared very quickly and scarcely any traces of it can be seen in the new designs. Another feature borrowed from Italy were decorative horizontal friezes in relief. But a number of the features characteristic of the north still remained, even though artists adopted Italian Renaissance subject-matter for their decorative scenes and Italian designs for the shape of their vessels. Late-Gothic motifs such as quatrefoils, thistles and interlaced foliage survived well into the sixteenth century, and so did miniature Gothic lettering and inserted ribs, generally on the base. A good example of this survival is a mortar adorned with scenes showing the Judgement of Paris; the inscription reads that it was made in 1527 for Johannes Ocke, who was at first curate in Osnabrück and then pastor in Emstecke. This godfearing gentleman had asked that his mortar should be decorated with a scene from the Old Testament; a tribute to the new age was paid by placing an incident from classical mythology by

88

Bronze and brass: Renaissance

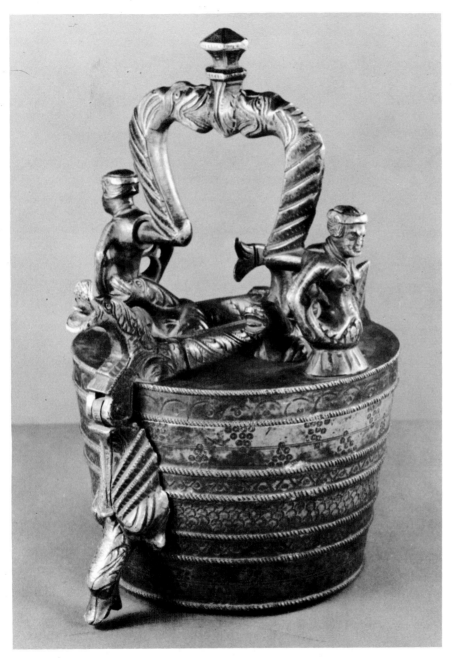

67 Nest of weights; South German, seventeenth century.

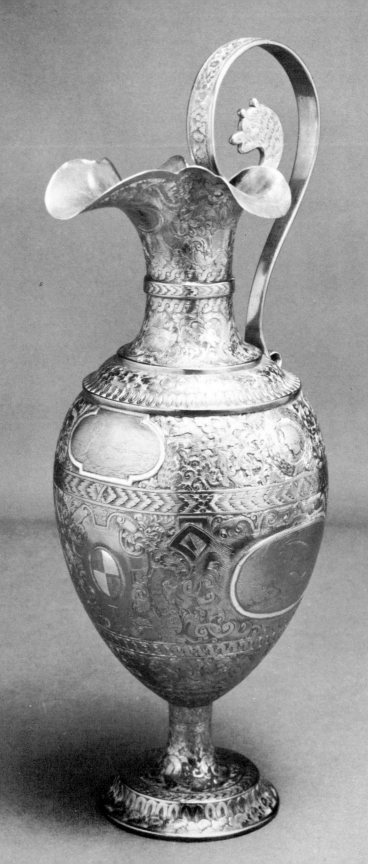

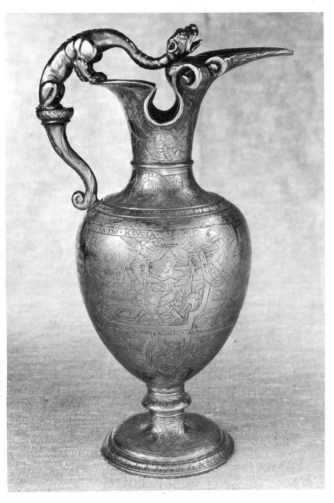

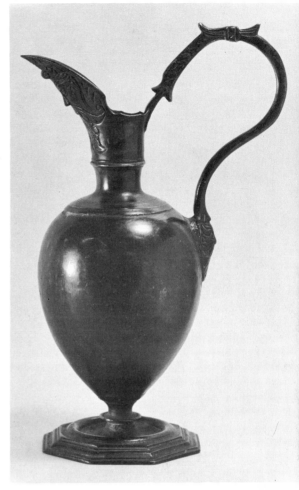

69 Helmet jug in gilt bronze with chased decoration, and a handle in the form of a dragon; Venetian, sixteenth century.

70 Bronze helmet jug, with a masked face upon the spout; Nuremberg, mid-sixteenth century.

68 (*opposite*) Helmet jug of engraved and gilt brass; Italian, sixteenth century.

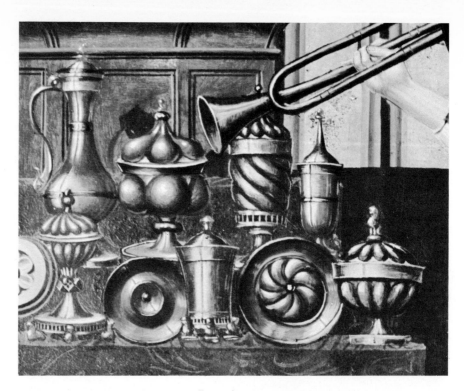

71 Dresser with
worked metal vessels,
mostly silver and
silver-gilt; from a
feasting scene, by
Bernt Notke,
Lübeck, 1496.

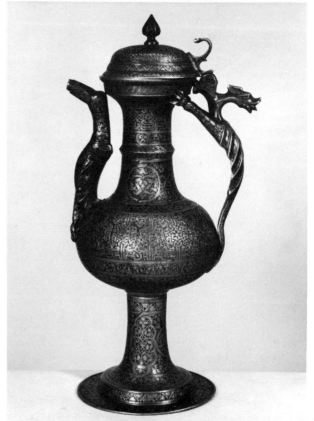

72 Brass damascened
ewer in Venetian
style; Flemish,
fifteenth century.

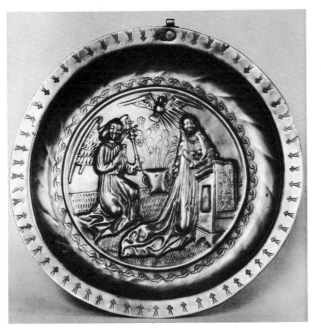
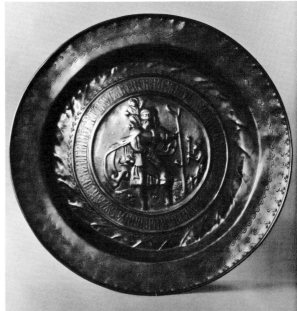
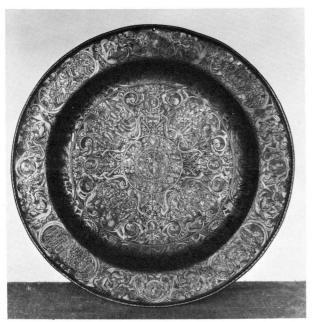
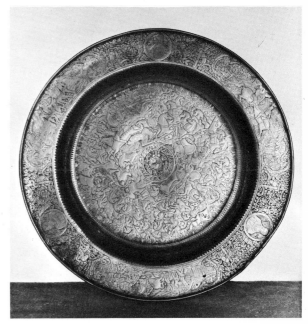

73 and 74 (*top*) Dishes with stamped decoration, with scenes of the Annunciation and St Christopher; German, *c.* 1500.

75 and 76 (*bottom*) Brass dishes with damascened decoration showing scenes from Roman history; Venetian, sixteenth century.

77 Portrait of Nicholas Kratzer (1486–1556) by Hans Holbein. Kratzer became astrologer to Henry VIII. He is shown surrounded by his scientific instruments.

78 (*left*) Gilt-brass astronomical dial made for Cardinal Wolsey by Nicholas Kratzer; *c.* 1520–30.
79 (*below*) Brass pocket compass and dial made for James I of England by Elias Allen; London, 1617.

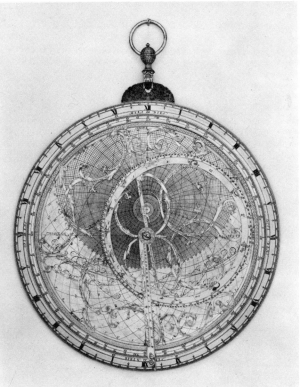

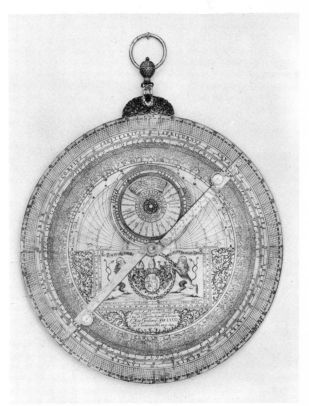

80 Brass astrolabe made by Kanonikus Graf and engraved by Michael Kayser; Augsburg, 1681.

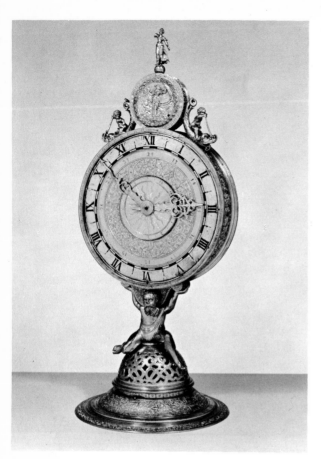

81 Brass standing table clock; Augsburg, 1560.

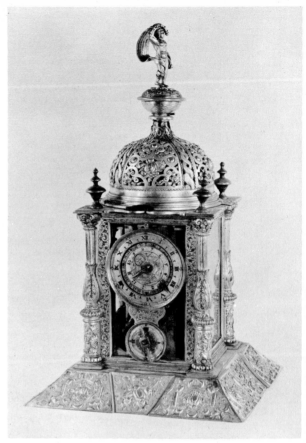

82 Gilt bronze table clock; Augsburg, *c.* 1560.

its side. The actual arrangement of the scenes is still completely late-Gothic in conception, for they appear as separate illustrations set side by side rather than being transformed into a flowing frieze typical of the Renaissance. The circular inscription in miniature lettering and the ornamentation with quatrefoils is typically Gothic, while the whole structure of the vessel, with its slender lines giving it the appearance of a conical drinking-mug, its elegantly shaped base and the restrained division into a series of horizontal zones, represents a compromise between the modern Renaissance and traditional sentiment. The projecting ribs look quite pathetic and superfluous, inserted as they are between the base and the curving side of the vessel. They fulfil no function and have no formal significance.

For the first thirty years of the sixteenth century the late-Gothic and Renaissance styles continued to vie with each other throughout northern Europe, i.e., in Germany, the Netherlands, France and England, but then the new style triumphed and influenced the style of mortars for many years into the late Baroque period. From now on mortars are uniformly squat, no longer slender and narrow as they were in the previous period. The base projects sharply and is richly curved to a greater or lesser degree, while the sides of the vessel are generally divided into two separate zones marked by raised horizontal ribs. Bronze-casters would display their artistry by decorating these zones with pictorial images or ornamental motifs. The lower frieze is usually the more artistically important since it is wider than the upper one and any figurative decoration will appear here rather than above. There are, of course, exceptions to this general rule: from time to time we may come across mortars divided into three sections; into two with the top wider than the bottom; or into two zones of equal width. Mortars with a single moulded frieze were fairly rare in the Renaissance period and do not appear frequently until the second half of the seventeenth century, becoming quite common in the eighteenth. Mortars with two sections, one containing a moulded frieze and the other left plain, are less common.

The friezes of the mortars were surmounted by a rim, which from the sixteenth century onwards was accentuated by jutting out from the centre of the vessel, and becoming wider and decorated with its own frieze. This gave craftsmen an opportunity to incorporate inscriptions with a variety of messages into their designs. At first pious sayings were used and appear throughout the sixteenth, seventeenth and eighteenth centuries, always accompanied by the date in Arabic or Roman numerals. The sayings are sometimes in Latin – SOLI DEO GLORIA 1619 – and sometimes in the vernacular – GOT HABE DANCK VOR SINE GNADE 1564 – AN GOTTES SEGEN IST ALLES GELEGEN.

Metalwork Inscriptions connected with pharmacy are fairly common. The sayings on Dutch mortars often have an ironical note: FIT NOSTRO DIVES PHARMACOPOLA SONO ('My sound makes the apothecary rich'), VOX MEA VITA MAGISTRI ('My voice is my master's life'); or HERBIS NON VERBIS MEDICORUM EST PELLERE MORBOS ('Herbs and not the words of doctors drive out disease'). The apothecary's name or that of his shop will often appear as well.

Mortars inscribed simply with the date and name of the client are very common, and we often find the name of the metalworker as well, proudly announcing that he was responsible for the work.[2]

In the second half of the fifteenth century the custom of indicating the artist's name began to spread; needless to say, Italy led the way, since it was at that time in the forefront of all artistic and intellectual developments; but the countries of northern Europe were not slow to follow.

Guild regulations required pewterers and also, in many areas, all other metalworkers to mark their goods so that their quality could be judged (see also notes on the guild system for pewterers on page 206). This may have influenced many bronze-workers, particularly those making mortars, to mark work with their full name. Of course the craftsman's pride in work well done was also instrumental in his wish to sign it, and he may well have realized the scope for publicity offered by inscriptions.

As we have already seen, it was customary in wealthy circles for a newly married couple to be given a mortar as a wedding present. Today we do not think of it as an essential piece of equipment for the bride's bottom drawer, but in the late-Gothic, Renaissance and Baroque periods it was most important because spices were used so much in cooking. The spices were of course ground at home, so that a mortar was essential in every household. Mortars given as wedding presents might be inscribed with some appropriate saying such as AMOR VINCIT OMNIA, which appears again and again. The names of the bridal pair were often added as well, together with the date of their wedding. In Italy the golden age in the production of mortars took place in the Renaissance, but in the Low Countries the first examples date from the end of the sixteenth century and the Baroque period. In both cases this particular branch of metal production was in its heyday in a period of economic prosperity when trade was both extensive and lucrative.

But in the eighteenth century, when other sea and land-powers such as England and France began to increase in importance, the Low Countries, and Holland in particular, went into a period of decline which affected their art and culture as well as their trade and economic

90

affairs. The golden age of the Baroque was over and even in a field such as bronze-casting we can observe a decline in production and in the creation of new designs. The decorative richness of mortars began to fade and by the middle of the eighteenth century the elaborate friezes have been replaced by smooth bare panels, the whole design has become more austere with severely straight lines predominating, and the overall appearance is governed by functional considerations. The mortar is no longer a show-piece, in the home at any rate, but has resumed its humble role as a piece of functional equipment.

By about 1800 the tradition of making mortars of elaborate design had died out all over Europe, partly because the guilds and craftsmanship in general were on the wane, but also because the spice trade became organized on more economic lines, as was the pharmaceutical trade. Thus apothecaries would now often buy their ingredients in powder form so that mortars were no longer necessary; they were sold or melted down, or placed in museums.

Chandeliers

The massive circular chandeliers of the Romanesque period were probably made exclusively for churches. It is very unlikely that even the mightiest potentates of the early Middle Ages could afford the luxury of equipping their halls and chambers with chandeliers of this type; they were content with the glow of an open fire and pine brands set round the walls in special iron holders.

In the Gothic period the wealthier town-dwellers of central Europe began to enjoy a higher standard of living and an increased degree of comfort in their homes, with a greater variety of utensils at their disposal. The need for better light than that afforded by a candle or pinewood torch may have made itself felt at this time, though the simple methods of lighting continued to prevail in the humbler town and country houses for several centuries. The most sought-after effect now was a multiple source of overhead light in the centre of the room. The first attempts at creating this effect involved two wooden beams nailed together to form a cross, with candle-holders at the four corners; this would be hung from the ceiling by means of a rope or wooden rod fixed to the centre. The fifteenth-century artist of the series of miniatures *Les Conquêtes de Charlemagne* chose a court banquet as one of his scenes and depicted the emperor surrounded by servants and lavish tableware; for the lamp he depicted a simple wooden cross with candles of the type just described, apparently finding nothing incongruous in the contrast between the essentially primitive design of the chandelier and the magnificence of all the other furnishings. Most of

Metalwork the domestic interiors which appear in fourteenth and fifteenth-century paintings do not include chandeliers at all.

The basic features of the Gothic chandelier are already present in this cruciform candle-holder, but craftsmen working in the highly advanced bronze workshops in the Low Countries fashioned this simple structure into a beautiful work of art. The device for suspending the lamp became a richly-moulded shaft embellished with scrolls of foliage, tracery, finials and all the other decorative motifs current in the late-Gothic period. The arms, often in their turn equally richly moulded, seem to grow out from a certain point on the lower part of the shaft and carry the candle-sockets and trays at the end of their soaring curves. During the fifteenth century this basic design became more and more elaborate, the shafts generally giving way to a filigree structure of finials and tracery with a human figure, generally of the Madonna and Child, placed in the centre. In the Gothic period the arms were always flat and often adorned with a rich decoration of foliage scrolls soaring upwards; sometimes they were set with little carved statues such as warriors in armour, gentlemen dressed in the latest fashion, savages, stags or birds. Furthermore the branches would be arranged in three tiers, one above the other with enough space in between so that the candles were not too close together when lighted. Small chandeliers would have six branches, but those with several tiers might hold as many as thirty-six. The bottom of the shaft ended in a sort of bracket while at the top there was a ring through which the chandelier would be suspended by a chain or rope. The rope passed through a hook on the ceiling and from there down to the wall, where it would be fastened with a knot; when the candles needed to be changed the whole chandelier could easily be lowered by means of the rope.

The main centre for making chandeliers was Flanders, though in the fifteenth century they were also made in southern and northern Germany. The circular hoop-shaped design continued in use for a while, but it gradually became less common and eventually died out altogether. To get some idea of the way in which bronze or brass chandeliers were used to decorate the homes of the patrician class we only have to look at Van Eyck's portrait of the Arnolfini Marriage in the National Gallery in London, which was painted in 1434. But we must of course remember that the owner of this room, in which he is portrayed with his wife, was an outstandingly wealthy man. In most of the domestic interiors painted in the fifteenth century and even in the sixteenth the ceilings are bare of this type of adornment. Even Annunciation scenes rarely include a chandelier, although as we have seen, painters of this theme were particularly anxious to portray

92

Mary in a truly magnificent setting; the same is true of paintings of *Bronze and brass* royal banquets or of the Last Supper. On the other hand town halls in the Gothic period were often equipped with chandeliers and this probably also applies to the assembly-halls belonging to the richer guilds and associations. Chandeliers set on a shaft can also be seen in sacristies and church-naves.

Quite apart from its influence in the Renaissance and Baroque periods, the chandelier set on a long shaft is still a common design today. In the middle of the sixteenth century less elaborate versions began to be made; the shaft is shorter and more compact, the outline is spherical and gradually begins to adopt the baluster design which is typical of chandeliers made in the years to come. The filigree canopy has died out altogether. The central shaft widens into a flattened sphere at the point where the arms branch off, and then culminates underneath in a console, often transformed into a decorative mask and a ring. The branches curve in an S-shape and are in the form of simple tubes; there is no longer any interlaced foliage decoration. The whole is often surmounted by a human figure, but by now this is generally a secular, rather than a religious image. The Baroque design which remained standard in the Low Countries, Germany and England at the end of the sixteenth century and in the seventeenth was based on this type of chandelier. It was so popular in England that it continued to be made well into the eighteenth century, although by then the rest of Europe had begun to prefer new designs which conformed more with the late Baroque and Rococo styles.

In the seventeenth century the basic design was enriched and enlivened by the use of new features which corresponded to the essence of the Baroque style, with its love of power, strength, splendour and surface brilliance. The lower part of the shaft swells into a spherical shape and ends in a boss; the shaft rises from the sphere into a series of richly curved smaller spheres and is often crowned by an eagle with outspread wings. The curve of the branches becomes further pronounced, with small scrolls sometimes curling away from the main stem. Bourgeois households sometimes possessed small six-branched chandeliers, and these are now much sought after since they are far more suitable for modern houses or apartments than are the large chandeliers made for churches. Ornamental reflecting panels would often be set above the branches so that the chandelier could shed more light. Many of the chandeliers made for the huge rooms in town halls, castles, palaces and churches, where they can most often be found, are quite enormous; in the eighteenth century some were made with thirty-six branches arranged in three tiers set one above the other.

93

Metalwork The chandelier originated in the Low Countries and many can be found there even today. They then spread to northern Germany, where many village churches still have splendidly elaborate examples, mostly dating from the Baroque period. No chandeliers appear to have been made in England until the middle of the sixteenth century, though some were certainly imported from Holland. But there is documentary evidence that some were being cast in London from about 1650 onwards, and a large number of chandeliers of English manufacture have survived in churches in London itself and in the provinces. They were made at some time between the end of the sixteenth century and the middle of the eighteenth. Up to about 1730 they resemble those made in the Low Countries and in Germany but after that the influence of French chandeliers begins to show itself, as we shall see in the next section.

In Italy, where ambitious patrician families had adopted an aristocratic way of life as early as the Quattrocento, the emphasis was on luxury and splendour. Here the light was brighter than in northern Europe and the days lasted longer, men lived much of their lives in the streets and open air rather than indoors and little importance was attached to the elaboration of lamp fittings for the lower classes. But this was compensated for by the lavish splendour of the chandeliers made by some of the most important artists for palaces and churches. The component parts of chandeliers of the north would always be completely visible when they were hanging up, but in Italy the basic structure became buried under a mass of elaborate detail. The central axis is transformed into a series of vases, scrolls, foliage and hanging festoons of decoration, and is further ornamented with a wealth of human figures, grotesque monsters, animals and fabulous creatures, while the joins are disguised with goats' heads, decorative motifs or human figures. The branches are scarcely ever the plain and simple tubular structures we find in the north of Europe, but are intertwined with leaves and blossoms and from them grow angels, or sometimes erotic figures modelled on classical art, holding the drip-trays with their candle-sockets. Some chandeliers have curving arms but others echo the traditional hoop design. One example of this is the hanging candelabra designed for Pisa Cathedral by Batista Lorenzi and made by Vincento Possanti in 1584.[3] But although it uses the old design the structure of this chandelier is again almost entirely concealed under a wealth of decorative details.

Italian metal chandeliers became more and more elaborate, with dangling bunches of fruit, garlands, tendrils of foliage, blossoms and *putti*. Chased bronze-gilt was the favourite material, but towards the end of the seventeenth century the glass-making island of Murano

94

entered the scene and chandeliers made of glass and crystal began to take over from their metal counterparts. *Bronze and brass*

The basic features of the Italian chandelier were adopted by French craftsmen in the second half of the seventeenth century, but they stripped it of superfluous detail and restyled the decoration to conform with the clean rational lines of the basic structure. The vertical axis generally consists of a series of vase-like elements arranged one above the other, and decorated with festoons, flowers, leaves, pendants, masks, in other words, with the whole decorative repertoire of the period. The branches are curving and are again decorated, as are the drip-plates and the candle-holders themselves. It was almost inevitable that elaborately decorated chandeliers should be chased and fire-gilded, unlike their Flemish counterparts in the Baroque period which shone with a warm coppery glow only to be achieved by painstaking polishing. Many of the decorative details on the bronze chandeliers made in France were modelled on the work of local goldsmiths, though in fact both goldsmiths and craftsmen working in bronze relied heavily on engraved pattern-books of ornaments; these played as important a part in the France of Louis XIV as did the sixteenth-century pattern-books in the Low Countries and Germany. In those days architecture, interior decoration and furnishings were conceived as forming a whole, which meant that many architects would design the inside of a house or palace as well as the external structure. For instance, both Marot and Mansard, famous French architects, designed chandeliers as well as many other furnishings, which explains why the aesthetic quality of French chandeliers is so extraordinarily high.

Louis XIV had summoned to Paris the finest artists and craftsmen from all over his kingdom, even setting aside a number of apartments in the Louvre as workshops and lodgings for the most brilliant. Soon French taste was setting the tone for the whole of Europe. An aristocratic society flocked to the Sun King's court at Versailles, eager to copy both their sovereign's artistic tastes and his extravagance and love of luxury. Bronze-casters and metal-gilders soon found their craft entering a period of enormous prosperity which was increased by a brisk export trade. German princes and princelings were particularly eager to follow the example of Louis XIV's splendid court and encouraged the spread of French culture and French styles within their own country. German culture remained under the influence of France until the second half of the eighteenth century.[4]

English chandeliers began to show the influence of those made for the French court from about 1735 onwards. It is true that the spherical design of the Flemish type of chandelier continued to be copied by some English makers down to the end of the eighteenth century, particularly

95

Metalwork for church chandeliers, but at the same time there was a growing preference for chandeliers with a vase-shaped shaft. This latter type had details picked out with ornamental boss-beading, little tubular ornaments and moulded contours, all of which, as in France, were inspired by the techniques employed by gold and silversmiths. But the details of the basic Baroque structure (which was in fact Flemish) were clearly visible, unlike those of their French models, because the various decorative motifs of the Regency style in France, acanthus leaves, masks, ornamental heads, interlaced foliage and ribbons (strapwork), were not adopted by English craftsmen. Later, we find that they also ignored the lavish medley of interlaced foliage, leaves, volutes and rocailles which characterize the French Rococo style.

The Louis-Quatorze style was preoccupied with glitter and show and its champions quickly took advantage of the discovery that crystal prisms are capable of reflecting candlelight a hundred times over; crystal chandeliers began to make their appearance in the early eighteenth century, at first at court and then in the house of the *grande bourgeoisie*, and soon replaced metal completely. Whereas the various kinds of metal had been handled with painstaking care in the preceding period, with much chasing and gilding, the metal was now a purely functional background and there was no point in decorating it with a wealth of ornament which would be completely hidden by the hanging crystals of glass. The metal frameworks of the better glass chandeliers were, in fact, still gilded throughout the eighteenth century, but they had no independent artistic merit as pieces of decorative metalwork. This does not mean, however, that the bronze-casters and brass-casters in France, the Low Countries and Germany, whose livelihood had depended on the demand for metal chandeliers, now found themselves penniless; for they were still needed to make the framework of the glass chandeliers.

We have already seen that the old type of chandelier with a spherical framework and a baluster shaft continued to be made in England for many years to come; this was also true in the Low Countries, where craftsmen and patrons were by no means eager to abandon a design which had originated in their own country and had entered the homes of the bourgeoisie at a time when trade was booming and Dutch sea-power was enjoying its golden age. Prism chandeliers were used to adorn the grand rooms of the richer merchants from the middle of the eighteenth century onwards, but the spherical design was still popular among all the social classes for many years, as in Germany.

In the Empire period metal chandeliers regained some of their former glory, and craftsmen working in France, the Low Countries and Germany turned back to the old hoop shape with its branching arms

Domestic bronze and brass:
Gothic to nineteenth century

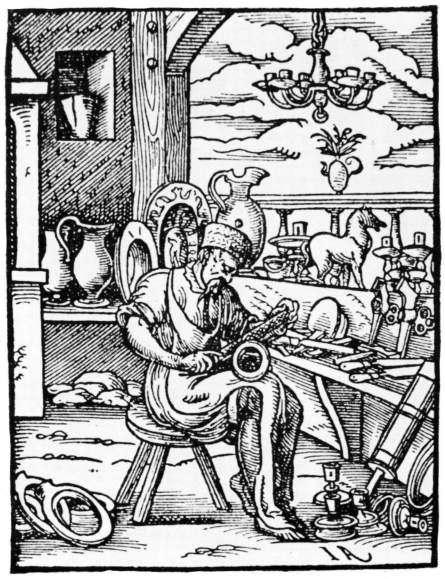

83 The bronze founder in his workshop, making chandeliers, candlesticks and other articles for use in church and home; woodcut, Frankfurt, 1568.

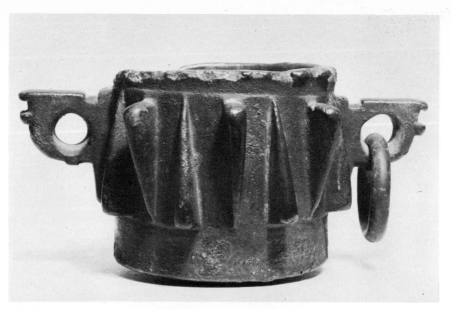

84 (*top*) Medieval bronze mortar, based upon an oriental type; English, fifteenth century.

85 (*bottom*) Alchemist's laboratory with cauldrons, bowls and flasks and a pestle and mortar; Pieter Breughel the Elder, *c.* 1566.

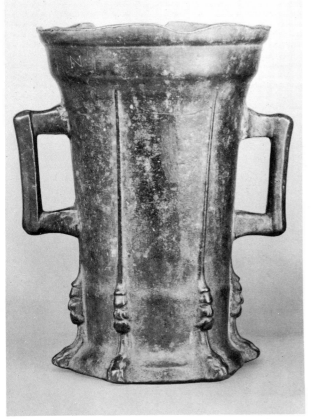

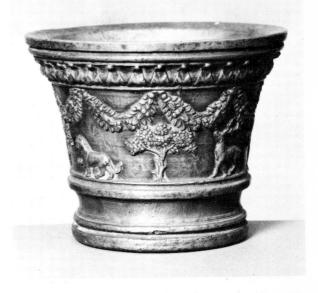

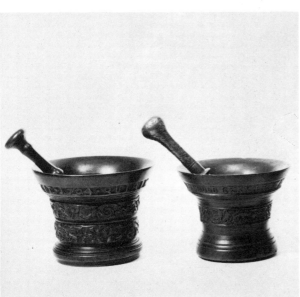

86 (*top left*) Mortar of bronze of tall, slender, Gothic type, with vertical ribs; Austrian, fifteenth century.
87 (*top right*) Bronze mortar, decorated with Renaissance motifs; Italian, sixteenth century.
88 (*bottom left*) Bronze mortars, with moulded decorative designs and inscriptions; English, *c*. 1700.
89 (*bottom right*) Detail from a painting showing a pestle and mortar in domestic use–probably for pounding spices; Diego Velasquez, *c*. 1630.

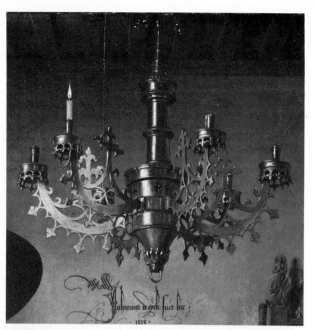
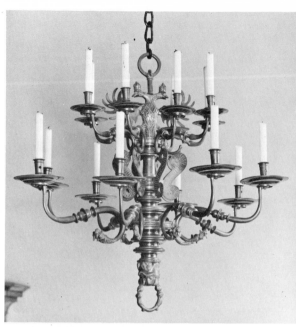

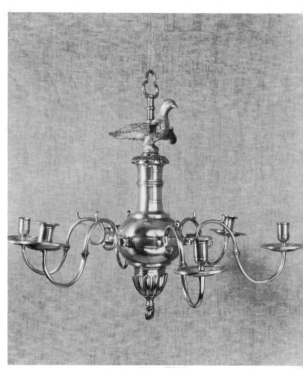

90 (*top left*) Bronze chandelier from the painting *The Arnolfini Marriage*; Jan van Eyck, 1434.
91 (*top right*) Bronze chandelier with double-headed eagle; North German, sixteenth century.
92 (*bottom left*) Bronze chandelier in the Baroque style, surmounted by a double-headed eagle; Detail from a painting by Jan Vermeer van Delft, late seventeenth century.
93 (*bottom right*) Brass chandelier; English, eighteenth century.

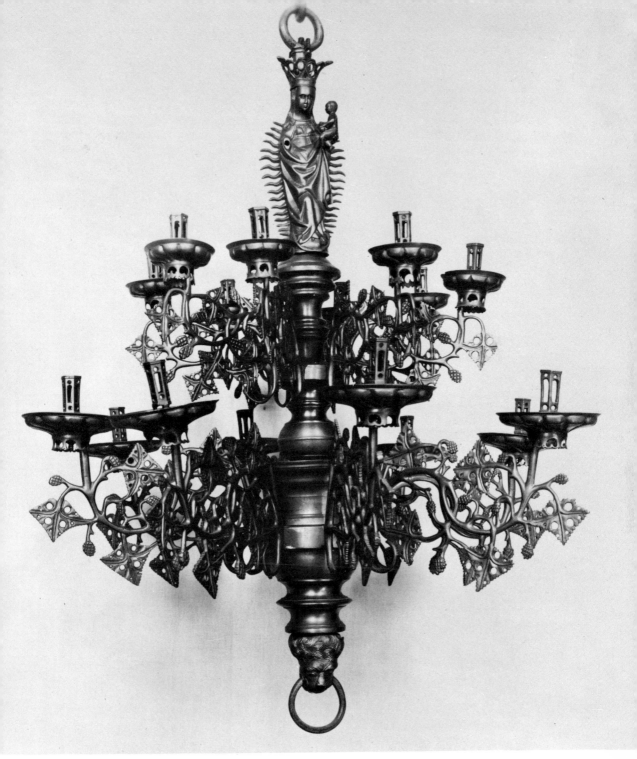

94 Bronze chandelier, surmounted by Virgin and Child; Netherlands, late fifteenth century.

 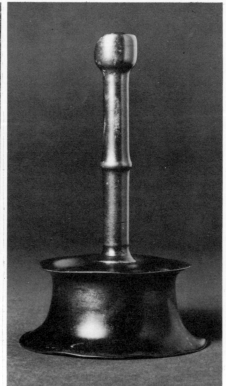

95 (*left*) Detail from the *Madonna di Lucca*, showing a candlestick of bronze and brass, with bell-shaped base; Jan van Eyck, 1436.

96 (*centre*) Bronze candlestick with bell-shaped base; probably Italian, sixteenth century.

97 (*right*) Detail from the portrait of Cardinal Albrecht of Brandenburg as St Jerome, showing a wall cupboard with a dish and a long shafted candlestick; Lucas Cranach, 1525.

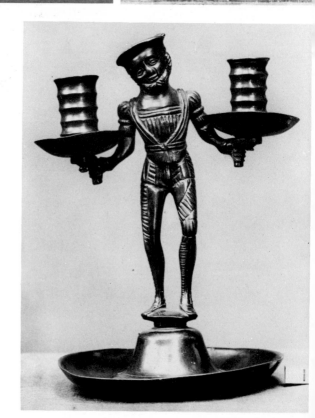

98 Double brass candlestick in the form of a man in doublet and hose; Flemish, sixteenth century.

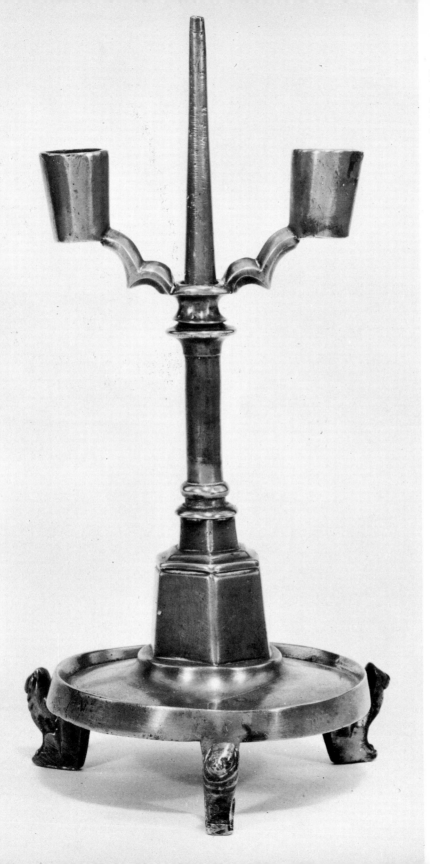

99 Two-branched bronze candlestick on an elaborate base; Flemish, fifteenth century.

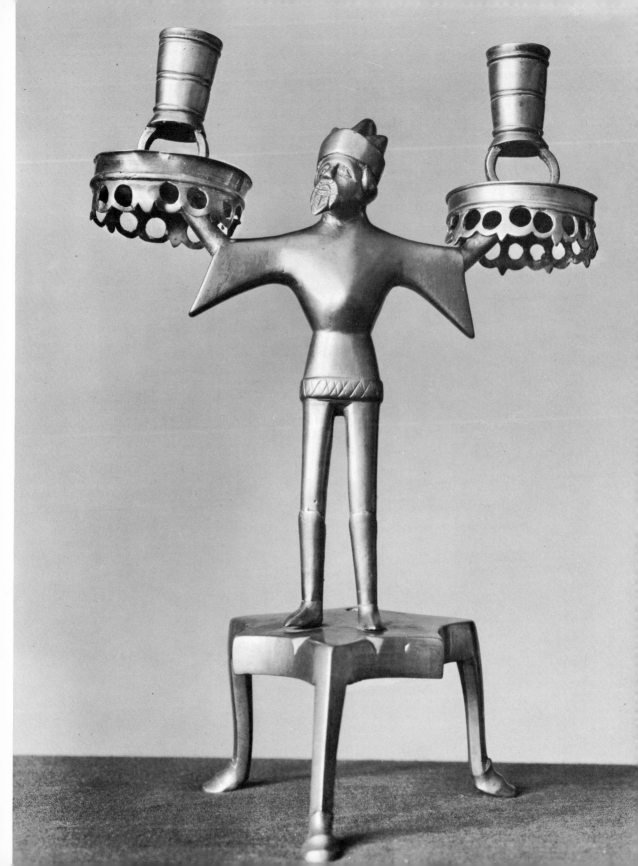

101 (*left*) **Pair of brass candlesticks; Netherlands, sixteenth century.**
102 (*right*) **One of a pair of brass candlesticks, with rich decoration; Venetian,**
sixteenth century.

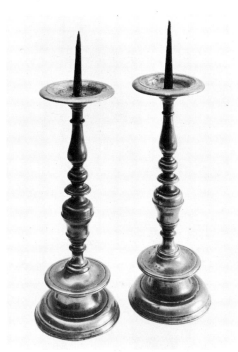 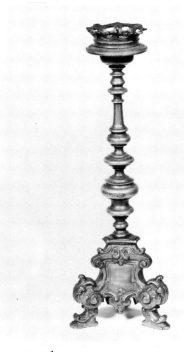

103 (*left*) **Pair of brass candlesticks; South German, seventeenth century.**
104 (*right*) **Baroque altar candlestick of bronze; Italian, late seventeenth century.**
100 (*opposite*) **Double brass candlestick in the form of a courtier with outstretched**
hands, upon a high base; Dinant, fifteenth century.

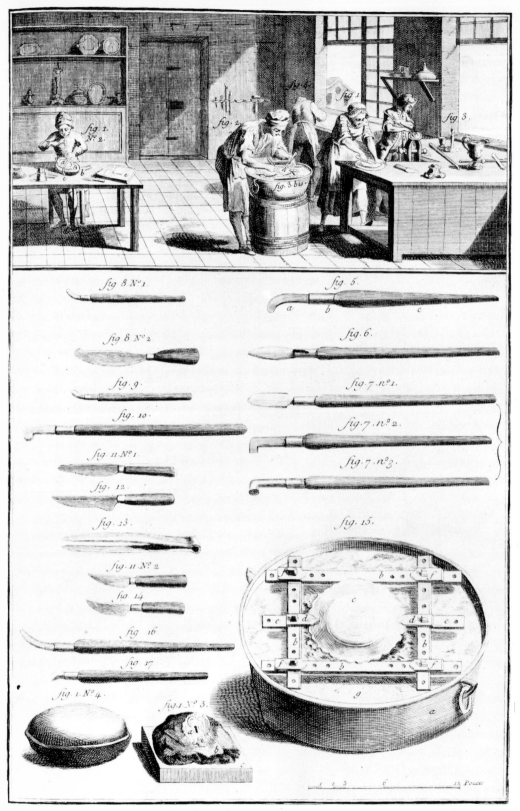

105 Silver-plater's workshop and tools from Diderot's *Encyclopedia*; eighteenth century.

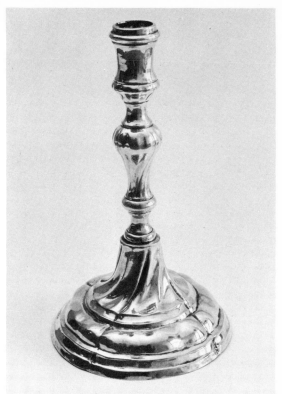

106 (*top left*) Silvered brass candlestick; German, *c.* 1720.

107 (*top right*) Silvered brass candlestick; German, *c.* 1750.

108 Brass silvered candlestick in elaborate Rococo style, from a painting by Jean-Baptiste Oudry; 1753.

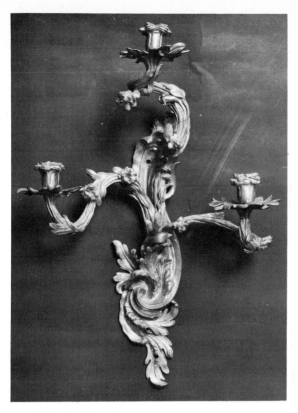

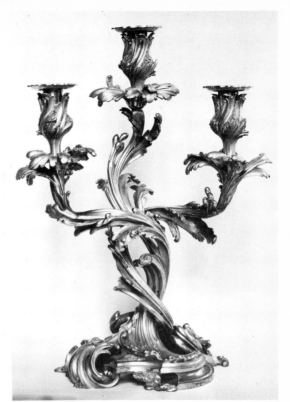

110 (*above left*) Appliqué bronze wall-light in the style of Oppenord; French, reign of Louis xv.

111 (*above right*) Candelabra of elaborate Rococo style in engraved and gilt bronze; French, *c.* 1756.

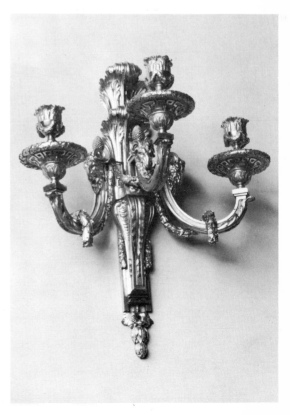

112 (*right*) Appliqué bronze wall-light, engraved and gilt; French, reign of Louis xvi

109 (*opposite*) Bronze wall-lights in elaborate forms, from Boucher's painting *the Breakfast*; French, mid-eighteenth century.

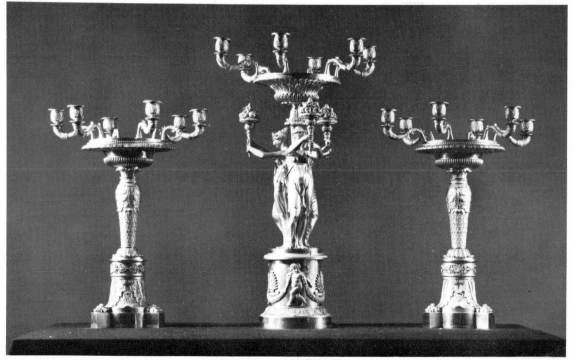

114 (*top*) Brass candlesticks; English, early nineteenth century.
115 (*bottom*) Elaborate table lamps in bronze-gilt of the Empire period with statues holding cornucopia and columns; Jean Thomire, Paris, early nineteenth century.
113 (*opposite*) Rococo candlestick of gilt bronze with Meissen porcelain figures; French, reign of Louis xv

116 Brass dog collar; Dutch,
seventeenth century.

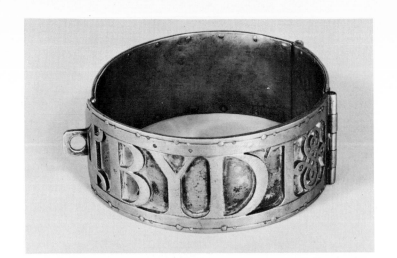

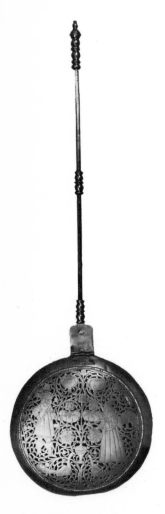

117 (*above*) Brass warming pan;
English, seventeenth century.

118 (*right*) Detail from the
painting, *Mother at the Cradle*,
showing a Dutch warming pan;
Pieter de Hoogh, seventeenth
century.

holding the candles; in Germany this development took place mainly *Bronze and brass* in Berlin. This type culminates underneath in a shallow dish made of glass or metal; alternatively the lower part was often left open and given an articulated effect by means of decorative struts. The whole circular structure was suspended on metal chains and it is fairly unusual to find a central axis bearing the main weight of the chandelier. At the top the chains were fastened together with a rosette. The decorative details display a rich variety of typically Empire motifs, the exact components of the decoration depending on the particular stage of development of the Empire style at the time, on the region where it was made, and on the temperament of the artist. It was normal practice everywhere for bronze chandeliers to be gilded.

Candlesticks

In an earlier chapter we traced the development of candlesticks in the Romanesque period with examples of both ecclesiastical and secular pieces from the age of chivalry.

From the fourteenth century onwards the desire to own beautiful and artistically designed candlesticks grew steadily. Patricians and merchants, middle-class citizens and craftsmen alike aspired to higher standards of living.

At the beginning of the fifteenth century it became fashionable in Dinant and Flanders to make candlesticks more decorative by replacing the ordinary shaft with a human figure with outstretched arms, holding a candle-holder and drip-tray in each hand. The figure stands on a round pedestal mounted on claw-feet or on a base shaped like a plate or bell. It is generally of a man with a pointed beard who is dressed in the elegant and indeed rather foppish fashions which prevailed in 1400-30; this particular fashion is known as the 'effeminate style' in Europe and includes pointed shoes, skin-tight hose, a doublet curving in very tightly at the waist and accompanied by a belt slung low over the hips; the sleeves fit tightly at the shoulder but flare at the wrists. A curly hair-style and a little hat added the final touches to the *ensemble* of these late-Gothic dandies. This type of candlestick also spread later from the Meuse area to southern Germany. Towards the end of the fifteenth century and especially in southern Germany the fashionable gentleman was replaced by a savage with a coat of shaggy hair covering him from head to foot; he often holds a club surmounted by the candle-socket. These 'wild men' were borrowed from contemporary tales and romances and appear in various branches of applied art at this time, in particular in the Upper Rhine area.

In the sixteenth century the popularity of candlestick holders made

97

Metalwork in the shape of human figures continued, though the figures and the design of the base underwent various changes. In one example we can see St Christopher with the Christ Child perched on his shoulder. Candlesticks portraying human figures were always valued as luxury articles and originate from the same tradition as the dragon and equestrian candlesticks which were regarded in the same way. Incidentally, these attractive figure candlesticks were often copied in the nineteenth century, so collectors beware!

For a while European candlesticks, and especially those made in Italy, came under the influence of an Arabic design, which reached Europe via Venice. The base resembles a deep upturned bowl with curving sides and is surmounted by a short cylindrical section leading up to a flat drip-tray; this in its turn is surmounted by a squat contoured baluster stem which is made in one with the actual candle-socket. It is assumed that the first examples of this type of candlestick were made by Arab craftsmen working in Venice, and that the design spread from there to the whole of northern Italy and thence into the rest of Europe. As the Arabs were masters in the art of inlay work, they covered their brass candlesticks with a thick network of arabesques, Moorish patterns and trellis-work worked in silver inlay. As this technique was not widely known in Europe, the silver inlay work would often be replaced by simple engraving or filigree work.

The baluster-stem met with considerable approval in Europe, as did the swelling bowl-shaped foot, though different regions modified the traditional design in various ways. In Italy, for instance, the squat baluster stem was retained, but was set on high claw feet and embellished with motifs taken from the classical world and the Renaissance; on the other hand, German craftsmen elected to use the slender stem but combined it with a deep arched base shaped like a bowl. Drip-trays had almost completely disappeared by this time.

While the extravagance of the Renaissance and Baroque periods had not yet appeared, there already existed in the fourteenth and fifteenth centuries, certain fixed ideas about gracious living. Contemporary paintings sometimes depict the ideal interior of a middle class home – the furniture includes a strong cupboard, where are displayed jugs and candlesticks, and sometimes a mortar; in the wall there is often a niche holding a lavabo with two spouts, or a bowl and matching jug. Chandeliers are rarely included, since none but the very wealthy could afford them. Most people, including poorer citizens, could, however, possess a bronze candlestick.

From the fourteenth century onwards the development of the domestic candlestick followed very different lines from that of liturgical pieces. Candlesticks used in churches were made to hold fatter candles,

98

whereas those used in private houses contained narrow sockets for small candles. By the Gothic period, the candlestick had developed into a simple round form with short claw feet, and a squat shaft with a knop and drip-tray. This basic form continued to be used for ecclesiastical candlesticks until well into the sixteenth century. The rounded base was decorated with a variety of raised lines, and formed an upside-down dome-shaped basin; it was smoothly polished and had no feet. This later developed into a pillar-like shaft, either squat or tall and slender segmented by a series of whorls, surmounted by a drip-tray. The spike, on which the candle was placed, was frequently made of iron. We have no space here to analyze the individual peculiarities which characterize the different European countries in their interpretation of this basic form. This continued to be made in various pockets of central Europe right down to the seventeenth century. In Italy, however, a much more extravagant design was in use in the Renaissance; the basic theme consists of a triangular pedestal moulded into an arched shape and surmounted on a base which is again triangular, but made up of decorative panels, often with relief-moulded patterns; the stem rises directly from the base into a series of rounded baluster shapes, culminating in a drip-tray with a spike for the candle. The design reached Austria and southern Germany in the seventeenth century and was often made in pewter, or occasionally brass. In the northern half of Europe, the influence of the Low Countries prevailed and the traditional shape was more commonly used. These two designs continued into the eighteenth century in both northern and southern Europe. The three sides of the triangular base now begin to sprout angels' heads, shell-patterns, foliage, scrolls and rocailles, with the swelling contours of the shaft more pronounced. When the neo-classical style superseded Rococo, the design was modified accordingly. However, the result was never very satisfactory, and most of the new designs have an old-fashioned look about them. This type of candlestick died out altogether in the nineteenth century; the examples made after 1850 harked back to older designs.

Candlesticks made for domestic use developed along very different lines. In the fourteenth century in France and the southern part of the Low Countries, which included Dinant and the Meuse area, the round candlestick was revived, but the shaft now became longer and slimmer or even angular in cross section, while the single knop developed into one or several rings encircling the shaft. The round base, with its claw-feet, remained unaltered, as did the drip tray with its spike for the candle.

In the fifteenth century, a new type of candlestick developed, which was to exert a great influence on the design of candlesticks of central

99

Metalwork Europe for over a century; it probably first appeared in the Low Countries. The base of this type of candlestick resembles a bell – it is thus described as the bell-footed type – and is surmounted by a shallow dish or plate for catching the wax. A round or square shaft rises from the centre of the drip-plate; it is generally very slender and may be broken up by a series of widely spaced rings shaped like discs. The candlestick ends in a cylindrical socket with two right angles cut out of it, for removing the remains of the candle, once it has burnt right down. Flemish versions of this type have two rings round the shaft, while German and Venetian examples usually have four.

The invention of the two-branched candlestick dates from the late Middle Ages – this represents merely a further development of the ordinary single candlestick. There were a number of variations on this basic shape; the curves of the branches and the central shaft could vary, as could the proportions and size; occasionally the sockets were given extra support by a pair of curving metal rods.

Alongside the bell-footed shape, a version of the candlestick developed with an upturned plate or shallow dish, with steep sides. In the sixteenth century, this type of base superseded the more wasteful bell-footed shape.

In the seventeenth century some of the most common candlesticks in Germany, France and England, were those with a base shaped like an upturned bowl and a squat baluster stem. This is essentially a plain and homely design which fits in with the Baroque mood prevailing in the first half of the century; it finds its perfect expression in the chandeliers made by Flemish craftsmen. A full description of the many different styles which were invented is beyond the scope of this book, so we will limit ourselves to the category known as 'collar-candlesticks' which have the drip-tray halfway up the stem and were particularly popular in the Low Countries.

In the second half of the century craftsmen in France began to bring to ordinary household utensils some of the splendour of those used at court. Their lines became more elegant and they began to resemble contemporary silverware, but there was no question of their being merely substitutes for objects made in more precious metals, since they underwent a completely independent process of development, during which the various potentialities of brass were exploited to the full. As a matter of fact, when they had been treated to a final layer of gilding, the general effect was even more splendid than if they really had been made of silver; and indeed a bronze-gilt candlestick was probably only very slightly cheaper than a silver one.

The basic design of candlesticks of the late seventeenth century is very different: the round arched base disappears and is replaced by a flatter octagonal shape which is slightly pointed to give a pyramid effect.

100

This was then followed by a shallow rounded tray from which rises a baluster stem. Unlike the round spherical design which characterizes the High Baroque period, the stem is now polygonal and much taller, generally rather slender at the bottom and widening towards the top, though it is possible to find examples where the opposite is true and the narrowest part is at the top. The basic baluster shape could be handled in a variety of ways: it could be plain and undecorated or ornamented in the same way as other parts of the candlestick, with flowers, leaves and interlaced foliage moulded in relief; it could be fluted or grooved, wreathed and gadrooned, or even completely enmeshed with decorative volutes and foliage. Finally the baluster shape, with its architectural emphasis, disappeared completely in the Rococo period and the stem was instead adorned with *putti* climbing or playing around it, rocaille ornament, volutes and curves, so that the element of decoration predominated. The design of the candle-sockets conforms with the style of the rest of the candlestick; they are generally round, occasionally polygonal.

Candlesticks with branching arms fitted with two, three, or even more, candle-sockets were being made in the Baroque period. These are known as candelabra and were generally used at table or on a mantelpiece. In the Rococo period they were transformed into winged structures with branches interwoven like foliage and flower-calyxes growing from them as candle-sockets. Wall-brackets for candles (sconces) also had an important place at this time; they would be fixed permanently to the wall and generally spaced out at regular intervals. In the Baroque period they consisted of curving arms ending in candle-sockets with a shield of chased or tooled metal behind to reflect the candlelight.[5] In the eighteenth century, bronze-gilt wall-lamps were used, generally with two or three richly contoured arms fashioned into shapes from vegetable or plant life: they branch from a panel screwed to the wall which bears the same kind of decoration. This type of wall-lamp never has a reflector behind it.

Juste-Aurèle Meissonier, Gabriel Huquier and various other French artists designed large numbers of candlesticks, although it is not always clear whether they intended them to be made up in silver or bronze-gilt. If we compare their extravagant and fanciful designs, many of which are very over-elaborate, with the candlesticks actually made in Paris at the time, we can see that craftsmen working in bronze demonstrated their practical commonsense, their understanding of the material and above all their own good taste by stripping away much of the over-elaboration. Their candlesticks are now much sought after by collectors and admirers of the French eighteenth-century style; one

Metalwork of the greatest of these bronze-founders in Paris was Caffieri, who was in fact of Italian extraction.

Parisian bronze-founders specialized in candlesticks set with groups of porcelain figures and flowers. They are generally Dresden figures and are mounted on a pedestal curved in rich rocailles, against a background of bronze-gilt shrubbery, scattered with candle-sockets and porcelain flowers. Settings of the same type were also made in Meissen, but in both centres they were considered luxury goods and were restricted to aristocratic circles.

By the eighteenth century Paris had become the centre of the fashionable world and the *arbiter elegantiarum* of Europe. Its influence reached all civilized countries and many attempts were made throughout Europe to imitate the elegant lamps of Paris, but these rarely reached the perfection of the originals. In Germany bronze-casting and bronze-gilt articles in the Rococo style were enjoying great success.[6]

From the eighteenth century onwards the new designs inspired by the work of French craftsmen met with general acceptance, and the various possibilities offered by the vase-shaped baluster stem were exploited to the full. But articles for use in the home were generally kept fairly simple and few attempts were made at imitating the gadrooned curves of silver candlesticks. The overwhelming majority of domestic candlesticks remained true to the functional qualities of bronze or brass, and none of them was ever gilded.

English candlesticks at the end of the seventeenth century and in the early Georgian period developed independently and were rather different from those made on the Continent. They sometimes have a saucer-like base, although rounded bases can also be found, from which the shaft rises straight up. The baluster stems which were so popular on the Continent are very rarely found in England, where the shafts were generally rounded and taper towards the top or towards the bottom. Certain parts of the shaft are accentuated by being moulded to a different shape or swelling into bumps or rings; it is also sometimes broken up by spherical ornaments which gradually became a characteristic method of articulation as the eighteenth century continued. The candle-socket is slender and contoured, while the drip-tray, which is fairly small and is set right up at the top, was cast in one piece with the shaft and the socket.

Towards the middle of the eighteenth century there were various types of base: the flat plate shape gradually disappeared and in the late Georgian period a square base was adopted. The corners are now always deflected and the whole schema is varied in a number of ways. The bottom half of the stem is rounded or bell-shaped, spherical or cylindrical, while the top half is broken up by spherical curves, rings or

102

bulges. The whole candlestick is squat and gives a general impression of being strong and solid, rustic rather than refined. The Rococo style, as it appeared on the Continent and especially in France, was not transferred to the brass candlesticks made in England in the middle of the eighteenth century.

In about 1750-60 the Rococo style was followed in France by the classical lines of the Louis-Seize style. This reaction is reflected in the design of candlesticks, girandoles and wall-brackets: there is still a certain vegetable element in their ornamentation, but it is now austere and disciplined. More severe motifs, such as urns, pendants, pilasters, festoons, goats' heads and decorative friezes, now make their appearance on an enormous number of types of candlestick; indeed there are now so many variations that it is impossible to keep count. The rich reddish gilding which was used previously gives way to a cooler silvery shade far more suited to the classical mood of the period.

In Germany the old late Baroque designs continued to be used for candlesticks for many years, in fact until the last quarter of the eighteenth century. When the newly-established neo-classical style superseded Rococo, it had very little effect on the design of candlesticks, and very soon art and culture, craft and social life were all brought to an abrupt halt by the Napoleonic Wars.

The Napoleonic Empire style was essentially international; it was dictated by Paris, and all the courts of Europe which were under Napoleon's power or influence adapted their work accordingly, in particular their metalwork articles.

Fire-gilding regained its former importance. Candlesticks are severely rectilinear, with corners and borders adorned with deeply engraved friezes made up of leaf-motifs, meanders and other similar classical patterns, while the sides are divided up by patterns consisting of straight lines applied by the guilloche technique.

The showy designs and sometimes rather pompous effect of the Empire style were confined to articles purchased by the property-owning aristocracy and the wealthier bourgeoisie; on the other hand, its straight simple lines stimulated those craftsmen whose clients came mainly from ordinary middle-class families to create a new homely sort of style which is known in Germany as *Biedermeier*. Originally evolved at the beginning of the nineteenth century, it soon became popular throughout Europe.

Its main characteristics are thriftiness, expediency and a cheerful kindly note, all of which can be seen in the candlesticks of this period (the early Victorian period in England). They are generally simple and undecorated with straight fluted shafts rather like pillars, frequently set on a square base. Candelabras and girandoles are no longer as

Metalwork common as they were in the preceding periods. One particulaly economical and functional design has an adjustable mechanism to raise or lower the candle inside a hollow shaft.

Technical progress was also made in lighting equipment. In 1820, for instance, Argand invented a method of using oil to create a brighter (and cheaper) light; he designed a burner to supply the necessary air and a special container in the lamp for the oil. His system was used for chandeliers as well as for ordinary table-lamps. All the light fittings made at this time were designed in the neo-classical style which was then in vogue.

Solid cast metal was now very rarely used, except for large candlesticks made for show. On the other hand lacquered sheet-metal, glass, covered rods and various other types of material would be combined to satisfy technical requirements and to offer greater convenience. This trend was developed a stage further when the paraffin-lamp was introduced in 1860, and finally the invention of gas-lighting brought an end to the gracious bronze light fittings of the past.

When the *Art Nouveau* style began to sweep through Europe in about 1900, it naturally affected candlesticks as well; a number of extraordinary new motifs were created, and we find stems which seem to sway in the breeze, with drifting leaves and blossoms containing the candle-sockets. Functional considerations are completely subordinated to aesthetic appeal and this type of article is more a piece of sculpture than a utensil. But this undulating, swaying aspect of the *Art Nouveau*, practical style with its predominant theme of vegetable and plant life is offset by its other equally original element of rectilinear and strongly stylized design. These *Art Nouveau* creations represent the last manifestation of the candlestick as an individual article with its own style. Attempts have occasionally been made in the twentieth century to create new styles, but the advent of electricity has inevitably meant that any such styles could do no more than reflect earlier trends.

Other utensils

In the fifteenth century the town dweller led a very different life from his counterpart in the country. The invention of many new utensils meant that life was more comfortable and work was less back-breaking; kitchen utensils had also undergone many modifications and become more specialized. In 1477 an inventory drawn up of the possessions of the Gartzweiler family in Aachen mentions the following items, which were all made of 'copper' (though in those days the term also included brass): pots, crucibles, lids, pans, skimmers, buckets, rings, basins, weights, lamps. Another inventory, this time compiled at the end of

the sixteenth century, mentions the same type of articles and also lists: chandeliers, hand-tubs (i.e., lavabos), mortars, escutcheons and a brass chamber pot. Jost Ammann's book about the different trades practised by men of his time was published in 1568; it tells us that metalworkers were also making the following items out of brass and bronze: belts and seals, thimbles and bracelets, tops of steeples, brewing-vats, cooling-pots and slop-basins, cannon barrels and clocks, escutcheons for gravestones and chandeliers, sprayers for fire-fighting equipment, bells for cows and jesters, trumpets and flutes, wall-hooks and hand-lanterns, screw-heads and spigots, warming-pans and table-rings for standing dishes on, smoothing-irons and cupping-glasses.

This list represents an enormous number of everyday items and we can assume that the demand for them must have been high, since the metalworking trade was so specialized that most craftsmen would produce only one type of article.

The range of smaller metal utensils which had been made during and just after the Baroque period was beginning to reach a wider public; the consumer society had made its appearance. Significantly, producers of sheet-brass in Aachen were very prosperous at this time; as we have seen they sold their goods to craftsmen as partly finished products. They now took on the title of 'worshipful and noble lords', adopted coats-of-arms and maintained splendid town-houses. The equipment needed for the Thirty Years' War may have helped to foster their trade. Bronze articles were very popular among the richer bourgeois families in the Low Countries in the seventeenth century, as we can see both from the large quantities made at the time and the fact that contemporary painters often depicted bronze articles in their still-lifes, placing them alongside gold and silver vessels, precious rock-crystal goblets and porcelain from the Far East.

While Europe was recovering from the Thirty Years' War bronze-workers found themselves faced with strong competition from a source which considerably decreased the importance of their wares. The influx of silver from Central and South America had begun as early as the sixteenth century, and resulted in a considerable reduction in the price of silver, which had previously been extremely expensive. In the seventeenth century, the seafaring nations and the trading companies imported an increasing amount from overseas, so that more and more became available in the Old World. The silversmiths' trade blossomed and by the beginning of the eighteenth century many people could afford to buy silver tableware. We even find that utensils which had formerly been made of pewter or bronze were now being made in silver.[7]

Another source of competition was the Far East, from which porcelain

Metalwork and faience were now being imported. With this demand for both silver and porcelain there remained little scope for bronze and brass. The only field where they were still pre-eminent was in lighting equipment – chandeliers, candlesticks and wall-brackets. The golden shimmer of this type of article was still popular right into the Rococo period, though articles of greater luxury would be gilded.

Bronze was given a new lease of life when metal mounts and fittings were used to decorate luxury furniture; this custom was mainly confined to France and began during the reign of Louis XIV, continuing under his successors in the eighteenth century. Charles André Boulle developed a technique of marquetry which involves the use of tortoise-shell and sheet-brass inlay; it was copied by many other cabinet-makers in France and Germany. Another way in which bronze could be used was for the gilt mounts accompanying precious porcelain articles in the eighteenth century, though this practice was confined to court circles.

On the whole we can say that articles made of bronze and brass were no longer as important in the eighteenth century as they had been in the fifteenth and sixteenth centuries. It is true that articles such as bells, cannon-barrels, well-designed warming-pans and bellows, water-pipes and small portable stoves for keeping one's feet warm in church, dog collars, measuring-jugs and snail-pans, and many more, were still being made in bronze and brass; but now the material was just one among many and no longer had an individual style of its own.

The arrival of the nineteenth century and the disappearance of the tradition of craftsmanship only hastened this process, and finally even the last bastions of decorative bronze and brassware were destroyed: chandeliers were now made of lead, wood, zinc, glass, iron, sheet-metal and many other materials, as were smaller lamps. Even ordinary vessels and containers were now made in cheaper materials which required less exacting designs. On the other hand, bells and mortars were still being made of bronze, and in the field of sculpture monumental cast-brass enjoyed a period of great prosperity and was used for statues, monuments, and similar items.

The age of historicism naturally did not miss the opportunity of copying the bronze articles of former centuries and providing new variations on them. Ewers, lavabos, mortars, bowls, jugs and lighting equipment were made as cheaply and quickly as possible, so that all could imitate Renaissance, Gothic or Baroque in their own home. This type of article would be offered for sale in catalogues which came direct from the warehouse and was then supplied at a very reasonable price by a wide range of firms. The majority of these wares are immediately recognizable as copies, though there are a few cast-bronze articles, mainly ewers, which pose a problem even for the expert. Increasingly

106

skilful methods of mass-production were the undoing of *Art Nouveau*. Industrialists with an eye to rising profits produced machine-made implements for the writing-table and other articles of shining brass which were intended to give an impression of gracious living. These used the characteristic decorative motifs of the *fin de siècle* style but conveyed no feeling for quality nor for the inherent properties of the material. So even the artists of the *Art Nouveau* were not permitted to scale the peaks of craftsmanship reached by metalworkers in the Romanesque and Gothic periods.

Part III Iron

1 Iron-mines and foundries

The early stages of the history of iron are even more obscure than those of other metals. The first real evidence of its use is offered by the colossal statues carved by the ancient Egyptians at a very early date; they were hewn out of granite, basalt and syenite and have certain markings which indicate that iron or steel tools were used.[1]

By the time we come to the reign of Rameses II (1350 BC) iron ploughshares were in general use. Although relatively little has survived from either the late or the early period, this is simply because iron does not stand up well to dampness and exposure to air; it rusts easily, whereas bronze is more durable. In the ancient world many nations mined iron, traded with it and used it for making weapons and utensils.[2] Thus the Egyptians had iron-mines in the mountains between the Nile and the Red Sea, but also imported iron from Armenia, Lebanon, Crete and Cyprus.

Deposits of iron were discovered in central and northern Europe in prehistoric times, and it may even have been used before bronze for fashioning utensils. Most of the earliest mines were founded in the area between Bohemia and Moravia, in the Swabian Alps, the Pyrenees and Gaul. The Romans mined iron in Styria; according to Caesar, copper and iron coins were being used by Britons in his day, and the Emperor Hadrian set up an arms factory in Bath.

In the Middle Ages, the most important mining area was Germany, though iron deposits were worked in many other parts of Europe.[3] By the end of the Middle Ages, the iron and steel trade in Germany was controlled by the Hanseatic League. The Hanseatic merchants, known as the 'Osterlinge', had a trading station in London, called the Steel Yard. They used a currency known as the 'Osterling pound', from which the modern term 'pound sterling' is derived.

Iron is obtained from iron ores, oxides and carbonates;[4] carbon and

Metalwork carbon monoxide are used to extract the metal. The oldest and most primitive method, still used today by a few tribes in Africa and Asia, consists of installing a cupola furnace made of fired clay, filling it with alternate layers of iron-ore and charcoal and then heating it to a very high temperature by fanning the flames with a pair of bellows. The slag flows out at the bottom leaving behind a porous mass of fairly soft iron known as a 'lump', which is then hammered. This very simple though rather unprofitable method continued to be used in Europe until the fifteenth century.[5]

At the beginning of the fifteenth century the discovery of how to produce cast-iron or pig-iron meant that the iron industry could be run on much more economical lines: water power was used to drive the bellows, and the exceptionally strong draught caused the iron to flow out in a liquid state instead of remaining in the furnace in a waxy lump. The liquid quickly hardened and then cracked if hammered. After it was smelted again a piece of pure iron was obtained (equally malleable throughout). This process is known as fining.[6] The iron was now free from any impurities, particularly of sulphur admixtures, and was known as wrought-iron or malleable iron with a melting point somewhere between 1350° and 1528° centigrade. Most of the decorative ironwork, which will be discussed in the following chapters, is made of wrought-iron.

At the beginning of the eighteenth century Abraham Darby and his son, also called Abraham, again experimented with pit coal in the iron works at Coalbrookdale, and in the 1740s Darby senior's son-in-law, Richard Ford, succeded in smelting iron with coke. English production methods soon became the most advanced in Europe and served as the model for the blast-furnace built in Creuzot in France; meanwhile Germany lagged a long way behind. Various methods were used for fining the iron, which, as mentioned above, involved removing any surplus carbon and other impurities. In 1767 Henry Cort took out a patent for a process known as 'puddling', in which the molten pig-iron was heated with an extra supply of air, fired and then stirred until it had been completely refined. At approximately the same time a similar process was patented by a man called A. Onions who managed to keep it secret for many years. The enormous increase in iron production which took place in the nineteenth century and the increasingly successful, and highly complicated, methods of extraction which were used do not come within the scope of this book, since they really belong to the history of industrialization.

Steel is a modified form of iron. The following quotation from Johannes Beckman's *Beyträge zur Geschichte der Erfindungen* (1805) shows

110

how little was known at that time about the constituents and the pro- *Iron* cessing of steel:

Steel is iron, but has various remarkable characteristics which differentiate it from iron. It is much harder, and so is capable of filing iron, drawing sparks from vitreous stones and cutting the hardest glass. It is heavier, rings more loudly and has a finer grain when broken; it takes on a pale whitish glow and is more pliable . . ., does not rust as easily . . . and if it is plunged into cold water when it is red-hot it becomes harder, more friable and less flexible . . . However, we do not know what turns iron into steel. Anyone who is willing to admit the truth entirely without prejudice must say that we do not even know for certain whether iron becomes steel when it is compressed or when one of its component parts is removed or when something is added or whether this may be carbon, some inflammable matter, mangane, blacklead, or some other substance; new opinions are always superseding the old ones.

So steel production was a thoroughly experimental business. The oldest method consisted of heating pieces of iron with charcoal for a fairly long time, without allowing air to penetrate, so that the iron absorbed carbon. This method is still known as cementation or the direct process. The metal bars were then welded together, and the resulting raw material was forged and tempered by being chilled in water and other liquids; the exact nature of these liquids was often kept secret. Armourers in the Near East had perfected the technique of producing steel, and their sword blades (Damascene blades) became famous throughout the world.

In the seventeenth century steel workers in England succeeded in cementing iron in crucibles, and this method of steel production is still used today in places. The firm of Alfred Krupp perfected a method of casting steel in sand moulds and did so on a large scale.

The smiths, like all the other trades, were organized into guilds from the Middle Ages onwards. Their patron saint was St Eligius. Legend has it that he was once a goldsmith and was commissioned by the Frankish King Clotaire to make a golden throne. He later became bishop of Noyon, but did not give up his work as a smith. He is generally represented shoeing a horse, one leg of which – as the animal was particularly fierce – he has removed for the purpose. His performance of a miracle with fire and the tools of their trade probably endeared him to the smiths as much as the fact that he was a goldsmith, and as such, a practitioner of one branch of their craft. In spite of their choice of patron saint, they soon divided into two separate guilds, one for those working with non-precious metals and the other for goldsmiths and silversmiths. In many towns, however, the guild of smiths still usually included many more different crafts than any other guild. It often acted as a reservoir for absorbing the various trades not sufficiently large or

Metalwork powerful to form their own guilds. The *smits gild* of St Loyen in Amsterdam included blacksmiths, locksmiths, sword-cutlers, braziers and cutlers, and occasionally even managed the affairs of the carpenters and the clothmakers.

The regulations of the smiths' guild concerning apprenticeships, journeymen's travel periods, masters' examinations, etc., were similar to those which applied to bronze-founders and braziers. Individual towns and regions occasionally varied the regulations slightly, but the basic principles were the same everywhere.

Specialization in the smiths' trade reached its peak in the sixteenth century, and craftsmen were rigorously divided into an enormous number of specialist categories.[7] Most of these craftsmen made ordinary articles for everyday use, very few of which have survived the passing of time. A fair number of them, however, also produced very fine work which was to play an important part in the history of the applied arts.

The job of the smith is to fashion objects from his raw material, by forging the iron, or in other words, hammering it when it is red hot, or occasionally cold-hammering it. The hammer is used for the most important part of the whole process, i.e., for fashioning the piece of iron into the required shape as far as possible. Any little bumps or uneven patches can be filed down afterwards if necessary, but smiths pride themselves on their ability to complete their job without using anything but a hammer.

Like other metals, iron can be engraved, either by using a steel graving-tool or, though this method is less usual, by driving in the tool with a hammer. Since iron is such a hard metal this is a very lengthy process, and the technique of etching was invented as an alternative. The whole surface to be decorated is covered with a coat of wax or asphalt and the design is scratched into it, leaving the wax on the parts to be raised. The craftsman can also apply the protective layer free hand, leaving the part to be etched unprotected. Then he pours acid over the whole surface and leaves it to erode those areas which are not protected by the wax. Finally the wax layer is removed with turpentine.

Niello-work consists of engraving a design, filling the lines with a mixture of sulphur, silver, copper and lead and then fusing the mixture together by the application of low heat. The niello-work motifs create a blackish effect against the lighter colour of the iron. The technique known as inlaying (or damascening) was perfected by the Islamic nations and probably reached Europe via Venice. After the design has been engraved into the iron, gold or silver threads are driven firmly into the individual engraved lines and finally the surface is smoothed down.

112

The process known as counter-damascening, the design was produced *Iron* by burnishing gold or silver wires or foil to the previously-roughened surface of the object being decorated.

Iron can be polished with a polishing powder, a burnisher or a piece of haematite. Alternatively, the surface can be given a permanent coat of colours by being 'browned', in other words, acid is used to create a smooth artificial layer of iron oxide. The blueish tinge of steel is obtained by tempering it evenly over a slow fire.

The most tricky way of decorating iron is to cut it. The craftsman uses a chisel to carve out his figures, which are either three-dimensional or raised in high relief. He uses a technique similar to that used by the sculptor. Since iron is very hard, only a very few master craftsmen have ever been able to master this laborious technique properly, those who did, spent almost all their time decorating weapons and special show-pieces for high-ranking patrons.

Forging is the most basic method of processing iron. For a long time casting was out of the question because no one had yet found a way of melting down the metal so that it was liquid enough to be poured into the moulds, as bronze and brass could be.

It was not until the end of the fourteenth century that this was made possible by the discovery that sufficiently high temperatures could be reached by using water-powered bellows to fan the flames in a blast-furnace. So from the fifteenth century onwards, the art of casting iron advanced by leaps and bounds.

113

2 Weapons and cutlery

Weapons

Swords

The most important weapon in Europe was the sword, which underwent a number of drastic changes over the centuries. The earliest examples were made of bronze and were often elaborately decorated, but some time between 1200 BC and 900 BC iron began to supersede bronze, though the two metals were probably used side by side for some time after this. There is some evidence to suggest that iron was being used much earlier than the dates we have given, and in fact the earliest known iron sword, was discovered in a grave dating back to 2500 BC near Dorak, close to the Sea of Marmora.[1] A number of iron swords dating from what is known as the Hallstatt period have been found: the name is derived from the burial chambers discovered near Hallstatt in the Salzkammergut in Austria. In the Landesmuseum in Stuttgart, there is a particularly magnificent sword with a hilt inlaid with gold, dating from *c.* 600 BC, which was found in a burial ground near Gomadingen in Württemberg. It is a full 3 feet 7 inches in length, which suggests that it was used by the chieftain of some clan when on horseback; in fact, it probably served as a symbol of its owner's high office as much as a weapon of war. It is possible that its elongated design was influenced by the bands of Eastern horsemen who left the steppes of southern Russia during this period and made their way into Central Europe. Up to this period, swords had been considerably shorter. In the following period, the *La Tène* age, doubled-edged swords were the general rule, but knives with a single cutting-edge were also used.

Bent sword blades have been found in both Teutonic and Celtic graves, probably because some solemn ritual required them to be deformed in this way. Perhaps the idea was that at some future

114

date the warriors would be given the opportunity of straightening out *Iron*
their sword blades and using them again in the next world. Whatever
the reason, it is clear that the iron which was then available must have
been extremely soft. According to Polybios, the swords used by the
Celts were often bent right out of shape after the first blow and had to
be straightened out on the battlefield; the Roman warriors naturally
chose this moment, while their adversary was completely defenceless
and had his hands full, to stab him with their own short swords. Roman
legionaries carried *gladii*, short swords of this type, in a scabbard hanging
down by their right sides, and held a large shield on their left arms;
officers, on the other hand, did not have shields and so had their swords
on the left. The Roman Emperor wore a dagger (*pugio*) round his neck
as a symbol of his authority over the life and death of his people; later
on generals and commanders of the Praetorian guard also carried this
symbol.

The sword was very important to the Germanic peoples whose attacks
on Rome and whose migrations were such decisive factors in the history
of the period 200–600 AD. Their sagas and tales clearly show that the
blacksmith was held in very high esteem and was treated with great
honour, although at the same time he was feared for his enormous size
and tremendous physical strength.

The story of Weland (or Wayland) Smith often recurs in the old sagas
of various peoples, from the Irish to the Franks; if he really did exist,
then he would have lived somewhere round 500 AD, for one of his
tasks was to make weapons for King Theodoric.[2] Weland was lame,
like the Greek smith-god Hephaestus, and his character and way of life
were similar to those of the dwarfs who are represented as miners and
blacksmiths in the saga. They are friendly and helpful to all those who
treat them well, but are jealous and quick to seek revenge when dealing
with their enemies. Experts on folk lore claim that these sagas are a
way of expressing the miseries of a whole nation enslaved by the Ger-
manic tribes.

Some of the wonderful heroes in the sagas forged their own swords,
such as the royal prince Siegfried; and the Nordic Jarl Skallagrim is
supposed to have built a forge in Iceland and himself worked there as
a smith.

Swords were thought to have magical powers and each was given
a name. The heroes of old had a personal relationship with their
swords, treating them not merely as a piece of equipment but as their
companions-in-arms. The poets describe them in as much detail as their
owners, singing their praises with equal fervour.[3]

During the period of the mass migrations swords belonging to the
greatest heroes and commanders were often very richly decorated, as a

115

Metalwork token of the love and respect borne to them by their distinguished owners. For instance, a sword scabbard embellished with gold fittings and garnets was found in the grave of the Merovingian King Childeric, who died in about 480, and the burial-ship at Sutton Hoo, east of Ipswich, contains among many other objects a sword dating from *c.* 650-70 with a golden pommel and set with cut *cloisonné* garnets.

Thrasumund, king of the Vandals, sent Theodoric, king of the Ostrogoths, a gift of a sword and received in return a fulsome letter of thanks, in which the colouring of the blade was particularly mentioned; the metal seemed to have been woven through with a variety of different colours as if little worms were wriggling their way in and out of it, an effect which the swordsmith had achieved by welding the bar-iron over and over again, hammering it out and then welding it together again. This particular technique had been perfected in India, and Indian sword blades were exported to Europe at a very early date; in the Middle Ages they were considered a great luxury and indeed Thrasumund's gift was probably made by an Indian craftsman. Indian blades were allegedly shipped to Europe via Damascus, which is why they became world-famous under the name Damascene blades. Another theory, however, suggests that Damascus had had it own blade industry since the early days of Islam. The technique used for making Damascene blades involved smelting together and hammering the steel of old broken swords which produced a very pliable steel, although, since it was not equally hard all the way through, it dented easily. This may account for the fact that scarcely any original blades have survived from the early period.

Towards the end of the period of mass migrations all the swords made on the Continent began to look very similar in style, which seems to indicate that there was a number of professional blacksmiths working on a mass-production basis. A very large number of swords has come to light in Scandinavia, including some particularly sumptuous, richly decorated examples; they were presumably imported from the Rhineland or southern Germany, or occasionally from England. But there are also many swords of a far more simple design, some of which have a name stamped on the handle or inlaid in softer iron on the actual blade. Originally these names referred to famous master blacksmiths, but after their death their names were adopted as a sign for various Frankish workshops.

The terms *sax, seax* or *sachs* occur in Old Frisian, Old High German and Anglo-Saxon to denote the knife-like weapon with a single cutting-edge used by the Teutonic tribes. It was probably originally a short knife between 8 and 14 inches long and was used as a household utensil, a weapon or even as a missile. The long *sax* was 16–24 inches long and

was used exclusively for fighting. The ordinary *sax*, also known as a *Iron* *scramasax* (wounding *sax*), was sometimes as long as 30 inches.[4]

The spear was never considered as important as the sword although its history is long. For many years spears were used as a symbol for freemen and were also sometimes given names; for instance, the Nordic sagas refer to Odin's spear at Gungnir or Gungne. The Vikings used spears with damascened tips which were also often decorated with niello-work and copper inlay. Tall officers carrying lances with little banners attached to them are portrayed in the Bayeux Tapestry. They were not purely decorative for they denoted high-ranking figures such as William the Conqueror and King Harold.

The Franks preferred to use battle-axes, which were also used as missiles; a *francisca*, which is a weapon of this type, was placed in the grave of Childeric, king of the Franks, who died in 481. During Charlemagne's reign the Franks had already given up using *franciscas*, but they were still in use among the Alamans, the Burgundians, Langobards and Goths. From the eighth to eleventh centuries axes were very popular among the Vikings, Normans and English. They were often inlaid with sumptuous strips of decoration and animal motifs, and were used even by the highest-ranking commanders, such as Count Guy de Ponthieu, who can be seen holding an axe in the Bayeux Tapestry.

During the Crusades, the sword was the chief weapon of the knights and their retinue. It was also a very important ceremonial object, as is shown by a number of richly decorated swords set with gold and precious stones. One eleventh-century example can be seen in the cathedral church at Essen.[5]

These show-pieces have simple iron blades, like the ordinary swords of the period, though their pommels, handles, hilts and scabbards are, of course, very different in design from ordinary weapons, and are set with a magnificent selection of gold and precious stones.

As we have already noted, Frankish craftsmen marked their work with their own names, which soon developed into a sort of trademark. Workshops dealing exclusively with cold steel weapons – which frequently meant swords – sprang up all over Europe in the Middle Ages. Certain centres became particularly famous, such as Passau, Toledo and Solingen as well as Brescia and Milan.[6]

Oriental weapons – weapons made in the Near East and India – had long been highly prized in Europe, and were correspondingly expensive. When Islam gained control of North Africa and Spain, Moorish smiths found it easier to import their wares into Europe, and they were soon providing keen competition for the local European workshops. There was a long-established tradition of weapon-forging in the Iberian peninsula. This region of the world had rich deposits of iron and had

117

been making iron swords and other items even before the invasion of the Goths and the Vandals, who had excellent sword-cutlers of their own.

In the ninth century Toledo was the chief centre for the production of Moorish blades,[7] with a particularly enthusiastic patron in Abd'er Rahaman II. While Islam was driven further and further back by the Christian leaders of the Iberian countries in the Middle Ages, many of the Moorish craftsmen went on working in their old workshops, thus keeping alive the ancient traditions. Swordsmiths were people of standing in those days, as borne out by the story of Reduan, employed by the last Moorish king in Granada, Boabdil (Mohamed XI). Reduan was converted to Christianity in 1495, when he probably changed his name to Julian del Rey; his godfather was none other than His Most Catholic Majesty, Ferdinand I.

Production was booming in Solingen in Frederick Barbarossa's time, although large numbers of swords were clearly being manufactured before then and exported to other countries, mainly to northern Europe. The goods were sent via the neighbouring town of Cologne, which is why, in the early medieval period, all the swords produced by the craftsmen of Solingen were known as Cologne swords. In common with nearly all the other trades in most of the towns in Europe, the Solingen guild arranged that the craft of making sword blades was subdivided into as many different categories as possible, in order to give as many master craftsmen as possible the opportunity of earning their living while at the same time achieving extremely high standards by hyper-specialization.[8]

This rigid sub-division of labour was not in force everywhere. Craftsmen often tried to save money and increase their profits by carrying out as many of the different processes as possible themselves on their own premises, which, naturally, led to frequent disputes and quarrels. For instance, sword-cutlers and the men who made hilts and pommels were strictly forbidden to have a forge in their workshops or to let their journeymen do any forging. This meant of course that they were compelled to give work to the smiths.

Like their colleagues in Passau, the swordsmiths of Solingen also marked their work. These marks soon became not only an indication of the provenance of any article, but also a symbol of superior workmanship, and marking soon became a formal privilege awarded as a token of rank. Medieval marks were recorded in special registers, just as registered trade-marks are today. First an application had to be nailed to the door of the official bureau; if no objections were raised, it would be announced in all the churches in the town and the surrounding district on three consecutive Sundays that a certain master proposed to

register a certain mark. Trade-marks could be sold, bequeathed to one's heirs, or pawned. One of the blade-making firms in Solingen still *Iron*
uses a trade-mark which was first registered in 1584 and changed hands
in 1774 for four *Krontaler*.

The history of sword design begins with the basically simple and
straightforward lines of Carolingian swords, develops into those used
by Crusaders and from then on into an ever-increasing variety of styles
and designs. Changes in style and fashion and a general tendency to
aspire to an ever greater degree of luxury and richness have all been
decisive factors in the evolution of the sword; on the other hand gradual
changes in methods of fighting have also had a great influence on
design.

The double-edged swords used in the period 1000–1200 vary enor-
mously in the design of their pommels, hilts and crossguards – these
variations do not appear to follow any rigid rules, and there are no
distinctive features characteristic of one specific period. Pommels are
classified as the mushroom design, the Brazil nut, the disc or wheel, the
fish-tail. In the early period cross-guards were usually straight or curving
very slightly downwards, but by about 1100 they tended to curve more
sharply into a crescent shape. The outer casing of the grip has survived
in only a very few cases, but presumably it was either wooden, cover-
ed with leather, or wound round with string.

Very broad straight horizontal cross-guards became noticeably more
popular at the time of the Crusades. According to one suggestion, the
idea was to make the swords look as much like a cross as possible. From
1100 onwards disc-shaped pommels were very popular, and a wide
range of variations on this basic theme were being made right down to the
fifteenth century.

The great majority of the swords which have survived from the
Romanesque and High Gothic periods are elegant and well-balanced
masterpieces, but very few of them are decorated.

One example of a decorated sword is that belonging to a Crusader,
which was discovered near Eura-Pappilanmäki in Finland. It dates
from the period between 1150 and 1250 and has a curving cross-guard
and a rich silver inlay decoration of rosettes and cross-motifs. But these
ornamental pieces are exceptions. Even the ceremonial sword of the
Holy Roman Empire, which Frederick II carried at his coronation in
Rome in 1220, is undecorated apart from a few simple strips of orna-
ment on the cross-guard and the hilt. On the other hand, the scabbard
is far richer in design and decorated with enamel; it was probably made
in Palermo in Sicily, where the craft of making weapons had been
influenced by Saracen art for many years.

Towards the beginning of the thirteenth century, the cross-guard

Metalwork began to have a short branch curling downwards against the blade, an indication that methods of sword-fighting had changed considerably. Instead of grasping the whole hilt with his hand, as before, the warrior now gripped the cross-guard with his index finger, so that it was protected by the branch; this meant that his grip on the sword was more flexible and he could aim more accurately so that he was not just restricted to a chopping stroke as before, but was able to fence with his opponent.

At about the same time – the first half of the fourteenth century – tucks first made their appearance; the idea was to find the chink in the enemy's armour – plate-armour was worn by now – and then stab him. Tucks had a raised spine down the centre of the blade to strengthen them and were tapered down to a sharp point, which had not always been the case with the swords used in earlier centuries. Their length varied from more than 40 inches to less than 30 inches.

Until the middle of the fourteenth century there were virtually no rules about sword-fencing and warriors were not particular about the methods they used, so long as they won. It was common practice, for instance, to grab the enemy's weapons with one's gauntlet or deal him blows with one's fists, or even to trample him underfoot. In 1389 Hans Lichtenauer undertook to compile the first manual of conduct in single combat, and in 1443 the first of the Thalhoffer books on fighting appeared; these were soon to enjoy widespread popularity.

At the beginning of the fourteenth century swords were sometimes longer, for the hilt was now so much larger that it was quite possible to wield it with both hands if necessary; the right hand was placed right round the hilt, while the left hand grabbed the pommel, so that a steadier blow could be aimed. This type of sword was known as a hand-and-a-half sword (German *Anderthalbhänder*, French *epée à main et demi*) or a bastard sword. Later, the hilt was lengthened even more, so that it was possible to get both one's hands right round it; this later development is known as a two-handed sword. There is documentary evidence that it was used during the Battle of Laupen in 1339 by the second line, who were close to the halberdiers, and that it played a most important part in the final outcome. The use of the two-hander in single combat is explained and described in detail in both of the two manuscripts, already mentioned. But towards the end of the Middle Ages powerful swords of this type seem to have been used merely for show; one example is an enormous two-hander in the Tower of London which is just over $7\frac{1}{2}$ feet long and was probably carried by the guard of Edward III. It was made in the fourteenth century and bears the mark of the episcopal workshop in Passau. This type of elongated and rather heavy sword is known as a 'bearing sword', an indication that it was

120

Iron: Arms and cutlery

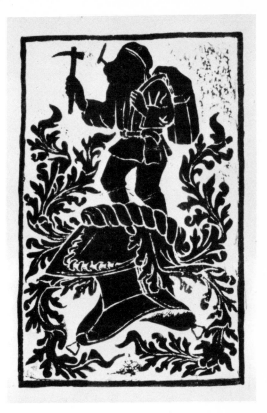

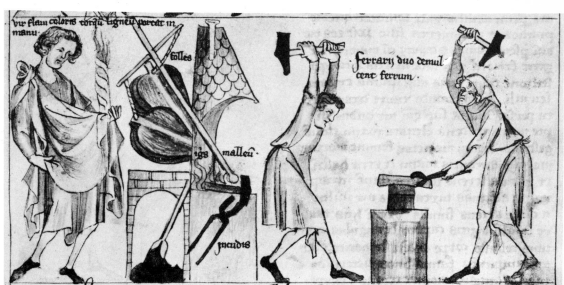

119 (*top*) Iron miner with his pick and hod, from the brass of Sir Christopher Baynham;
English, *c.* 1460.
120 (*bottom*) Blacksmiths at work in their forge, heating and hammering the iron;
Flemish, fourteenth century.

121 (*below*) The Winchester pommel, inlaid with silver and decorated niello; English, ninth or tenth century.

122 (*centre*) Hewing 'bastard' sword, with the inscription 'Ingelri'; German, *c.* 1000.
123 (*right*) Double-handed bearing sword of Edward III of England. This sword is more than 8 feet in length and was used solely for ceremonial purposes; English, mid-fourteenth century.

124 Detail from a Habsburg family tree, showing two monarchs fighting, using their swords as cut and thrust weapons; Austrian, sixteenth century.

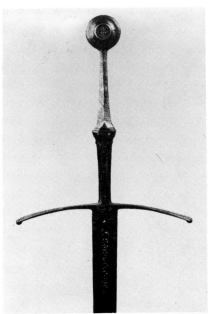

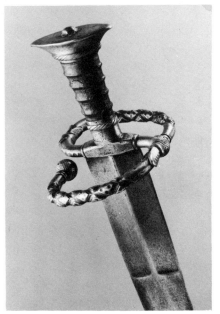

125 (*left*) Thrusting sword; Italian, *c.* 1500.

126 (*right*) Landsknecht's sword ('Katzbalger') with decorated iron guard; South German, early sixteenth century.

127 (*left*) Execution of St John the Baptist. The executioner uses a falchion, with an umbrella handle to protect the hand; Andrea Pisano, Florence, fifteenth century.
128 (*right*) Halberd, etched and gilt. This weapon was used by the Saxon Guard on ceremonial occasions; late sixteenth century.

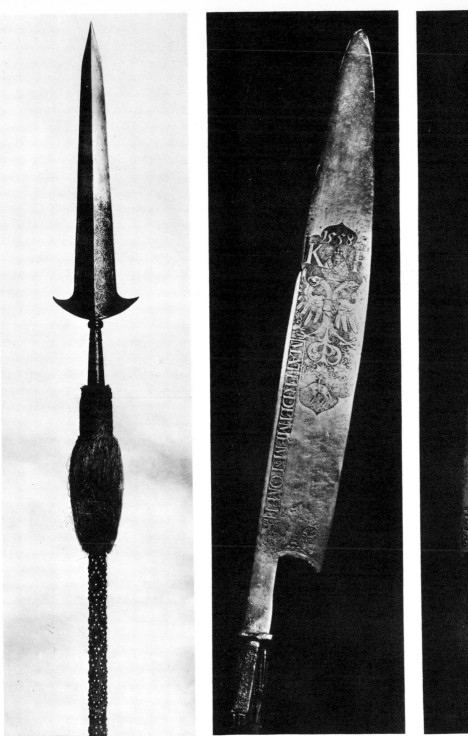
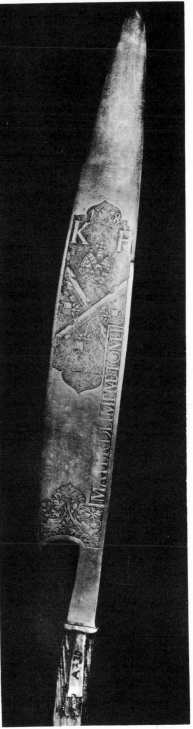

129 (*left*) Partisane with etched decoration. This was a parade weapon for ceremonial purposes; German or Swiss, sixteenth century.

130 a and b (*centre and right*) Etched glaive of Emperor Ferdinand I, 1558. This was a staff weapon for slashing and cutting; Austrian, 1558.

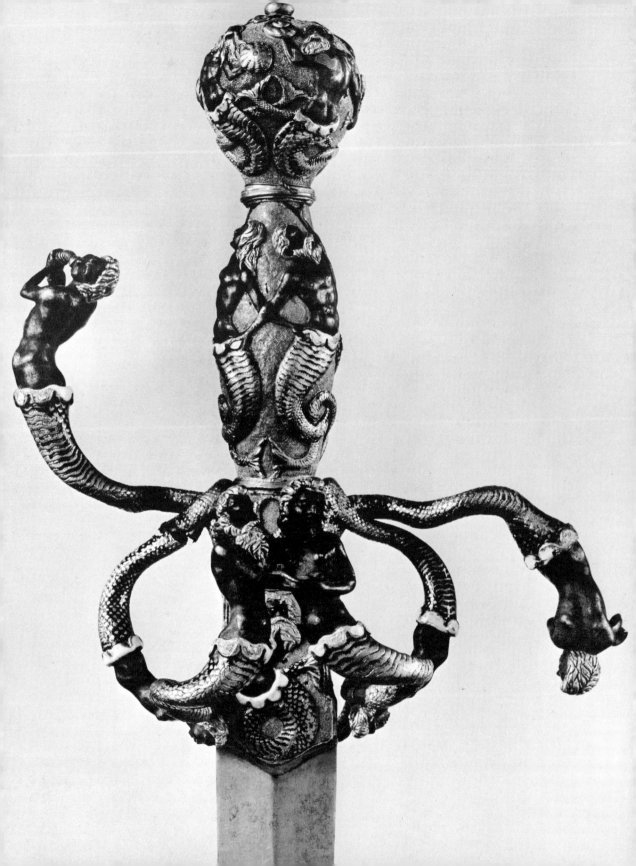

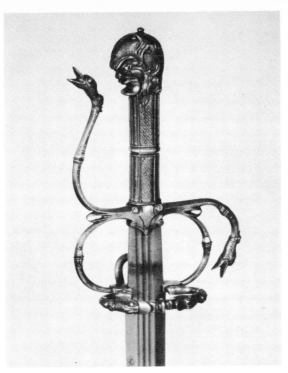

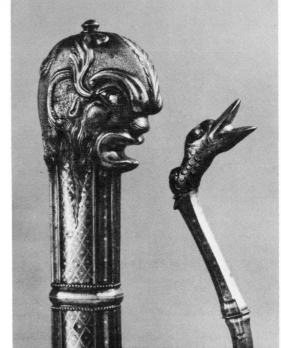

132 (*top left*) Sword of chiselled steel; Italian, early seventeenth century.

133 (*top right*) Detail of 132 with decoration of counterfeit damascening in gold and silver.

134 (*right*) Chiselled hilt in 'blued' steel with figure of Hercules; possibly of French workmanship, *c.* 1670.

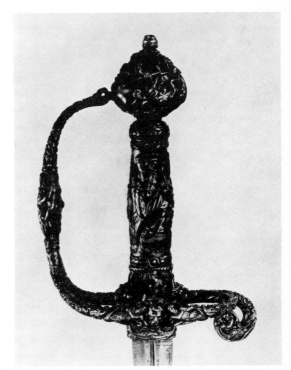

131 (*opposite*) Wrought-steel sword hilt, silvered and gilded; Italian, *c.* 1560.

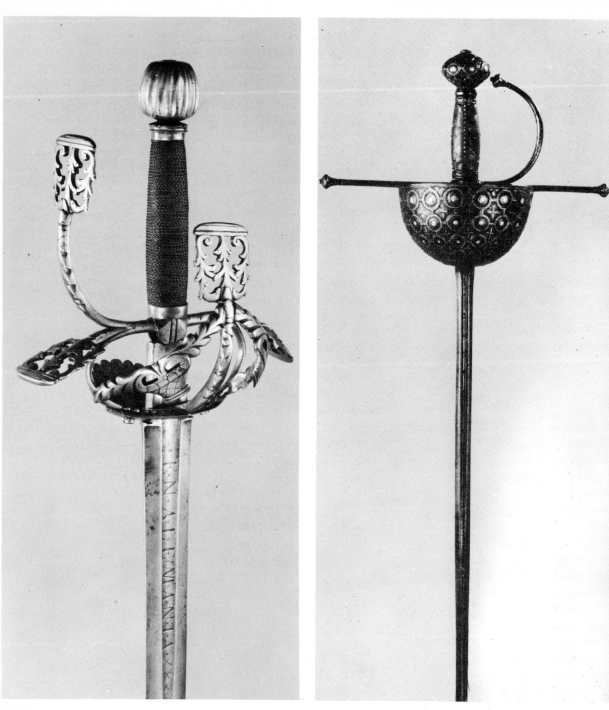

135 (*left*) Horseman's sword with hilt of chiselled steel bound with copper wire; made in Spain by a Solingen swordsmith, early seventeenth century.

136 (*right*) Duelling rapier. The hilt, with typical bell-shaped guard, is of iron with silver inlay; made in Toledo by Juanes Muledo, *c*. 1640–50.

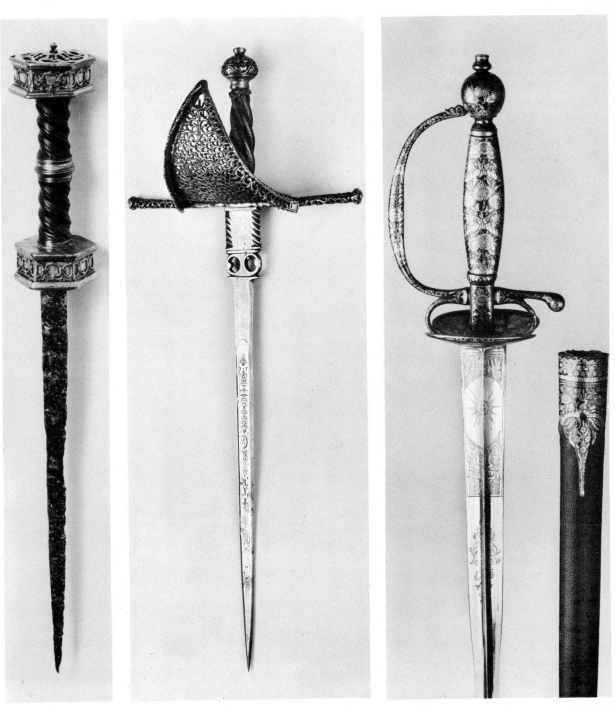

137 (*left*) Dagger with wooden hilt decorated with iron *à jour* ornament in Gothic style; Burgundy, *c.* 1400.

138 (*centre*) Left-hand dagger for duelling, with iron *à jour* hilt; Spain, *c.* 1650.

139 (*right*) Dress sword of fine proportions, made of 'blued' steel with gilt decoration; Russia, *c.* 1750–75.

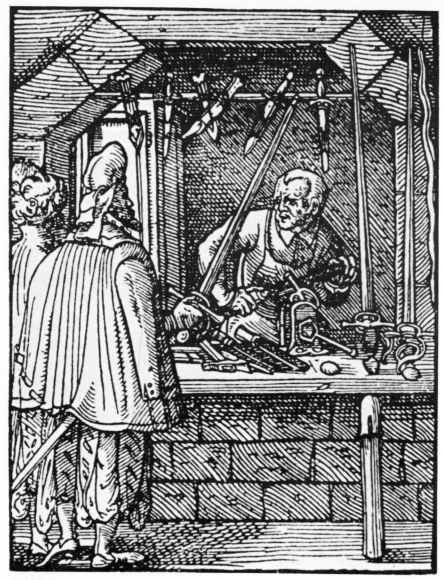

140 The swordsmith and cutler in his workshop, surrounded by daggers, swords and other weapons; woodcut, Frankfurt, 1568.

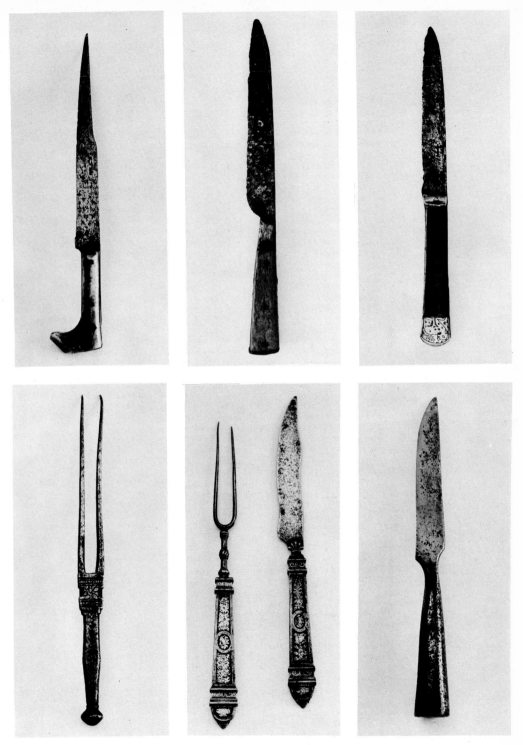

141-3 (*top*) Iron kitchen knives, one with decorated handle; fifteenth century.

144 (*bottom left*) Iron fork for carving or serving; French, sixteenth century.

145 (*bottom centre*) Knife and fork of iron with silver and gold decoration. The fork was used to hold the meat as it was cut; Augsburg, later sixteenth century.

146 (*bottom right*) Iron kitchen knife; seventeenth century.

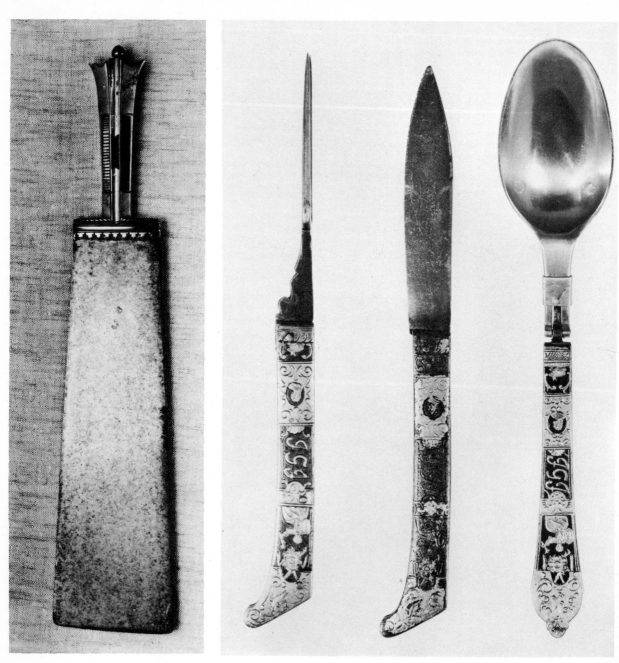

147 (*left*) Broad-bladed knife for serving; the handle is of bronze with wood and ivory inlay; German, early sixteenth century.

148 (*right*) Fork, knife and spoon hinged for folding when travelling. The handles are of 'browned' iron with gold and silver decoration; probably Solingen, *c.* 1700.

never meant to be anything but a show-piece.[9] The idea of show *Iron*
weapons was developed even further in the Renaissance, as we shall see.

In the fifteenth century there was a marked preference for more
elaborate swords. It is true, of course, that only princes could afford
the luxury of having their swords decorated with engraving and chisel-
ling and with enamelling and gilding on the cross-guard, hilt and
pommel; the ordinary knights had to be content with swords whose
sole beauty lay in their design and proportions. However, the arrival
of the late-Gothic style brought about more decorative swords for all
ranks.

The collection of weapons in the Doge's Palace in Venice includes
hundreds of swords used by the Slavonic and Dalmatian Guards (*gli
schiavoni*) in about 1500. The cross-guard here is basically horizontal, but
is bent into an 'S'. One weapon which was intended solely for fighting
is the so-called '*Schweizer Degen*', a sword with the pommel and hilt-guard
curling to meet each other. Another model is the so called '*Katzbalger*' the
standard broad-sword of the landsknechts in late fifteenth- and six-
teenth-century Europe; the cross-bar is again curved into an S-shape or
sometimes into a figure of eight, but the hilt and the pommel are designed
more as a single unit than before, while the blade is comparatively short.
Nevertheless, it would be wrong to think that these models were kept
exclusively for the ordinary troops, since the *Katzbalger* was occasion-
ally magnificently decorated. An example of this model was owned by
Ulrik von Schellenberg in about 1515, in which the individual sections
of the iron hilt are richly decorated and gilded.

Before we come to the final phase in the evolution of sword design,
we must briefly consider daggers.

Daggers
The sword had always been the weapon of the highest social class in
the medieval hierarchy. In Germany, traditionally, no one but a free man
was entitled to wear a sword, and equally, only knights were permitted to
engage in warfare and duels. This arrangement was part of the natural
order and could not be challenged because it was ordained by God
Himself, so that it would never have occurred to a town-dweller or
farmer to buy himself a sword. In fact ordinary people went about
quite unarmed until the social unrest of the late Gothic period forced
them to defend their communities against attack from wandering
knights, most of whom were fully armed. But even in such circumstances
they would use something more effective for their purpose than
a sword. They would therefore use a dagger or knife, in fact it is not
always easy to distinguish between the two. Even in the Middle
Ages there was no clear distinction between them, so that it is best to

121

Metalwork follow the normal practice of experts in this field and use the term dagger for a short weapon worn at the side of the body, with a symmetrical hilt ending in a pommel, and a blade which may have either a single cutting-edge, or two edges, or even several cutting-edges. The term knife is used for blades surmounted by an asymmetrical hilt which can be used as tools, household equipment or weapons. When used as weapons, they were treated as status symbols by bourgeois society in the fifteenth and sixteenth centuries.

The dagger was a fairly common weapon in the Iron Age and in the ancient world, but in the following centuries it sank into oblivion. At the end of the thirteenth century it reappeared with variations in the design of the hilt and blade, and experts distinguish between rondel daggers, ring daggers, cross-guard daggers, which are a type of miniature sword, misericords, used for boring through plate-armour, ear-daggers, kidney daggers and many others.

Daggers were also carried by knights, and the more elaborate models were undoubtedly used by senior officers and commanders both for show and for fighting. Thalhoffer's fighting manuals, compiled between 1430 and 1460, illustrate dagger fights, although, as with sword fights, the rules do not seem to have been properly formulated at this time, so that contestants merely tried to grab each other's arms, knock their opponent's weapon out of his hands and try to get the upper hand by fair means or foul. The contestants here did not wear plate-armour for dagger fights but were dressed in fashionable doublets or leather capes, with no distinguishing marks at all, which suggests that they belonged to a knight's retinue. In the later Middle Ages ordinary citizens carried daggers decorated with magnificent mounts and fittings. Moreover, rules and regulations as to who should be allowed to carry which type of dagger became absolutely necessary. In 1376, the citizens of Riga were told that 'all those who work for their living are forbidden to carry knives' and this decree was repeated many times. In Wismar, from 1419 to 1430, only those who had inherited property in the town were allowed to wear knives, while in about 1400, the goldsmiths' apprentices in Lüneberg were expressly forbidden to sleep away from home, to play at dice, or to carry long knives.

Since daggers and knives looked so alike, it was obviously difficult for the authorities to prevent simple, non-privileged people like farmers and carters from carrying weapons which could be used in self-defence, and it was no easy matter to forbid the use and carrying of knives altogether. In southern Germany and Switzerland at the end of the fifteenth century and during the sixteenth century, it was common practice for people to keep a weapon in the house for defence purposes, usually a

122

broad knife with a horn or wooden handle. In the sixteenth century it *Iron*
was apparently quite normal for knives to be carried even by country
people, as we can see, for example, in Dürer's drawings.

Pikes and halberds
In the Romanesque and early Gothic periods, staff weapons – lances
and spears – fell into second place behind the knight's sword, and did
not begin to regain their earlier importance until the thirteenth cen-
tury. Eventually they were to revolutionize methods of warfare by gain-
ing complete ascendancy over the knight's typical weapons, thus in the
long run contributing to the downfall of feudalism.

Pikes were being used in Venice at the beginning of the thirteenth
century and are generally considered to be an Italian invention. In 1327,
the city militia in Turin was commanded to carry pikes 18 feet long.
The use of the pike spread from Italy to Switzerland and thence over
the whole of Central Europe. The staff was made of ashwood and was
usually between 5 feet 9 inches and 17 feet 9 inches long, while the
length of the point varied according to the design and the period of
manufacture. Both the spear and the halberd which will be discussed
later, and all other types of weapon consisting basically of a staff, were
used by troops in formation and not as individual duelling weapons. A
whole body of troops could place their pikes close together to form a
defensive barrier, or alternatively they could advance to attack the
enemy as one closely-knit phalanx.

In the fifteenth century the Swiss armies were mainly equipped with
pikes, and an inventory drawn up in the arsenal in Vienna records,
that 322 *Ahlspiesse* were supplied to the local militia between 1497 and
1500. There are extremely few fifteenth-century pikes which definitely
belong to noblemen, either because of their very elaborate design or
because they bear some inscription. The few which have survived were
probably used as hunting spears, whereas pikes were normally used
solely for military purposes, even those of special design. The sword
was still considered the only weapon fitting for a knight.

A new type of weapon in this same group made its appearance in the
last two decades of the thirteenth century — the halberd. Its name is
derived from the Teutonic word *Helmbart*, which is made up of *Helm*,
meaning in this case stick or staff, and *barta*, which is roughly equivalent
to 'axe'. It originally consisted of an axe blade with a spike on the front,
which could be either long or short; it was socketed and was fixed to
a shaft. The design later changed and in the fifteenth century a hook
was added.

Halberds played a crucial part in the Battle of Morgarten in 1315,
when the Swiss civic army, armed with halberds, attacked the cavalry

123

Metalwork troops of the Austrian duke Leopold I, knocking the knights off their horses and hacking them to pieces, thus completely upsetting the battle-array of the feudal army. The knights had been expecting a series of single combats, but these never even materialized and the throngs of ordinary people with their essentially proletarian cut-and-thrust weapons won the day. Their victory symbolizes the dissolution of the age of chivalry and the beginning of a less aristocratic era.[10]

A whole new range of staff-type weapons appeared in the fifteenth century, all of which were especially designed for fighting and were handled by ordinary soldiers.[11] The only ones still used as weapons in the sixteenth and seventeenth centuries were pikes and lances, while the others became progressively more elaborate in design, and were used exclusively as show weapons carried by gentlemen-at-arms, or for hunting. This is particularly true of the halberd, whose distinctive outline with point, axe, and hook, offered Renaissance artists all sorts of possibilities for modifying and developing the design. Since it was now used purely for display purposes, aesthetic considerations could ride rough-shod over the problem of its effectiveness as a weapon, and it would often be lavishly decorated with etched motifs, generally consisting of coats-of-arms, interlaced foliage, dates and initials. These instruments remained in fashion until well into the eighteenth century and, in fact, are still used by the Swiss Guards at the Vatican.

Decorated swords

The coming of the Renaissance brought about not only a complete transformation of the social order, but also of the function and design of armour and weapons. The invention of gunpowder made many weapons obsolete. Its main victim was the sword, which did not completely disappear, but underwent an enormous number of modifications and changes in design. Its nominal survival was due more to certain social factors than to practical considerations.

The landsknechts of the early sixteenth century were armed with short swords, pikes and various other types of weapons. Special squads earning higher pay than the average soldier were equipped with powerful two-handed swords. To begin with, these forces were certainly used in open battle and for storming fortresses, but their main function was to protect the commander and his standard. From the second half of the sixteenth century onwards, however, they tended to be used primarily for display and on parade. A book on warfare by Leonard Fronoperger (1573) includes a woodcut depicting landsknechts, following the colours and shouldering two-handed swords. On the tombstone of the Swedish admiral Nils Karlsson Gyllenstierna, who died in 1584, there is a portrait of the dead man in full late Renaissance armour with a two-hander

124

at his belt. In fact, the sword is so long and unwieldy that it seems highly unlikely that he would have been able even to draw it, let alone fight with it. It is clearly meant solely as a symbol of his rank as knight, as are the gauntlets which are so decoratively arranged in the background, and the helmet and coat-of-arms.

Two-handers were embellished with bent and curving decorative hilt-guards with hooks, richly contoured handles and various ornamental motifs, mostly on the hilt-guard. Finally, a fashion grew up for using flaming swords or 'brands', which were sometimes as long as $6\frac{1}{2}$ feet from pommel to tip. Two-handers made in Scotland, which were called claymores, were simple and elegant in design, and rather reminiscent of Gothic weapons.

A remarkable number of extremely elaborate swords were made in the sixteenth century; they mark the beginning of a cult of personal glorification by many of the ambitious princes of this period, while at the same time representing a turning-point in the history of the sword. Up to the sixteenth century the most important elements of the sword had been the quality of the iron or steel used for the blade, together with its effectiveness as a weapon, its suppleness in handling, its durability and general proficiency, but from then on the emphasis was on its beauty and splendid decoration. This change came at the very time when doubts were being cast on the inherent usefulness of the sword as a weapon, and indeed on knightly warfare in general. So decorative weapons began to gain ascendancy, and remained supreme for the next two hundred years.

But from now on the brilliant and splendid swords so beloved of rich lords were not necessarily made of iron: goldsmiths and silversmiths also began to participate in their manufacture. Silver, gold, enamel and precious stones were all used to decorate swords, although swordcutlers do not seem to have been overjoyed at the idea of collaborating with their colleagues in the precious metal trades. This reluctance drove them to evolve their own types of decoration, which could be just as beautiful and subtle as work in precious metal, but did not force them to abandon their traditional iron. The techniques they used were chiselling, etching and inlaying.

One of the earliest show-pieces was a sword made towards the end of the fifteenth century for Duke Christoph of Bavaria, who was nicknamed 'Christopher the Strong'. The handle is worked in silver set with moulded figures, little pillars, recesses, stones and rods, while the crossguard is covered with interlaced foliage, and the pommel and centre of the guard are decorated with enamelled coats-of-arms. This is one of the most magnificent swords of this period, but it was scarcely suitable for use on the battlefield, because the uneven surface of the

Metalwork hilt made it difficult to grip. It seems almost certain that the duke used it solely for display.

The German Emperor Maximilian I, who has been called a 'romantic on the throne of the Caesars', was responsible to a large extent for the change of attitude and the new passion for very elaborate swords. Part of him longed for a return to the medieval past with its knights and chivalry, and he wanted to rescue the ideals of the good old days, which represented for him all that was good in the world.

On the other hand he was thoroughly open to new ideas and determined to introduce a number of innovations into military affairs, even if they were contrary to his ideal world of chivalry and threatened its very foundations. The magnificence of the emperor's weapons, especially his armour, naturally set a precedent for all the potentates of Europe, great and small, who were all connected in one way or another with the imperial court. As a result, the smith's craft enjoyed a period of great prosperity, and they began to produce works of art which are comparable with the finest work of contemporary goldsmiths, woodcarvers or painters. Both their actual work and the documentary evidence available show that sixteenth-century sword-cutlers enjoyed a position in society comparable to that of artists. Moreover, the greatest artists of the age, such as Albrecht Dürer, Hans Holbein the Younger, Heinrich Aldegrever, Hans Burgkmair, Pierre Woeriot, were not too proud to design decorations for swords, hilts, daggers, scabbards, helmets, armour, etc.

The craftsmen who decorated iron were held in the highest repute: they actually belonged to the guild of smiths and were of equal rank to the knife-makers, whose job was to produce simple, but richly worked weapons. If a particularly gifted iron-carver succeeded in obtaining the position of court-supplier, he was sure of a brilliant career; he would ask to be released from the guild and would be appointed a free craftsman under protection of the court, which entitled him to certain privileges, though these were often partly cancelled out by the obligations he was called upon to fulfil in return.

A study of clocks, locks and keys made in the Gothic period will show that iron-carving was common practice at that time. The same treatment was applied to weapons, and swords in particular, from the middle of the sixteenth century onwards in places such as Milan, Augsburg and Nuremberg. One of the most famous iron-carvers in the second half of the sixteenth century was a man called Ottmar Wetter, who worked in Munich and Dresden; others were Emanuel Sadler, Daniel Sadler and Caspar Spät, all of whom worked for the court at Munich. Contemporary accounts and records illustrate the elevated status enjoyed by iron-carvers such as Emanuel Sadler, who is sometimes described as an iron-worker and sometimes simply as an artist.[12] Sadler was even a

126

member of the royal household for a time, which entitled him to eat at the 'officers' table'; 'officer' was really the equivalent of 'official'. When funds at court ran low a large number of men were dismissed, but Sadler was one of the few who were kept on.

By the end of the sixteenth century, the traditional cruciform design, which consisted of pommel/hilt/hilt-guard/blade, had been superseded by the rapier, which was lighter, shorter and more graceful than the ordinary sword. Its design was closely bound up with the development of the art of fencing, which began in the fifteenth century and was particularly popular in the sixteenth and seventeenth centuries. The rapier was intended for cut-and-thrust fighting, but this no longer meant a series of haphazard blows, since weapons were now handled with great elegance and skilful feints would be made. The old-style cross-guard no longer provided adequate protection for the hands, so they were covered up as far as possible with a new type of hilt which protected them from their opponent's strokes. This new development offered the craftsman a wide range of opportunities for displaying his artistry, since the rapier's hilt was made up of a series of separate parts: Back-quillons, side-rings, knuckle-bows, hilt-arms and diagonal counter-guards.

The art of fencing soon became tremendously popular, eventually leading to the duels which were such a characteristic of life in the sixteenth and seventeenth centuries. However, they soon degenerated into a mere sport. Duelling reached the most bizarre proportions in France during the reigns of Louis XII and Henry III and a contemporary historian states that 8,000 French noblemen were killed in duels over a period of only twenty years. In 1626 duelling was prohibited on pain of severe penalties, and in the following year a pair of duellists were actually beheaded. Duelling was also very fashionable in seventeenth-century Germany, remaining popular with students and officers until the beginning of the twentieth century. The craze never really caught on in England; it started during the reign of James I and immediately came up against strong official opposition, though this was not always successful in suppressing duels altogether.

Rapiers were often simply worn as ornaments by fashionable courtiers at that period. The terms 'town sword' and 'court sword' and the French *epée de ville* all show that this type of rapier was confined to the upper classes. Even those carried by officers were not really thought of as effective military equipment and were far less important from this point of view than the staff-type weapons and firearms used by ordinary soldiers.

In the seventeenth and eighteenth centuries, the design and style of small-swords and rapiers vary considerably and the extremely wide

Metalwork range of decorative motifs and methods of ornamentation is astonishing. The majority of the weapons which have survived from this period are richly decorated, though large numbers of simple rapiers of the kind used by warriors and landsknechts in the Baroque period have also been preserved. This means that the rapier was both a military weapon and a status symbol. Although its importance as a weapon was almost non-existent in the eighteenth century, it was given to government officials at court and to scholars who must scarcely ever have felt the urge to use it. Moreover, the delicate elegance of this type of court-rapier was not exactly an encouragement to its owner to get himself involved in a fight. But its unsuitability as a genuine weapon did not deter craftsmen from decorating it, rather the reverse, for they often lavished great skill and artistry on their rapiers, incising and gilding them, tempering them, setting them with precious stones, inlaying them with gold and silver or etching the blade.

Sabres and falchions

In addition to swords and rapiers, there was one other type of weapon which had been in constant use since the Middle Ages: the sabre, a cut-and-thrust weapon with a long curving blade, a hilt which was generally incorporated in the actual weapon and had no pommel, and a cross-guard. This type of weapon originated in the East and has always been very popular among those Eastern races who spend much of their time on horseback. Sabres were never really popular in the West as a standard weapon, although at certain times and in certain places great store was set by them; a large part of their attraction was due to their strangeness and outlandishness. The earliest and most magnificent sabre to have survived is the one known as 'Charlemagne's sabre' or 'Atilla's sword' in the Treasury (Weltliche Schatzkammer) in Vienna. Legend has it that the Emperor Otto found this weapon when Charlemagne's tomb was opened in Aachen, and it once belonged to the crown insignia and crown jewels of the Holy Roman Empire. Various theories have been put forward as to where it was made, some experts saying that it is Tartar work and was made in Turkey, others that it comes from central Asia, and yet others that it is of Russian origin.

The sabre was not adopted by the peoples of Central Europe, but a weapon which looks like a cross between a sabre and sword does occasionally appear on miniatures executed in the thirteenth and fourteenth centuries; this design is known as a falchion and has a curving blade with a single cutting-edge, but a straight hilt with a pommel, just like that of a sword. In the fourteenth and fifteenth centuries the falchion was particularly popular with Italian artists when they wanted to

128

Iron: Firearms and armour

149 Detail from an embossed steel shield with gold and silver counterfeit damascening. This detail shows prisoners in antique armour, an ornamental trophy with cuirasse, pike and spear and other weapons; Antwerp, 1560.

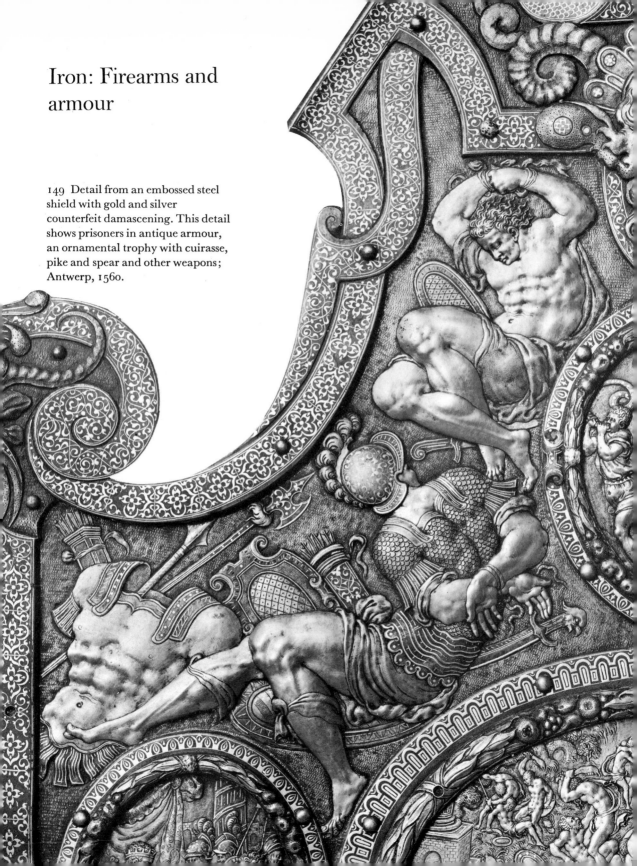

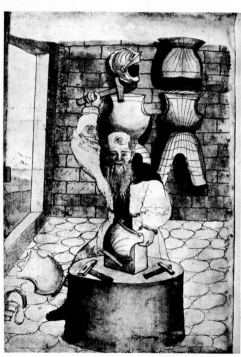

150 a and b (*left*) Craftsmen making armour; Nuremberg manuscript, sixteenth century.
151 (*right*) Rubbing from the engraved brass of Sir John D'Aubernoun, showing a
knight in mail, with plate poleyns, holding a lance with pennon; English, 1327.
152 (*opposite*) The figure of Sabothai in full plate armour in German style. His
companion is wearing mail but no cuirasse; painting by Konrad Witz, *c*. 1435.

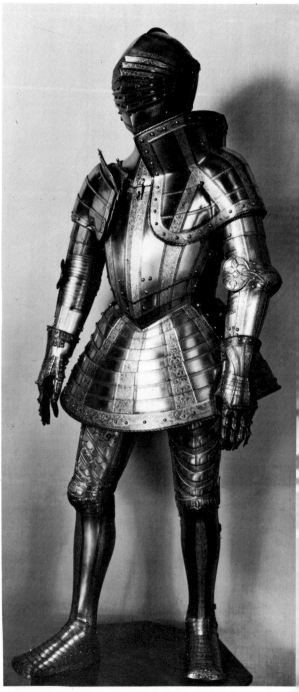

153 (*left*) The cavalry field armour traditionally of Sigmund of Tyrol; Lorenz Helmschmidt of Augsburg, 1470.

154 (*right*) Foot combat armour from the garniture made for Emperor Ferdinand II; Matthias Frauenpreiss of Augsburg, *c.* 1550.

155 (*opposite*) Stefano Colonna in light field armour; painting by Bronzino, 1546.

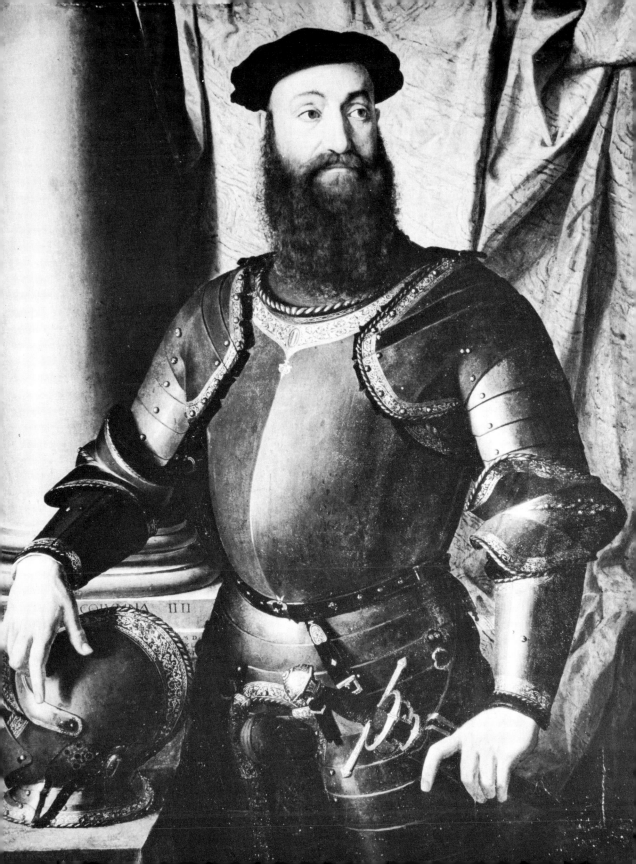

156 Cannons and gun stones in a painting from Chronique d'Angleterre, *c.* 1480.

157 'Mons Meg', the famous bombard, now in Edinburgh Castle. Made of wrought iron in the Low Countries in 1449.

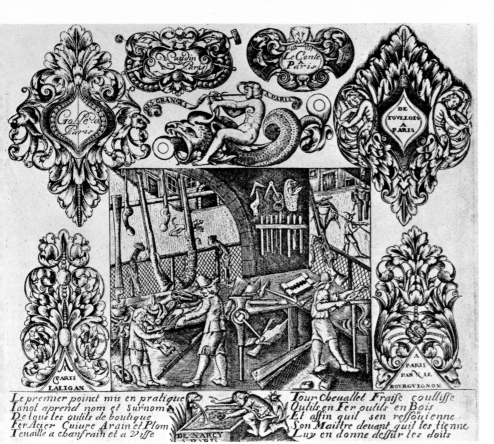

158 The gunsmith in his workshop, surrounded by marks and designs of various gunmakers of Paris; Engraving, French, late seventeenth century.

159 Various types of gun locks, decorated with engraving, chiselling and inlay; (*top left*) Dutch flintlock, eighteenth century; (*right top and bottom*) Spanish locks; (*bottom left*) A wheel-lock from a pistol, sixteenth century.

160 The prophecy of Isaiah–'They shall beat their swords into ploughshares and their spears into pruning-hooks' (Isaiah II. 4) as envisaged by Jan Breughel the Elder, c. 1600. He shows every type of metalwork, including weapons, armour and utensils.

portray warriors; it was also used by artists as the model for executioner's weapons, one example being Andrea Pisano's scene of the execution of John the Baptist on the bronze doors of the Baptistery in Florence; this dates from 1336.[13] *Iron*

But although it was so popular with painters and sculptors, very few actual examples of the falchion have survived; it was perhaps used more for decoration than for fighting.

The same is true of the sabre in the sixteenth century and after, since by then it was mostly made for royal collectors and was accordingly lavish. On the other hand, officers would wield what are known as *Schweizsäbel* (Swiss sabre) in the fifteenth and sixteenth centuries. In about 1600 King Christian IV of Denmark bought a large number of sabres with basket hilts – which completely covered the hand – to be used by the peasants of Norway. This type of weapon is very simple, sometimes primitive in design.

Peasant weapons

Most books on arms and armour have a chapter on 'peasant weapons' right at the end, treating them as a sort of curiosity rather than as real weapons. In fact very few have survived at all; they were generally made hastily when they were suddenly needed, and consequently tend to be very primitive. This lack of aesthetic merit explains why they were so often rejected as not worth preserving. Since they were generally made when a crisis arose, rather than being carefully designed beforehand, weapons of this type did not develop along individual lines. Moreover, they were generally made by amateurs rather than professionals, perhaps by the peasants themselves, or by the village blacksmith. The most common type is the club, which consists in its simplest form of a plain cudgel set with nails or spikes. It has been known as a military weapon – even used on occasions by knights – ever since its first pictorial appearance in the Bayeux Tapestry. From the fourteenth century onwards the head of the club was made of iron or bronze but later it was transformed into the knight's mace, which was made completely of iron and was set with ornamentally designed flanges or blades.

'Peasants' weapons' also include the flail, which is a club with a chain fastened to the end of it; at the end of the chain there are prickly round weights or a piece of wood set with spikes. Finally there are battle-scythes and simple pieces of wood studded with spikes and hooks.

Cutlery

Another category of iron and steel utensils comprises the cutlery used for ordinary meals, together with that designed especially for

129

banquets and other festive occasions. Iron was the first material to be used for making knives and forks, and over the centuries, it has continued to be the most popular, although it has often been combined with other metals. Later, in the seventeenth century, when silver became cheaper and supplies from the Spanish colonies began to flood the markets of Europe, solid silver forks were made. This did not affect knife blades, however, since they needed to be made of some material which could be sharpened, a prerequisite which remained valid until the beginning of the twentieth century. Spoons have always been in a separate category and have only very rarely been made of iron. Originally they were made of wood, but later were often made of pewter and silver, and less frequently of brass or bronze.[14]

The most important implement needed to divide up food into pieces of a suitable size for eating was some sort of knife, and even Stone Age Man knew how to make flint blades for chopping up the meat of the animals he had killed. When metals were discovered, knife-blades were first made of bronze, and later of iron. The common people, however, did not use knives at table. The normal custom was to pick up the roast meat in one's fingers and gnaw it, and this custom applied to rich families as well as poor until well into the Middle Ages. But a study of paintings and drawing of grand banquets held in the early Gothic period reveals that a few knives were being used at table at that time. If we count them up and compare them with the number of guests, however, it is clear that several guests were required to share one knife between them. On the other hand, guests would often bring their own knives with them, usually carried in their belt, in the same scabbard as their dagger. A great deal of painstaking work was lavished on the handles, which might be plain wooden, or, alternatively, made of silver, horn, bone, mother-of-pearl, ivory, rock-crystal, brass, fish-skin, leather, enamel, gold, or other materials. This provided an excellent opportunity for the owner to display his wealth and his taste for ostentation, since the degree of elaboration of his knife handle was an indication of his social status. The simpler types of knife-handle were made by a special group of craftsmen known as blade-mounters, who were frequently involved in quarrels with their rivals, the sword-cutlers. However, we are dealing here with only the iron part of the knife and with the way in which cutlery was used.

At the end of the Middle Ages, knives were straight-backed and had a cutting-edge which curved down to a point. The section where it joined the handle was often shaped or contoured in some way, particularly in the later period, and the whole knife was approximately the same size as the knives we use today. The normal practice was first to cut the meat into manageable pieces, spear a piece with the tip of

the knife and put it straight into the mouth. Books of etiquette compiled *Iron* in the Gothic period instruct the reader on the most elegant ways of handling the knife, such as 'Dip not thy meat in the salt-cellar, but take it with thy knife', or 'Pick not thy teeth with the knife nor with thy finger-ends'.

At grand banquets the meat would be served up as whole joints, carved by a professional carver, employed solely for this purpose, and then handed round to each guest. The Italians in particular made a great ceremony of carving, and they even had special schools where carving was taught. A number of manuals give very detailed advice on carving from which we learn that several different knives of varying shapes and sizes were required, as well as large forks. The handles were naturally very elaborate, since the ceremonial aspect was so important. Carving-knives always have very broad blades, with the point curving towards the cutting-edge, or alternatively towards the blunt side. Special serving-knives were used for offering meat to guests. They had broad blunt blades rounded off at the end and were often embellished with gilding and etched decoration. For instance, two serving-knives which belonged to the Emperor Charles v are decorated with the imperial coat-of-arms, surrounded by various ornamental motifs, figures drawn from mythology, and inscriptions.

Various contemporary paintings and engravings depict carvers kneeling before their royal masters, showing how lavish the whole ceremony of carving and serving used to be. Court carvers who carried out their difficult task in a particularly elegant fashion are often mentioned by name with the greatest respect in contemporary documents.

In the sixteenth century this type of ceremony spread to the households of rich merchants and craftsmen. They were now in a position to eat and drink on as lavish a scale as in royal households and, therefore, also wished to adopt the appropriate aristocratic table-manners. Meanwhile ordinary country-people continued to eat in the traditional manner from a communal bowl of wood or earthenware each using a small knife. In fact this was still the custom in country districts until quite recently.

Ordinary eating forks, unlike carving-forks, were very rarely used until the sixteenth century and were at first only adopted by fashionable ladies for eating sticky sweetmeats and fruit. They were slow to become popular and according to legend, were not widely used until the large millstone collars of the Baroque period came into fashion, which made it necessary to have some kind of implement for conveying food to one's mouth. A German traveller, writing as late as 1705, reported that he had not come across anyone using a fork at

131

Metalwork table, either in England or in Italy. In fact forks were widely used in the first half of the eighteenth century, often forming part of a set of cutlery, together with a knife, spoon and dessert spoon. Silver became the most popular material for making cutlery at about this time and, eventually, only knife-blades were made of iron or steel, while silver or some other precious material was used for handles and fork prongs.

3 Armour and firearms

Armour

Quite apart from playing an important part in the manufacture of weapons, iron and steel were also used for the armour worn by knights to protect them from their adversaries' blows. Even in the ancient world, warriors were already wearing wrought-iron helmets, as well as breast-plates and leg-guards, or greaves. During the period of mass migrations, however, the Teutons relied mainly on shields to protect their bodies and set little store by armour-plating. But later, the various western peoples began to feel the need to cover themselves with some kind of protective armour. Their ideal protection, as described in the Saga of Horny Siegfried, was totally impenetrable wrought-iron armour, enveloping them from head to foot, but this was purely theoretical and protection was on a far more modest scale. At first quilted and padded coats reinforced with horn plates or iron rings were used. Eventually the rings were riveted together and made to interlock, thus creating mail, which was to remain the most effective form of protection in battle for several centuries. But coats of mail were very expensive to produce and only the richest knights could afford them; the Ripuarian Franks, for instance, valued a shirt of mail at 12 *soldi*, which was the equivalent of the price of four cows and represented a very large sum in those days.

The use of armour became increasingly widespread during the Crusading period in the twelfth and thirteenth centuries as western knights taking part in Crusades in the Holy Land came into contact with the Islamic peoples of the Near East, who had perfected the art of producing mail.

A number of miniatures and paintings depicting European knights wearing coats of mail and dating back to the fourteenth century or

Metalwork later have survived. The mail often envelops them from the shoulders downwards, while their heads are protected by helmets, but this type of total armour was confined to the richer knights and the minor landed gentry had to make do with only partial protection, perhaps just a coat-of-mail, neck-piece and mittens or mufflers, or even less. Probably the mercenaries in full armour who are sometimes portrayed in paintings of the period were in the service of some rich lord, who provided them with this protection.

The effectiveness of mail was jeopardized by the arrival of the cross-bow, which had enough impact to smash right through it. In spite of the opposition of so august a figure as the Pope, this weapon continued to be made and improved. It proved to be a highly dangerous instrument and attempts were made to counter it by reinforcing the coat of armour with iron plates, until eventually full-scale plate-armour was developed. This consisted of a large number of pieces of iron carefully made to fit the body, and designed with adjustable rivets and bolts to give the wearer as much freedom of movement as possible, while at the same time giving him full protection. It was essential that these metal plates should be able to withstand the shock of a crossbow bolt, and many examples were tested with a trial shot before being accepted by the client.

In the late-Gothic period, armour reached the height of perfection, both in the elegance and beauty of its design and in its technical development. Its stylized lines were in keeping with the fashions of the period and with the style of contemporary pictorial art and statuary. However, armour-plate was even more expensive than mail and its use was therefore restricted to a very limited group of knights.

These two factors – the fashionable and exclusive aspects of armour – explain why, during the fifteenth and sixteenth centuries, armour was made with the greatest possible artistry and looked really magnificent.

The craft of making plate-armour flourished in a large number of towns in Central Europe, though towards the end of the fifteenth century and in the sixteenth, the finest and most magnificent suits of armour came first of all from Milan and later from Innsbruck, Nuremberg and Augsburg. The craftsmen working in these centres accepted commissions from the most distinguished men of the age, and their social status was correspondingly high; their important patrons knew them by name, so that their fame was handed down to posterity. In fact early documents and records tell us more about them than about contemporary painters or sculptors.

The families of armourers were very conscious of their superior social status and would intermarry within the profession, so that the skills and tricks of the trade were handed down from one generation to another,

134

creating virtual dynasties. The most important armour-making families *Iron* in Germany were the Treytz and the Seusenhofers, the Colmans, Pfeffenhausers and Frauenpreiss, the Lochners, Speyers, Rockenbergers and Halders. As well as receiving commissions from the German princes of the sixteenth and seventeenth centuries – the Habsburgs, the Wettins in Saxony, the Wittelsbachers in Bavaria, the Hohenzollerns and the sovereigns of the kingdoms of Brunswick, Württemberg, Schleswig and Holstein – they also made armour for kings of England, Scotland, Denmark, Sweden, Hungary, Poland, Naples and Portugal, for the Italian and Spanish grandees, and even for ecclesiastical dignitaries. Armourers in fact moved in such illustrious circles that they became more and more self-assured and were soon in a position to refuse commissions, to insist on payment in advance and to stipulate terms for delivery. It became customary for princes to exchange court armourers or to lend their own personal armourer for a certain length of time as a gesture of friendship. In certain periods, suits of armour were much prized as gifts and would be given by one head of state to another, particularly in the first half of the sixteenth century. Plate-armour was a vital factor in warfare until the middle of the fifteenth century, since it served as an effective means of protection. When the landsknechts or mercenary troops arrived on the scene and single combat between knights grew less and less important, a transformation in armour took place, encouraged by the development of a number of different designs for plate-armour in the late-Gothic period. As the importance and practical usefulness of armour diminished, so its aesthetic value increased. The knights withdrew from the battlefields to the lists, where they prolonged an already anachronistic way of life, harking back nostalgically to the past. In Germany the main champion of this approach to life was Maximilian I of Habsburg, who was known as the last of the true knights. Princes all over Europe modelled themselves on him. His armour was made by the most important armourers throughout his empire.[1]

In the late-Gothic period, armour was designed on the same elegant, spikey, and indeed almost graceful, lines as the ordinary dress of the period, and also closely resembled Gothic sculpture, painting and architecture. The effect of the glistening, sparkling material, with the light glancing off it to form irregular patterns, was enhanced by subtle texturing of the surface, and details were picked out in silver or gold, though never ostentatiously. During the Renaissance elegance was relegated to second place and armourers concentrated on giving their clients an exact fit. The surface was enlivened by fluting, which also served as decoration. But from about 1520 onwards a variety of decorative techniques was used. Etching was the most important of these, the work being carried out by professional etchers although armour

135

Metalwork could also be gilded, blued or even occasionally painted in different colours. All these different methods were used during the sixteenth century, and as a final touch the armourer might add chased reliefs or gold inlay.

By about 1530 fluted armour had gradually been modified and developed into a new type of costume armour which was on the design of the landsknecht's costume. Exaggerated versions of this fashion in the Baroque or Mannerist style are quite common, though a large amount of elaborate armour which was still perfectly functional was also made in the second half of the sixteenth century. This type of dress-armour still retained some of its original significance even in the seventeenth century, though by now it served as little more than a symbol of its wearer's authority. Since jousting had gradually gone out of fashion, this armour could not even be used for that.

A reduced version of plate-armour survived, however, in the ceremonial breast-plate or cuirass which was virtually the standard wear for absolute rulers in the eighteenth century when they had their portraits painted. The fact that ecclesiastical leaders, such as the archbishop of Cologne, who was also an elector, wore a cuirass, shows that it was no longer thought of as battledress but merely as a sign of rank.

The most glittering chapter of all in the history of arms and armour is represented by ceremonial armour. Germany acted as the supreme leader in this particular field throughout the sixteenth century. But manufacturers of this type of dress armour also made armour for the ordinary warrior serving under army commanders, for the mercenaries who hired themselves out to different armies, and for the ordinary town-dwellers who had to defend their city's fortifications when the need arose.

Individual sovereigns would make themselves responsible for equipping their armies, obtaining supplies from the armourer's workshops which are known to have existed all over Europe, though Germany was here again in the lead. The main centres in the Rhineland were the Bergisch district and Cologne, which sent supplies to the Low Countries and to southern Germany. In the sixteenth century, there was great rivalry between individual workshops and distributors in Cologne tried to undercut their competitors in southern Germany, though probably at the expense of quality.[2] The 'bush-masters' who – as we know from an earlier chapter – were not members of the guild, again helped to keep down prices.

In many towns, particularly in northern Germany, prospective masters were required by their various guilds to provide their own suit of armour for inspection, since membership of a guild also entailed fighting to defend one's city if war broke out. Newly appointed masters

136

IX (*opposite*) Portions of the field and tilt armour of Henry VIII of England, from Greenwich; English, 1540.

X (*over page*) Magnificently elaborate Milanese cabinet, worked in ebony and bronze, overlaid with silver and gold; sixteenth century.

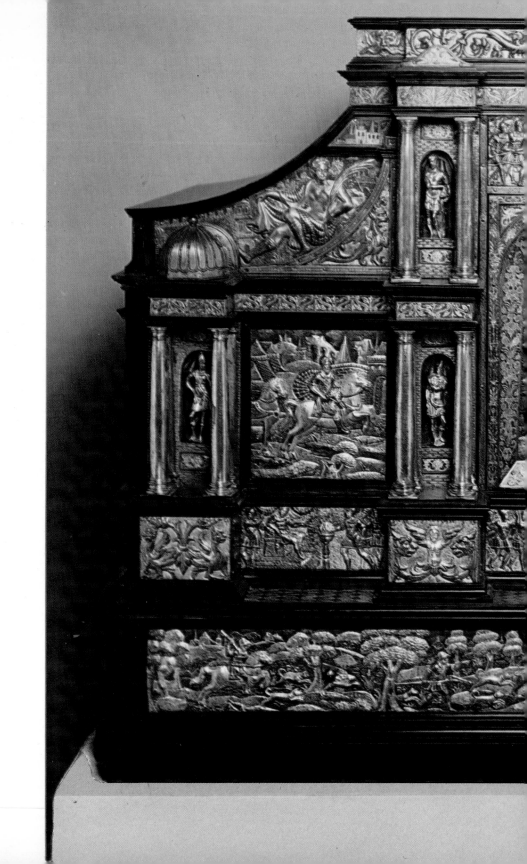

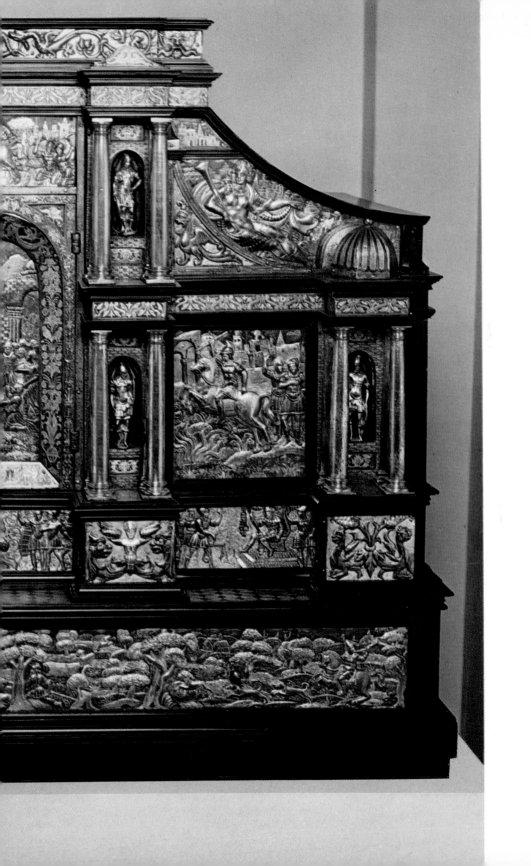

had to purchase a suit of armour at their own expense within a certain *Iron* number of months of passing the guild examination; the armour then officially belonged to the guild and its value can only very occasionally have been reimbursed. This regulation was, of course, partly intended to make sure that the town was prepared for military action, but at the same time the guilds wished to restrict the number of members to an élite of wealthy craftsmen.

Armour for ordinary soldiers and craftsmen obviously did not compare with the dress-armour worn by the nobility, but this does not mean that it had to be completely plain, even among the lower ranks. Arsenals and armouries in a few European towns still possess the occasional suit of infantry armour. Parts of them were blackwashed, while other sections were left plain, but polished to improve their appearance; they were also studded with brass rivets with decorative heads. In the sixteenth and seventeenth centuries, Venetian mercenaries wore armour etched with ornamental motifs and figure decoration, though this was generally confined to the helmet. During the Thirty Years' War, infantry armour began to cover less of its wearer, since the ideal of having one's whole body protected had in fact been abandoned long before, in favour of greater mobility. All that now remained was the breast-plate. Some armies went on using this until the eighteenth century and its final manifestation was as the cuirass worn by élite cavalry troops until about 1870, though by then the existence of fire-arms had made it completely anachronistic.

Firearms

Firearms first appeared in Europe in the middle of the fourteenth century – first in Italy and then in Germany. Their arrival hastened the decline of the old feudal way of life led by the knights. Many a knight's castle which had been considered utterly impregnable now collapsed under fire from the new bronze guns, or much later from guns made of iron.

Many fifteenth- and sixteenth-century guns had nicknames: 'Mons Meg' in Edinburgh, 'Dulle Griette' of Ghent and the 'Faule Magd' in Dresden were famous examples. Barrels were made of wrought-iron at first and later of cast-iron or cast bronze. In the early period it was very unusual for guns to be decorated, but ornamentation was more common from the sixteenth century onwards. Since guns are always the property of some institution, such as the army or the state, they are not related to any specific individual, and however much princes, industrious craftsmen and inventors may have longed to redesign and

137

XI (*opposite*) Wheel-lock pistols worked in steel; German, *c.* 1560.

Metalwork decorate them, they have always been considered as impersonal objects by society.

This does not apply to small-arms, however, and from the sixteenth century onwards craftsmen and owners lavished as much loving attention on them as they had once lavished on swords. So their fittings were often highly elaborate. The short fire-lock, which was used in the early days, was still a primitive weapon without any decoration; one of the earliest to have survived was found in the castle of Tannenberg, which was destroyed in 1399. Firearms were used by the infantry but were not normally used by the cavalry. This distinction also applied in the fifteenth and early sixteenth centuries, when the hackbut and (matchlock) were in fashion; they were unwieldy, inelegant looking weapons and were thought, therefore, to be more suitable for the common soldiery.

But with the invention of the wheel-lock at the beginning of the sixteenth century small-arms became both more effective and practical, and were also lighter, more manageable and aesthetically more pleasing. The wheel-lock created a spark for igniting the powder-charge by means of a rotating wheel, which rubbed against a piece of iron pyrites held in place by the cock. From the middle of the sixteenth century onwards, the wheel-lock pistol and the wheel-lock gun were used by aristocrats as well as the common people.

At the same time the gun and pistol trades were beginning to expand. Small-arms were only very rarely made from beginning to end by a single craftsman, and in the very early days of this type of weapon, making a rifle required at the very least the services of a blacksmith and a woodcarver. In the sixteenth century, which was the age of specialization *par excellence*, the barrel was made by a barrel-smith, the firing-mechanism by a locksmith and the wooden part by a stockmaker, while the whole weapon was put together by the actual gunsmith.

The individual component parts of the simpler type of small-arms were mass-produced even at a very early date. Certain towns became famous as production centres, such as the little town of Suhl in Thüringia, which was already producing large quantities of gun-barrels and pistol-barrels by the sixteenth century. The town of Liége had a flourishing export trade in accessories for firearms from the seventeenth century onwards, and in the nineteenth century Birmingham became one of the leading suppliers.

More elaborate weapons required the services of even more craftsmen, since the iron parts were often decorated with rich engraving, etching, gold and silver inlay and incised motifs, while the wooden parts were embellished with silver or bronze fittings – occasionally

gilded, inlaid with engraved pieces of ivory, set with tortoiseshell, *Iron*
incrusted with mother-of-pearl or carved.

The wheel-lock proved to be too expensive and not practical enough as a military weapon, so its use was restricted to cavalry officers. This was especially true in the sixteenth century, the golden age of this type of weapon. The elaborate decoration of wheel-lock pistols during this period befitted their status as a weapon used by gentlemen and very few simple examples are to be found. They enjoyed a certain degree of popularity as hunting-weapons up to the eighteenth century, but hunting is essentially a pastime enjoyed by the privileged classes; they were connoisseurs' weapons.

In the middle of the seventeenth century the flint-lock pistol came into use – this was probably first made in Paris. The principle on which this weapon works is the same as that of a cigarette lighter: a cock holding a flint strikes against a steel pan-cover, raises it, and the resulting spark ignites the priming powder. Originally the flint-lock was reserved for *de luxe* weapons, but later it was in general use among cavalry troops, and eventually took precedence over all other small-arms.

The quality of the firearms made in the seventeenth and eighteenth centuries was very uneven; they ranged from the simple, purely functional, military weapon to the elaborately decorated weapons collected by princes and the richer members of the aristocracy for their private armouries. There has always been great historical interest in firearms, even in those which can no longer be used or which have been technically superseded; so many fine pieces have been preserved for posterity.

4 Wrought-ironwork during the Romanesque and Gothic periods

The opening chapters of this section dealt with the development of weapon-making. We began with such a highly specialized craft because weapon-making is the oldest-established branch of the iron trade and can be traced right back to antiquity. Sociologically, this is an interesting situation, because the motivating force which encouraged the growth of the iron trade arose out of the basic struggle for existence fought on the battle-field, rather than from the inspiration of artists and craftsmen.

Many centuries passed before wrought-iron began to establish its own individual identity in the fields of pure or applied art – excluding weapons, of course. Although this may be partly due to the fact that most pieces of decorative wrought-ironwork have suffered from the ravages of time and have been eaten away by rust, nevertheless, there is scarcely a single reference to this type of work in early documents, which seems to indicate that very little was made. The first pieces of decorative ironwork appeared in Europe in the first centuries AD, in the form of fittings on church portals. Only the very richest churches were able to afford this type of luxury. In order to solve the problem of expense, ordinary wooden doors were built set with strips of iron. Thus the doors were not only solid, but also created a pleasing effect, rather different from that of cast-bronze fittings, but equally suited to the style of the times and to the particular type of decoration which was in fashion. The medieval craft of making wrought-iron articles seems to have begun with these door-fittings. The craftsmen had to evolve their own individual styles, since this particular branch of their trade had scarcely existed in the classical world, so that they had no early models on which to fall back. It is possible, however, that they may have drawn some of their inspiration from the Scandinavian plaited ornaments and ribbon-like decoration which were common during the

140

period of mass migrations, particularly in England, where one good *Iron*
example is the church at Homead.

It is extremely difficult to date work made in about the tenth century, because the usual concepts of style cannot be applied to this relatively early branch of applied art. The wrought-ironwork on the double door of Durham Cathedral is extremely elaborate. The fittings were probably made at the beginning of the thirteenth century, when the art of decorative wrought-iron was already in its heyday, especially in France. The craft spread rapidly from France to the rest of Europe, accelerated by the movements for reform within the Church.

At the beginning of the eleventh century, Cluny was the chief centre of monastic life, with a strong influence over the monasteries of Europe both in the intellectual and religious fields and in art and architecture. At the beginning of the twelfth century a second great reform movement grew up, led by the Cistercians. Both the Cluniac and Cistercian orders had a special relationship with the craftsmen who worked for them: the Cluniacs had a system of recruiting lay-brothers and the craftsmen were treated as part of this group, particularly the *fabri lignarii et ferrarii latomi quoque et muratores*, for whom a special part of the church was reserved, so that they could take part in masses. Bands of craftsmen would remain at the monastery while building was in progress and then move on to another monastery of the same order, so that their style was carried over long distances.

The design of door fittings made in the twelfth and thirteenth centuries shows clearly that the basic function of the decorative ironwork was to strengthen the wooden planks of the door and give effective protection against blows intended to destroy it. As the wooden planks are arranged vertically, the iron bands are laid across them in a horizontal direction, with ornamental pieces branching off to form patterns which vary from one district to another. By the thirteenth century the emphasis lay on the decorative aspect, especially in France. The fittings on the west doors of Notre-Dame in Paris are some of the finest wrought-ironwork ever produced in the Gothic period and it is difficult to remember that their original function was simply to reinforce the wood. There is a delicacy and beauty about the wrought-ironwork which, in spite of being almost too rich and ornate, reveals a clear design. The artist has retained the traditional arrangement of horizontal bands to form the basis of his design, and branches off from there into interlaced foliage and volutes made up of myriads of intricate ramifications, interwoven with luxuriant leaves and blossoms, birds, palmettes and fabulous creatures. In contrast to the flat strips of the early period, these fittings are three-dimensional. Even at the time, people found it difficult to believe that the artist had been able to perform

Metalwork such an amazing feat, and a seventeenth-century master blacksmith called Mathurin Jousse put forward the theory that he must have used some secret technique which had since been forgotten. He even suggested that the iron might have been cast in the same way as bronze or pewter, even though it would have been quite impossible to cast iron with such finesse in those days, or for many centuries to come. Many fantastic legends grew up about the artist, and it was even claimed that supernatural forces had been at work. It was popularly believed that the devil himself had been responsible for this miracle in iron and indeed the name traditionally given to the blacksmith of Notre-Dame even today is 'Biscornette' or 'Biscornet', which is merely another name for Satan, the devil with two horns.

The originality of these fittings and their astonishing beauty has never been equalled, though certain other door fittings in France, made during the same period, were clearly inspired by them. The portals of the cathedrals of Sens, Noyon and Rouen all appear to be modelled on Notre-Dame, but the only ironwork which can almost compare with the illustrious model are the doors of St Paul's in Liége, which are now exhibited in the local museum of antiquities.

English smiths of the thirteenth century produced wrought-iron-work which can match the work of their French counterparts. The work upon the doors of Notre-Dame influenced English wrought-ironwork, though there are certain stylistic changes. Thus the foliage scrolls are thinner and the horizontal arrangement is replaced by a vertical one. Zoomorphic shapes, which were so popular in earlier periods, now appear only rarely. Church doors with fine wrought-iron fittings include St Peter's, Colchester, the chapel in the cemetery at Norwich, Lichfield Cathedral, Chester Cathedral, the church at Market Deeping and the abbey-church of Radford. Two more buildings have doors with beautiful wrought-ironwork – the chapter-house of York Minster, and Merton College, Oxford. Very few doors of secular buildings have been reinforced in this way during the Middle Ages. This is partly due to the fact that castle doors have tended to be destroyed over the centuries. Also it is unlikely that the doors of ordinary secular buildings would have been as elaborately decorated as those of religious buildings. Castles which were exposed to enemy attacks had strong wooden doors held in place by heavy, undecorated strips of iron and rivets, while ordinary town dwellings had just plain wooden doors.

Medieval citizens who had valuables to protect followed the example of the Church and secular authorities by making use of wooden chests, surrounded by powerful iron fittings. These fittings are often very similar to door fittings. One of the finest examples of a chest of this period originally came from the Abbey of St Denis, and can be seen in the

Musée Carnavalet in Paris. Iron-bound chests continued to be made until the sixteenth century, and later various systems were devised, based on the traditional shape of the chest, to surround and secure the receptacle.[1]

Another important achievement of blacksmiths is the creation of iron grilles. The earliest examples of these grilles were discovered beneath the ashes of Pompeii. As mentioned above, Charlemagne preferred to use bronze for the grilles in his Palatine Chapel, but from the eleventh century onwards, wrought-iron grilles became more common. At first they were restricted to ecclesiastical buildings and were used to separate chapels and chancels from the main body of the church and to protect church treasures and graves. Once again, France and England were the leading countries, both in the quantity and in the quality of the work they produced, although well-designed grilles were also being made in Spain and Germany during the Romanesque and early Gothic periods. Very little is known about the craftsmen who produced this type of work, since, like most of their colleagues in other skilled trades, they remained anonymous and were scarcely ever mentioned in documents or other written records. However, we do know the name of the artist as well as the price of one particularly fine grille made in England. This appears above the tomb of Eleanor of Castile in Westminster Abbey and was made by a master craftsman called Thomas de Leghtone. He completed it in 1294 and was paid a fee of thirteen pounds which was probably equal to the annual salary of a court official – a huge sum of money in those days. It has been suggested that this sum was in fact paid for a larger grille which reached down to the ground as well as surmounting the grave. Thomas de Leghtone probably also made the decorative door fittings for All Saints' Church, Leighton Buzzard, which have clearly been influenced by the ironwork at Notre-Dame. It seems likely that he got to know the work of French blacksmiths by spending some time in France and he may have received his training there.[2]

During the early Gothic period, craftsmen became aware of other aspects of ironwork as an art-form, apart from the predominantly functional role of strengthening doors and partitioning rooms, so they gradually moved towards the creation of three-dimensional objects. One of the finest examples of this new approach is the Paschal candlestick in the cathedral at Noyon, which dates back to the thirteenth century. This candlestick, which is larger than life-size, should be compared with similar articles of the same period made in bronze, the material normally used for ecclesiastical candlesticks from the Carolingian period onwards. Surprisingly, such a comparison reveals that there are virtually no similarities at all between the two types; for, while the

iron candlestick does bear a few of the interlaced scroll motifs which appear on the base of the bronze candlesticks, its structure and style are completely different and are the result of the inherent properties of a material which is forged rather than cast. Consequently, the shaft consists of a series of individually worked struts, the details of which are predominantly vegetable in character and enlivened with animal figures, while the normal drip-tray is replaced by a cluster of flowers. The elegance and lightness of the design, carried out in a masterly fashion, are a clear indication that the idea of making a Paschal candlestick in wrought-iron had nothing to do with lack of funds or a shortage of bronze. This was not a question of making a virtue out of necessity, but rather of creating a completely independent work of art suitable to the material. Unfortunately, this first step towards the creation of an independent style for wrought-ironwork was not developed in a consistent manner so that a whole new series of stylistically related objects might be produced. It is true that French smiths in the thirteenth century made the occasional well-designed chimneypiece or lectern, but to judge by the few pieces which have survived, they happened to be made by some very imaginative craftsmen, and are not evidence of a new stylistic trend.

The production of decorative wrought-ironwork increased in the fourteenth and fifteenth centuries, with grilles still taking pride of place, although by this time non-ecclesiastical objects were also being made. In the countries of northern Europe, ironwork had adapted itself to the special requirements and realities of ecclesiastical architecture and had developed along the same lines as the buildings which it was to adorn. In the south, however, decorative ironwork did not begin to flourish until the fourteenth century when the principalities had become powerful and the noble families had grown rich and prosperous. Wrought-ironwork therefore is found mainly in palaces and castles, grand residences and halls. Even thirteenth-century palaces often have bent pieces of iron curving upwards with a ring underneath which can be swung away from the wall; they were fixed at shoulder height at intervals along the façades so that travellers or visitors could tie their horses to them. In the early days, hooks of this type were merely decorated with a grotesque head or decorative ornament on the tip, created with a few deft blows of the smith's hammer, and a little punching on the surfaces. Later on, however, during the Renaissance, they were more richly decorated and the heads had a far more lifelike appearance. Very fine examples of this style have survived on the Bargello and the Palazzo Vecchio in Florence.

The grander palaces often have ornamental iron fixtures near the windows consisting of a ring on the end of a long stem. Probably poles

Wrought-ironwork

161 (*right*) Iron door knocker from Merton College, Oxford, in the form of a double-headed monster; *c.* 1300.

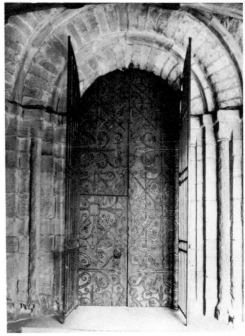

162 (*left*) Heavy wooden door, studded with iron, and the inner iron grating door at Crathes Castle; Scottish, late sixteenth century.
163 (*right*) Decorative ironwork on the south-west door of Durham Cathedral; English, thirteenth century.

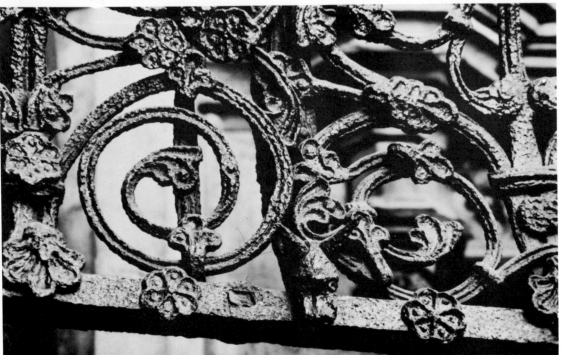

164 (*top*) Iron trelliswork on the tomb of Eleanor of Castile in Westminster Abbey; completed in 1294 by Thomas Leghtone.

165 (*bottom*) Detail of the ironwork on the tomb of Eleanor of Castile, showing the fine decorative motifs.

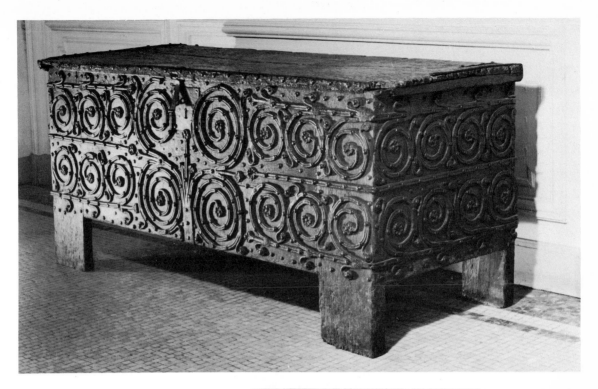

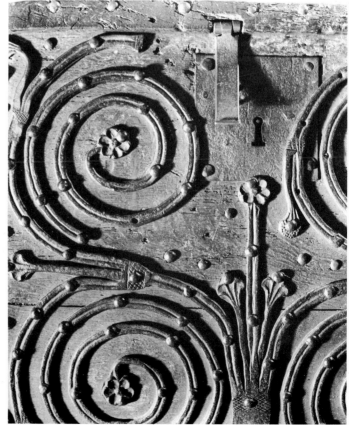

166 (*top*) Coffer of iron and wood, from the Abbey of St Denis, Paris. The decorative ironwork is similar to that found on church doors; thirteenth century.

167 (*right*) Details of the ironwork and lock from the thirteenth-century coffer at St Denis.

168 (*left*) Ironwork from the Scaliger tomb in Verona : made by Bovinio di Campilione, *c.* 1380.

169 (*right*) Iron torch bracket from the Palazzo Strozzi, Florence, combining Gothic and Renaissance motifs; made by Niccolo Grosso, called Caparra, *c.* 1500.

170 (*left*) Speaking grill of decorated wrought-iron; French, fifteenth century.

171 (*top right*) Decorated iron door knocker; French, fifteenth century.

172 (*bottom right*) Casket of chiselled iron with gold inlay. This was made as a display piece and its combination lock is opened by the letters of a girl's name; French, second half of sixteenth century.

173 Wrought-iron pothook with hanging cauldron, from a middle-class household; English, 1660.

174 Wall-lamp of wrought iron; Italian, sixteenth century.

175 Iron reading-desk for ecclesiastical use; French, fifteenth century.

176 (opposite) Crown chandelier made of iron and wood; Gerd Bulsinck, Westphalian, 1489.

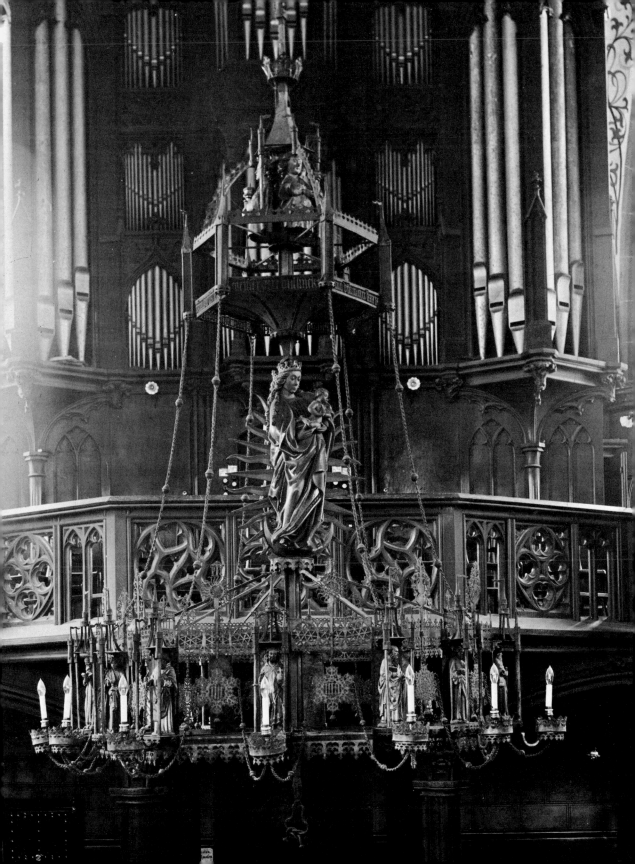

177 and 178 Fragments from wrought-iron gates made by the French Huguenot artist, Jean Tijou, at Hampton Court; late seventeenth century

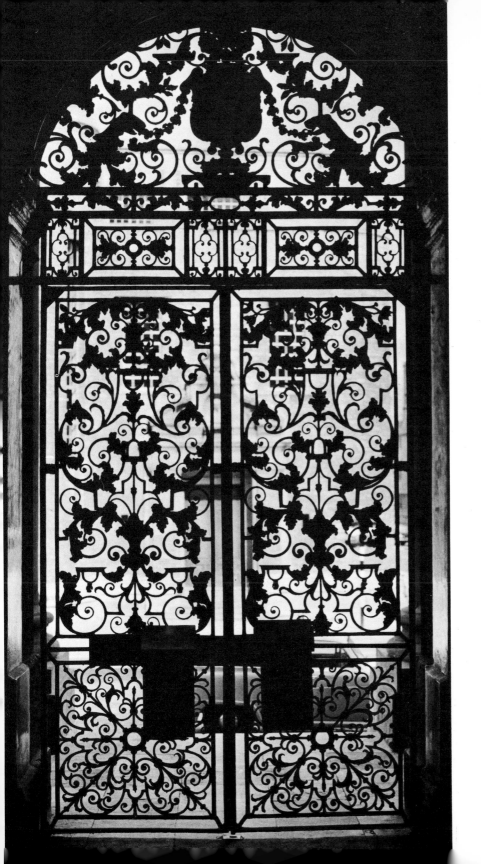

179 Wrought-iron gates of the Clarendon building, Oxford, made by Jean Tijou; *c.* 1710.

180 (*top left*) Lock from a chest; German, end of the fifteenth century.
181 (*top right*) Cabinet hinge; South German, sixteenth century.

182 Steel lock in the shape of a firearm, a virtuoso example of locksmith's art; Krengerup, Denmark, *c.* 1770.

183 (*opposite*) The locksmith's forge, showing the different stages in the manufacture of locks; from Diderot's *Encyclopedia*, eighteenth century.

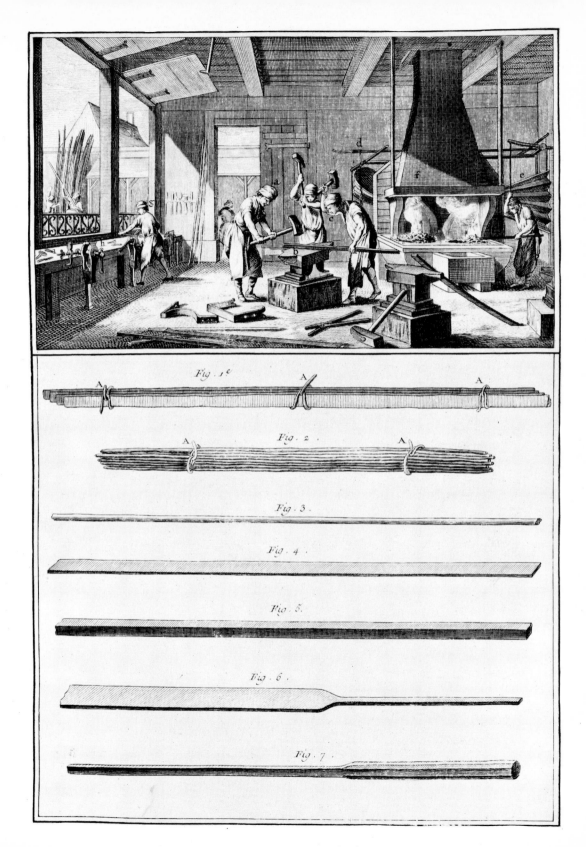

Fig. 1.e

A A A

Fig. 2.

A A

Fig. 3.

Fig. 4.

Fig. 5.

Fig. 6.

Fig. 7.

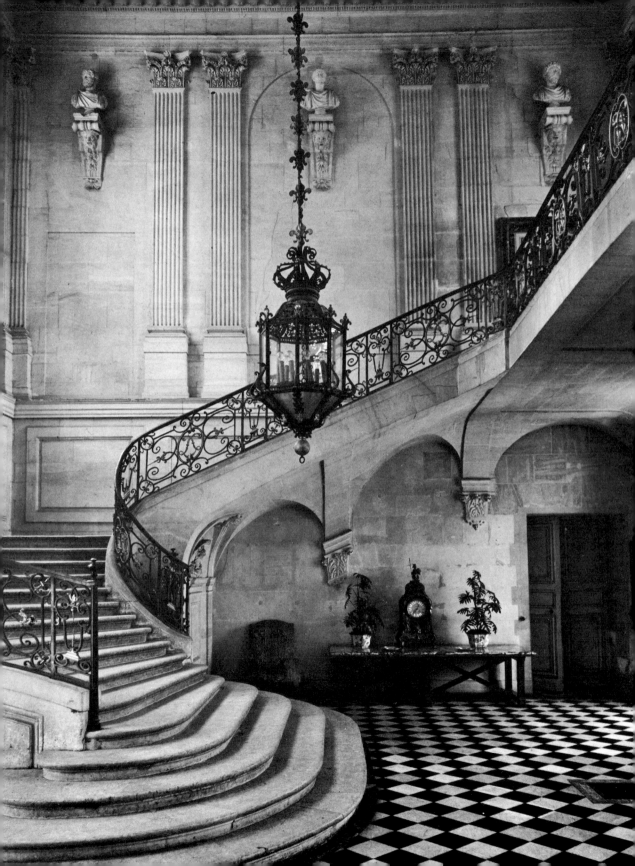

184 (*left*) The hall and stairway at Anet, with its magnificent wrought-iron balustrade, constructed by the Duc de Vendôme in the 1680's. The elaborate hanging lamp is also of wrought-iron.

185 (*right*) Wrought-iron latticework on the door of the Apollo Gallery, formerly at Maisons-sur-Seine; French, *c.* 1650.

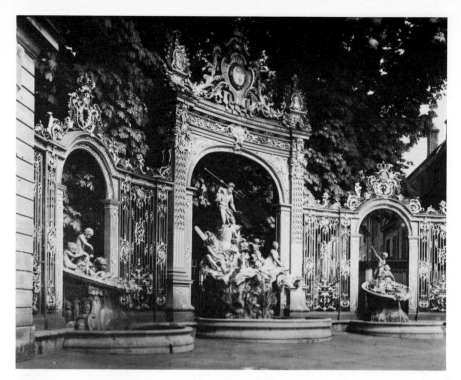

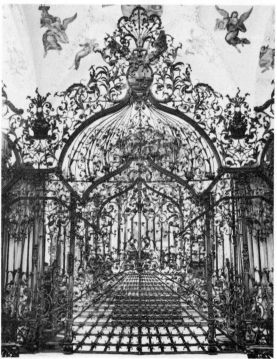

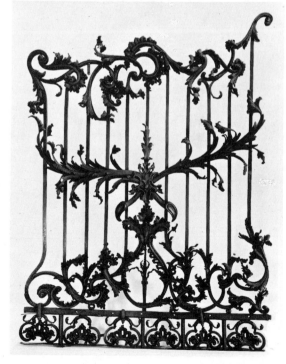

186 (*top*) Wrought-ironwork by Jean Lamour around the fountains in Place Stanislas, Nancy; mid-eighteenth century.

187 (*left*) Perspective wrought-iron screen in the abbey church of Muri, Switzerland.

188 (*right*) Rococo wrought-ironwork by J. G. Oegg, from the Residenz at Würzburg, 1752.

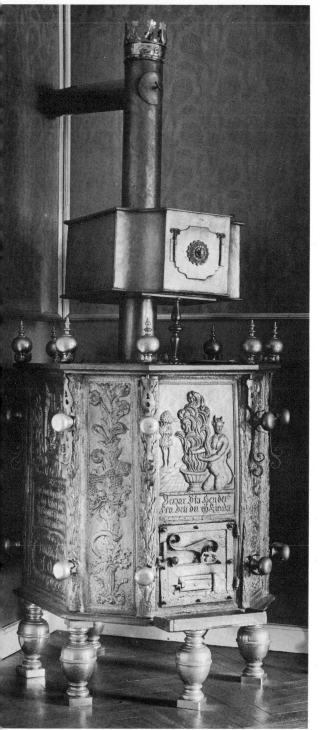

190 Bracelet of cast iron; Berlin, 1813–20.

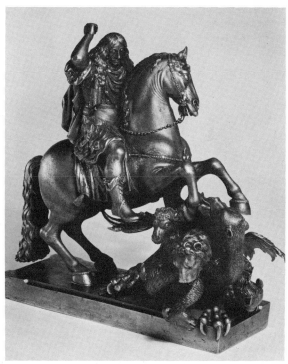

189 (*left*) Cast-iròn stove; from Egeskov Castle, eighteenth century.
191 (*right*) Charles II of England as St George, victorious over the dragon,
cut-iron statuette by Gottfried Leygebe, after 1660.

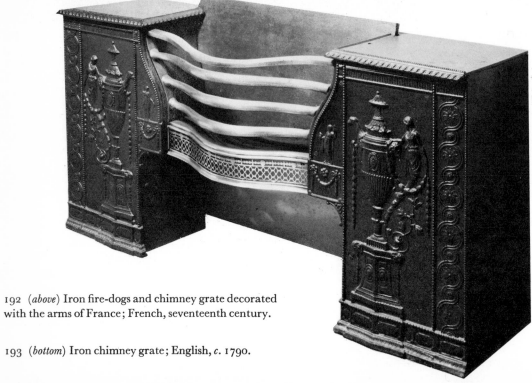

192 (*above*) Iron fire-dogs and chimney grate decorated with the arms of France; French, seventeenth century.

193 (*bottom*) Iron chimney grate; English, *c.* 1790.

were slipped through the rings on festive occasions and tapestries hung *Iron*
on them for decoration, or perhaps pieces of cloth were hung up as
sun-blinds.

The lanterns and torch-holders on the walls of the town-palaces of
Italian *nobili* were designed with infinite care and reveal great originality
on the part of the artist. According to Steche in his book *Über Kleinwerke
italienischer Schmiedekunst* (Small wrought-ironwork in Italy) (1881):
'Initially only certain distinguished families had the right to illuminate
the outside of their buildings with torches and fire-baskets, both of
which were used, whereas other less distinguished families seem . . . to
have been allowed to illuminate their battlements.'

In about 1500, Nicollo Grosso, known as Caparra, made the torch-
holders for the Palazzo Strozzi in Florence, as well as four lanterns to
decorate the corners of the palace. The torch-holders are in the shape
of winged dragons with women's heads, mounted on richly articulated
pillars, while the lanterns with their columns and their architectonic
structure look rather like the little houses made to hold the sacrament,
or rounded temples. Examples of Caparra's style can also be seen in
many other Florentine palaces, such as the Palazzo Guadigni, the
Palazzo Gondi, Roselli del Turco.

Another type of ironwork which was of equal importance was the iron
grilles which were made in Italy from the fourteenth century onwards.
One of the most famous is the grille round the Scaliger tombs in Verona,
executed by Borinio di Campilione in 1380. The characteristic motif
of this grille, and indeed of many others made in Italy during this
period, is the quatrefoil, and the whole structure is designed round it.

The number of blacksmiths whose names have come down to us is
an indication that the Italians set great store by wrought-ironwork.
Sometimes their actual signatures can be seen on the work, or else they
may be mentioned in contemporary documents. In Siena, for instance,
we know of a master smith called Berlino di Piero, who came from
Rouen and made several pieces of decorative wrought-iron for the
cathedral in 1384, 1387 and 1388.[3]

The fittings on church doors became richer and more ornate, amusing
and elegant, and the profusion of late-Gothic ornamental motifs typical
of the architecture, graphic work and sculpture of the period begin to
cover the whole surface of the door. Soon wrought-iron alone was not
enough to satisfy the demand for more and more decoration, so
other methods were combined with it. The background, for instance,
might be covered with coloured leather, or filled in with pieces of sheet-
metal punched with ornamental motifs or figures in flat relief. The
general decorative effect was enhanced with gilding and painted orna-
mentation. The majority of the door-fittings which have survived from

145

the late-Gothic period were made in Germany, Austria or Poland, the countries which were producing the finest work at that time. Meanwhile in England and France, this type of work was declining, having reached its peak in the thirteenth century.

The smiths now turned their attention to locks, devoting infinite care and artistry to them and to their mounts, known as lock-plates. German locksmiths applied tracery and interlaced foliage motifs onto the curved plate, leaving the background smooth, whereas their French counterparts created masterpieces of plastic art by carving and incising the iron. The most ornate examples have an architectonic framework of arches and pillars and tracery, often enclosing scenes portraying many figures, each carefully finished down to the last detail. The keyhole is often concealed and can only be found by touching a spring. These highly decorative locks involved an enormous amount of painstaking attention and were usually meant as show-pieces used on display chests, or on the doors of palaces, libraries or sacristies. The town hall in Ulm in Germany has a door which is decorated with this type of plastic contoured lock and fittings, and other rich trading towns and guildhalls set great store by such work in the late fifteenth century and in the sixteenth century.

In the late-Gothic period, it became a regular cult to have ornamental door-handles and knobs, particularly in France, the Low Countries, Italy, Germany and Spain. This time they were not restricted to church doors, and could also be seen on the houses of rich town-dwellers.

Utensils made of wrought-iron were comparatively rare during the early-Gothic and late-Gothic periods, but in the fifteenth century they could compare with bronze articles in design and variety of decoration.

The finest chandeliers and candlesticks were made in Germany during this period. It is noticeable that the two different areas which were flourishing in this type of work, the Lower Rhine district, including Cologne and Westphalia, and northern Germany from Magdeburg to Lüneberg, were also highly advanced centres of bronze-casting. From the Romanesque period onwards the neighbouring workshops had been supplying these areas with their work. In the fifteenth century a number of different factors may have coincided to give the blacksmiths the opportunity of competing with the bronze-founders. The destruction of Dinant and Bouvignes had been disastrous for the bronze workshops in the Meuse area, and the metalworkers who had moved off elsewhere to find work did not find it very easy to pick up the threads again. Moreover, the demand for all types of products had increased because of the rapid expansion of the towns, which created an opportunity for the blacksmiths, who were quick to take advantage. It is astonishing that the smiths made no attempt whatsoever, not even a tentative one,

146

to adopt the shapes and designs used by the bronze-founders. Evidently *Iron*
they preferred to create a style of their own, more suitable for their
material.

In the late-Gothic period, smiths who had been commissioned to
make a chandelier would occasionally hark back to the old hoop design
which had been in its heyday in the Romanesque period. In 1489 a
craftsman called Gerd Bulsinck made a chandelier in this style for the
parish church at Vreden in Westphalia, but enriched it with a wooden
figure of the Madonna and Child carved in the round. This style was
more common in the period that followed, when blacksmiths and wood-
carvers worked together on chandeliers. In addition to the hoop-shaped
chandeliers, important examples of which can be seen in the cathedrals
of Magdeburg and Halberstadt, there are also hanging chandeliers in
the shape of a lantern. The struts of this rather cage-like structure gave
the smiths ample opportunity to create new designs and shapes.

One of the most famous iron chandeliers can be seen in St Peter's
in Louvain, which surpasses all other bronze chandeliers made in the
same period in the beauty of its overall design. The delicacy and finesse
of the work is reminiscent of the work of goldsmiths. For many years
this masterpiece was thought to be the work of the well-known painter
Quentin Massys, but today informed opinion tends to attribute it to a
craftsman called Jesse Massys, who was a relation of Quentin, possibly
his brother. Small hanging chandeliers may have been used for lighting
the rooms of wealthy middle-class citizens, though this cannot be
verified because none has been preserved *in situ*. On the other hand
quite a number have been found in churches and sacristies.

Other types of ironwork made for churches include candlesticks to
be attached to grilles, candle-holders, Paschal candlesticks, funerary
candlesticks, supports for font-covers, wall brackets for holding candles,
lecterns and racks for hanging up cloths. In Spain and Germany a
complete pulpit would occasionally be made of wrought-iron.

Wells were constructed in the towns for the use of all members of the
community during this period, and some of these had wrought-iron
covers. A number of particularly fine ones has been preserved in a
few towns in Belgium and France. The cover of the well in Antwerp,
which bears the date 1470, is attributed to Jesse Massys, already men-
tioned, and is a miracle of late-Gothic exuberance. Two humbler, but
nevertheless very distinguished-looking well-covers can be seen in the
courtyard of the Musée de Cluny in Paris and in the castle of the dukes
of Brittany in Nantes. This type of work did not flourish in the German-
speaking countries until the sixteenth century.

A study of the evolution of decorative wrought-ironwork reveals that
in the early days – the Romanesque and early Gothic periods – smiths

147

Metalwork were attracted by the idea of creating items on a monumental scale, such as door-fittings and grilles. At this time they were working exclusively for the Church. During the late-Gothic period there was a far greater variety in the design of wrought-ironwork, while at the same time the smith had changed his field of activity, as well as the type of articles he was making. Smiths no longer had the wealth and power of the great patrons, such as monasteries, abbeys and episcopal churches, behind them. Their most important clients were now ordinary city churches and middle-class citizens.

5 Wrought-ironwork in the Renaissance, Baroque and Rococo periods

Decorative wrought-ironwork

In the sixteenth and seventeenth centuries, smiths continued along the same lines of development that they had begun in the late-Gothic period, promoting their trade, improving their skills and extending their range to cover secular as well as ecclesiastical articles. At this period, however, their dependence on architectural designs was finally abandoned in favour of a specific type of decoration, derived in part from the actual technique of forging, but also from the ornamental styles of the other applied arts and from the patterns designed by the ornament-engravers.

During the late-Gothic and Renaissance periods the traditional relationships between the smiths and the Church ended. The smiths abandoned ironwork based upon architectonic design in favour of more decorative motifs. Leaves and flowers, scrolls, knots, interlaced patterns, grotesques, moorish patterns, networks of lines, shoots and sprays, all these reached the height of luxuriant splendour in the sixteenth century, particularly in iron grilles made in Germany. Many of these decorative motifs can be found in the pattern-sheets issued by the Nuremberg ornament-engravers, who intended their designs to be copied by craftsmen. Artists such as Albrecht Dürer, Hans Holbein or Urs Graf, among many others, engraved this type of pattern sheet. Once again, most of the grilles which have survived from the sixteenth century belong to ecclesiastical buildings, not only because these were less likely to be destroyed, but also because they existed in greater numbers than the grilles in castles or patrician houses, for obvious reasons: the churches had special areas which were meant to be looked at but not entered, and ornamental grilles were the ideal solution for screening them off from the rest of the church. On the other hand, castles and private houses needed privacy from prying eyes as well as

from unwelcome intruders. As a result, those who lived in castles or grand town-houses limited themselves to having the openings above the doors – or fanlights – designed to be seen through and adorned with wrought-iron grilles, while the actual doors, which led to courtyards and gardens, were made of solid wood. The desire to display one's property while at the same time remaining shut away did not reach a climax until the end of the seventeenth century and the beginning of the eighteenth.

There is no space here to describe in detail the development of iron grilles in Europe, nor to describe the enormous variety of ornamental motifs which adorn them. The technical achievements of the makers of decorative wrought-ironwork seem to have been limitless. They handled their inflexible material as easily as if they were merely wielding a pen, creating a wealth of highly elaborate and fantastic decorative motifs. As well as round, flat or square rods, they also produced cast figures, busts, heads, pilasters, pillars and every possible type of motif cut from sheet-metal. The ordinary work of forging the iron was now accompanied by painting and gilding to create an effect of colour; this part of the work was left to the painters' guilds. But no matter how fantastic and ornate iron grilles became in the sixteenth and seventeenth centuries, they were essentially flat, whereas towards the end of the seventeenth century and during the eighteenth, wrought-ironwork was developed along three-dimensional lines, particularly in France. One type of grille which deserves special mention is the perspective grille which made its appearance from the Baroque period onwards, chiefly in Switzerland and southern Germany. These grilles were sometimes used to screen off the chancel, or alternatively they might be placed just inside the entrance to the church. The composition of a perspective grille generally consisted of a large portal in the middle, flanked by two slightly smaller ones; the curving lines of the grille were arranged so that one seemed to be looking down a long barrel-vaulted passage, giving the impression of great depth. This *trompe l'oeil* effect was probably inspired by the passion for perspective effects which characterizes the late Mannerist style, and by the art of landscape-gardening.

Another type of grille was built for fountains and wells. The most famous is the one over the '*Schöner Brunnen*' or 'Beautiful Well' in Nuremberg, made by the Augsburg craftsman Paulus Kuhn in 1587.[1] Ordinary citizens took an enormous interest in the decoration of their wells, as shown in a contemporary report on the Florian well in Salzburg: it was completed in 1687 and was put on view on the dance floor in the town hall, which meant that anyone was allowed to inspect the quality of the work.[2]

In seventeenth-century France a creative upsurge took place in the

field of decorative ironwork. French towns had never attained the same degree of power and importance in the Renaissance period as those of Italy or Germany. This may account for the fact that the art of forging iron declined in France at the very time when towns were flourishing elsewhere. But this temporary lull came to an end when France emerged as the only country in seventeenth-century Europe to have benefited from the Thirty Years' War. As a result she began to enjoy a period of economic prosperity, and the smith's craft went through a corresponding period of recovery. Baroque ironwork in France was closely linked to the great building projects initiated during this period.

Sheets of engraved decorative motifs played an important part in providing models from which decorative metalworkers could draw their inspiration. Some of these motifs were designed by professional ornament designers who supplied the other trades with their needs, and in so doing, learned enough about the individual crafts to be able to take into account the particular properties of the material involved. Alternatively, the designs were drawn by the wrought-ironworkers themselves and then printed and published. French designers were far more active in the late sixteenth century and in the seventeenth century than their colleagues in Germany, while the pattern books available to smiths were much more specialized and detailed. The earliest work of this type is Mathurin Jousse's *La Fidèle ouverture de l'art du Serrurier*, published by La Fleche in 1627. This was followed by a whole collection of other books during the seventeenth century, two of which deserve special mention as outstanding examples of their kind: a manual for locksmiths by Hugues Brisville (1663) and another one by Duhamel du Monceau. A large number of architects and interior designers created decorative ironwork, among other things, including François Mansart, Jean Marot, Jean Lepautre and Jean Bérain. An excellent example of the French ironwork of this period is the pair of doors now in the Apollo Gallery in the Louvre, which were originally made for the château of Maisons sur Seine, built by François Mansart, between 1642 and 1651. They are decorated in a severely classical style, with great richness and imperial grandeur. The iron is filed and polished, and the finesse and perfection of the work can be compared with the finest masterpieces in bronze. When compared to a German grille of the same period, the difference between court and bourgeois art is immediately apparent. But like the decorative ironwork produced in Italy during the Renaissance, these portals go beyond the limitations of their material. They are collectors' items and far too original to be produced on a larger scale.

Metalwork The château of Versailles played a decisive role in the development of wrought-iron grilles and gates and their importance to architecture. The architect Lemercier began to build the first château during the reign of Louis XIII. He designed the building to have a courtyard surrounded by a wall, in which seven rounded arches were cut. These arches were given grilles, so that the courtyard could clearly be seen from outside, and thus the architecture could be viewed in its proper setting.

This château was replaced by a building even more open to public gaze. Louis XIV's architect, Le Vau, laid out three courtyards, each leading into the next, diminishing in size, and each enclosed by an oblique grille, so that the whole architectural structure could be seen through them. Passing through these grilles soon developed into a ceremonial ritual. Every carriage had to pass through the first grille, but only those privileged personages who possessed *les honneurs du Louvre* were entitled to drive through the large grille leading to the *Avant Cour*, which in turn led to *les appartements du roi*. This exclusive group consisted of royal princes, *maréchals de France* and foreign ambassadors.

There was also a good deal of ironwork inside the château and in the courtyards. In the *Cour de Marbre*, for instance, there were two large aviaries built by the metalworkers Mathurin le Breton and Christophe Maugin, who received 5,600 *livres* each in payment. These aviaries have disappeared as well as many portals, railings, balustrades and wrought-ironwork in the grounds. The large grilles in the courtyards were badly damaged during the French Revolution. On 6 October 1789 the mob tore out the lance-like iron rods and stuck the head of the murdered members of the *garde-du-corps* on the ends. The only grille to have survived leads into the forecourt, though even this has been altered in the course of reconstruction.

Of course, there are copies of the courtyards at Versailles both in other parts of France and abroad, and trade was flourishing for the French decorative metalworkers. French influence was felt particularly strongly in England, in the person of Jean Tijou, who was probably engaged by Christopher Wren to execute decorative metalwork items for the royal palace at Hampton Court. His style can be recognized in a large number of grilles in both ecclesiastical and secular buildings. Only a small proportion of this work can have been carried out by Tijou himself, and in fact most of it was probably executed by native English artists, working under his supervision. In 1693 Tijou published a model-book called *A New Booke of Drawings*. His decorative style is unmistakably French, though his use of luxuriant acanthus decoration is rather heavy, adding a touch of something very un-French to his designs.

152

Tijou had a most salutary influence on English decorative metal-workers, inspiring them to reach greater heights. Since financial and economic conditions in England were rather similar to those which prevailed in France in the seventeenth century, this lavish style was able to expand and develop with great success. Ironwork in the Rococo style was quite unknown in England, where the late Baroque style of Jean Tijou was followed immediately by the Adam style of classicism.

Smiths working on the Continent in the eighteenth century continued to make the same type of articles. Their main patrons were still the leaders of the Church and owners of castles, who still commissioned large grilles and portals. But the richer members of the bourgeoisie now began to assume the role of patrons. They chiefly ordered balcony frames and staircase railings, window baskets and fanlight grilles.

Any study of Rococo ironwork must include the most magnificent masterpiece of the period: the grille and ironwork in the Place Stanislas in Nancy, which took the artist Jean Lamour four years to complete; he finished this in 1755, and was paid the enormous sum of 149,324 *livres* for his labours. When the square was officially inaugurated, the fountains spouted wine instead of water and four aldermen threw down money from the balconies to the crowds massed below. Lamour was much admired by his patron Stanislas Lesczinsky, the exiled king of Poland, who had commissioned the grille as king of Lorraine; Stanislas had a double portrait painted of himself and his metalworker.

The ironwork made by Johann Georg Oegg for the Residenz in Würzburg is fine enough to compare with Lamour's work. These two grilles – in Nancy and in Würzburg – are the most grandiose examples of the style of ironwork which flourished mainly in France, but also throughout Germany and Italy in the eighteenth century. An amazing number of portals and screening-grilles were made during this period, in spite of the very high costs involved.

The Rococo style was popular with French and German metalworkers for a comparatively long time even when most of the other trades had already adopted the classical Louis XVI style. This situation was partly due to the conservative attitude of smiths, but it is also more than likely that craftsmen who had excelled for so many years by using the graceful lines of Rococo were reluctant to part from a style which had served them so well. This reluctance to adopt the classical style meant that very few Louis XVI grilles were made at all, since after the Revolution the craft of decorative ironwork came to a complete standstill just as in Germany. Another important factor, which contributed to the decline of the smiths' trade at the end of the eighteenth century, was the appearance and increasing popularity of cast-iron, which became predominant in the nineteenth century.

Wrought-iron utensils

When studying the highly decorative wrought-ironwork, made in the Baroque and Rococo periods to satisfy the craving for luxury rife among the richer members of society, it is only too easy to forget that ordinary utensils for everyday use were also being made. These were commissioned and bought by farmers and the minor landed gentry, by craftsmen and the petite bourgeoisie, since iron was inexpensive.

Some museums possess a few candlesticks made of sheet iron and chased iron from the sixteenth, seventeenth and eighteenth centuries. They generally consist of a base mounted on a small pedestal, a shaft and a clamp for holding the candle, with a simple handle projecting from the shaft. Alternatively, the shaft is sometimes spiral and contains an adjustable socket for the candle. A fairly large number of variations on this basic schema can be found, most of which make use of the fact that iron is a flexible material; in nearly all cases the candle is held in place by a clamp. Amazingly enough there is a far greater variety of shapes and designs among wrought-iron candlesticks than among their counterparts in brass dating from the same period, which indicates that the smiths invented a completely new range of designs instead of merely copying the brass candle-holders which were so common at that time.

The quality of wrought-iron candlesticks varies considerably from very primitive pieces, which can be assumed to have been made by the village blacksmith for local farmers, to others which have been most carefully designed and are equal in quality to their counterparts in brass. Compared to brass candlesticks, only very few iron examples have survived; this is partly because people tended to treat them with contempt, because their material value was so low that they were thrown away without any misgivings, but also because far fewer of them were made. Inventories of assets drawn up for inheritance purposes almost always mention bronze or pewter candlesticks, but scarcely ever iron ones; this applies both to town-dwellers and country people.

Other functional articles made in iron are the hoop with hooks used by huntsmen for carrying home their spoils, the pot-hooks for hanging the water-pot over the open fire, sets of implements for stoking the fire – which were particularly popular in eighteenth-century England – gridirons, roasting spits, scales, pans and cauldrons. All these could be either plain and simple, or highly elaborate. The majority of this type of article were used in the kitchens and households of ordinary middle-class citizens, but also in royal households.

The craft of making locks and keys had started in the late-Gothic period, and elaborate pieces were made for doors, chests, cupboards and caskets, which involved a good deal of complicated chiselling, forg-

154

ing and filing. As locks were much more in demand in the Renaissance, *Iron* much less care tended to be lavished on them and on their keys. The most richly decorated locks in the second half of the sixteenth century were etched rather than chiselled; this technique was particularly popular in Germany, and locksmiths undoubtedly took their inspiration from their colleagues, the armourers. French locksmiths preferred to chase and engrave their work, especially in the seventeenth century. In the seventeenth century bronze – generally gilt-bronze – took over from iron for the type of lock used on doors, since it fitted in better with the requirements of the late Baroque and Rococo styles than the more homely iron. In the Victoria and Albert Museum, there are two elaborate locks made in England, one of which is made of brass filigree and tempered steel and bears the signature of Richard Bickford, who made it for Grand Duke Cosimo III of Tuscany when he visited London in 1669; the other was made by Philip Harris, a London blacksmith, in about 1700.

The keys which went with these magnificent locks were equally splendid, with both bit and handle richly chiselled and filed. We must also mention the complicated locking devices, with supports and claws, which were favoured by householders in the seventeenth and eighteenth centuries for their chests and closets. They bear witness to a solid and straightforward demand for equally solid and straightforward industry on the part of the craftsman, who fulfilled his task with a zeal at which we still marvel today.

Elaborate and richly decorated locks made during the Renaissance and Baroque periods are reasonably common, but alongside these we can find large numbers of simple and essentially functional locks and keys, which show that the ordinary man was also interested in safe-guarding his belongings. But even these simple locks are always well-designed and their dignified lines are clear evidence of their creators' sound technical skill and instinctive sensitivity to beauty.

Art ironwork

In this section we shall discuss a category of ironwork which demon-strates how this often humble material could be used to achieve the most subtle and pleasing effects. This type of work is sometimes completely unfunctional; it was handled with exquisite artistry and was collected by princes to place alongside show-pieces made by gold-smiths and jewellers.

Some of the earliest examples of art ironwork are caskets, the first of which were made in the Gothic period, though they continued to be made along the same lines in the Renaissance and Baroque periods. A large

155

Metalwork number of fifteenth-century caskets have come down to us, the majority being French or Spanish. They are generally in the shape of a small chest with a lid like the frustrum of a pyramid, or alternatively slightly curved, while their decoration consists of elaborate filigree work arranged in two layers, one on top of the other. The decorative motifs – tracery, rosettes, lozenges and trellis-work – are characteristic of the late-Gothic period. The part of the lock which comes down over the top is also richly contoured. Most of these caskets have one or two rings attached to them; these were partly for carrying them, but their most important function was as a means of fixing them to one's saddle or one's belt. This is a clear indication that they were used as miniature treasure-chests for jewellery, gold and ordinary money while travelling. They could also, of course, be used for safeguarding valuables at home. They were richly designed to match their contents, but in spite of the fact that they were decorative articles in their own right, they were essentially functional and remained so in the following centuries, though they were used only by the wealthy. Caskets made during the Renaissance have high domed lids; the filigree decoration gradually disappeared and the iron was generally kept smooth and undecorated, but reinforced with iron fittings. Decoration remained rather meagre and it seems that the merchants of the Renaissance set greater store by solidity than by elaborate design.

In the middle of the sixteenth century, a special category of *de luxe* caskets known as 'Michel Man' caskets began to be made; their name comes from a master craftsman of that name who worked in Nuremberg, but although they were all made in that town, many of them were made by other craftsmen. They have straight sides and both casket and lid are etched with interlaced foliage, arabesques, volutes, foliage, moresques – in other words, with the whole decorative repertoire of the late Renaissance; we may also find costume figures which were taken from contemporary pattern-books, as indeed were the ornamental motifs. The idea of etching was borrowed from the armourers, and the finest examples of all would also have gold inlay. The 'Michel Man' caskets are generally fairly small, only about 3 inches or 4 inches high, but nevertheless they often have highly complicated locks. They may have been used as gifts, possibly filled with gold coins.

Italian craftsmen, especially those working in Milan, used a special technique which involved casting, chiselling and polishing the iron and then combining it with gold and silver. Once again, the idea originated with the armourers. Iron plaques, or even large panels of iron, would be decorated with pictorial scenes, generally of mythological or historical incidents, treated in relief; the details would then be picked out in gold or silver inlay and the whole plaque would be used to adorn display

156

cabinets, caskets, small altars for private homes, small jewel-caskets, *Iron* chess-sets, mirrors and writing implements. We can tell from the complicated work involved in chiselling the iron, and the use of expensive materials for inlaying, that such items were made as show-pieces for royal collectors.

Caskets made of iron or steel were less common in the seventeenth and eighteenth centuries, though a few exclusive show-pieces were made; most of these are still linked with the name of their illustrious owners, one example of this being a casket made of cut and polished steel which was owned by the Medici.[3]

The art of cutting or chiselling iron was extremely tricky and much admired; it is at its most effective on elaborate weapons made for show. One of the most expert craftsmen at this type of work was Gottfried Leigebe, who made small decorative pieces in chiselled iron, as well as statuettes. In 1660-2, he carved an equestrian statuette of the Emperor Leopold I from a single block of iron, and another one of Charles II of England as St George. Frederick William, Elector of Brandenburg, known as the 'Great Elector', bought the statuette for 600 *taler* and presented it to the elector of Saxony in 1667. It was later incorporated in the Grünes Gewölbe Collection in Dresden, and can still be seen there today. The Great Elector would have liked to bring Leigebe to his Berlin court to work for him, but the artist said quite openly that he preferred to work independently and did not like the idea of working for great lords. When he was appointed official iron-cutter to the Mint in Berlin, he was promised a salary of 400 *taler* plus free board and lodging. In fact he never actually received his full salary and his accommodation did not materialize either, so that his family were left in straitened circumstances when he died in 1683. His case was no exception and we hear only too often of promises made by royalty to their artists which remained unfulfilled.[4]

Medals made of turned steel are another rarity. This technique is known as '*contrefait* work' and can be mentioned as a curiosity. Landgrave Carl of Hesse-Kassel (1670-1730) became fascinated by it and actually made some steel medals himself, as well as some ivory articles.

6 Cast-iron

For many centuries the only known method of treating iron was to forge it with a hammer. Iron was not suitable for casting because it could not be melted down sufficiently. Until the fourteenth century, iron smelted in an ordinary smelting furnace merely turned into a lump which could be doughy in texture but never became any softer or more liquid. Before the invention of the blast furnace, iron had never been reduced to a red-hot molten state, but the blast furnace contains a type of bellows which is able to induce very high temperatures. The first blast furnaces were probably made in western Germany in the Siegerland area and in the Eifel, which had been important centres of the iron industry for many years. This new method of extraction, however, was not generally accepted for a very long time.

Iron was cast in the same way as bronze; the molten metal was poured, when red-hot, into sand moulds; these had been made by preparing a detailed model with the decoration and pressing it down into the sand.

The first articles to be made of cast-iron were cannonballs. These were in fact the staple products of the various iron foundries which were springing up all over Europe, while decorative cast-iron objects, although far more interesting to us today, were no more than a sideline in most cases. Cast-iron cannonballs were produced on a fairly large scale, and in the first half of the fifteenth century they revolutionized warfare, since they were perfectly capable of smashing through thick castle walls. Cast-iron cannons were also made, because bronze ones were too expensive. The earliest examples were fairly small and were undecorated, but by the middle of the fifteenth century, we hear of an elaborate cast-iron cannon made in the shape of a lion and some sixteenth-century howitzers which have come down to us are lavishly decorated in a way which is strongly reminiscent of decorated bronze articles.

158

Iron foundries also made connecting shafts for service in mines *Iron* and mills, cauldrons, pots and mortars, and finally panels for stoves, fireplaces, cooking stoves and even for graves. For greater convenience, these attractively designed panels would be dovetailed together while the metal was being cast. Casting utensils was a slow business, particularly in the case of cannonballs, because the red-hot metal had to be poured separately into each individual mould. Panels would be cast while this was going on, so that the smelting furnaces were used to their full capacity and not left standing idle. Iron panels were cast in a sand-bed, in which a negative imprint of the decorative motifs had been made by pressing wooden models into the sand. Occasionally, and especially in the fifteenth century, the ornamental motifs were carved separately, so that they could be interchanged or rearranged, but later moulds contained not only all the decoration, but also the complete outline of the frame to be used. The models were prepared by wood-carvers or sculptors acting on instructions from the iron-founder, and it was only very occasionally that the client went straight to the sculptor and asked him to supply his models to the foundry. The main products in the fifteenth century were fire-backs, used at the back of fire-places; they were made in many different districts, though obviously they were particularly common in the iron-producing areas.[1] The decoration used on fire-backs varied from one district to another in the fifteenth and sixteenth centuries, so that it is not too difficult to discover their provenance.[2]

Fire-backs made in England in the fifteenth and sixteenth centuries are mainly decorated with rows of weapons, coats-of-arms, crosses, flowers or heraldic beasts, usually against a plain background. This predilection for heraldic motifs reveals the type of client who bought the backs: both the nobility and the landed gentry used this type of back to decorate their fireplaces, which were traditionally in the centre of the English house. Coats-of-arms remained the favourite means of decoration right through to the nineteenth century, although from the sixteenth century onwards the background was filled in with whatever decorative motifs were popular at the time, and with inscriptions, interlaced foliage, fruit and birds. During the seventeenth century the shields bearing the coats-of-arms grew progressively Baroque in style, filling out and with a three-dimensional appearance. Heraldic animals and supporters became very popular, and were depicted with great pomp and circumstance to enhance the general impression of might and importance. One fire-back made in 1636 by a founder called Richard Lennard of Brede Fournes in Sussex is full of civic pride, since the artist himself is represented on it, surrounded by his tools and articles made in his workshop.

159

In Germany, however, fire-backs were popular with ordinary town-dwellers and even with country-people from the very outset. In the Eifel District, for instance, some of these backs could still be seen in large farmhouses up to a few years ago; in some instances they were still *in situ*, although most of them had been transformed into cover plates for manure pits or dog kennels.

Fire-backs made in Germany in the sixteenth century were usually decorated either with scenes from the Bible or incidents taken from classical mythology. Totally non-figurative decoration is occasionally found, and scenes portraying soldiers or peasants dancing. Coats-of-arms, Baroque flowers, fruit, reversed monograms, inscriptions, figures and allegories were not widely used before the seventeenth century. The favourite themes in the sixteenth and seventeenth centuries were the stories of the jug of oil belonging to the widow at Sarapeta and the marriage at Cana. These stories concerning wine may well have been particularly popular in the wine-producing districts near the Rhine. In Protestant districts, scenes from the Old Testament were given precedence, but in Catholic areas we still occasionally find saints being depicted, even in the sixteenth century. The copper-plate engravings executed by the 'Little Masters' in the middle of the sixteenth century had a profound influence on the craftsmen who designed fire-backs.

Although this type of work was produced in quite large quantities, very few fire-backs have survived in their original state. Stoves consisting of cast-iron panels at the bottom and tiles at the top are even rarer; they are known to have existed at the end of the fifteenth century, but the earliest ones to have survived date from the beginning of the sixteenth. Production methods and design are very similar to those of fire-backs, but since iron stoves needed far more panels, many of which were coloured, as well as the tiles and framework, they were very expensive to buy. Consequently in the first half of the sixteenth century the only people who were in a position to have such stoves made were royalty, church dignitaries, the wealthier monasteries and other religious foundations, or the town halls in the richest cities. At the beginning of the sixteenth century, a stove cost as much as a small folding altar decorated with carved wooden figures and paintings, or a small house. The position began to change in the second half of the century, so that a craftsman called Georg Schwarz was supplying the town hall at Leipzig with at least twenty stoves in 1556. But even as late as 1663 a Saxon foundry owner called Abraham Conrad wrote that buying a stove was a very expensive business and not everyone could afford one.[3]

The subject matter used for decorating the stoves was the same as

XII (*opposite*) Two views of a pewter jug with allegorical figures, made by Paul Weise of Zittau; late sixteenth century.

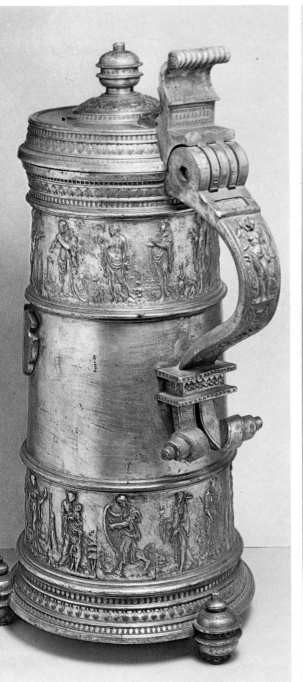 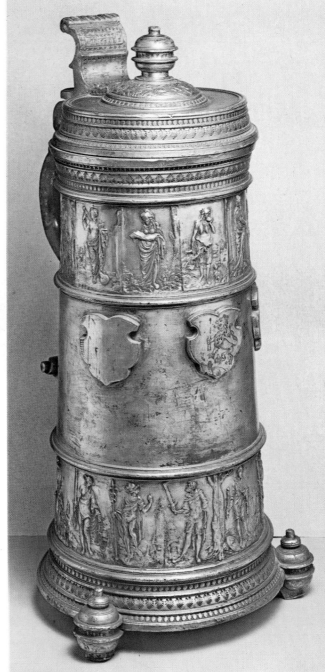

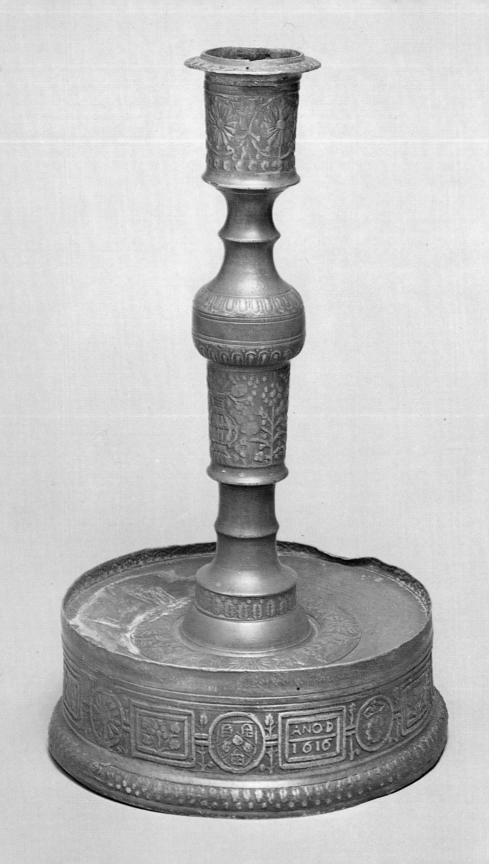

for fire-backs. In the sixteenth century, images from the classical *Iron* world were frequently used, which shows that the iron-founders were familiar with the ideas of the Humanist age; many of these must have reached them via the ornament-engravers.

Eighteenth-century backs are faithful to the style of their period, and their designers were just as willing to participate in this exuberance and profusion as their predecessors had been to conform to the florid decoration of the Rococo style. A large number of backs, mainly those made for royal castles, resemble sculpture in the intricacy of their design. They are clearly the work of highly skilled artists who had mastered their craft to such an extent that they no longer had any technical difficulties to overcome.

From the second half of the seventeenth century onwards, cast-iron gravestones began to appear, most of which bear fairly long inscriptions, decorative motifs and at times even human figures on them. Most of them were bought by bourgeois families, who were delighted to have a way of honouring their dead with appropriately dignified memorials without having to turn to a stone sculptor; this would have involved far more expense than commissioning a woodcarver to produce a wooden model and then merely paying for the casting.

At the beginning of the nineteenth century the production of cast-iron panels became less and less important as cast-iron began to be used for other types of articles. During this period, which was, after all, the beginning of the industrial age, the economic and technical advantages of casting such objects as grilles, pillars, balusters, candelabra and other architectural objects began to be appreciated. Since the guilds had now forfeited both their power and their former significance, iron-founders had no qualms about competing with the blacksmiths, whose craft was in any case on the point of dying out. On the other hand, the iron-founders were able to supply the sort of work which suited current fashions in the Empire period, and it was this which led to the victory of decorative cast-iron. In the art centres of Europe, above all Paris, Berlin and Munich, gifted architects and an artistic tradition could still combine to produce highly important work.

At the beginning of the nineteenth century the technique of casting iron had been developed into such a fine art that relief-moulded work could be produced which was the equal of cast-bronze articles. It had the same sharpness of detail and the same smooth surface. Improvements in technique resulted in work of a higher artistic standard and also opened up a whole new series of possibilities for cast-ironwork. As 'art ironwork' it could compete with cast-bronze articles and even with the work of the gold and silversmiths. The idea of breaking new ground was made all the easier by the fact that in the period following

XIII (*opposite*) Pewter candlestick made by the London master, William Grainger, in 1616.

Metalwork Napoleon's domination of Europe, precious metals had become rare in Germany, the very country where decorative cast-iron reached its highest peak. The Wars of Independence against Napoleon had strained the gold and silver reserves of various districts to bursting point. 'I gave gold for iron' ran the slogan which urged the German people to send vast quantities of art treasures to be transformed into coins. Cast-ironwork flourished under such favourable circumstances, particularly in Berlin and Silesia, and later in the Rhineland. Iron cast with extreme delicacy was used for making brooches and pendants, earrings and bracelets, chains and clasps, all designed in the Empire style. Surfaces were covered with a fine layer of black lacquer and jewellers achieved contrasting effects by polishing certain surfaces until they shone like mirrors, or making individual sections in brass instead of iron.

Plaques made of cast-iron were very popular until well into the nineteenth century. They were shaped like small rectangular, oval or round pictures with frames, depicting portraits of royalty moulded in relief, or contemporary figures, allegories or views showing important buildings or cities. From the middle of the nineteenth century onwards it became the custom to give cast-iron plaques as New Year gifts.

Eventually, small three-dimensional figurines were made in cast-iron, including chess pieces, statuettes of Frederick the Great, and busts of contemporary royal figures, especially the Empress Marie-Louise. The artists who made the models for this type of work included such famous men as Schadow, Rauch, Rietschel and Schinkel, and the work made from their designs is appropriately outstanding.

One of the most important champions of decorative cast-ironwork was Schinkel, who recognized its potential as a vehicle for architectonic designs. He left his imprint on the new architecture created in Berlin and Prussia during his age; under his influence railings, river bridges, candelabra and lamp-posts tended to be made of iron. This saved huge sums of money which had previously been paid out for the skilled workmanship involved in wrought-iron, sculpture, stone-cutting and bronze-casting. The financial aspect began to play an important part from now on. Cast-iron became a cheap substitute for other materials which were too expensive, either because their intrinsic value was greater, or because they needed to be treated by some time-consuming process.

As so often happens, nineteenth-century craftsmen went too far in using cast-iron and there is no excuse for the way in which they exhausted its various possibilities. In the second half of the century a new and remarkable architectural style was evolved with the help of iron; its influence is still felt today. But in spite of its uninhibited attempts at progress and its optimistic belief in the value of progress,

this style of historicism still tried to reproduce in iron traditional architectural structures such as pillars, architraves and so on, forgetting that every material has its own inherent aesthetic limitations. Objections were soon raised to the way in which iron was being misused, and Ruskin was one of the first to demand a return to the idea of allowing the inherent properties of a given material to determine the uses to which it is put.

Art Nouveau, whose influence was felt in all the civilized countries of Europe, finally overcame the effects of historicism in the applied arts. In the realm of decorative ironwork one or two individual craftsmen working at the turn of the century produced some outstanding work; but by this time wrought-iron could no longer occupy the exalted position which it had enjoyed up to the eighteenth century. It was now more than ever restricted to an élite of wealthy art lovers who were more interested in aesthetic quality than in saving money by using cast-iron.

On the other hand the production of cast-iron grilles and railings flourished during this period. The entrances to the metro stations in Paris are proof of the artistic possibilities in the design of cast-iron grilles made in about 1900. Cast-iron gates, doors, park grilles and garden railings still grace the estates and houses of all ranks of the bourgeoisie in Central Europe. They give a clear idea of how widespread *Art Nouveau* had become at the turn of the century and of the way it had penetrated all the different levels of society.

In the evolution of ironwork, we have seen that there are two main branches of the craft, developing along parallel lines but only very rarely coming together. Firstly, there were the armourers making armour and weapons, and secondly there were the blacksmiths making iron-fittings, grilles, locks and various types of utensils. Both crafts provide ample evidence of great technical and artistic skill and of the craftsmen's desire to ennoble the material used. However, in so doing, they transformed iron into an expensive material, restricted to an exclusive circle of wealthy patrons. It was not until the nineteenth century, when all the technical possibilities inherent in the production of cast-iron had been experimented with, and casting had been reorganized on more economic lines, that decorative ironwork became cheap and therefore popular.

Part IV Pewter

1 Tin-mining and the making of pewter

In the ancient world tin was known and used from an early date. At first, however, it was not used in its pure form, but was combined with copper to make bronze, which is a harder and more serviceable metal than either of its components.

Tin is only very occasionally found as a pure metal. Normally, it is obtained from cassiterite, also known as tin-stone. The resulting substance is tin dioxide (SnO_2), which takes the form of transparent crystals, yellowish-brown in colour, and is found in veins and strata. After being brought to the surface, it is washed, the tin-stone is smelted in order to free it from impurities, then heated in furnaces or kilns to reduce it. This crude tin, or 'working tin', then has to undergo further processes to remove certain admixtures until the final result is pure tin.

The earliest tin mines were probably developed in the countries to the north and north-east of Mesopotamia, in the mountains of Chorasa and Transoxiana. Initially tin was apparently very highly valued, and, like gold and silver, was treated as a very precious metal. In northern Persia it was used for jewellery, examples of which have been found in tombs dating from 2000 to 1500 BC.

When the Phoenicians began to increase their trading activities in the Mediterranean in 2000 BC, tin began to be more widely used. Probably, even at this early date, the Phoenicians obtained it from the Cornish tin mines which were already in use in prehistoric times, i.e., in about 1500 BC, and which continued to be one of the main producers of tin until the Middle Ages. In about 360 BC a Greek historian called Pytheas visited the so-called 'Cassiterites', by which he clearly meant Cornwall, and described his impressions in the following words:

In the foothills of Britain the natives are very helpful to foreigners and contact with overseas traders has softened their manners and behaviour. Their method of preparing tin involves an artificial treatment of the layers

165

Metalwork of earth, which run through their rocky land; they extract the pure metal by smelting and always fashion it into cubes. The precious metal is transported to an island called Ictis [the Isle of Wight] near Britain, where it is bought by traders who then take it over to Gaul.

Tin mining in Cornwall is not specifically mentioned in any documents until 1156, although by then it had been supplying the countries of the civilized world for hundreds of years. In 1337 Cornwall produced 600 tons of tin. The raw metal was exported to northern France, Provence, Majorca, Genoa and Venice, where it was melted again to purify it and either resold as a precious commodity, or else subjected to further processes. Genoa and Venice in particular supplied refined tin to Constantinople, Asia Minor and Persia and other places, until the sixteenth century. From the twelfth century onwards the tin mines in the Erzgebirge in Germany began to compete with the Cornish mines. In the fifteenth and sixteenth centuries the production of tin and silver from these mines brought unparallelled prosperity to the cities of this region and encouraged great political, economic and cultural activity. Although tin mining declined in this area at the time of the Thirty Years' War it never came to a complete standstill and the eighteenth century saw another rise in production.

In the Middle Ages, tin used to be sent from the foundries to the large trading towns, and the Hanseatic League monopolized the tin trade in its heyday. The raw material reached the foundries via fairs and markets or through middle-men. The foundries could not however use the crude tin for manufacturing utensils without further processing since it was too brittle and when cast would not fill all the little details of the moulds properly. In order to overcome this disadvantage other metals were added to make what we call pewter. Pewter was divided into three categories, according to the percentage of alloys it contained: (1) good clear, pure pewter, also referred to as 'English pewter'; (2) test-pewter; and (3) low-grade pewter. The first type was usually mixed with copper, or occasionally with bismuth.[1] Very occasionally brass was used in place of copper. Copper and bismuth gave a lighter shade, a pleasant timbre and great compactness. This first type was considered to be the best quality and was therefore the most expensive. The so-called test-pewter contained a lead alloy, which made the raw material more pliable, easier to mould and substantially harder than pure pewter. Since lead is much cheaper than tin, the price of the metal was reduced. This reduction in price tempted many founders to add as much lead as possible in order to save money and be more competitive in their prices. There are many disadvantages, however, in adding too much lead. This changed the colour of the products to an unattractive blackish-grey, gave them a hollow sound and made them heavy

166

and unwieldy. Moreover, there existed the possibility that when they came into contact with certain substances contained in foodstuffs, such as acetic acid, poisonous compounds would be released; this made utensils manufactured from this type of test pewter dangerous, especially those used for eating or drinking.

As early as the fourteenth century, governments had found it necessary to issue directives about the composition of tin alloys, partly to protect their citizens against poisoning, but also to prevent foundries from making excessive profits by the use of too much cheap lead in place of tin. The guilds and corporations, acting as self-controlling organs for the artisans, developed a system by which all tin foundries, or their products, could be regularly inspected; it was compulsory for their members to stamp their products with special marks. We shall discuss this later.

The proportion of lead to tin was laid down in the regulations for tin-founders. In German-speaking areas, the alloy most widely produced was the one known as test-pewter, the composition of which varied from state to state, district to district, and town to town.[2]

Low-grade pewter included all alloys in which one part of lead was mixed with less than six parts of tin. The lowest limit was 1:1. This very inferior alloy was normally only used for objects which did not come into contact with food, such as decorative articles, vases, ornamental fittings, handles.

Articles made of pewter are always cast. Pewter cannot be hammered as it is not as malleable and resilient as silver or copper. The moulds which were used for casting simple everyday utensils were made of clay mixed with calves' hair. They were made up of separate parts so that they could be taken to pieces after the metal had been cooled without any risk of damage, and could be used again as often as required. Brass moulds, or occasionally moulds made of slate, ophite or sandstone, were used for items with relief decoration. A pewterer always made his own clay models, but brass moulds were made by special mould cutters, mould engravers or mould etchers.

After they had been cast, the utensils – dishes and containers – were turned on a type of lathe, to plane down their surfaces and remove the casting seams.

It was not long before pewter objects were decorated. There are two possible methods: the decoration could be either cast with the object in relief, or drawn – i.e., engraved – into the surface. Relief decoration has always been used for special, highly-prized utensils and receptacles, although in fact it can be cast again and again, whereas engraved decoration usually retained the flavour of popular art, although, in some cases, it too was raised to the level of fine art.

167

Relief decoration was normally applied in brass moulds and was carved *intaglio* with a chisel. Very occasionally the motif was etched into the mould, a method which was popular for a time in Nuremberg during the second half of the sixteenth century. The result was a clear-cut, although rather flat, image, rather reminiscent of wood-cutting.

The craftsmen who executed the engraving – occasionally the pewterer himself, but usually a specialist engraver – worked with a burin on the actual object, after it had been cast and turned on the lathe. There are several techniques of engraving: long, thick engraved lines, tooling in which dots are set close together in rows, and in which the line made by the engraving tool breaks up to form short zig-zag strokes. This last method is intended to give a broader effect to the design, to make it stand out more and to create a feeling of greater depth. Designers normally used this method for ornamental motifs such as flowers, foliage scrolls, simple figures and monograms. Pewter is only very rarely embossed, but punching is far more common, with specific decorative motifs stamped close together to form a frieze. It is very unusual to find etched decoration on pewter, although it can be seen on a group of dishes made in southern Germany in the middle of the sixteenth century.

Sometimes pewter utensils with a dull silvery lustre would be combined with golden-yellow fittings or mounts made of brass, especially in northern Germany, where brass foundries were very important.

Pewterware has only rarely been coloured, partly because it was difficult to make the colours, or even gilding, last for any length of time, and partly because the silvery lustre of the metal itself was so attractive that designers were reluctant to conceal it with bright colours. In two particular periods, however, coloured pewter is known to have been produced: at the end of the seventeenth century in France, and during the nineteenth century in Germany. In both cases the reasons for this were economic.

Guilds and marks

During the twelfth and thirteenth centuries, pewterers were often associated with other metalworkers as part of the guild of smiths, but as their numbers and their reputation grew they began to form their own corporations. These corporations appeared as early as the thirteenth century in the largest European cities, and spread in the fourteenth century.

Regulations concerning apprenticeships, journeymen's years of travel, tests for the status of master, enrolment in the guild and payment in old age and for sickness were similar to those for blacksmiths, braziers

Pewter: Gothic

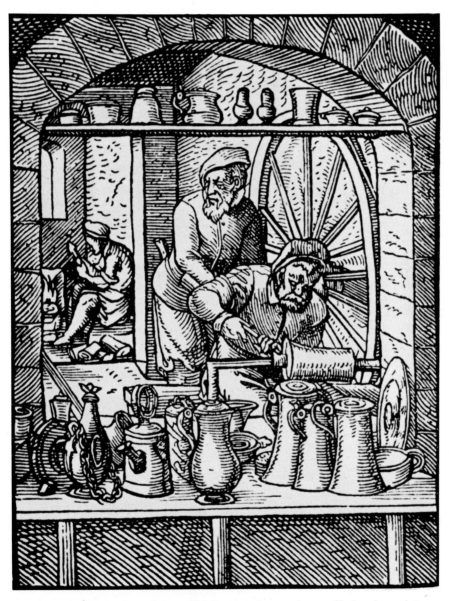

194 The pewterer in his workshop, which serves also as a shop to display the variety of his wares; woodcut, Frankfurt, 1568.

195 (*above*) Apostle spoon of pewter; German, sixteenth century.

196 (*top right*) Pewter candlestick in Gothic style, probably adapted from bronze original; German, later fifteenth century.

197 Pyx made from pewter with Gothic surface ornament; Italian, before 1450.

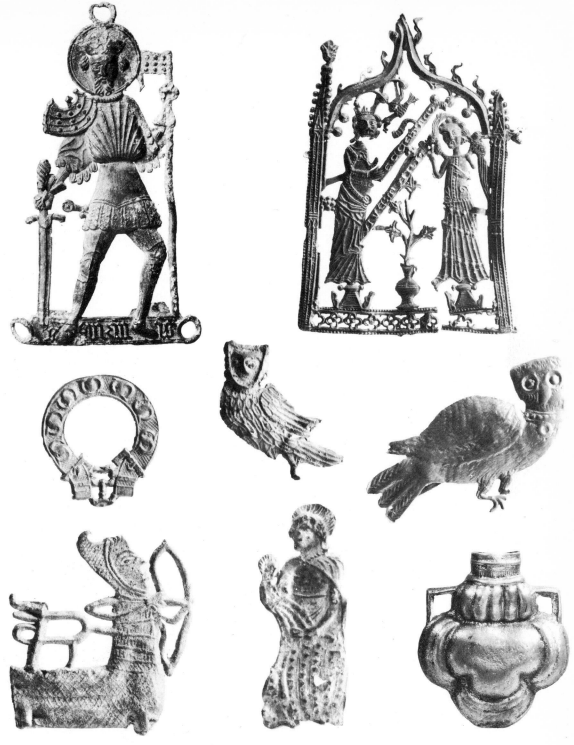

198 Pewter badges and objects connected with the medieval pilgrimage trade; most were manufactured by monks using moulds of stone and iron; (*top; bottom centre*) fifteenth-century pilgrims' badges; (*centre and bottom left*) agraffes or hat badges, showing heraldic devices; (*bottom right*) ampulla for holy water from a pilgrimage shrine.

199 (*right*) Octagonal jug with handle and lid; fourteenth century.

200 (*far right*) Pewter jug with long spout and engraved lid, designed to contain holy oil; from the treasury of Basle Minster; French, fourteenth century.

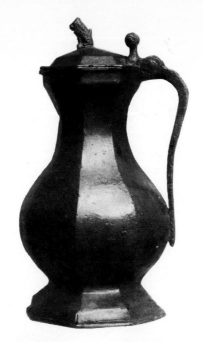

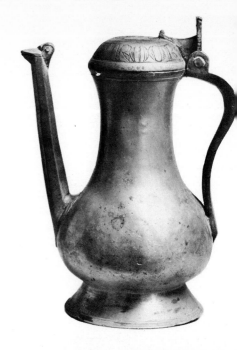

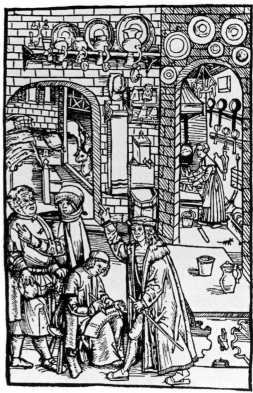

201 (*left*) Detail of a painting showing water poured into a beggar's bowl from a pewter jug; Hans Holbein, *c.* 1500.

202 (*right*) House interior showing living room, bedroom, kitchen and stables. Many pewter vessels are to be seen hanging on the walls – plates, jugs and a candlestick; woodcut, Mainz, 1508.

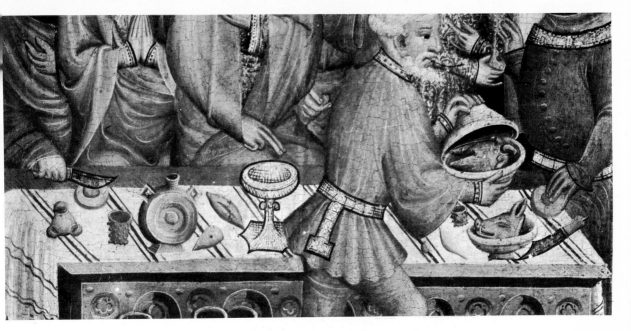

203 (*top*) Table laid for a marriage feast, the pilgrim's flask is of pewter, and other utensils are of pottery, glass and silver; from a painting by Master Bertram, *c.* 1390.
204 (*bottom left*) Pewter jug with foot, nearly 2 feet high; display piece by the Regensburg master Cunz Haas, 1453.
205 (*bottom right*) Tavern bottle in the form of a field flask; Cologne, fifteenth century.

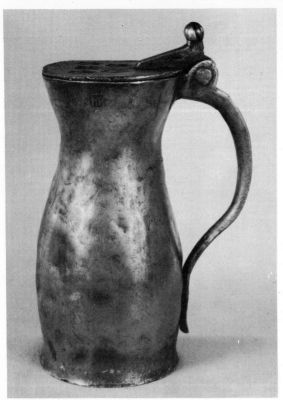

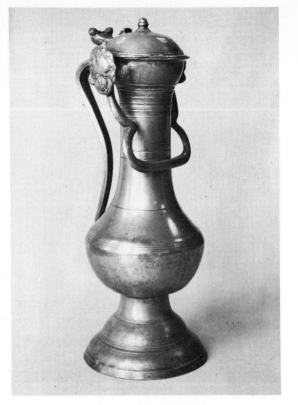

206 (*above*) English measuring jug; London, sixteenth century.

207 (*top right*) French *cimarre*; Champagne, *c.* 1600.

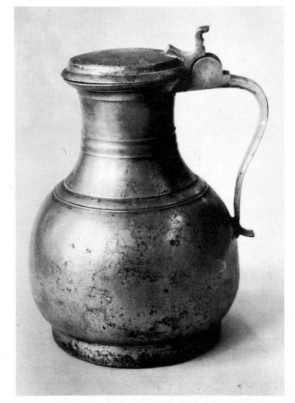

208 Dutch tavern jug with broad belly; Amsterdam, seventeenth century.

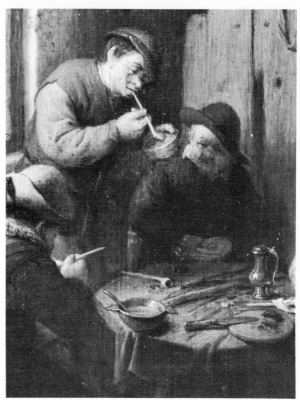

209 (*left*) Pantry sideboard with pewter dishes, jugs and tankards; from a painting by Lucas Cranach, 1525.

210 (*right*) Detail from a Dutch tavern scene, showing a pewter jug; from a painting by Isaac Ostade, seventeenth century.

211 Allegory of a guild dispute between a pewterer, armed with a syringe, and a file-master; engraving by Jost Amann, sixteenth century.

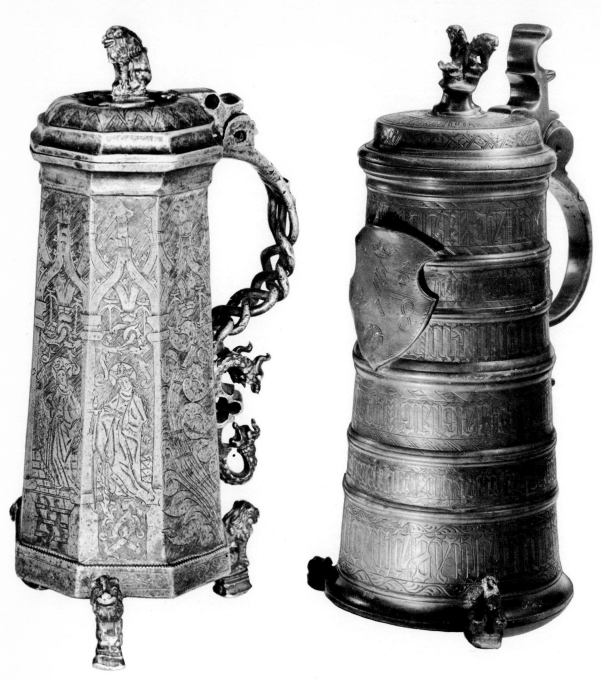

212 (*left*) Polygonal 'Schleifkanne' from Villach, engraved with figures of saints and with an elaborately worked handle; Villach, end of fifteenth century.

213 (*right*) Guild tankard (Schleifkanne) of the bakers in Schweidnitz; 1498.

and coppersmiths. They were intended to ensure that the individual masters could continue to earn their livelihoods, and to guarantee the privileges accorded to their status. In England regulations concerning the training and establishment of masters differed somewhat from those on the Continent, and were more generous. In 1555, a regulation issued in London laid down that apprentices had to serve for seven years, but after this period, provided that they had reached the age of twenty-four, they were entitled to receive the freedom of the city, thus becoming yeomen. A yeoman had the right to enter his touch on the touch-plate, kept in the guildhall, without having to prove that he had travelled as a journeyman or had practised his trade for some time. He was required to show a sample piece made by himself (known as an 'assay' or 'test piece') which was judged by the chairmen of the guild. He had to pay a fee to enter his touch. These were the only conditions necessary to start up a business. Of course not every young man who had just completed his apprenticeship could raise enough money to found a business and pay the fee for entering his touch, so many had to start working as a journeyman under a master and try to save up enough capital. Those who had entered their touch and opened a workshop were admitted to the guild as 'liverymen', which was the equivalent of the rank of 'master' on the Continent.

Great importance was attached to touches, and one of the guild's main duties was to control them. As mentioned above, it was laid down that metal used for making utensils had to consist of specific proportions of tin to lead. By putting his touch on every piece of pewterware made by him, the master-pewterer guaranteed its high quality, and also that it observed the appropriate guild regulations. In Germany, Switzerland, Austria, and also in France until the seventeenth century, all master-pewterers possessed a stamp of the town's coat-of-arms, which they were allowed to use on their own responsibility as well as their own symbols. These individual touches were registered after the examination for admittance as master had been successfully passed and generally consisted of a master's personal coat-of-arms, his family mark or some other emblem selected by him, together with his initials.

Occasionally, however, the guild chairmen would test pewter by making spot checks. They used weight tests, although such tests were not, in fact, very accurate. This is how they were described:

The pewterers, i.e., the comptrollers, have two small slates about an inch square which fit together exactly; in the underneath one there is an indentation shaped like the segment of a sphere and with a gutter. The upper slate is placed onto the grooved surface and then they are pressed together between two boards in a carpenter's vice. The pewterer fills the indentation with his molten test-pewter and when it has cooled trims away anything

169

Metalwork which has formed outside the casting duct. Then he tests his assay on a scale normally used for weighing gold. He weighs it with a piece of test-pewter exactly the same size and shape as his test-piece and prepared straight away after the other was cast.

Now if a pewterer had used too much lead in his alloy, the piece taken away would be too heavy and his error would be discovered. He would then be reprimanded and punished. Guild and municipal documents are full of disputes over this particular question, since it was a great temptation for a pewterer to economize by substituting as much lead for tin as possible.

On the Continent, the normal procedure was for a piece of pewter to be stamped with the city mark and the mark of the individual master. Pewterers were responsible for marking their products as early as the fourteenth century, but, since the few pieces that have survived from the Gothic period are rarely marked, we can assume that regulations were not taken very seriously. Marking did not become general practice until the sixteenth century.[3]

Apart from the valuable information which they provided for contemporary inspectors, pewter touches are an extremely important source of information for modern historians and collectors; with their help it is possible to establish the maker of any given piece, always provided that the touches can be correctly identified. Town-marks do not present much of a problem; they generally show the town's seal or coat-of-arms, which can easily be looked up in the appropriate reference books. The master-touches present a far greater problem, since there are so many thousands of them. The normal practice was for a newly qualified master to choose a touch and enter it in the touch-plate which was kept in the guild hall. When the touch-plates have survived and can be consulted easily, we can use them to identify the individual touches. If they have not survived, it may still be possible to identify the master's initials by consulting the lists of guild-members. When these have also disappeared, a correct identification can be no more than a matter of luck.

In those countries which have produced a large amount of pewter-ware, much painstaking research has been devoted to identifying pewter touches and publishing collections of them during the twentieth century. As a result, many pieces can now be classified according to the place and date of their manufacture. The following standard authors should be mentioned: Erwin Hintze for most of the different districts in Germany; Gustav Bossard for Switzerland; Tardy for France; Howard Herschel Cotterell for England; B. Dubbe for Holland; and G. Wolfbauer for Austria. In addition, a number of monographs have been published to complete the big collections.

170

2 Antiquity to the Gothic period

Pewter utensils do not seem to have been used in any quantity until Roman times. In one of Plautus's (254-184 BC) comedies a banquet is described at which the food is served off pewter dishes. Galienus, a Graeco-Roman doctor, recommends that medicines should be kept in containers made of glass, horn, silver or pewter, a piece of advice which is given by other authors of the same period writing on medical matters. All that has survived from the Roman period is a completely haphazard collection of pewter utensils. Some interesting pieces have been found in England, which had the richest and most important tin mines in the ancient world. The pieces which have survived are all bowls with ornamental bevelled edges decorated with circular motifs such as stylized heads. A plate dating from the third century and found in Cambridgeshire is divided into sections and concentric grooves; its decoration suggests that it belonged to a cultured household. On the other hand, a completely undecorated bowl has been found in France, presumably used by a soldier for his food. Some vases and jugs dating from the second and third centuries AD have been excavated near Bridlington and Bristol; and these, together with some excavated at Zaltbommel in Holland, closely resemble ceramic and silver articles of the same period.

Compared to the enormous number of items made of bronze, silver, clay, and glass which have survived from the Roman period, very few pewter objects have remained. This is partly due to the fact that pewter easily corrodes when buried but it also indicates that pewter could not have been used widely at this period. The design on the few surviving pewter objects is so similar to that of pieces made of other metals, that it is clear that pewterers had not succeeded in evolving their own individual style and remained relatively unimportant.

The earliest pieces of medieval pewter which have survived were made in the Gothic period. The only information about the use of

171

Metalwork pewter in the pre-Gothic period comes from written sources, which are mainly concerned with the problem of whether church plate, particularly communion chalices, may be made of anything other than gold and silver. At the Council of Rheims (803-13), poorer churches were given permission to use pewter chalices, and this decree was confirmed by the Council of Tribur (895). During the next few years the Catholic Church discussed this question time and time again at all its councils, assemblies and congresses, but a final, unanimous solution was never reached. Even when the decrees of the Church leaders had been published it was by no means certain that priests of small parishes could act in accordance with them, since they were often so poor that it was impossible for them to have altar vessels made of precious metals and the only alternative was pewter. Copper, bronze, iron, lead, glass, horn and clay could not be used since they either oxidized when they came into contact with wine, or else there was always the risk that they might break and desecrate the sanctuary. Such misgivings did not apply to pewter.

Inventories drawn up in the ninth century occasionally refer to small pewter containers which presumably held elements for the Mass. The fact that later inventories do not include this type of pot does not mean that they were no longer being made but simply that only objects made of precious metal were listed at that time. The monk Theophilus Presbyter devotes a whole chapter of his *Schedula diversarum artium* to casting pewter objects, under the heading *De ampullis stagneis*. The method he describes is based on the *cire perdue* or 'lost wax' principle of casting bronze. This method was only used for pewter at a very early date; it was too expensive for producing large numbers of everyday utensils.

Although bronze and brass were often melted down because they were precious metals, pewter was even more in danger of being destroyed since it is a fairly soft material and because it was used to make everyday utensils in continuous use and soon became dented, scratched and cracked. Thrifty householders were only too willing to return their worn-out utensils to the pewterer in exchange for hard cash; the pewterer would melt them down without further ado and make a profit by making new, up-to-date implements.

For present-day collectors and admirers of antique household utensils this system was most unfortunate, since it means that an enormous amount of fine and valuable pieces have disappeared for ever – even today pewterware is occasionally melted down. As a result only a small number of household and kitchen utensils have survived from the Gothic and late-Gothic periods. The few pieces which have remained have survived purely by chance, thanks to some contemporary catastrophe

172

such as a shipwreck. Although they give us some slight idea of the quality *Pewter* and appearance of late-Gothic implements, they cannot provide us with a complete picture of the riches produced in the period.

The treasure preserved in Monza Cathedral contains a number of ampullae which look like small roundish or disc-shaped bags. They were used as containers for consecrated oil and pilgrims would buy them as souvenirs of places they had visited. They were made of pewter and the sides were decorated with Biblical scenes moulded in relief and short Greek inscriptions. The earliest examples date back to the end of the sixth century and the beginning of the seventh. In the fourteenth and fifteenth centuries pilgrimage ampullae were particularly fashionable in France and Italy, owing to the great popularity of pilgrimages at this time among all classes of society.

Apart from ampullae of consecrated oil or holy water, throughout France, Germany, England, Italy and Spain churches would sell small badges to pilgrims, some of them depicting the patron saint of pilgrimages, or whatever relic was on show in that particular church, or perhaps a stylized image symbolizing the miracle that had taken place there. The badges that have survived from the twelfth to the sixteenth centuries are small and moulded in flat relief, with loops or pins to fasten them on to pilgrims' clothes. They were more than mere mementoes, or souvenirs, since they were believed to be amulets and, as such, capable of working miracles. The pilgrim churches held the monopoly for the manufacture of these badges and made a considerable profit out of it. Bishops who had pilgrim churches in their sees would often demand a fee in return for granting the monopoly.

In addition to the pilgrim badges, another group of basically similar pewter objects appeared in the Middle Ages, particularly in France. These are the clasps, or brooches, which the common people used to adorn their hats or clothes instead of real jewellery; they were also worn sometimes as political badges, for example, the badges worn by the followers of Étienne Marçel during a revolt among the citizens of Paris in 1358; the people of Armagnac wore similar favours in 1411.

Some richly decorated caskets which have survived from the late thirteenth century and the fourteenth century were used as reliquaries. The actual shrine is made of wood, with pewter fittings nailed on the sides. One group of reliquaries made in the Rhineland or in France have the usual wooden body, but the walls are lined with silver leaf and the fittings are worked in filigree. They were modelled on reliquaries made of precious metals, and by combining gold and silver craftsmen sought to emulate their material as well as their style and technique. They were also influenced by ebony caskets and other pieces worked in the technique known as *opus interrasile*. Filigree

173

ornaments of pewter were made with the same type of matrices as those normally used by goldsmiths, although the goldsmith obtained his ornamental silver sheets by punching them out of the stencils, while the pewterer had to cast his patterns. We can assume that goldsmiths sometimes worked in collaboration with pewterers, and this is confirmed by the close resemblance between the designs of the different ornaments.

Other objects which resemble their counterparts in gold and silver are the small boxes for holding consecrated wafers, chalices and a late-Gothic candlestick, where the subtle texture of silverwork has been imitated in pewter.[1]

Several receptacles from the cathedral treasure at Basle are made in the shapes normally used for everyday utensils; an inventory was made of them in 1477, but they probably date back to the fourteenth century. They were used for the holy oil which was consecrated annually on Maundy Thursday, and their lids are engraved with the labels s x o x PUERORUM, S x CRISMA; S x OLEUM INFIRMOR (oil for baptisms, oil for anointing, oil for the sick). Occasionally a plaque engraved with an eagle can be seen set at the bottom of one of the containers, probably referring to the arms of the bishop of Basle, the Burgundian Jean de Vienne, who was in office in 1366–82. Three cylindrical vessels accompany the group of oil containers and their basic shape is that of the turned wooden containers used by apothecaries.

We have seen that very few religious pewter vessels have survived from the Gothic period, but secular pieces are even rarer. The only articles that remain from the fourteenth century are a few pot-bellied tankards made somewhere along the North Sea coast. They were usually discovered during dredging operations or while a wrecked ship was being brought to the surface. They are known as Hanseatic tankards because they were all found near the coast in the region forming the major part of the Hanseatic League.

Although pewter objects seem to have been very rare in the period, contemporary inventories, chiefly those drawn up by monasteries and abbeys, suggest that more and more pewter was being used for everyday utensils. In 1470, for instance, it was stated that the nuns in the convent of the Holy Cross at Erfurt had 150 pewter *amphorae*, as well as 70 dishes, 12 tankards and 33 bowls, while the nuns at St Zyriak's had 200 *amphorae*, flasks or jugs, and the Cistercian nuns 150 pewter items. These large quantities of pewter tableware are due to the fact that convents and monasteries were flourishing during this period and had huge numbers of inmates, so that they were rich enough to buy pewter instead of the more usual clay or wooden tableware.[2] But pewter tableware did not become common among small farmers and the poorer town-dwellers until the seventeenth century.

174

Most of the pewter vessels made in about 1500 which have survived intact are tankards used for serving wine, beer or water. The different areas of Europe had their own local shapes which can easily be recognized; in fact they scarcely ever changed, and were very rarely adopted by another region, so it is fairly easy to distinguish between tankards made in northern Germany and Franconian ones made in the Main area, between articles made in Switzerland and Burgundy, Paris and London. A study of contemporary paintings showing tables set for meals reveals that ornamental glasses or stoneware goblets were preferred for drinking, and that silver goblets were used in royal households. Pewter tankards holding $1\frac{1}{2}$-3 litres can be seen standing on tables or being cooled in cooling basins on the floor. The drinks would either be poured out by servants into individual mugs or people would help themselves; occasionally they would drink straight out of the jug, as in a painting of the Seamen's Guild in St Olaf's chapel, Nymwegen, but this was certainly considered bad manners.

One particularly elegant type of pitcher appeared at the end of the fifteenth century in north-east Germany. Only a few examples of this design have survived, but they are very slender, baluster-shaped vessels and were probably inspired by the stoneware jugs from Siegburg known as 'Jacoba' jugs. One baluster jug found in Sweden has polygonal sides broken up into panels, engraved with the figures of St Ursula, St Barbara and St Apollonia; it was probably imported from Stettin. A painting by Hans Bornemann executed in 1444-50 depicts St Andrew using a baluster-shaped stoneware jug to baptize a child, which suggests that the Swedish jug was also used in church.

The earliest domestic pewterware which has survived in England dates back to the beginning of the sixteenth century, but the Pewterers' Guild was registered in 1348. In 1475 the Guild bought a piece of land in Lime Street, London, but the building which they erected there was destroyed in the Great Fire of London in 1666. It was later rebuilt and still stands on the site.

The earliest surviving domestic pewter objects made in England – as in France, Germany and Holland – were jugs for wine or beer. Typical examples are sturdy, squat baluster-shaped vessels, with simple curved handles and completely flat lids, on which the mark is generally stamped. Baluster jugs of this type were made in London, with only minor alterations to the design, until the nineteenth century. Another type of early English pewterware is a series of plates stamped with a feather surmounted by a Tudor crown. This symbol probably refers to the badge of Henry VII's eldest son, Arthur, so that this type of plate must have been made in the sixteenth century.

The oldest everyday pewter utensils which have survived in France

Metalwork are again wine jugs. Most of them come from Paris and belong to a specific type known as *pichets*, rather similar to the baluster pitchers made in London. Very few *pichets* made in the early sixteenth century are marked, and French pewterers obviously ignored the regulations as blatantly as their counterparts in England and Germany.

The most valuable early examples of the pewterer's art are the large flagons used by the guilds in Silesia, in their heyday at the end of the fifteenth century and in the first decades of the sixteenth. The largest ones are as much as thirty inches high, but they were made with consummate skill down to the smallest detail. The outsides of the flagons are polygonal, and each facet is engraved with a saint standing beneath a canopy, while secular and at times positively frivolous figures romp about on the lid and up by the rim. These Silesian flagons continued in this late-Gothic style until about 1530, but quality had deteriorated by the time of the Renaissance. Production waned and the neighbouring district of Moravia took the lead in this field with a design more in keeping with the new Renaissance style.

These flagons provide interesting documentary evidence about the full significance of the guild system and the extent of the power it wielded. One of the most important features of guild life was the masters' meetings, at which advice was given, decisions were made and judgments passed on matters which often affected the political and cultural life of whole towns and communities. These activities also included the admission of new members, swearing them in, and the whole proceedings were rounded off in fine style by a banquet. The banquets were organized according to specific rules, most of which applied to drinking rituals; measures were generous, judging by the size of many of the flagons. They have rich fittings and are embellished with figure decoration executed by professional engravers. Almost all guilds in the area were able to acquire enormous flagons. Several of these have survived, including the ones belonging to the Bakers' Guild in Breslau, which dates from 1497, the Clothmakers' Guild in Hirschberg (1506), the Ropemakers' Guild in Breslau (1511), the Guild in Löwenberg (1523) and the Farriers' Guild in Lauban (*c.* 1523).

The flagons used by the guilds in Moravia were as large as the Silesian ones, although they were always conical in shape and divided up into horizontal patterns consisting of engraved inscriptions running right round the flagon. The inscriptions were sometimes blessings, but usually they were simply rows of letters arranged to look decorative in the same way as the rows of letters on brass bowls made in Nuremberg during the Renaissance.

In other parts of Germany, the guilds did not start to acquire large flagons until the seventeenth century, when drinking rituals and beer-

176

XIV (*opposite*) Pewter 'bulge' made by Samuel Kahn; Swiss, mid-seventeenth century.

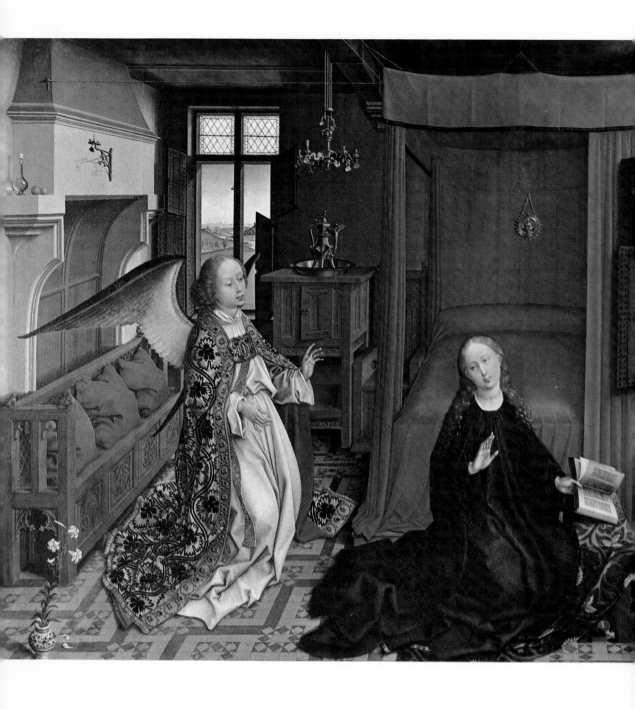

and wine-drinking in general were very widespread throughout *Pewter* Europe. The polygonal, conical, or cylindrical shaped flagons, however, never spread beyond the German-speaking countries. Drinking customs were different in England, France, Scandinavia, Holland, Italy and Spain.

Vessels set on legs are continually mentioned in the regulations for pewterers in the various regions of Germany from the Gothic period onwards. This type of object was often set as a test-piece for aspiring masters, but the only one to have survived from the fifteenth century is a very fine piece made by Cunz Haas in Regensburg in 1453. Friedrich Herlin's painting of Simon the Pharisee's room (painted 1460-5) shows a row of seven tankards with feet, arranged according to size and hanging downwards from a wall shelf. There is another tankard of the same design on the floor near the table, which is set for a meal. A pewter bowl full of food stands in the middle of the table and each place is laid with a small flat plate containing a piece of pastry. Christ, as the guest of honour, has a gilt double goblet set before him, while Simon the Pharisee and his wife are sharing a drinking mug. The whole company has to make do with a single knife.

177

xv (*opposite*) *The Annunciation* by Roger Van der Weyden, a typical domestic interior of the period, showing a chandelier, ewer and bowl, in bronze; *c.* 1440.

12—SHMW • •

3 Pewterware in the fifteenth and sixteenth centuries

Display pewter in France

As far as we can judge from the relatively few pieces of pewter made between 1450 and 1550 which have survived intact, the traditional shapes changed very gradually and the basic design of everyday objects remained the same. This was true even at the beginning of the Renaissance, when every other realm of pure and applied art was affected by the new style. A combination of various factors brought this about.

First, pewter was hardly used in Italy. As far as we know, no tradition of making domestic pewterware had been built up there over the years; nor were any pieces of much artistic merit made in the field of 'display pewter' (*Edelzinn*), to lay the foundations of a school of Italian pewterware. Thus, the birthplace of the Renaissance failed to provide the necessary stimulus for pewterers working in the other countries of Europe. Another important point was that most of the civilized countries in Europe already had a well-established body of craftsmen producing ordinary well-designed pewter goods; indeed many of the individual pieces were extremely beautiful in their own right. But this type of work was strictly functional and pewterers very rarely attempted to produce works of art. Their only opportunity for making non-functional pieces was in the field of religious art, as shown in one or two reliquaries and pyxes. Moreover the class of buyers prepared to spend money on 'luxury pewter' simply did not exist in the fifteenth century. While the really rich, royalty and the wealthiest merchants, could afford silver, the great majority of the ordinary people in both town and country had not yet reached the stage of aspiring to anything more than a bare livelihood with enough food and clothing. Utensils made of wood, clay or pewter were perfectly adequate for their requirements, and even pewter was a refinement rather than a necessity. Finally,

178

pewterers were encouraged to remain conservative and stick to their own models because it was an expensive business to obtain moulds. A pewterer was only too happy to take over the inherited moulds from his predecessor's workshop and go on using them for as long as possible, resigning himself to the fact that his wares were not absolutely up-to-date.

These were the factors which affected the design of pewterware until about the middle of the sixteenth century, when the spirit of the new era finally penetrated into the pewterers' workshops. The essential conditions for change had now been fulfilled. The rich bourgeoisie of Central Europe had established itself as a new urban middle class and wanted to take part in intellectual life, in the world of scholarship, art and culture, and to enjoy a certain degree of luxury, all of which had previously been the exclusive province of the Church and the aristocracy. The Renaissance encouraged the spread of intellectual and artistic values, and everywhere men were taking advantage of the new fund of treasures offered by the new age.

Painting and sculpture had paved the way for the Renaissance in the countries of the North, but the applied arts did not follow suit until about the middle of the sixteenth century, by which time the style known as Mannerism, an early reaction to the classical ideals of the Renaissance, was in vogue. Mannerism fitted in well with the inclinations and aspirations of its bourgeois patrons, since it meant that household equipment, which was essentially functional, could at the same time be richly decorated. This led to a revaluation of the functional nature of the utensil concerned, until finally a new style of craftsmanship in pewterware developed and articles were produced which could claim an absolute artistic value of their own. They were no longer functional but had become display pieces, serving purely as decoration.

This type of work had relief decoration and was displayed on dressers, sideboards, cabinets or plain shelves. It was classified in the nineteenth century as 'precious pewter' or 'display pewter'. This term was not intended to belittle ordinary pewter utensils, as a number of purists seem to suspect today – in fact their plain unadorned lines often give them a far more distinguished appearance than the more elaborate pieces – but was merely the name given to a specific type of work which was considered in its own day to be exceptionally elegant, stylish and fashionable. Display pewter gave the middle-classes of the second half of the sixteenth century their equivalent of the show-pieces which had been popular at aristocratic banquets a hundred years earlier, so that the expensive silver-gilt plates, tankards, and goblets were replaced by pewter pieces which were even richer and more sumptuous, but just as useless since their sole function was to stand ostentatiously on

sideboards. Display pewter was highly coveted, and individual pieces were treasured as *objets d'art*.

Display pewter, or more correctly pewter decorated in relief, originated in France. A good example is a tankard made in Lyons, which is now in the Kunstgewerbemuseum in Cologne. The sides are decorated with delicately moulded arabesques and it bears the mark of the master pewterer Rolyn Greffet, who is known to have lived in Lyons in 1528–68. This, and other similar pieces, represent a sort of preparatory stage for the work of François Briot, who is famous for having created and inspired the genre known as relief pewter.

Briot came from a family of artists and probably earned his living as a young man cutting coins and medals in Damblain, Lorraine. He was a Protestant and in about 1580 he fled to Montbéliard to escape the religious conflict which was raging in France at the time. Montbéliard, or Mömpelgard, was the capital of the province of the same name which belonged to the county of Württemberg and lay between eastern Burgundy and Upper Alsace. In 1585 he was appointed engraver to 'Son Excellence' Count (later duke) Friedrich of Württemberg, and in the same year cut several medals which he signed 'F. Briot' or simply 'F.B'.

His masterpiece, known as the *Temperantia Dish*, was made between 1585 and 1590 and brought him such fame among collectors and connoisseurs that it would be no exaggeration to call him the Raphael or Cellini of pewterers. Art critics writing in the second half of the nineteenth century, who believed that the Renaissance epitomized the highest form of art, greatly helped to enhance his reputation. He appears to have been accorded the highest honours even in his own lifetime, although he still died a poor man; he even had to resort on more than one occasion to pawning the copper moulds for his famous Temperantia Dish.

The dish itself is about 18 inches in diameter and is richly moulded, with an embossed circular medallion in the centre portraying the seated figure of a woman, who is an allegory of Temperantia. She is surrounded by a circular frieze made up of the Four Elements, *Terra*, *Ignis*, *Aer* and *Aqua*, and a series of oval cartouches around the rim portray allegories of the Seven Liberal Arts and their patroness Minerva. In between, the surface is covered with masks, bunches of fruit, fabulous creatures and decorative grotesques.

The treatment of the shapes, the composition and the choice of subject matter are all typical of the movement known as Mannerism which prevailed in the second half of the sixteenth century. The choice of subjects shows that the artist was a man of learning, who had received a classical education; he used images from classical mythology to

glorify the Christian virtues as exemplified by Temperantia herself and adds a new touch of grace and elegance, especially in his handling of the human body, slightly exaggerating the proportions and combining a predilection for comic detail with a cool classicism. This allusive style is the perfect expression of a type of art which thrived in court circles and was favoured by a few cultured connoisseurs; its artists had to be men of learning as well as skilled craftsmen.

By applying to pewter this new range of images and ideas (which in fact found its main expression in prints, especially in France), craftsmen transformed the metal from its former status as a functional material for everyday utensils, into a vehicle for pure art. The Temperantia Dish was made by a medallist, but it is really a piece of sculpture. It is completely non-functional, and although it could conceivably have been used, along with its companion piece, a ewer, for washing one's hands on ceremonial occasions, we have no evidence that it was ever used for this purpose.

The ewer which goes with the Temperantia Dish was also made by Briot and is decorated with a frieze depicting the Christian virtues of Faith, Hope and Charity (*Spes, Fides* and *Caritas*); below the frieze appear some unexpectedly grotesque motifs, some of which are blatantly obscene. Briot also made another set, comprising a dish and a ewer; the dish this time was decorated with the seated figure of Mars in the centre; he also made a salt cellar and another bowl portraying the figure of Susanna.

As with most pewterware of the period, most of Briot's work is not officially marked, but he stamped a panel on the bottom of both the Temperantia Dish and the Mars Dish with his profile and the legend SCVLPEBAT FRANCISCVS BRIOT. So even the inscription distinguished his work from the ordinary run of pewter pieces, and his use of the word *sculpebat* classifies it as a piece of sculpture, a genuine work of art.[1]

Briot's two masterpieces were much admired in France and glazed ceramic copies of the Temperantia Dish and its ewer were made by the famous faience artist Bernard Palissy at the end of the sixteenth century; they were also reproduced in silver.

Display pewter in Nuremberg and elsewhere

The greatest response to Briot's work came from pewterers in Nuremberg, where pewter decorated in relief became even more fashionable than in France, remaining at the height of fashion for several generations. As we have already seen, trade and craftsmanship had been flourishing in Nuremberg ever since the end of the fifteenth century. Beaters were making brass bowls with embossed decoration to grace middle-class

drawing rooms in the late-Gothic and Renaissance periods and up to about 1550, but at this time pewterers were producing purely functional articles, mainly tankards, plates and bowls. It is true that a book called *Des Johann Neudorfer, Schreib- und Rechenmeisters zu Nürnberg, Nachrichten von Künstlern und Werkleuten daselbst* (*News of artists and craftsmen in Nuremberg, by Johann Neudorfer, scribe and accountant of the same*) (1547) mentions a pewterer called Martin Harscher (1435-1523) and praises his work very highly, observing that he made pewter articles of a quality usually attained only by goldsmiths. However, this was still not pewter decorated in relief. The rhymes of Hans Sachs (1543) describe every possible type of pewterware, but although decoration consisting of plants, flowers and images is mentioned, this was always engraved, not cast.

The first master pewterer in Nuremberg to make large pewter bowls with figure decoration cast in low relief was Nicholas Horchhaimer. His technique, which was also being used at approximately the same time by a colleague called Albrecht Preissensin, is different from that used by pewterers working in Lyons during the same period. The decorative motifs on Horchhaimer's early pieces are not engraved in the copper or brass moulds with a graving tool but are etched in the metal or stone moulds in the same way that armourers decorate their work, but in *intaglio*. This technique gave a flat, two-tier relief rather reminiscent of wood-cuts in its interplay of light and shade, and is, in fact, known as the 'wood-cutting style'.

The large bowls made by the two main exponents of the style, Horchhaimer and Preissensin, are mainly decorated with figures or scenes from Christ's Passion and Salvation, or from classical mythology; smaller bowls are decorated with abstract ornamental motifs, mainly arabesques. Pieces made in this way which date from somewhere between 1560 and 1600 are not as common as the other type of relief cast pewter and are much sought after by collectors.

Relief-decorated pewter cast in an engraved mould was also made in Nuremberg during this period, generally with non-figurative decoration. The new fashion for using relief pewter for decoration in the home was disastrous as far as the brass-beaters were concerned, and their business collapsed. Popular taste rejected their shining copper bowls with their somewhat blurred decoration in favour of the dull gleam of pewter plates and bowls, whose decoration was, for technical reasons, much sharper and richer.

In 1583 a pewterer called Kaspar Enderlein emigrated from Basle to Nuremberg; three years later he became a master in the Nuremberg guild, received the freedom of the city and got married. He won great fame by engraving copies of Briot's Temperantia Dish and in fact his

reputation was equal to Briot's. In those days, questions of originality Pewter and intellectual copyright were considered in a rather different light. In this particular case, there was no objection to a Nuremberg pewterer making line by line copies of a celebrated piece made by a colleague in Lorraine. Enderlein's Temperantia Dish was admired without reservation and he did not receive a word of criticism from his contemporaries. He even went so far as to imitate Briot's signature by stamping his profile on the bottom of some of his dishes and altering the inscription to read SCVLPEBAT CASBAR ENDERLEIN. Other pieces were simply signed with his initials cut into the mould.

This was the beginning of the golden age of relief-decorated pewter in Nuremberg. Apart from his Temperantia Dish, for which he cut two different moulds, both probably made of Solnhofen stone, Enderlein also made two tankards in collaboration with a colleague called Jacob Koch II, a smaller dish with the figure of Lot and another with St George, a jug, a flat plate adorned with the Creation of Eve and another depicting Christ's Resurrection. Some of the subject matter was borrowed from Briot, but other images were probably taken from contemporary prints. Amazingly enough, none of the surviving pieces cast from Enderlein's moulds are signed with his stamp, and in fact they are all marked by different pewterers. The models continued to be used for the next hundred and ten years, particularly that of the Temperantia Dish.

Many pewterers were casting relief-decorated pewter during Caspar Enderlein's lifetime, and after his death in 1633. At the end of the sixteenth century non-figurative decorative motifs were very popular and the fashion continued into the early seventeenth century. One very popular model which began at the end of the sixteenth century was a series of small disc-shaped plates decorated with scenes showing Christ's Resurrection, Noah's Ark, the Creation of Eve, or various other scenes from the Old Testament. From about 1635 onwards pewterers began to make disc-shaped plates with an equestrian portrait of the German emperor in the centre, and portraits of the electors in medallions around the edge. No less than nine different models of this type of souvenir plate were cut; they may have been specially made for the coronation of the Habsburg Emperor Ferdinand III in 1637. Similar plates with portraits of the Turkish emperor and King Gustavus Adolphus of Sweden were made at about the same time.

From about 1630 onwards, the broad rims of these embossed plates began to be decorated with a frieze of Baroque flowers which were a favourite decorative motif of this period, although up to now they had mostly been used by silversmiths. Probably pewterers began to use them

183

Metalwork to prove that their skill equalled that of the silversmiths, rather than to attempt to offer direct competition. The close connection between pewter and silver pieces is particularly noticeable in a group of screw-top flasks, decorated with luxuriant flowers, modelled in high relief.

The old regulations laid down by the Pewterers' Guild continually hark back to the rule that an aspiring master must prepare his clay moulds himself for specific articles. But this idealistic view of craftsmanship was apparently completely abandoned when it came to the relief plates made in the seventeenth century. It is believed that Caspar Enderlein, who was a skilled pewterer and a master of his craft, specialized in cutting moulds and did none of the actual casting himself. But in the case of seventeenth-century pewterers the reverse was true: they had their copper or stone moulds made by professional cutters and just did the casting themselves. Occasionally the cutters would put their own monograms on the moulds, but if we compare their signatures with the lists of master pewterers which have been preserved in Nuremberg, we see that none of them was a member of the guild.

Pewterers seem to have carried on a brisk trade in buying and selling moulds and one often comes across pieces cast from the same mould, but signed by different masters. The moulds represented a pewterer's main capital and were, therefore, either passed on to his heirs or sold; they were used for long periods even when their decorative motifs were no longer in the latest style. Towards the end of the eighteenth century P. N. Sprengel stated in his great work *Handwerke in Tabellen, 4. Sammlung Berlin, 1769* (*Lists of trades, fourth compilation, Berlin, 1769*) that a pewterer setting himself up in business could easily spend as much as 2,000 *reichstaler* on moulds alone, and that this initial outlay was sometimes so large that he was compelled to purchase his moulds jointly with some of his colleagues.[2]

The pewterers' craft was also flourishing in the sixteenth century in Saxony, where they used a method which largely simplified the process of casting relief decoration as well as cutting down the cost. Pewterers would get hold of plaques made of lead, tin or bronze of a type produced in large quantities by Peter Flötner's Nuremberg workshop. The function of these was similar to that of the pattern books used by copperplate engravers. The plaques were arranged in rows and a fine clay or plaster cast was made of them which was then used for casting strips of decorative or figure motifs to work into the body of the tankards. This is really nothing more than a form of reproduction, but the elegant lines of the finished products and the tasteful arrangements of Flötner's plaques create a pleasing effect which can bear comparison with

184

display pewter made in Nuremberg. This technique was used mostly for
tankards and jugs, and very few plates in this style are to be found.

The popularity of relief cast pewter varied from district to district
and from year to year. In France, for instance, it flourished for only a
very short period (1560-1600), while in Saxony the most important
pieces were made between 1560 and 1620. In Nuremberg, where pro-
duction was accompanied by a thriving export business, pewterers con-
tinued to use the display pewter style from 1560 right down to about
1670, when they went through a phase of employing only the Baroque
flowers used on silver. In about 1700, however, even the Nuremberg
pewterers turned to something new. Pewter ceased to be used as a
vehicle for skilled craftsmanship and resumed its former humble role
as a functional material, allowing other metals to take its place where
elaborate decoration was required.

In England, some relief cast pieces made in the first years of the
seventeenth century were inspired by the work produced in Nuremberg.
One of the best pieces is a pewter candlestick which has become famous
under the name of the 'Grainger candlestick' because its maker, William
Grainger, signed it with his full name and the date, 1616. He was the
master of the Pewterers' Company in London at that time. Another piece
which may have been made by him is a bowl mounted on a high
pedestal in St Mary's church, West Shefford, Berkshire. Its shape is
reminiscent of a type of bowl using Limoges enamel, or of certain *objets
d'art* made of silver and gold. In the Victoria and Albert Museum, there
is a beaker decorated with bands of arabesque which was probably
inspired by the work of French pewterers. Another four mugs with
friezes of interlaced ornament are also decorated with the arms of
various noble houses, including the Stuarts. All the pieces of relief cast
pewterware made in England, including those mentioned above, were
intended as show-pieces to be displayed in churches or in houses.
Relief cast pewter never reached a wider market in England, probably
because silver was the favourite metal used for making household
articles for the wealthier families.

During the first thirty or forty years of the eighteenth century there
was a sudden rise in the popularity of relief decoration in Stras-
bourg and some French towns including Lyons, Rouen and Bordeaux.
The work produced in these places has the delicacy of goldsmiths' work
and is almost always used on two-handled bowls, which are called
Wöchnerinnenschüssel in German, or 'bowls for women in labour'. They
have lids and handles decorated with delicate and very elegant motifs
characteristic of the French Regency period (1715-23), and cartouches
depicting figurative, allegorical or romantic themes. This type of con-
tainer was modelled on designs in contemporary pattern-books and

185

Metalwork copper-plate engravings. It was probably a pewterer who invented the idea of two-handled bowls, since the first examples were made in pewter; it was not until later that silver examples began to be made. Thus the necessary inspiration was probably provided by modest pewter containers.

Two-handled bowls with relief cast decoration were also made in England in the late seventeenth century and the first half of the eighteenth century, where they were known as porringers; the technique is very similar to that used in the Strasbourg pieces, although the decoration is cruder and the shapes far less delicate; they also have cast decoration on the bottom of the dish as well as on the lid.

Relief-decorated pewter was rarely made anywhere but in the places already mentioned; utensils with this type of decoration were occasionally produced in a few towns in southern Germany, Austria, Switzerland, in a number of places in France, in the Balkans and even in the East, but none of these places has ever produced pewterware of sufficient importance to influence the style of work in other places.

4 Pewterware from the seventeenth century to the period of Art Nouveau

Apart from what we have called 'display pewter', ordinary everyday pewterware was of course also being made. In the sixteenth and seventeenth centuries its use became more and more widespread and in middle-class households it began to supplant the clay and earthenware bowls and the wooden platters which had been used as vessels and plates throughout the Middle Ages. At the end of the Gothic period, and in the first half of the sixteenth century, drinking vessels of every possible shape and size were the most widely used items in most parts of Europe, but in the second half of the sixteenth century and in the period after, plates, dishes and smaller drinking-mugs began to predominate.

In the humbler middle-class households, pewterware would be confined to one plate, bowl or basin for each member of the family, plus presumably one drinking-mug each. There would also be a jug or two for pouring and a few larger bowls for serving food. The custom of having a single communal bowl set in the middle of the table for everybody – family plus servants – to eat from was still observed in the poorer type of country household for many years, in fact right down to the nineteenth century, and even occasionally down to our own day – the staple food everywhere being some form of porridge or soup.

The spoons used at table were also made of pewter from a very early date, and some have even survived from the Romanesque period. The design of pewter spoons has always been modelled on those made of silver or sometimes of wood; this is also true of salt-cellars, of which a particularly large number of English examples have survived. During the Renaissance they were triangular in design, as were silver ones made in the same period. In the Baroque period they were polygonal or round and were set on short, richly contoured stems; this design is again the same as that used by contemporary silversmiths, and the analogy can be taken even further in the eighteenth century.

If we take a look at contemporary wills and inventories, we can build up a clear picture of the type and amount of pewterware and other metal kitchenware used in the average household. A number of such inventories has been published by M. W. Barley in his book *The English Farmhouse and Cottage*; here is a typical extract. In 1570 the belongings of a yeoman called Alexander Paramore in the county of Kent were valued at £128, of which only £7 worth consisted of household goods, made up as follows: on his hearth he had two cauldrons, two iron pans and three brass pots; his tableware consisted entirely of pewter articles and he also had some pewter spoons; the family had originally used a dozen wooden cutting-boards instead of plates, but had later been in a position to replace them with pewter ones; the rooms were lit by three pewter candlesticks.[1]

Many inventories drawn up towards the end of the seventeenth century are far less detailed and merely state the total quantity of household goods, made of brass or pewter as the case may be. For instance a brewer's household is stated to contain £3 worth of household goods. Larger houses would normally have approximately ten pewter plates or bowls, one or two jugs, one large bowl and two or more candlesticks. People living in the country had much the same type of articles until the eighteenth century. Both country people and town-dwellers thought of their pewterware as valuable objects, as we can see in the fact that large hoards of pewter pieces have occasionally been found during building-operations or excavations; they have obviously been buried by their owners to protect them from being seized as booty by invading soldiers. During the Thirty Years' War in particular, officers would promptly sell it to the army stores, or to any dealers who were among the usual crowd of camp-followers. Precious metal objects, on the other hand, had to be handed over to the commander. Pewter articles would occasionally be accepted for melting down at six-sevenths of the purchase price, which means that the value of the material must have been far greater than the cost of the work involved in recasting it. So even pewterware which was damaged, or no longer in fashion, could be regarded as an investment, in that it could be turned into cash at any time.

The Thirty Years' War had deeply affected the whole of Central Europe and had also struck at trade everywhere. After the end of the war, the various crafts gradually began to revive, but they now developed along rather different lines. The power of the guilds had diminished to a marked degree and they were no longer in a position to regulate trade. This was one of the reasons why mass-production could now be implemented; any such system still depended on craftsmanship, but by this time it was definitely industry proper. The charac-

teristic features of manufacture were firstly, that large quantities of con- *Pewter* sumer goods were produced in them; secondly, that the employees were no longer grouped in the old interrelationship of master, journeyman and apprentice, but were employed on the grounds of their ability, their knowledge and their proficiency; and finally that the initiator, owner and director of the firm was a man who possessed money and courage, but was not necessarily a skilled craftsman himself; he may simply have been a skilful administrator who was an expert at leading men. The days of guild privileges, master's examinations and graduated status were over. The most important factor now was the consent of the local sovereign, who was interested in the success of this type of enter- prise and in helping to promote it, if it meant more taxes and revenue for the state coffers and at the same time provided more work for his subjects. Factories were also encouraged by the new theories concerning controlled economy which governed economic policy in every European country, large and small, in the second half of the seventeenth century and in the eighteenth. The idea behind the theories of state control was an attempt to make the best possible use of local resources, which in this context included both mineral wealth and the manual skills of local workers.

Attempts at organizing a state-controlled economy encouraged enter- prise and initiative, ambition and inventiveness, and at the same time led to an increase in the supply of goods, which in its turn brought about a rise in the standard of living. On the other hand, it also gave rise to a good deal of trade rivalry. Supplying on a large scale was detrimental to many of the trades, damaging their monopolistic posi- tions and ruining many craftsmen. This development reached its peak in the middle of the eighteenth century.

The new developments had a considerable effect on pewterers. The wave of prosperity which they had enjoyed in the sixteenth century, with the demand for display pewter on the one hand, and the needs of the ever-increasing urban population on the other, was followed by the period of stagnation and setbacks caused by the Thirty Years' War. From 1650 onwards, the trade began gradually to recover, but it was soon to come up against strong competition from faience. The first faience factory was built in Delft at the beginning of the seventeenth century, and others followed in Hanau in 1661 and in Frankfurt in 1666. These faience factories were typical of the system of controlled economy, the idea being to use their products to curb the import of the more expensive porcelain made in the Far East, so that the money which might have been spent on this could stay in the country. The necessary raw material – ordinary clay – was available almost every- where, and so, during the first half of the eighteenth century, faience

189

factories sprang up all over Europe. They offered an opportunity of making a profit by working with local mineral resources. Local sovereigns were only too glad to see this type of factory flourishing, not only because they brought both profits and work, but also because their products could provide a substitute for the *de luxe* Chinese porcelain.

But pewterers suffered considerable losses when faience dishes, plates, bowls and tureens began to replace their pewter equivalents. Faience articles did of course have the disadvantage of breaking easily, but on the other hand they had two definite advantages: firstly they were cheaper, partly because the actual raw material was less expensive, and partly because manufacturing methods were run on very economical lines; and secondly, they were more attractive to look at. The porcelain made in the Far East had a fairly strong influence on popular taste, which meant that the blue and white decoration typical of faience at that time was preferred to the matte, monochrome gleam of pewter. This tendency continued in the first half of the eighteenth century and actually increased when faience began to be decorated in a variety of colours, and a method of making porcelain was invented in Europe. Nevertheless, porcelain was still so expensive throughout the eighteenth century that it competed with silver rather than with pewter.

Pewterers now began to copy the design of silver articles. Their craft was based on a long-standing tradition, and they only began to make copies of articles in a more expensive and grander metal because they were impelled by the demand of crude trade competition. Pewter spoons and salt-cellars made as early as the fifteenth and sixteenth centuries are quite clearly copies of silver articles, but the plates made in the sixteenth and seventeenth centuries, with their broad, smooth rims and rather small, hat-shaped bases, were highly individual in design and typical of pewterware.

In the mid-seventeenth century, French pewterers began to make plates and dishes to the same design as those being made by contemporary silversmiths, and a large number of those which have come down to us are engraved with the coats-of-arms of their owners, some of whom were from the nobility, while others were of middle-class background. These splendid pieces were clearly used at the grandest tables in the land. The explanation for the use of pewter instead of silver lies in France's precarious financial situation during the second half of the seventeenth century, when a large number of monetary problems arose. The monetary system during this period was entirely based on gold and silver, but continuous warfare had created such a shortage of silver that the only way to replenish the state coffers was to requisition all silver plate and impose heavy taxes. Even the royal family handed over

all its silver to the state mint in 1689 – sovereigns do not often make *Pewter* this type of sacrifice! But although the silversmiths' craft suffered heavy losses, some of the other trades – including the pewter and the faience trades – enjoyed a corresponding upsurge in production. In both taking over the work of the silversmiths by making tableware, and also adopting traditional silver designs, they were merely complying with the wishes of their clients; we also find candlesticks copied from silver examples, and occasionally jugs with handles and spouts, brandy goblets, sugar dredgers and salt-cellars.

Although the pewterers had begun their work by providing substitutes for silver in a time of emergency, their work had come to stay, so that throughout the eighteenth century any changes in the design of silver were reflected in pewterware. This meant that pewter went on being very popular in France, even when the shortage of silver had been remedied and silver tableware was once more available.

It is true that the circles in which the different metals were bought were no longer the same. Since there was no longer any question of having pewter instead of silver for patriotic reasons, or simply because there was no alternative, the criterion was now purely a financial one, so that those who could afford to do so bought silver and those who could not, had to make do with pewter. But even if one could not afford silver, one was not compelled to forgo the fashionable elegance of the designs of the Rococo and Regency periods, since these too could be reproduced in pewter.

This situation seems once again to have given a new impetus to the pewter trade and to the sales of pewter. In Germany in particular the rich middle-class was prepared to acquire large amounts of pewterware in modern designs, to match the silver owned by the nobility.

It was not long before pewterers began to branch out from making the usual basic plates, bowls and dishes, into tureens modelled on silver pieces and used as épergnes, snuff-boxes, tea-pots and coffee-pots. This type of work was known as 'silver-type pewter'.[2]

By the end of the eighteenth century, the middle-classes lived as comfortably as in royal households, except that their utensils were made of pewter.

Thanks to the growing number of wealthy households both in the towns and in the country, to the general rise in the standard of living and to the number of utensils needed in the average household, the pewter trade enjoyed a new upsurge of prosperity in the first half of the eighteenth century, which lasted until shortly after 1750. The number of journeymen asking for work every day in certain centres is a good indication of the situation. At the same time, more and more master-pewterers were opening up their own workshops. The guilds could no

191

Metalwork longer uphold their old policy of restricting the number of master-craftsmen in view of the flourishing state of the trade, nor did they want to.

In this time of prosperity, a large number of pewter workshops switched to a policy of specialization, making only certain specific types of utensils. For instance, we learn that in the Bohemian centres of Karlsbad and Schlaggenwald some master-pewterers produced nothing but plates and bowls, whereas others restricted their output to candlesticks, and yet others made only crucifixes and holy-water fonts, or perhaps spoons. This specialization could lead to an increase in output, for when production was intensified, the cost of articles could be kept down, and competition and profits increased.

This system of specialization, which was aimed at by some craftsmen in the middle of the eighteenth century, was basically beneficial and practicable, and it has all the features of the profit-seeking attitude which is typical of capitalism. This makes the eighteenth-century system quite different from the restrictions and specialization practised by the guilds in the sixteenth century, a system which aimed at spreading out the fairly limited amount of work available into as many subdivisions as possible for the general good of all guild-members. Specialization in the pewter trade was, however, restricted to a handful of towns in the eighteenth century and it was not long before the whole development came to an end with the general decline of the craft.

Guild regulations were still an important factor in the life of German craftsmen, but on the other hand it is clear from contemporary letters and documents that by this time the guilds had to permit healthy discussions and to adapt themselves to the new economic climate. In 1740 the Frankfurt Guild disputed the right of a master-pewterer, called Johann Georg Klingling, to employ more than six journeymen; answering his case before the guild committee, which included Goethe's uncle, Hermann Jakob Goethe, Klingling said that they could all have six or more journeymen, and, providing that everyone worked diligently and with enthusiasm, nobody would suffer.

Thus the power of the guilds had been broken and they could no longer control either the professional activities of their members, or their private lives. In the middle of the eighteenth century some Italian pewterers began to appear in a number of different parts of Germany, and they were soon travelling round the countryside repairing damaged pewterware. They then started casting and selling pewter themselves, which naturally gave rise to disputes with their German colleagues. The guilds tried to ban all foreign craftsmen, but failed to do so, and eventually had to come to terms with them; a large number of them were even admitted into the guilds. The competition offered by these

192

Pewter:
Renaissance to *Art Nouveau*

214 (*right*) Medallion with portrait of
François Briot, from the reverse of his
Temperantia Dish. The inscription reads
'SCULPEBAT FRANCISCUS BRIOT.'

215 (*below*) Pewter Temperantia Dish;
François Briot, *c.* 1580–90.

216 Pewter dish depicting
Fame and heroes of Roman
history; Nicolaus Horchhaimer,
Nuremberg, 1567.

217 Display pewter dish with
arabesque decoration; Jakob
Koch II, Nuremberg, c. 1585.

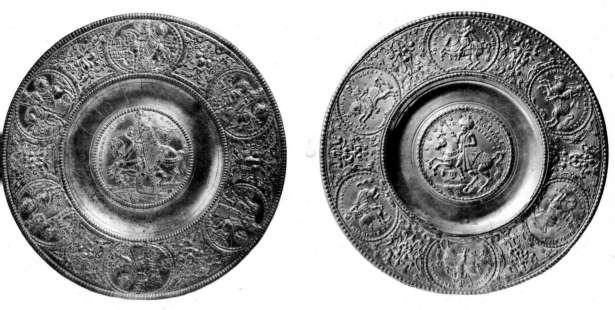

218 (*left*) Pewter dish depicting Ferdinand III, surrounded by other European rulers. Designed for Paulus Öham the Younger of Nuremberg, 1639. Cast by Johann Sigmund Wadel, *c.* 1700.

219 (*right*) Pewter dish showing the Turkish Emperor and other kings, designed for Andreas Dambach of Nuremberg, *c.* 1636. Cast by Hans Spatz, 1636–40.

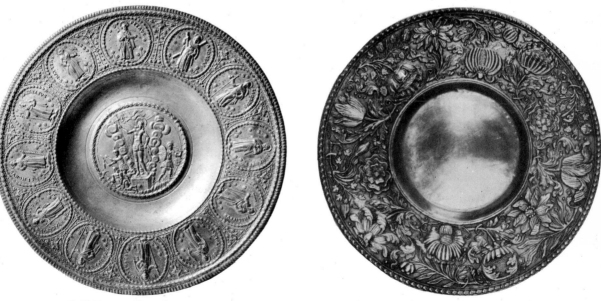

220 (*left*) Pewter dish of the Resurrection of Christ and the 12 Apostles, by Paulus Öham the Younger; Nuremberg, late seventeenth century.

221 (*right*) Pewter dish decorated with flowers in Baroque style; Hans Spatz II, Nuremberg, late seventeenth century.

222 Pewter goblet with Renaissance relief decoration; English, sixteenth century.

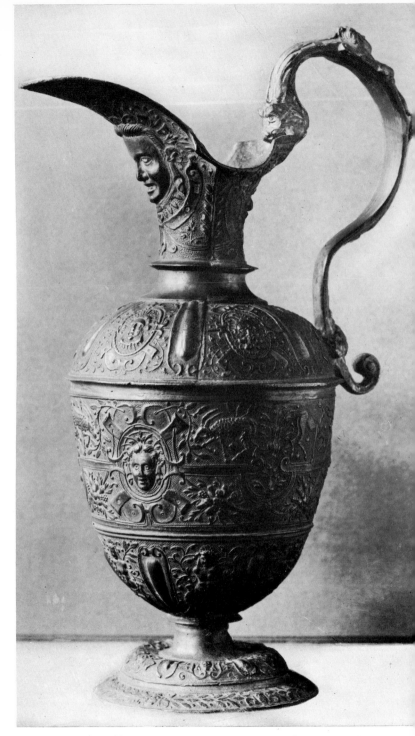

223 Helmet jug with elaborate Mannerist decoration; French (Lyon), late sixteenth century.

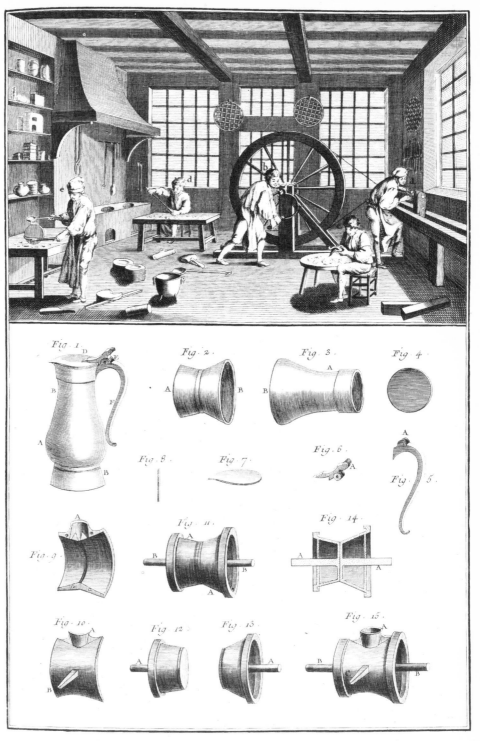

224 Engraving of a pewter foundry and the moulds used for making tankards and jugs; from Diderot's *Encyclopedia*, eighteenth century.

225 (*below*) Broad-rimmed dish; South German, 1693.
226 (*right*) Detail of a painting showing kitchen utensils, many of pewter; Jan Thielens, Antwerp, seventeenth century.

227 (*left*) Pewter communion flagon; Württemberg, seventeenth century.
228 (*right*) Jug with engraved decoration and inscription; Jacob Ganting, Bern, early eighteenth century.

229 (*top*) Jan-Steen jug; Netherlands, *c.* 1600.
230 (*bottom*) Still life showing a pewter Jan-Steen jug, plates and a silver beaker;
Pieter Claesz, seventeenth century.

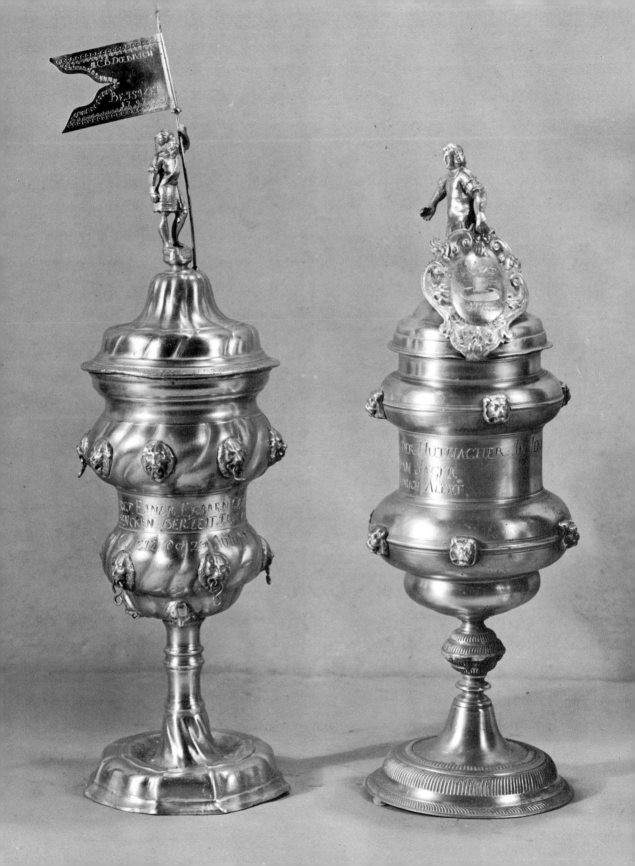

232 (*above*) Pewter Rörken; Hans Conrad Gottespfennig, Rostock, 1737.

233 (*top right*) Pewter altar vase; Central Germany, dated 1760.

234 (*right*) Pewter guild tankard; Philip Aichinger, Salzburg, *c.* 1790.

231 (*opposite*) Guild welcomes made of pewter; (*left*) the welcome of the armourers at Grez, 1770; (*right*) the welcome of the hatmakers at Jena, 1722.

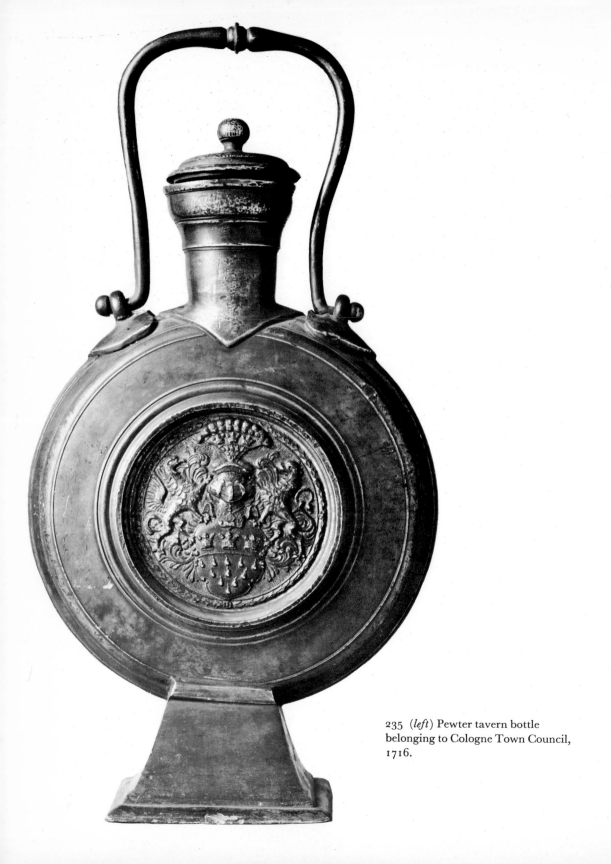

235 (*left*) Pewter tavern bottle belonging to Cologne Town Council, 1716.

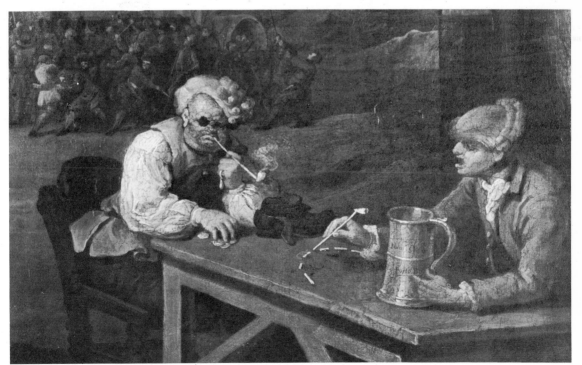

236 (*top left*) Tavern pot by Philip Adam Goppelt; Heilbronn, late eighteenth century.

237 (*top right*) Pewter tankard; English, eighteenth century.

238 (*bottom*) Detail from Hogarth's *Canvassing for Votes* showing a pewter tankard in use; English, eighteenth century.

239 (*top*) Punch work pewter box; by Christoph Ruprecht of Augsburg, *c.* 1720.
240 (*bottom*) Pewter midwife's dish; by Elias Bernhard Kreuchel of Strasbourg after a model by Johan Peter Kamm, early eighteenth century.

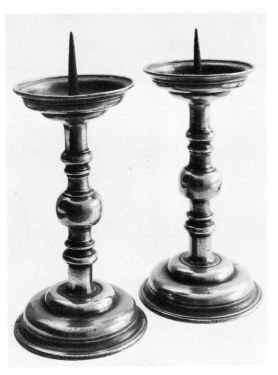

241 (*top left*) A pair of pewter candlesticks with wide collar drip trays; Cologne, seventeenth century.
242 (*top right*) Pewter candlestick; Central Germany, early eighteenth century.
243 (*bottom left*) Pewter candlestick with a neo-classical fluted stem; German, early nineteenth century.
244 (*bottom right*) Pewter candlestick, with relief decoration; Leipzig, early nineteenth century.

245 Prismatic screw jug; Johannes Weber of Zurich, 1766.

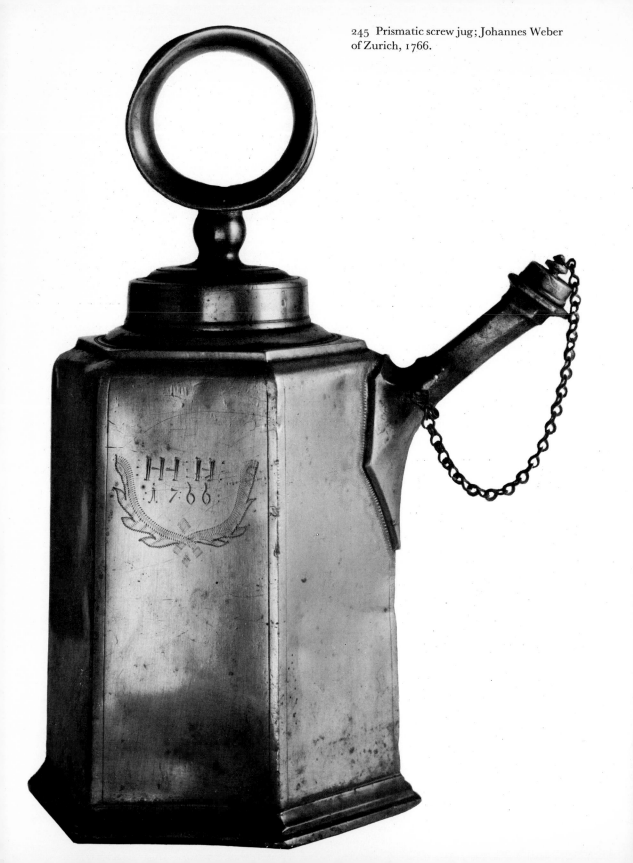

246 Pewter tureen made to look like silver; J. P. Heinicke, Frankfurt, mid-eighteenth century.

247 (*bottom left*) Pewter coffee jug made to look like silver; Werdau (Saxony), mid-eighteenth century.

248 (*bottom right*) Pewter christening jug; Johann Christoph Schneider of Augsburg, 1770.

249 Pewter teapot in *Art Nouveau* style, made by the firm of Kayser at Oppum near Krefeld; *c.* 1900.

Italian pewterers was a particularly bitter pill to swallow at a time when Pewter the trade was beginning to decline.

Even as early as the end of the seventeenth century, pewterers in northern Germany had been complaining that the competition offered by Dutch faience articles was damaging their sales. Competition became even stiffer in the first half of the eighteenth century, when large and small faience factories were being opened all over France and Germany. In the following period, however, the rival craftsmen seem to have come to some sort of arrangement and both trades flourished. Although faience had the attraction of being coloured, it was also very fragile, whereas pewter – although less elaborate – was more durable.

This delicate situation came to a head between about 1750 and 1775, eventually leading to the events which were to spell the downfall of all types of craft in the nineteenth century. Competition grew stiffer, faience factories mushroomed everywhere and began to make cheap everyday utensils as well as pieces designed and painted with painstaking care. Meissen and Vienna could not hold the monopoly of porcelain production, and porcelain factories appeared all over Europe; some were large and some small, but all of them were now making ordinary utensils for middle-class households alongside luxury articles for the nobility and the very rich. The ordinary middle-class citizen, who up to now may well have thought of his 'silver-type pewter' as the last word in elegance and beauty, was now in a position to buy genuine painted porcelain, just as if he were a grand lord. The temptation to sell off one's pewterware was very great, and even if porcelain was too expensive for some people, they could always buy the English earthenware which was now flooding the market on the Continent. Pewter could not stand up to this multiple competition and the upsurge of prosperity in the middle of the eighteenth century was followed by a very rapid decline after about 1765. In many towns pewterers were compelled to turn to some other craft in their old age and places which had once had twenty or thirty workshops had no more than one or two by the end of the century.

Comparatively few pewterers followed the change from the Rococo style to the decoration and design of the Louis-Seize style, now that demand had dropped so sharply. In Germany, the demand for pewter does seem to have risen for a few years with the arrival of the Napoleonic era, because the country was impoverished and even the middle-classes were living frugally. But by about the middle of the nineteenth century the introduction of industrialization finally put an end to one of the most important traditional trades.

The Swiss – always a traditional people – remained faithful to

<div style="text-align:right">193</div>

pewterware and to the typical pewter designs. From the sixteenth and seventeenth centuries onwards the different towns or cantons had evolved their own individual styles, which were then retained. For instance there were *Stegkannen* from Berne, *Rundele* from Basle, *Stitzen* from Solothurn and Fribourg, jugs from Geneva, Vaud and Valais, all of which are typical of their regions and were only very occasionally found in the neighbouring districts or abroad. The population of Switzerland remained predominantly rural right down to the nineteenth century, which meant that pewter was widely used and highly treasured. Swiss pewter workshops held their own for a long time against the industrial competition which appeared in the nineteenth century, and some of the workshops which are still in use today can trace their origins back to the seventeenth and eighteenth centuries. Guild regulations in Switzerland were not as oppressive or as restricting as in Germany, and it was very unusual for a journeyman to be prevented from becoming a master-craftsman. Pewterers therefore occasionally took advantage of this freedom to practise some other trade on the side.

There was no rivalry between silver and pewter in Switzerland either in the early period or in the eighteenth century; in fact there seems to have been no point of contact between the two. The reason for this may possibly be that Swiss silver was made exclusively for the aristocracy and on the whole never had the same importance as French, English or German silver. On the other hand, the Swiss liked to keep to the old traditional designs which had their own local significance. This attitude – which applied both to makers and to buyers – remained unaltered in the eighteenth century. 'Silver-type pewter' failed to become popular, even in the western part of Switzerland, which has always been strongly influenced by France, so it had to be imported from Germany; the main sources of supply for this type of article were Frankfurt, Augsburg and Karlsbad in Bohemia.

The relationship between the designs of silver and pewter in England was always close. Seventeenth-century silver and pewter vessels of very similar design are found side by side, and it seems possible that the silversmiths borrowed designs from the pewterers. This is particularly true of flagons, tankards and mugs, but it can also be seen in candlesticks and chalices. It is true that the baluster-shaped jugs, which were made from the sixteenth century right down to the nineteenth century, were made exclusively in pewter, but flagons – cylindrical jugs with lids and set on a projecting base – are found in both metals. Pewter flagons were often used to hold the Holy Communion wine, as we can see from the inscriptions engraved on them. Tankards are smaller drinking-mugs with lightly contoured bases which do not project as much as the bases on flagons. The

body of the vessels generally tapers towards the top and the lid can be Pewter either flat or arched. The unmistakable rustic note leads us to attribute the design of both flagons and tankards to the pewterers, but the silversmiths frequently made vessels of a similar type with few differences. English silversmiths did occasionally adorn the bodies of their tankards with chased decoration or decorative friezes, a practice which was common among their counterparts on the Continent. As for mugs, they were made either in pewter or in silver, with neither metal predominating. English candlesticks in silver were straight copies of bronze candlesticks right down to the eighteenth century, and the pewterers were no more inventive, since they too depended on bronze articles for their designs.

Towards the middle of the eighteenth century English pewterers felt the need to match the grand silver pieces inspired by French work, and they began to make plates with curving rims and later with beading, and Adam-type candlesticks in classical designs and with classical decoration; tea-pots and coffee-pots, wine-coolers and boxes were all modelled on their silver counterparts.

The freedom with which English pewterers and silversmiths swapped their designs and their basic design principles among themselves from as early as the seventeenth century onwards shows that guild regulations were not as restrictive and cramping as on the Continent. At the same time, the influence of pewter design on seventeenth-century silverware casts some light on the mentality and tastes of the age, showing as it does that rustic and unsophisticated designs were in fashion, even for objects made of precious metals. The idea of having grand and splendid pieces was no longer the first priority, the most important criterion now being whether an object was functional, and pewterers bore this in mind when designing their work. In the mid-nineteenth century, stylistic imitations of earlier artistic periods became extremely popular, especially in the field of applied art. First came neo-Gothic (which had had some devotees as early as the end of the eighteenth century), followed by a whole series of imitations, sometimes combined in a single object: neo-Rococo (already popular in France during the 'middle-class' monarchy of Louis-Philippe), neo-Baroque, neo-Romanesque, neo-Renaissance, neo-Louis-Seize. By this time industry was mass-producing articles and manufacturers were eager to satisfy popular demand. Pewter production was also affected by the prevailing mood, although the pewterers, painstakingly practising their craft in their workshops to produce objects for everyday use were replaced by fully mechanized factories and metalworks, manufacturing artistic articles to adorn middle-class salons and public-house saloons. Pewter tankards, jugs, plates and vessels of every description were manufactured, weighed

down with decorative details borrowed from different periods, elaborate *genre* scenes depicting human figures and pseudo-antique sayings. Suppliers volunteered to patinate their wares in order to give them a genuinely 'antique' finish, but anyone who felt that this made them look dirty could buy highly polished pieces. Many of the pewter articles made in this period can easily be recognized as monstrosities, but others, for example plates, or plain jugs and tankards, have developed a genuine patina of their own during their lifetime of nearly a hundred years and sometimes pose a tricky problem for collectors and scholars. This craze for reviving earlier styles continued in some areas into the twentieth century.

Natural pewter was supplemented during this period by various new alloys considered to be more practical, attractive and generally grander-looking, as well as being cheaper. The best-known is, of course, Britannia metal, which is shinier than pewter and yet does not need much polishing, although it does not glitter like silver. It was basically a hybrid, and articles made of it had no individual style of their own, nor did they succeed in adapting the style of either pewter or silver objects.

The reaction which set in throughout Europe in the 1890s against the wave of imitations was as universal as the imitations themselves had been. The artists, and especially the craftsmen, of the period aimed at creating an individual and original style which would be totally independent of any earlier movements; this new approach to art is known as *Art Nouveau*. Art journals such as the *Studio*, *Deutsche Kunst und Dekoration* or *Jugend* published articles discussing the aims of the new style, reproduced illustrations, made suggestions and generally encouraged the public to take an interest in the new movement.

The realization that the artist must fully appreciate both the possibilities and limitations inherent in various materials and only expect them to give what they are capable of giving was a very important departure from earlier attitudes. This was another aspect which artists in the preceding period had completely ignored, calmly producing monstrosities – imitation stoneware jugs made of pewter and copper, majolica vases made of porcelain and other such articles. *Art Nouveau* artists, however, were concerned with allowing the innate properties of the materials themselves to condition the design of their work, and in this way achieved effects which did justice to the particular material, whether brass, bronze, copper or pewter.

But although they were concerned with the problem of creating spontaneous and realistic applied art by means of pure craftsmanship, *Art Nouveau* artists and theorists were determined not to overlook the fact that industry had more or less usurped the function of skilled

196

craftsmanship. This old-style craftsmanship which had been practised *Pewter* up to about 1800 was no longer capable of satisfying the enormous demands made by the newly emerged consumer society. The champions of *Art Nouveau* were clever enough to realize that if they demanded a general return to the old production methods, they would simply hinder the spread of their new ideas and stylistic theories; so they put their faith in technical progress, and included industry with all its possibilities in their plans for reform, making precise demands and proposals. The day of the designer had come. Pewter manufacturers began to commission well-known artists to work for them, so that pewter was now being designed by architects, graphic designers, modellers, interior decorators, painters and jewellers. The manufacturers then reproduced their designs on a large scale and sold them as consumer goods. In Germany, a firm called Kayser had a virtual monopoly of pewter articles and was able to call on famous and presumably expensive artists to act as designers. The firm, which was flourishing from the turn of the century to the outbreak of the First World War, had its design office in Cologne and its factory in Oppum, near Krefeld. The end of the *Art Nouveau* period, which had lasted some time, led to the collapse of Kayser's and their goods were either forgotten or treated as a joke until our own day, when they have come back into fashion, along with *Art Nouveau* in general.

Pewter has never played a leading role in the history of metals, but it has always occupied an important position somewhere between the non-precious metals and silver. It has been made into purely functional utensils by humble craftsmen, but certain artists have also won lasting fame by fashioning it into genuine works of art.

Metalwork For thousands of years men have used three different metals for their tools and utensils: bronze/copper, iron and tin. Other metals, such as lead, nickel and zinc, have also been used when some special technical or artistic effect was required, but their use has always been strictly limited and they have never been in a position to spread new styles, as have the three main metals.

The individual metals, and the pieces made from them, have gone through periods of fashion, have reached the heights of artistic perfection – and have suffered periods of decline. The reasons for their changes of fortune have been many and varied: trade and economics, high-level politics and local politics, the emergence of new styles, fashion, wars, new discoveries, natural phenomena, population changes, changes in taste, princely whims and individual theories, the requirements of specific groups – all these factors have affected the popularity of a particular metal or of a particular type of utensil and have decided whether it is within the reach of the poor or just for the rich.

The men who have worked with metal – artisans, craftsmen or artists – have left behind them a legacy of creative work, to which they devoted their skill, enthusiasm and sometimes even genius, but always with the aim of serving their fellow-men and warming their hearts.

Notes

Part I Copper

1 Mining and processing

1. The most extensive copper mines during the Eighteenth Dynasty (*c.* 1580–1322 BC) were at Akaba, and under Tuthmosis III (*c.* 1479 – 47 BC) there were copper mines on the slopes of Sinai.

2. Spanish mines provided copper for the Romans; Pliny writes of copper which came from the rich source of the Marianus mountain in the Roman province of Hispania Baelica, where the famous city of Cordova later developed. The old Phoenician mines in the province of Huelva were taken over by the Romans, who continued to work them until about AD 400. Of these, Rio Tinto and Tharsis were the most productive. From the size of the slag heaps it has been calculated that production must have been in the region of 2,400 tons per annum, which is an astonishingly large figure, considering the conditions of the time. However, the copper mines of Spain were completely worked out under the Goths and Moors and the Rio Tinto mine was not reopened until 1727.

3. One example is the mine at Rammelsberg near Goslar, which was opened during Otto I's reign in 968, and is still being worked today. Production in Saxony began near Mittweida and Frankenberg in about AD 922 – 30.

4. The mines near Frankenberg in Hesse, Stadtberg in Westphalia Ilmenau, Kommern in the Eifel, and at Rheinbreitbach near Honnef should also be mentioned.

5. In Hungary, copper mining began in Roman times and was revived by Saxon miners in about 1140 in Szepes. The usual method for extracting copper in Herrengrund was to heat it, a process known as 'converting it with iron'. The most important copper deposits in Sweden are in Falun and have probably been worked since the end of the twelfth century. Russia's most important copper mines are in the Urals and Caucasus: Xenophon noted that the people in the districts of Rubar and Merchesch often used copper articles.

6. Early in the ninth century an ordinance declared that chalices must normally be made of gold or silver, but that very poor parishes might use pewter instead; copper and bronze were never to be used because there was a danger that the communion wine might be polluted by verdigris and cause vomiting. The Synod of Winchester (1076) and Archbishop Aelfric of Canterbury also prohibited the use of copper or bronze. In the eighth and ninth centuries individual areas had their own ecclesiastical decrees and no central directive was issued from Rome. But since a whole series of edicts was published on this particular topic, we can assume that it was a question which worried the heads of the church a good deal. It is also clear that there were a great many differences between the rich monasteries and sees, most of which were under the patronage of some prince, and the poorer churches.

7. In 1927 Gustav Alexander published a monograph in which he refers to 410 different articles made in Herrengrund, comprising hemispherical and double drinking-mugs, goblets,

199

conical mugs, dishes with double handles, ordinary dishes, spoons, boxes and a table centrepiece in the shape of a *Handstein*. (A composition of ore samples mounted in silver.)

Part II Bronze and brass

1 Production of bronze and brass

1. The Bible tells us of a man called Tubalcain, who was 'an instructor of every artificer in brass and iron' (Genesis IV; 22), and of the Phoenician Hiram of Tyre, who cast two pillars of brass . . . 'and two chapter of molten brass to set upon the top of the pillars . . . and he made a molten sea (i.e., a basin) . . . and upon it stood twelve oxen . . . and ten bases of brass . . . l vers . . . pots, and the shovels, and the basins' (1 Kings VII; 13 f.). At the entrance to the harbour of Rhodes could be seen the towering bronze Colossus, a statue of Helios 97 feet 6 inches high, and with legs wide apart so that sailing ships could sail between them.
2. The word 'calamine' (and the German word *Galmei*) was presumably derived from the Latin *cadmia* or *cadmea*, but it has also been traced back to the Arabic *kalmeia, kalmija,* and *kalminia,* though in fact these are also a corruption of the Latin. It occurs in various forms in German, ranging from *Kalomynna* and *Kailmynne* to *Kalmyn, Clam* and *Kelmis.*
3. The calamine found here is the very best quality, and is found in large beds in the sections belonging to the middle and upper Devonian and lower Carboniferous series.
4. The weights given are only approximate and differ considerably from the information given by Brown in *Reysen door Nederland*, p. 207.
5. The colour of brass depends on how much zinc it contains: if the proportion of zinc is between 1 and 7 per cent it will be copper-coloured; 14 per cent zinc produces a reddish-gold (this alloy is called 'tombac' or 'red brass'); 17 per cent zinc means that it will be a pure golden colour; 30 per cent gives a pale gold which is known as *cuivre poli*; 50 per cent of zinc produces an alloy known as 'pinchbeck', which is a golden colour; with 53 per cent of zinc the metal becomes reddish-white; at 56 per cent it is yellowish-white; at 67 per cent bluish-white; at 70 per cent it will be the colour of lead and at 80 per cent the colour of zinc. The melting point of brass is 850° Centigrade; it forms a smooth liquid which is thinner than bronze.
6. A chemical analysis shows that they contain $17\frac{1}{2}$ per cent zinc, 5 per cent tin and $77\frac{1}{2}$ per cent copper.
7. One example being a monumental lion made in Brunswick in 1166, which contains 81 per cent copper, 6.5 per cent tin and 10 per cent zinc, as well as 2.5 per cent lead. A seven-branched candlestick, also from Brunswick, has 84.62 per cent copper, only 3.69 per cent tin, 10.64 per cent zinc, and admixtures of other metals, which means that it can be classified as brass.
8. In English, for instance, the word 'bronze' is used with considerable hesitation and generally refers to antique pieces, whereas 'brass' covers a wide range of meanings and in general use includes any article made of an alloy based on copper. Hammered sheet brass is called latten. In Dutch, both alloys are simply known as *coper* or *coperwerk*, while in French *laiton* is the usual word for brass, although *cuivre* (which really means copper) is also used as an alternative. *Laiton* is thought to be a derivation of *latte* or *latta* – beaten sheet-metal – (cf. English latten). During the sixteenth and seventeenth centuries the word *Messing*, which is the normal word for brass in modern German, was relatively rare in the Rhineland, where the largest centres of brass production were situated. At that time the designation was either *Kupfer* (copper), or more often *latoen*, a word borrowed from the French-speaking Walloons, which was probably introduced into the area, as were various other words connected with brass production, by emigrant metalworkers from the Meuse district. The word *Messing*, sometimes written as *messe, mösch* or *missinc*, is derived from *massa*, meaning a lump (of metal).

2 The Carolingian period to the Romanesque

1. For instance, in 807 the Byzantine ambassador Abdella brought Charlemagne '. . . a tent . . . lengths of silk, scents, pomades and ointments, two brass candlesticks of wondrous size

200

and shape, and in addition a clock most artistically fashioned in brass . . . with twelve horsemen appearing out of five windows to indicate the passing of each hour'. That is the description in the imperial records, but unfortunately this technical miracle from the East has not survived the centuries, and neither have the brass candlesticks.

2. The same applies to craftsmen in other branches of the metalwork trade, one example being 'Kandler' (*Kannenmacher* or 'tankard-maker') which was initially used by pewterers to show their trade but later became a family name.

3 The Gothic period

1. There were brass-smelters, brass-rubbers, brass-turners, copper-founders and brass-founders, smiths for copper and brass and tin, basin-beaters, wire-makers, needle-makers, handle-makers and thimble-makers, gun-lock makers, wagon-makers, makers of weights, jewellers, makers of geometrical compasses and makers of navigational compasses. The smith's trade itself was sub-divided into blacksmiths, toolsmiths, farriers, nail-makers, sword-cutlers, armourers and helmet-makers, sheet-metal workers, braziers, brass-workers and tinsmiths.

2. The main difference between the *Grapen* made in northern Germany and the *Glockenspeishafen* (or 'bell-metal pots'), as they are called in southern Germany, is that on the *Grapen* the join between lip and vessel is very obvious, whereas on the examples from the south the join is smooth and flawless.

4 The Renaissance

1. The *Ständebuch* (Book of trades) by Jost Ammann with verses by Hans Sachs, which was published in Frankfurt in 1568, gives us some more detailed information about the people who bought from the basin-beaters:

Gestempfft mit bildwerk, gweckss und blum
einstheils ir spigel glatt auff kum
wie gross Herrn und Balbierer han
auch gring, für den gemeinen Mann.

(Embossed with pictures, foliage and flowers,
Their surface is sometimes polished like a mirror
As great Lords and barbers have
But there are little ones for the common man.)

2. We must also remember this when considering the concentric bands of inscriptions on the brass bowls. Early authors often tried to decipher and interpret them, but such attempts were never successful for the simple reason that the letters had been arranged quite arbitrarily and were never intended to form a coherent statement or saying.

3. The rich figure decoration on the nests of weights shows the creative ability of the brass-founders. This is not surprising when we remember that this was the golden age of bronze statuary in Nuremberg. The most famous example is the Sebaldus monument by Peter Vischer, which can be seen in the Sebaldus church, and many other bronze panels on monuments to the dead prove that much bronze sculpture of the highest quality was being created.

5 Domestic metalwork from the Gothic period to the nineteenth century

1. Wernherus of Constance incorporated a mortar in his coat-of-arms in about 1270 and Leutfried of Augsburg had the same idea in 1302. The mortar took on a symbolic significance which led to its manufacture purely for decoration and to be displayed preferably mounted on an ornamental pedestal in the apothecary's shop.

2. Craftsmen working in bronze were in fact more communicative than other artists because their traditional inscription gave them a golden opportunity of handing down their names to posterity. The custom of signing works of art is a relatively recent innovation which

201

Metalwork did not become a mania among artists until the second half of the nineteenth century, until in our own day it has become a mockery. In the Romanesque and Gothic periods, artists kept modestly out of sight and left the work to speak for itself; mostly they were working for God and the Church and wordly vanity would have been quite out of place.

3. It is traditionally believed that Galileo once used it for an experiment, which is why it is known as the *Lampada di Galileo*.

4. And Germany was not alone, for French influence spread to England, to Italy, to Russia, Scandinavia and the Balkans, though of course it must be remembered that it was generally only the very highest strata of society that were affected.

5. Known in Germany as *Blaker*, they were particularly common in northern Germany, the Low Countries and England.

6. Candlesticks achieved particular importance in Saxony where founders received much encouragement from Augustus the Strong. Another important centre after the middle of the eighteenth century was Potsdam, where Frederick the Great had his official residence. Artists summoned from all parts of Germany to the courts of these two monarchs followed the French originals very closely but always retained something of the local German styles.

7. According to Wilhelm Treue in his *Kunstgeschichte des Alltags* (History of Everyday Objects), in England 'silver plates and lids spread even to the poorest classes . . . in Göttingen Professor Gottfried Sell, who had married a wealthy Dutch lady, has silver spitoons and candelabras, even in the lecture-room.' In Paris, at the time of the financial swindle involving the Scottish financier John Law, 1715–20, gold and silver replaced copper and pewter, even for the most ordinary utensils, for example even for chamber-pots.

Part III Iron

1 Iron-mines and foundries

1. A broken piece of an iron tool has actually been found in a crack in the stone wall of the Cheops pyramid, erected *c.* 3000 BC; and several small objects dating from a later period have also survived.

2. The Chaldeans, Israelites, Arabs, Lydians, Phoenicians, the peoples of India and China, Persians, Etruscans and on rare occasions even the Greeks, are also known to have mined and used iron.

3. The most important medieval mining districts are: Styria, the Tyrol, Bohemia, Bavaria, Franconia, Württemberg, Nassau, the Harz Mountains, Westphalia, Silesia, southern Westphalia, Siegerland, the Eifel mountains, the Erzgebirge, the Meuse district, Lorraine, Normandy, the Basque provinces, the Forest of Dean, Sussex and Scandinavia. In some places the iron was extracted from the bottom of lakes.

4. Especially from magnetite, haematite, limonite and siderite, most of which contain more than 50 per cent iron.

5. In many cases iron-mining was carried out entirely by farmers as a side line, and professional ironworkers were only to be found in places where there were particularly large deposits of good quality iron-ore.

6. The blast furnaces which were used for producing iron in the sixteenth century were between $15\frac{1}{2}$ feet and $17\frac{1}{2}$ feet high, and were known in Germany as '*Hochofen*' or 'high furnaces'. In seventeenth-century England some blast-furnaces were nearly 30 feet high. English producers were experimenting with pit coal at an early date, instead of the charcoal generally used throughout Europe. Such attempts were initially a failure until in 1619 a man called Dud Dudley was successful in finding ways of producing iron much more cheaply, but his success did not last long and he soon went out of business.

7. Swordsmiths, scythe-makers and compass-makers, handle-makers and thimble-makers, wire-drawers, harness-makers, blade-smiths, who were only allowed to make double-edged sword blades, lock-makers, compass-makers, plate-armour makers, cutlers and armourers, helm-smiths, spurriers (Sporer), makers of metal-fittings, needle-makers, razor-makers, nail-makers, bore-makers or tool-makers, who manufactured drills and saws, chain-smiths, tinsmiths and tube-makers.

202

1. Another very early example of wrought-iron work is a sword belonging to the Egyptian pharoah Tutankhamen, which was made in about 1350 BC; this is a very rare and precious article, as befits the exalted status of its owner.

2. The Thidrek Saga, which belongs to the thirteenth-century *Prose Edda*, tells of a contest between Weland and the court blacksmith, Amilias. Amilias wagered that Weland's sword could not cut through his own armour, so Weland forged a sword and tested its sharpness by letting a piece of flock-wool be driven down the river against the cutting-edge. He found, however, that it did not cut clean through, as he had expected, so he filed down the sword, kneaded the cuttings with flour and milk and gave them to geese to eat. He then smelted their droppings to obtain a new type of iron which he used to forge a second sword. This still did not satisfy him, so he repeated the process all over again, until eventually he forged a sword called 'Mimung', which not only cut through flock but needed only gentle pressure to cut clean through both Amilias's armour and Amilias himself.

3. Thus poets tell us that King Arthur's sword was called Excalibur or Caliburn, that Weland Smith forged Mimung, that Siegmund's sword Gram was made by Regin the dwarf, that Siegfried's was called Balmung, Beowulf had Nagelin, and Fafnir fought Siegfried with Hrotte. Charlemagne's sword was called Joyeuse and Roland cut his way through the Pyrenees with Durendal or Durnhardt. There is no end to the list.

4. The Song of Beowulf describes how the hero struggled in vain to kill the dragon, but then drew his *walsachs*, or fighting-knife, and split the monster in two. It is generally believed that the *sax* gave its name to the Germanic race known as the Saxons.

5. Another, known as St Maurice's sword, dating from the same period, once formed part of the German imperial jewels; it is now in the Schatzkammer in Vienna.

6. Smiths working in Passau stamped their blades with a running wolf, which appears on the town's coat-of-arms, inlaying it with copper or brass. In 1349 the local guild of smiths is said to have given permission to use the wolf mark but, in fact, it can already be seen on a sword dating from the previous century. It was often copied, sometimes even by craftsmen in other towns with an excellent reputation of their own who had no need to practise this type of dishonesty. As well as the sword workshops organized by guild members, Passau also had an episcopal workshop, whose products were stamped with a crozier in front of the running wolf symbol.

The smiths of Brescia, who were producing blades of superb quality in the thirteenth century, had a long tradition behind them, since weapons had been made there even in ancient times. Gradually cold-steel weapons were superseded by gunpowder, whereupon the excellent weapon-makers of Brescia promptly changed over to the manufacture of fire-arms, especially pistols.

7. The workshops in Toledo were world-famous and attracted craftsmen from far and wide, such as Juan and Gil Alman, who undoubtedly came from Germany.

8. The process of sword making was divided up into the following stages: the iron was imported in bars from the neighbouring districts of southern Westphalia and Siegerland; first of all the smith took the bars and fashioned what is known as a black blade, which simply means a roughly shaped blade; next, a tempering-smith took over; the sword then went to a grinder, who gave it a cutting edge by turning it on his grindstone; (up to the thirteenth century it was normal practice for the cutting-edge to be sharpened by hand, but now grindstones harnessed to water-power were beginning to be used instead); the blade then returned to the tempering-smith, and then went to the cutler to be polished. Finally a craftsman put the finishing touches by the addition of the hilt and scabbard.

Consequently five separate craftsmen, whose functions were strictly defined were used to make one sword. The smith's craft, as well as those of the temperer and grinder, were all highly respected trades. The details of their work were kept secret, and a large number of guilds made their members swear on oath not to leave the district nor pass on the secrets of their craft to anyone but their own sons.

9. Another example of a sword made purely for purposes of display is the two-hander found in the grave of the Swedish regent, Svante Nilsson Sture.

10. Duke Leopold III of Austria sent out another army of the old type to fight the Swiss in

1386 but he paid for this tactical error with his life. Similarly, Charles the Bold of Burgundy, who may be considered as one of the last knights in the western world, fell to a halberdier's blow in the Battle of Nancy in 1477; the weapon split open both his helmet and his skull.

11. The following represent only a small selection of the many different types in use at this period: pikes, winged-spears, *ahlspiesse*, tridents, bills, glaives, fauchards, partisans, spears.

12. He is mentioned in a list of salaries for the artists employed at court which was drawn up in 1594. It appears that his annual salary was 320 gulden, while the painter Friedrich Sustris was paid 600 gulden, Peter Candid 500 gulden, and the sculptors Hubert Gerhard and Hans Krumpper only 100 and 200 gulden respectively.

13. In the following century, *c.* 1485–90, the falchion appeared again in the *Execution of St Matthew* by Andrea Sansovino, on the high altar of S. Spirito, Florence.

14. Gunther Schiedläusky gives a detailed picture of eating and drinking habits, based on extensive research into contemporary documents in, *Essen und Trinken: Tafelsitten bis zum Ausgang des Mittelalters* ('Eating and Drinking: Table manners down to the end of the Middle Ages') (Munich, 1959). For a study of tableware in particular, see Heinz R. Uhlemann: *Alte Tischgesellen* (Old Table Companions) (n.d., but *c.* 1966).

3 Armour and Firearms

1. A woodcut executed by Hans Burgkmair in 1516 for *Der Weisskunig* shows the emperor visiting a master-armourer called Konrad Seusenhofer in his workshop in Innsbruck; he is talking to him in a friendly fashion with his hand on his shoulder.

2. Some idea of the amount of armour which was ordered can be got from a few invoices which have been preserved: in 1508, for instance, an order was placed in Augsburg for 500 suits of armour for foot soldiers, and in the same year, 2,000 breast-plates, again for foot soldiers, were expected to arrive from Nuremburg. A master-armourer called Wolf von Speyer, who made some armour for Elector August of Saxony in the 1560s, also supplied him with 324 suits of armour for mercenaries at a cost of 7 fl. each.

4 Wrought-ironwork during the Romanesque and Gothic periods

1. These chests, which measured up to $6\frac{1}{2}$ feet in length, were perfectly adequate so long as the valuables they were to contain consisted merely of cash, jewellery, an outfit of clothes for special occasions and a few household utensils made of precious metals. In the Renaissance, however, ordinary citizens began to have larger households and more valuable possessions, so that a wider variety of furniture became available. Clothes were stored in wardrobes, personal and household linen in attractive wooden chests, silver and other tableware was displayed on a sideboard, and any cash not invested in the family business or yielding interest in the bank was hidden away in coffers. Iron chests and iron-bound chests developed later into war chests which could be easily moved and were taken on military expeditions as a sort of business-chest. Since this particular piece of furniture was only used for money and jewellery from the sixteenth century onwards, there was no need for it to be as big as its medieval counterpart. It was therefore replaced by a smaller iron casket or coffer which was often exceedingly heavy. The original metal bands and padlock were replaced by a highly complicated system of bolts, full of secret mechanisms.

2. Another craftsman, Henry of Lewes, made the grille formerly on the tomb of Henry III in Westminster Abbey in 1258–9, and is also thought to have been responsible for the ironwork on the east doors of St George's Chapel, Windsor.

3. Other blacksmiths include Andrea di Sano (1392), Jacomo di Giovanni (1402), and Giacomo and Giovanni di Vita (1445).

204

1. The people who commissioned it were so delighted with the beauty of the well and the richness and complexity of the decoration, that they decided to pay Paulus an extra *kreuzer* per pound of iron over and above the agreed fee. Apparently it weighed 102 cwt 47 lb and Paulus received 854 gulden; the gilding cost another 400 gulden, or half as much again as the cost of the actual grille.

2. It weighed 982 lb and a fee of 49 fl. 24 pf. was paid, which included a supplementary fee for particularly fine work. The painter received a further sum of over 40 fl. for gilding and painting it.

3. In the Victoria and Albert Museum there is a steel casket with the monogram of William and Mary; it was made somewhere between 1688 and 1694 and is covered with velvet and decorative ornaments made of brass-gilt and steel. In the Bayerisches National Museum in Munich we can see an iron and brass-gilt casket made by Pierre Fromery, a Huguenot refugee working in Berlin, for the Elector Josef Clemens, archbishop of Cologne. The Empress Maria Theresa is alleged to have owned a casket made of cut and polished steel, which had been made for her by a craftsman called Johann Baltasar Weis and which is now on loan to the Victoria and Albert Museum, London.

4. While he was employed in Berlin, Leigebe spent three years of painstaking toil making a statuette of the Great Elector; this was an equestrian portrait showing him killing a dragon and was a little under 12 inches high. He complained that the work had ruined his health.

6 Cast-iron

1. The main centres on the Continent were northern and eastern France, Belgium, Holland, Luxemburg, the Eifel, Siegerland, Hesse and Saxony; in England the most important county was Sussex.

2. Craftsmen working in the Eifel area, one of the oldest centres of the cast-iron industry, used not only family crests and the coat-of-arms of their sovereign, but also images of the saints, X-type motifs, which also appear on furniture made in Flanders and the Rhineland during the same period, parchment scrolls – these were again widely used elsewhere – the fish-bladder motif and interlaced foliage.

3. Oddly enough, from the second half of the sixteenth century onwards, the accounts of the foundry in the monastery at Haina in Hesse include details of the people who bought stoves and their social status. In the years 1555-6, for instance, stove panels were supplied almost exclusively to castles in the area, or sometimes some way away, but by 1573 a number of ordinary town-dwellers appear on the lists as buyers – for instance, a steward, a village bailiff, a scribe working in a foundry, parsons, chaplains, professors, citizens of various towns, villagers, some of whom paid in kind, village authorities and the smaller municipalities, plus the University of Marburg. The local Landgrave bought a very large number of stoves in the following period, but otherwise the majority of clients were ordinary middle-class citizens and farmers.

Part IV Pewter

1 Tin-mining and the making of pewter

1. 2–3 pounds of copper would be added to 1 hundredweight of tin.

2. The lowest-grade alloy of this type – which can only just be called 'test-pewter' – still contains six parts of tin to one part of lead, while the best quality metal consists of fifteen parts of tin to one part of lead. The most widely used proportion was 10 : 1, a standard followed in particular by the Nuremberg founders who were the greatest experts in this craft in the fifteenth and sixteenth centuries and thus set the fashion, which was followed by most of the guilds. This is the origin of the expression 'Nuremberg test' and explains the term 'test pewter'.

205

Metalwork **3.** In various places the two marks were combined to form a single coat-of-arms. The best known example of this is Nuremberg, where pewterers used a single touch in which half the eagle appears on the right to represent the city's coat-of-arms, with three bars on the left with the master's initials or some other emblem of his set between them. Cologne, Augsburg, Berlin, Basle, Paris and other towns also used single marks.

At the end of the sixteenth century dates sometimes began to appear by the side of the master's touch. They did not necessarily refer to the year in which the object was made, but they do help in establishing the date of the object. The date was worked for several different reasons. Sometimes it referred to the year in which the pewterer became a master. Occasionally a master-pewterer who had been detected using incorrect proportions of lead and tin in his alloys would be required to add the date of this discovery to his own stamp. This enabled the inspectors to check that he was now using the correct mixture.

In many cases, the pewter touches for whole districts or specific towns bear the same dates; the number referred to the year when a decree was issued, either by the sovereign or by the government, instructing all guilds in the area on the required content of pewter alloys. The date had to be incorporated in the stamp so that the inspectors could be certain that pewterers were actually abiding by the regulations.

When pewterware contained a higher content of tin than was normal in the district at any given time, one of the two touches – town-mark and master's mark – was stamped twice. This 'triple-touch' system was particularly common in Saxony. In other districts, instead of one of the touches being repeated, a state mark would be added, or else the Roman figure X, denoting the mixture $1:10$, or the letters CL linked together, which stands for *clar* (plain) and *lauter* (unalloyed). Pure pewter, purified in the English fashion, was given a special stamp indicating its higher quality, comprising a crown, a rose or an angel. From the eighteenth century onwards it was normal to add the pewterer's initials, or his touch, or even his full name so that the master's touch became superfluous. By this time, the city mark was often omitted too, which makes it difficult for present-day collectors to locate the origin of a piece. Nevertheless, it is also a remarkable historical phenomenon, evidence of the fact that the importance and power of the guilds was gradually declining in the eighteenth century. Long before complete freedom was achieved for any man to practise any trade he chose, pewterers were demanding the right to guarantee the quality of their goods by marking their own names instead of the coat-of-arms of their home-town.

In a few cases touches could be omitted without the guilds or the customers objecting, but only when a piece had been made by an important master who was recognized as a true artist, in which case material value was utterly unimportant compared to the aesthetic value and the detailed work involved. In such cases the best alloy was always used. This is particularly true of relief pewter made in France in the second half of the sixteenth century. The same situation applied in the case of silversmiths, some of whom, known as *Hofbefreiter*, who did not come under the jurisdiction of the guilds – did not hallmark their work. Moreover, pewterers often seem to have left their work unmarked when they had executed special commissions which went directly to the client. Thus wedding-services and pastry dishes which were used for presents would often be unmarked, as well as lamps, altar vessels, fonts, tombstones and wall-fountains.

In Paris a regulation published as early as 1304 stated:

'The hawking of pewterware is prohibited; apprenticeships shall run for eight years on a payment of forty sols, or ten years if no payment is made. No workshop may employ more than one apprentice. On entering the guild, all young masters are to pay twenty sols to the king and ten to the municipality. Master's sons shall be exempt from this payment. The guild shall appoint two jurymen. On certain holidays work will come to a halt.'

Nothing had been said so far about pewter alloys and the relative proportions of lead and tin. In fact, it was not until 1382 that a regulation, dated 1 September, stated in general terms that the mixture must be a good one and must bear a mark. There was still no specific ruling about the content of alloys. In the course of the next few centuries, there were regulations about the composition of the various qualities in current use, a distinction being made between high-quality pewter, ordinary pewter and a low-quality alloy, but the actual constituents of alloys seem to have been governed by a tacit agreement rather than by any centralized and exact definition of the stipulated proportions.

206

The rule that pewterware should be signed does not seem to have been observed very conscientiously and most of the few pieces which have survived from the period are unmarked.

In 1643 a decree, issued by Louis XIII and dated 15 August, stated specifically that Paris pewterers must punch their masters' touches on all their goods and that the touches must include the initials of the artist, together with a hammer surmounted by a crown and a large P. This was known as a 'small touch' and was used for ordinary pewter consisting of five pounds of lead and two pounds of copper to every 100 kilograms of tin. High-quality pewter contained three pounds of red copper to a hundred kilograms of tin; in accordance with the same 1643 ruling, pieces had to be marked with a touch in the shape of a cartouche and bear the name of the master pewterer, the date of the decree or sometimes the date of his enrolment in the guild, the hammer surmounted by a crown and the words *ESTAIN FIN*.

At the beginning of the second half of the seventeenth century, the king issued a decree whereby all pewterers and dealers were instructed to present all high-quality pewterware offered for sale to the appropriate government department for inspection. It would then be stamped with an official mark and the pewterer had to pay one sol per pound of pewter. The reason for this compulsory inspection was not so much anxiety about the quality and content of the alloy but rather the desire to find a new source of revenue for the state. Since it raised the price of the goods it was extremely unpopular and the law had to be repealed in 1676. In 1691, however, it was reinstated, and was retained until the end of the *ancien régime*. In Paris it was necessary to appoint eight inspectors (known as *contrôleurs-essayeurs*) in order to deal with all the pewter which had been offered for inspection. The same regulation also applied to all the other towns in France. The test marks or control-marks on high-quality goods displayed a double F surmounted by a crown and flanked by the name of the town, together with the year when the comptroller had been appointed. Since the comptrollers were always being changed, especially in Paris, the dates make it easy for us to establish when an article was made. In smaller towns, however, the dates did not change so often.

The mark for ordinary pewter was a C surmounted by a crown (C stands for *commun*) instead of an F.

In 1791, a new law proclaimed that the guild regulations with all their rights, privileges, and duties were no longer valid and that every citizen was free to take up any trade or profession he wished. At the same time it was pointed out that the correct proportions of tin and lead should still be maintained. In 1839 the correct proportion was fixed at 18 per cent, although in 1890 this was reduced to 10 per cent.

In England pewter articles were equally subject to inspection, so that pewterers had to mark their goods and take them to the guildhall to be examined by a warden and an inspector, or by a nominated member of the guild. After it had been tested each piece would be stamped again, this time with a 'hallmark' which guaranteed the correct proportions of the alloy. Surprisingly, the exact composition of the 'correct' alloy was never laid down nor were percentages ever given, as they were in Germany. The authorities seem to have been satisfied with a tacit agreement as early as 1474–5. The records of the London pewterers speak of official hallmarks and they are mentioned more and more frequently in the following years. A distinction was made between a stamp with a rose surmounted by a crown, used in 1671 for articles made for export, a fleur-de-lis used for jug lids, and another mark known as 'strake of tin and lilypot'.

In 1689 a mark consisting of the number X is mentioned for the first time. By using this mark, English pewterers were adopting a Continental custom, although they do not appear to have been fully aware of the fact that X indicated an alloy of 1 : 10 in Europe; this proportion was never mentioned in English regulations.

On various occasions guild members were forbidden to mark their work with their full name, but were allowed to put the word 'London'. Many provincial pewterers followed suit, and the London guild protested against this more than once. In 1697 the guild expressly permitted masters to include their full names in their stamps, while in 1746 it became obligatory to do so.

During the seventeenth century the rose surmounted by a crown was the mark most generally used to indicate quality, and it would appear next to the master's touch. The X was often still added but although it had originally been intended to indicate very special quality, it soon began to be used for ordinary goods as well.

207

In about 1635 disputes between pewterers and goldsmiths occurred because the former were using a combination of three or four marks which looked very similar to silver hallmarks. Initially, the combination of four marks would be stamped on the upper side of bowls and dishes, while the master's touch normally appeared underneath, generally in the centre. Hallmarks on pewter articles made in London usually have a lion or a lion's head, letters and emblems. It was not unusual for a pewterer to pass on his own particular combination of marks to a colleague, either because the business was changing hands, or because they had gone into partnership together, or sometimes because a man with a large business wanted to subcontract some of his work so that he could increase his production.

2 Antiquity to the Gothic period

1. A fine example of this is to be found in the Museum für Kunsthandwerk, Dresden. Most late Gothic pewter candlesticks were modelled on bronze examples, so this is a very unusual piece.

2. The following notes give some indication of the sort of possessions enjoyed by the rich in the late Gothic period: in 1370 Henri de Poitiers, bishop of Troyes, had a large pewter tankard and four small jugs, as well as two other jugs and three measuring jugs; in 1386 a canon from Troyes stated that he possessed four jugs, one pot, four flagons (*chopines*) and one measuring-jug; when a certain Jacques Coeur's belongings were sold off in 1453, they included nine dishes, fourteen double-handled bowls, a salt-cellar and four cups, as well as twenty-eight jugs of varying sizes; the household of a very rich man in Paris contained in 1393 ten dozen bowls, six dozen small plates, two and a half dozen large plates, eight tankards, two dozen jugs and two pots. When Nikolaus Uffsteiner, the extremely rich town-clerk of Frankfurt, died in 1473, his four children inherited no less than 10 cwt of pewterware, including tankards of various sizes, bowls, basins, plates and dishes.

3 Pewterware in the fifteenth and sixteenth centuries

1. Hans Demiani, who has written a monograph on Briot, has put forward the theory that the Temperantia Dish and ewer were commissioned by the duke of Montbéliard, who was an art lover and also fond of lavish decoration, but other experts claim that Briot was commissioned to make the copper moulds by several different pewterers, who then hired them out and prepared copies. This seems rather unlikely. On the other hand, Demiani's theory is no more than a supposition, although the following facts are indisputable: in 1601 moulds for a dish, an ewer, a vase and a salt-cellar were seized from Briot's workshop by one of his creditors; the court of appeal ordered that this pledge should be returned because Duke Friedrich also had claims on Briot, and the moulds guaranteed any such claim. They appear to have been returned to Briot on the grounds that they were the most vital tools of his trade and enabled him to earn his living. In 1661 he was again prosecuted for debt and this time it was decided that although the contents of his house had to be auctioned to repay his debts he should be allowed to keep the moulds.

After his death the moulds came into the possession of a pewterer working in Strasbourg, called Isaac Faust, who cast various pieces from them and stamped them with his personal mark as well as the mark for the town of Strasbourg, in accordance with the rules laid down by the local guild.

2. In the middle of the eighteenth century a pewterer's daughter whose husband was also a pewterer drew up a very detailed list of exactly what she had brought her husband in her dowry; 9 copper moulds for basins, weighing 98 pounds and worth 58 fl. 48 kreuzer; moulds for tankards and chamber-pots, weight 92 pounds, value 55 fl. 12 kreuzer; moulds for rings and handles, weight 22 pounds, value 8 fl. 4 kreuzer; moulds for knobs and handles, weight $2\frac{1}{2}$ pounds, value 1 fl. 54 kreuzer.

208

1. A labourer from Lincolnshire, who also ran a small-holding, had much the same type of possessions. He died in 1556, leaving three bronze pots, three small pans, two pewter candlesticks and four pewter bowls. If we compare these lists with others drawn up about seventy years later we find that much the same amount of pewter and copper is listed, and that the variety of articles is much the same as well. For instance in 1635 a farmer called Lillye from Leicestershire left two pots, one pan, one large cauldron, three saucepans, two candlesticks, one brass pestle and mortar, nine bowls and two pewter candlesticks, two double salt-cellars and one single, all of which were probably also made of pewter.

2. The following details from a book published anonymously in 1783 give an idea of the sort of milieux in which pewter was regarded as an investment; the book is called *Plans and Costings for furnishing a Household, for the use of Housewives and Family Men of various Social Classes (Brandenburg 1783)*, and the author recommends his readers to make the following purchases, among many others:

For a royal household, the following silver was to be bought:

1 large *plat de ménage*, 1 smaller version of the same, 2 large round tureens and 2 oval ones, with 2 accompanying bowls each, 10 large and small tureens of varying sizes, plus 10 matching bowls, 12 oval meat dishes of varying sizes, 24 round bowls, again of varying sizes, 8 *assiettes*, 24 covers or lids for the bowls, 24 hollowed soup plates, 96 hollowed ordinary plates, 36 plates for sweetmeats with filigree rims, 6 salvers set on stands, 4 salad dishes, 2 sauceboats, gilded inside, 8 salt-cellars, 2 pairs of carving knives and forks, 60 sets of knife, fork and spoon, 2 large soup-ladles, 2 serving-spoons for stews, 12 poultry spikes, 2 implements for removing the marrow from bones, 2 filigree serving-dishes with wooden handles, 2 butter scoops with gilt bowls, 2 pairs of asparagus tongs, 1 hanging kettle, with a matching *fontaine*, 1 ice-bucket, 4 four-branched candlesticks, 4 three-branched candlesticks and 4 two-branched candlesticks, 8 ordinary candlesticks, 12 fine English steel candle-snuffers, 2 punch-ladles, 16 candlesticks for card-tables, 4 spirit-lamps or night-lamps. The total cost of all this tableware, not all of which was silver, for some of the plates were porcelain, was calculated at 2,300 *taler*. This list is certainly very comprehensive, including as it does everything which could possibly be needed in a manorial household. Silver tea-pots, coffee-pots and milk-jugs are listed separately. The list of items considered suitable for *Offizianten*, which means those members of the royal household who did not eat at the sovereign's table, is much more modest. We do not know how many people were expected to use the pewterware in the following list, but we can assume that it was 48, since there are that number of soup-plates and knives and forks. It is not clear whether the silverware was for 60 people, in that there are 60 sets of cutlery, or for 24 people, which is the number of soup-plates mentioned. The *Offizianten* were expected to make do with the following items of pewterware:

4 tureens, 16 large bowls, 16 smaller bowls, 48 soup-plates, 144 ordinary plates, 4 serving spoons, 48 sets of knives and forks, 48 metal spoons. All of this was expected to add up to a cost of 178 *taler*, which is considerably less than the 2,300 *taler* earmarked for the silverware in a manorial household.

The author also makes certain recommendations for what he calls second-class households, which are somewhat lower down the scale in social rank, splendour and wealth, and also for a third class of landed gentry and urban nobility, with less money to spare for equipping their households. This third category included the richer members of the middle classes, such as merchants. The pewter dinner-service mentioned may be intended for just this type of person; it comprises the following items:

1 silver-type *plat de ménage*
1 silver-type oval tureen, large
1 silver-type oval tureen, medium
1 silver-type oval tureen, small
1 silver-type round tureen, large
1 silver-type round tureen, medium
1 silver-type round tureen, small

Metalwork

1 round flat tureen, large
1 round flat tureen, medium
1 round flat tureen, small
1 round flat tureen, very small
1 oval roasting-dish, large
1 oval roasting-dish, medium
1 oval roasting-dish, small
1 round bowl, large
1 round bowl, medium
1 round bowl, small
1 bowl with a high rim
1 lid or cover for the bowls
1 lid or cover for the silver-type bowls
2 lids or covers for the bowls, of a simpler design
1 large hollowed *assiette*
1 small hollowed *assiette*
24 soup-plates
24 ordinary plates
Warming-plates
Sweetmeat dishes in the shape of vine-leaves
Serving-dishes
1 mustard-pot
1 silver-type sugar-dredger
Silver-type salad-plates
Round sauce-boats
Silver-type sauce-boats
1 small salt-cellar
1 silver-type salt-cellar
1 ordinary salt-cellar with a lid
1 long salt-cellar with compartments, lids, garlands and feet
24 soup-bowls
1 large soup-spoon with decorated handle
1 large soup-spoon with plain handle
1 punch-ladle, silver-type
6 spoons with shell decoration
6 large children's spoons
1 butter-dish
1 small butter-dish
1 three-branched candlestick
1 two-branched candlestick
1 pair of large silver-type candlesticks
1 pair of wreathed candlesticks, small
1 pair of candlesticks with projecting sockets
1 pair of ordinary candlesticks
1 wall candle-bracket with handle
1 snuffer tray
 The cost so far was calculated at about 150 *taler* but the list then continues with:
1 silver-type oval wash-basin
1 oval wash-basin without a water-jug
1 water-jug on its own
1 round wash-basin
1 chamber-pot
Beakers of various sizes
1 drinking-vessel
Lamps
Night-lamps
1 sewing-lamp

210

1 hot-water bottle
1 barber's bowl
1 dish for holding soap-balls
1 inkwell
1 ink-stand with candlestick and shade

This list shows that pewterers were quite capable of matching silversmiths in the design and variety of their goods. The total cost of the pewter articles in our list was only one-fifteenth of the cost of the silver items for the royal household to which we referred at the beginning.

Postscript

At the end of this book on the social development of metalwork, I would like to thank all those who have supported me with advice, help, information and suggestions.

Mr Hugh Honour has been responsible for the new approach to the study of the decorative arts, which not only relates them to development, but also takes into consideration the life and social circumstances of the men who lived and worked with these objects. I am particularly grateful to him for his advice. In conversations and correspondence over a period of years I have been given many useful suggestions in the field of pewter, for which I am most indebted to him.

The publishers Weidenfeld and Nicolson have taken a lively and personal interest in the publication of this book, and the author wishes particularly to thank Miss Margaret Willes, Miss Vivienne Menkes and Mr Michael Raeburn.

HANNS-ULRICH HAEDEKE

Bibliography

GENERAL

Aitchison, Leslie, *A History of Metals*, 2 vols. London, 1960

Alexander, N. and Street, A., *Metals in the Service of Man*, London, 1956

Babeau, A., *La vie rurale dans l'ancienne France*, Paris, 1883

Benesch, L. von, *Old Lamps of Central Europe*, Rutland, Vermont, 1963

Chubb, G.C.H., 'Locks and Keys', *Antiques International* (edited by Peter Wilson). London, 1966, pp. 70–9

Coulton, George Gordon, *Life in the Middle Ages*, Cambridge, 1954

—, *Social Life in Britain*, Cambridge, 1956

—, *Mediaeval Village, Manor and Monastery*, New York, 1960

Curle, Alexander O., 'Domestic Candlesticks from the Fourteenth to the end of the Eighteenth Century', *Proceedings of the Society of Antiquaries of Scotland*, vol. LX (Edinburgh, 1925–6), pp. 183–211

Curtil-Boyer, C., *L'histoire de la clef*, Paris, n.d., 1969

Delourneaux, N., *La Vie quotidienne au Temps de Jeanne d'Arc*, Paris, 1952

Eras, V.J.M., *Locks and Keys throughout the Ages*, Dordrecht, 1957

Forbes, R.J., *Metallurgy in Antiquity*, Leiden, 1950

Gevaert, Suzanne, *Histoire des arts du métal en Belgique*, 2 vols. Brussels, 1951

Goodwin-Smith, R., *English Domestic Metalwork*. Leigh-on-Sea, 1937

Henriot, G., *Encyclopédie du luminaire*, 2 vols. Paris, 1933–4

Kisch, Bruno, *Scales and Weights. A Historical Outline*, Yale University Press, 1965

Lindsay, J. Seymour, *Iron and Brass Implements of the English House*, 2nd ed. London, 1964

Lister, Raymond, *The Craftsman in Metal*, London, 1966

New York: Cooper Union Museum for the Arts of Decoration, *Enamel: an historic survey to the present day*, New York, 1954

Rickard, T.A., *Man and Metals*, 2 vols. New York, 1932

Smith, C.S., *A History of Metallography*, Chicago, 1960

Swarzenski, Georg, *Profane work in the High Middle Ages*; in Bulletin. mus. Boston, vol. 47, 1949(270) S. 71–80

Metalwork Swarzenski, Hanns, *Monuments of Romanesque Art*, London, 1967 (2nd ed.)

Turner, T.H., *Manners and Household Expenses of England in the 13th and 15th centuries*, London, 1841

Waley, D., *Later Mediaeval Europe*, London, 1864

Wright, T., *Homes of Other Days*, London, 1871

Wurmbach, Edith, *Das Wohnungs-und Bekleidungswesen des kölner Bürgertums und die Wende des Mittelalters*, Bonn, 1932

COPPER, BRASS AND BRONZE

Bloch, Peter, *Siebenarmige Leuchter in Christlichen Kirchen*; in: Wallraf-Richartz-Jahrbuch XXIII, 1961, S. 55ff

Bonnin, Alfred, *Tutenag and Paktong*, Oxford, 1924

Bradbury, Frederick, *History of Old Sheffield Plate*, London, 1912

Burgess, F.W., *Chats on Old Copper and Brass*, revised ed. London, 1954

Coghlan, H.H., *The Prehistoric Metallurgy of Copper and Bronze in the Old World*, Oxford, 1951

Collon-Gevaert, Suzanne, *Histoire des arts du métal en Belgique*; in: Memoires, Académie Royale de Belgique, vol. 7, fasc. 1. Brüssel, 1951

Dettling, Käte, *Der Metallhandel Nürnbergs im 16. Jahrhundert*; in: Mitteilungen des Vereins für Geschichte der Stadt Nürnberg 27, 1928, S. 97ff.

Doorslaer, G. van, *L'Ancienne industrie de Cuivre à Malines*, Mecheln, 1929

Egg, Erich, *Nürnberger Messingwaren in Tirol*; in: Anzeiger des Germanischen Nationalmuseums 1965, Nürnberg 1965, S. 52ff

v. Falke and Frauberger, *Deutsche Schmelzarbeiten des Mittelalters*, Frankfurt/Main, 1904

v Falke and Meyer, *Romanische Leuchter und Gefässe. Giessgefässe der Gotik*, Berlin, 1935.

Hamilton, H., *History of the English Brass and Copper Industries*, London, 1926

Hauser, Arnold, *Sozialgeschichte der mittelalterlichen Kunst*, Hamburg, 1957

Jarmuth, Kurt, *Lichter leuchten im Abendland*, Braunschweig, 1967

Karl der Grosse, *Katalog der Ausstellung in Aachen*, 1965

Koning, D.A. Wittop, *Nederlandsche vijzels*, Deventer, 1953

Kovács, Eva, *Kopfreliquiare des Mittelalters*, Insel Verlag (Leipzig), 1964

Lippmann, Edmund von, *Entstehung und Ausbreitung der Alchemie. Mit einem Anhange: Zur älteren Geschichte der Metalle*, Berlin, 1919

Meyer, Erich, *Mittelalterliche Bronzen (Bilderhefte des Museums fur Kunst und Gewerbe Hamburg III)*, Hamburg, 1960

Montagu, Jennifer, *Bronzes*, London, 1963

Mummenhoff, Ernst, *Der Handwerker in der deutschen Vergangenheit*, Jena, 1924

Neumann, B., *Die Metalle*, Halle, 1914

Norris, Malcolm, *Brass Rubbing*, London, 1965

O'Dea, W.T., *The Social History of Lighting*, 1958

Peltzer, Arthur, *Geschichte der Messingindustrie und der künstlerischen Arbeiten in Messing (Dinanderien) in Aachen und den Ländern zwischen Mass und Rhein von der Römerzeit bis zur Gegenwart*, Aachen, 1909. Sonderabdruck aus Band XXX der Zeitschrift des Aachener Geschichtsvereins

214

Perry, J. Tavernor, *Dinanderie*, London, 1910

Presbyter, Theophilus, *Schedula diversarum artium*, ed. u. übers, von Albert Jlg. Wien, 1878

Radcliffe, A.F., *European bronze statuettes*, London, 1966

Robertson, R.A., *Old Sheffield Plate*, London, 1957

Savage, G., *A Concise History of Bronzes*, London, 1968

Sprengel, P. N., *Handwerk in Tabellen*, Berlin, 1767ff 4. Sammlung, Berlin, 1769

Squilbeck, J., *La dinanderie en Belgique*

Ständebuch, Das, *114 Holzschnitte von Jost Ammann mit Reimen von Hans Sachs 1568*, ed. Insel Verlag (Leipzig), 1960

Stengel, Walter, *Nürnberger Messinggerät*; in: Kunst und Kunsthandwerk XXI, 1918, S. 213ff.

Swarzenski, Georg, *Das Kunstgewerbe der Renaissance in Italien*; G. Lehnert, Illustrierte Geschichte des Kunstgewerbes, vol. 1, Berlin O.J., S. 49ff

Treue, Wilhelm, *Kulturgeschichte des Alltags*, Fischer Bücherei (1961)

Verster, A.J.G., *Bronze: altes Gerät aus Bronze, Messing und Kupfer*, Hannover, 1966

Walcher, von Molthein, Alfred, *Zur Geschichte unserer Küchen- und Apothken-mörser*; in: Österreichische illustrierte Rundschau. Wien, 1917

Weschsler-Kümmel, *Schöne Lampen, Leuchter und Laternen*, Heidelberg-München, 1962

Wietek, Gerhard, *Altes Gerät Feuer und Licht.* Oldenburg und Hamburg (1964)

Weigel, Christoff, *Abbildung der gemeinnützlichen Hauptstände bis auf alle Künstler und Handwerker, etc.* Regensburg, 1698. S. 315: über Galmei

Weitzmann-Fiedler, *Romanische Bronzeschalen mit mythologischen Darstellungen;* in: Zeitschrift für Kunstwissenschaft, Band X, 1956, S. 109ff und Band IX, 1957, S. 1ff

ARMS AND ARMOUR

Blackmore, H.L., *Guns and Rifles of the World*, London, 1965

Blair, Claude, *European Armour*, London, 1958

—, *European and American Arms*, London, 1962

—, *European Armour c. 1066 to c. 1700*, London, 1959

—, *Pistols of the World*, London, 1968

Hayward, J. F., *The Art of the Gunmaker*, London, Vol. I 1962, Vol. II 1963

Laking, G.F., *A Record of European Armour and Arms through Seven Centuries*, 5 vols., London, 1920–2

Norman, A.V. B., *Arms and Armour*, London, 1964

Oakeshott, R.E., *The Archaeology of Weapons*, London, 1960

—, *The Sword in the Age of Chivalry*, London, 1964

Peterson, Harold, L., *Arms and Armor in Colonial America*, Harrisburg, 1956

Reizenstein, Alexander von, *Der Waffenschmied*, München (1964)

Seitz, Heribert, *Blankwaffen*, Vol. I, Braunschweig; Vol. II, Braunschweig 1968

Stöcklein, Hams, *Meister des Eisenschnittes*, Esslingen, 1922

Thomas, Bruno, *Deutsche Plattnerkunst*, München, 1944

Metalwork Ullmann, *Das Werk der Waffenschmiede*, Essen, 1962
Wagner, ed., Zoroslaw Drobnà, Jan Durdik, *Tracht Wehr und Waffen des späten Mittelalters*, Prag, 1957

CUTLERY

Bailey, C.T.P., *Knives and Forks*, London, 1927
Essen und Trinken. Katalog der Ausstellung im Tiroler Landesmuseum Ferdinandeum. Innsbrück, 1962
Günther Schiedlausky, *Essen und Trinken*. München, 1959
Hayward, J.F., *English Cutlery*, Victoria and Albert Museum. London, 1956
Himsworth, J.B., *The Story of Cutlery from Flint to Stainless Steel*, London, 1953
Pagé, Camille, *La Coutellerie*, 6 vols., Chatellerault, 1896
Price, F.G. Hilton, *Old Base Metal Spoons*, London, 1908
Sheffield: Public Libraries. *Cutlery: a bibliography*, Sheffield, 1960
Uhlemann, Heinz R., *Alte Tischgesellen*, Bamberg, 1966

IRON AND STEEL

Ayrton, Maxwell and Silcock, Arnold, *Wrought Iron and its Decorative Use*, London, 1929
Beck, *Geschichte des Eisens*, Braunschweig, 1884
Blanc, *Le fer forgé*, Paris, 1954
Brickell, L., *Die Eisenhutten des Klosters Haima*, Marburg, 1889
Butter, Francis, *Locks and Lockmaking*, London, 1926
Clouzot, Henri, *Le fer forgé*, Paris, 1934
Coghlan, H.H., *Notes on Prehistoric and Early Iron in the Old World*, Oxford, 1956
Eudes, G., *Ferronnerie Ancienne*, Paris, 1955
—, *Ferronnerie Rustique et de Style*, Paris (ed. Charles Massin)
Foulkes, Charles, *Decorative Ironwork*, London, 1913
Frank, Edgar, B., *Old French Ironwork*, Cambridge, Mass., 1950
Friend, J. Newton, *Iron in Antiquity*, London, 1926
Gardener, J., *Ironwork*, London, 1892, 1896, 1922
Gloag, J., and Drinkwater, D., *A History of Cast Iron in Architecture*, London, 1948
Gardner, J. Starkie, *Ironwork*, 3 vols. (revised ed.). London, 1922–30
Hentschel, Walter, *Kursächsischer Eisenkunstguss*, Dresden, 1955
Höver, Otto, *Das Eisenwerk*, Tübingen, 4. Auflage, 1966
Husson, François, *Les Serruriers*, Paris, 1902
Johannsen, Otto, *Geschichte des Eisens*, Düsseldorf, 1925
Klein, R., *Le fer forgé dans la maison*, Paris, 1948
La serrurerie du XIV^e au XVIII^e siècle. Exposition . . . Toulouse, Musée Paul Dupuy, 1966
Lindsay, Seymour, *An Anatomy of English Wrought Iron*, London, 1964
Lister, Raymond, *Decorative Wrought Ironwork in Great Britain*, London, 1957
—, *Decorative Cast Ironwork in Great Britain*, London, 1960
Lüer, Hermann, Max Creutz, *Geschichte der Metallkunst*. I. Band: Kunstgeschichte der unedlen Metalle. Stuttgart, 1904

Made of Iron. Katalog der Ausstellung. University of St Thomas, Art Depart-
ment, Houston, Texas. Sept-Dz. 1966

Pedrini, A., *Il Ferro Battuto, Sbalzato e Cesellato nell' arte Italiana*. Milano, 1929

Phleps, Hermann, *Schmiedlekunst*, Berlin und Leipzig (1935)

Schlegel, F.W., *Kulturgeschichte der Türschlösser*, Duisburg, 1963

Schröder, Albert, *Deutsche Ofenplatten*, Leipzig, 1936

Schubert, H.R., *History of the British Iron and Steel Industry from c. 450 BC to
AD 75*, London, 1957

Straker, Ernest, *Wealden Iron*, London, 1931

Stuttmann, Ferdinand, *Deutsche Schmiedeeisenkunst*, Band I–V, München
(1927–30)

Verster, A. J. G., *Schönes Schmiedeeisen*, Hannover (1964)

Victoria and Albert Museum, *English Wrought-Iron Work*, London, 1950

PEWTER

Anon. ('Verfasser der Hausmutter'), *Entwürfe und Kostenberechnungen zur
Meublierung der Wohngebäude für Hausmütter sowohl als Hausväter von ver-
schiedenen Ständen*, Brandenberg, 1783

Antwerpen, Oudheidkundige Musea, Vleeshuis, *Catalogus* IX: *Tin. Antwerpen
o.J.*

Bapst, Germain, *L'Étain*, Paris (1884)

Boileau, *Livre des métiers, 1252;* ed. G. B. Depping, Paris, 1837

Bossard, G., *Die Zinngiesser der Schweiz und ihr Werk*, 2 vols., Zug, 1920–34

Cotterell, H.H., *Old Pewter: its makers and marks in England, Scotland and Ireland*,
London, 1929 (reprinted 1963)

Demiani, Hans, *François Briot, Caspar Enderlein und das Edelzinn*, Leipzig, 1897

Dexel, Walter, *Das Hausgerät Mitteleuropas*, Braunschweig, 1963

Dietz, Alexander, *Das Frankfurter Zinngiessergewerbe und seine Blütezeit um 18.
Jahrhundert*, Frankfurt/Main, 1903

Douroff, B.A., *Étains Francais*, Paris o.J.

Dubbe, B., *Tin en Tinnegieters in Nederland*, Zeist, 1965

Gahlnbäck, Johannes, *Russisches Zinn*, Vol. I: Moskau, Leipzig, 1928

—, Vol. II: Leningrad, Leipzig, 1932

Haedeke, Hanns-Ulrich, *Zinn*; in: Kunst und Antiquitätenbuch, herausgg.
von H. Seling. Heidelberg/München, 1957, S. 306ff

—, *Zinn*, Braunschweig, 1963

—, *Altes Zinn*, Leipzig, 1963

Harvard., H., *Dictionnaire de l'ameublement et de la décoration depuis le XIIIᵉ siècle
jusqu' à nos jours*, Vol. II, Paris o.J. Artikel Étain, Sp. 601ff

Hintze, Erwin, *Die deutschen Zinngiesser und ihre Marken.* 7 vols., Leipzig,
1921–31

—, *Nürnberger Zinn*, Leipzig, 1921

Kerfoot, J.B., *American Pewter*, New York, 1942

Markham, C.A., *Pewter Marks and Old Pewterware*, 1909

Massé, H.J.L.J., *Chats on Old Pewter*, 2nd ed., Edited by R.F. Michaelis,
London, 1949

Metalwork Michaelis, Ronald F., *Antique Pewter of the British Isles*, London, 1955

Tardy, *Les Étains Francais*, 4 vols., Paris, 1957–64

Tischer, Friedrich, *Böhmisches Zinn und seine Marken*, Leipzig, 1928

Verster, A.J.G., *Old European Pewter*, London, 1958

Welch, Charles, *History of the Worshipful Company of Pewterers of the City of London*, 2 vols., 1902

Wolfbauer, G., *Die Österreichischen Zinngiesser und ihre Marken*, Graz, 1934

Wood, Ingleby L., *Scottish Pewterware and Pewterers*, 1905

Index

Aachen (Aix-la-Chapelle), brass production, 28, 30, 31, 49, under Charlemagne, 32, 41–2; medieval, 43; sheet-brass producers, 105; utensils in, fifteenth century, 104; calamine, 30, 49; Minster, chandelier, 47; *see also* Charlemagne, court
Abd'er Rahaman II, 118
Absalom, monk of Trier, 53
agraffes, English pewter, *198*
Agricola, Georgius, *De Natura Fossilium*, 29
alloys, regulations, brass and bronze, 33; proportions in brass, 200-1-5; pewter, 166–7, 169–70, 205-1-1, 2, 207
Alman, Gil and Juan, 203-2-7
altars, enamelled, 51; pewter panel, *203*; portable, 42, 160, *5*; of S Spirito, Florence, 204-2-13
Altenberg, brass production, 28
Alton Towers triptych, *6*
America, silver, 21, 105
Ammann, Jost, *Ständebuch*, 105, 201-4-1, *1*, *47*, *83*, *140*, *194*, *211*
ampullae, 173, *198*
Amsterdam, 31; smiths' guild of St Loyen, 112
Anet, France, *184*
Anglesey, copper mines, 18

animal ewers, *see* aquamanile
animals, heraldic, in chimney backs, 159
Annunciation paintings, 71, 92–3, *59*; by Roger van der Weyden, XIII
Annunciation scene, embossed, *73*
Antwerp, well-cover of, 147
Apentager, Hans, 57
apothecaries, 86, 90, 91, 201-5-1
apprentices, admission, 61–2; work, 63; in England, 169; in Lüneberg, 122; in Nuremberg, 75, 77
aquamanile, 56–8, 67; bronze, 11; of chivalry, 56; equestrian, *42*, 57–8; Gothic, 57; heraldic, 57; lion, *44*, 56–7
Arabs, candlesticks, 98; *see also* Islam
architects, design pewterware, 197; French, design ironwork, 151
architecture, medieval, 53; seventeenth century, 95, 151–2; nineteenth century, cast-iron ware, 162–3, German, 162
Aristotle, 31
armour, 133–7; ceremonial, inlaid, 39, 136; costume, 136; cuirass, 136; decoration, 135–6; fluted, 135–6; Gothic, 135; Greenwich, IX; infantry, 137; mail, 133–4; plate-, 134, 135; provided for armies, 136, 204-3-2, for guilds, 136–7; being made, *150*; of Maximilian II, *154*; of Sigmund of Tyrol, *153*

armourers, 134–5; Guild welcome, *231*
Art Nouveau, 104, 107, 163, 196–7, 250
artists, design pewterware, 197; weapon decoration, sixteenth century, 126; bronze mortars, 88; sign work, 90, 201-5-2
astrolabes, 84, 85, *80*
Augsburg, 28, 126, 134, 194; Cathedral door, 42–3
Augustus the Strong, 202-5-6
Austria, 85; cauldrons, 68; wrought-iron, 146

badges, pilgrims', 173
banquets, medieval, 58, 131, 177; *see also* table manners; court, 77–8, 81; guild, 62, 63, 176
Barbarossa, Frederick, 47, 118
barbers, medieval, 62, 77
Barley, M. W., *The English Farmhouse*, 188
Baroque period, candlesticks, 100, 101; chandeliers, 93; flower motifs, 183–4, 185; French ironwork, 151; gilding, 38
basin-makers (-beaters, -pounders), 33, 76; of Nuremberg, 76–7, 78, 83, 84
basins; *see also* bowls; brass, 81, Gothic, 79; sixteenth century, 80, 81; copper, *bacinun* (pelvis), 58, cooling-, 22–3; Hanseatic, 58–9
Basle, Augst, 32; Cathedral treasure, 174

223

226